THE PORTRAIT AND FIGURE PAINTING BOOK

THE PORTRAIT AND FIGURE PAINTING BOOK

By Wendon Blake/Paintings by George Passantino

WATSON-GUPTILL PUBLICATIONS/NEW YORK

Published in the United States and Canada by Watson-Guptill Publications,
1515 Broadway, New York, N.Y. 10036

Library of Congress Cataloging in Publication data

Blake, Wendon.
 The portrait and figure painting book.

 1. Portrait painting—Technique. 2. Human figure
in art. 3. Figure painting—Technique. I. Pasantino,
George. II. Title.
ND1302.B55 751.4'5 79-14747
ISBN 0-8230-4095-X

Manufactured in Japan

First Printing, 1979
3 4 5 6 7 8 9/86 85 84 83 82

CONTENTS

Painting Portraits and Figures. For many artists around the world, the human face and the human form are the ultimate subjects of art. No one can walk through the world's great museums without being haunted by the portraits and figures in which artists have expressed their deepest personal feelings about husbands, wives, and lovers; parents and children; heroes, friends, and strangers. And most artists will freely admit that they reveal most about *themselves* in their portraits and figures. Once you begin to paint *people*, you may find this subject so absorbing that other subjects become pale by comparison. Like many painters, you may discover that there's no thrill as intense as watching a real human being come to life as your brush moves over the canvas.

Direct Oil Painting. Oil paint is the most popular medium for painting portraits and figures—and this book is about the oil painting method that professionals call the *direct technique*. In the pages that follow, you'll learn how to paint portraits of adults, children's portraits, and nudes—all in a rapid, spontaneous way that reflects the special character of oil paint. What makes oil paint so remarkable is that it stays wet and pliable for several days; thus you can keep working on the entire surface of an oil painting as long as the color stays wet. Working in the direct oil technique, you begin with a simple brush drawing in tube color diluted with turpentine to a very fluid consistency; then you mix the exact color you want on the palette and brush it onto the canvas, where it stays wet and patiently awaits your next move. Without waiting for the first layer of paint to dry, you can then alter the hue by brushing a second color over the first and mixing them right on the canvas. You can pile thick color over thin. You can start with broad strokes and paint right over them with small, precise strokes, without waiting for the broad strokes to dry. It's all one continuous operation, and the whole painting is a single, juicy layer of wet paint filled with spontaneous brushwork.

How to Use This Book. The basic principle of this book is "learning by doing." You'll see every painting operation demonstrated step-by-step by George Passantino, a noted contemporary oil painter who's won great admiration for his portraits and figures. You'll watch "over his shoulder," as Passantino paints an extraordinary variety of sitters—different racial and ethnic types, hair and skin colors, poses, backgrounds, and lighting effects. In these demonstrations, each illustration shows a stage in the progress of the painting, while the accompanying text describes the exact painting procedure. Having seen Passantino do it, you should then try the process yourself. This doesn't mean that you should copy the paintings in the book. Find a similar subject and attempt a similar painting, using the same methods you've seen in the demonstration.

How This Book Is Organized. You'll find that this book is divided into three parts: "Portraits in Oil," "Children's Portraits in Oil," and "Figures in Oil." Part One, "Portraits in Oil," shows you how to paint portrait heads of adults of various ages, ranging from sitters in their twenties to a sitter in his sixties. Part Two, "Children's Portraits in Oil," shows you how to paint portraits of children who range from pre-school age to teenagers. And Part Three, "Figures in Oil," demonstrates how to paint the female nude, both indoors and outdoors.

Portraits in Oil. After introducing the fundamental painting tools, painting surfaces, colors, mediums, and studio equipment, Part One presents the basic information you need to paint a typical head. You'll find information about the proportions of the head and the placement of the features; the basic steps in painting a head; and the steps in painting the eyes, nose, mouth, and ears. Then you'll watch George Passantino paint a series of ten complete portrait heads in color. These demonstrations are followed by suggestions about composition and lighting plus demonstrations that show you how to draw portraits in pencil, charcoal, and chalk—and how to make an oil sketch.

Children's Portraits in Oil. Part Two begins with demonstrations that show you the basic steps in painting the head of a young girl and a young boy. You'll learn how to paint the individual features of a child's head—the eye, nose, mouth, and ear. Then a series of ten step-by-step painting demonstrations in color show you how to paint children with various hair and skin tones. These demonstrations are followed by analyses of the head proportions of children of various ages; recommendations about lighting children's portraits; and demonstrations of various black-and-white media for children's portraits: pencil, chalk, and charcoal drawing, plus oil sketching.

Figures in Oil. Part Three begins with a series of demonstrations that show you the steps in painting a female head; the front, three-quarter, and back views of the female torso; the arm and leg. Then you'll watch ten step-by-step painting demonstrations in color; Passantino shows you how to paint a variety of poses and views of the figure. After these demonstrations, you'll study the proportions of the figure; learn the various ways to light the figure; and watch Passantino demonstrate figure drawing techniques in pencil, chalk, and charcoal, as well as figure sketching in oil.

Color Selection. For mixing flesh and hair tones, portrait and figure painters lean heavily on warm colors—colors in the red, yellow, orange, and brown range. As you'll see in a moment, these colors dominate the palette. However, even with a very full selection of these warm colors, the palette rarely includes more than a dozen hues.

Reds. Cadmium red light is a fiery red with a hint of orange. It has tremendous tinting strength, which means that just a little goes a long way when you mix cadmium red with another color. Alizarin crimson is a darker red with a slightly violet cast. Venetian red is a coppery, brownish hue with considerable tinting strength too. Venetian red is a member of a whole family of coppery tones that include Indian red, English red, light red, and terra rosa. Any one of these will do.

Yellows. Cadmium yellow light is a dazzling, sunny yellow with a tremendous tinting strength, like all the cadmiums. Yellow ochre is a soft, tannish tone. Raw sienna is a dark, yellowish brown as it comes from the tube, but turns to a tannish yellow when you add white—with a slightly more golden tone than yellow ochre. Thus, yellow ochre and raw sienna perform similar functions. Choose either one.

Orange. You can easily mix cadmium orange by blending cadmium red light and cadmium yellow light. So cadmium orange is really an optional color—though it is convenient to have.

Browns. Burnt umber is a rich, deep brown. Raw umber is a subdued, dusty brown that turns to a kind of golden gray when you add white.

Blues. Ultramarine blue is a dark, subdued hue with a faint hint of violet. Cobalt blue is bright and delicate.

Green. Knowing that they can easily mix a wide range of greens by mixing the various blues and yellows on their palettes, many professionals don't bother to carry green. However, it's convenient to have a tube of green handy. The bright, clear hue called viridian is the green that most painters choose.

Black and White. The standard black used by almost every oil painter is ivory black. Buy either zinc white or titanium white; there's very little difference between them except their chemical content. Be sure to buy the biggest tube of white that's sold in the store; you'll use lots of it.

Linseed Oil. Although the color in the tubes already contains linseed oil, the manufacturer adds only enough oil to produce a thick paste that you squeeze out in little mounds around the edge of your palette. When you start to paint, you'll probably prefer more fluid color. So buy a bottle of linseed oil and pour some into that little metal cup (or "dipper") clipped to the edge of your palette. You can then dip your brush into the oil, pick up some paint on the tip of the brush, and blend oil and paint together on your palette.

Turpentine. Buy a big bottle of turpentine for two purposes. You'll want to fill that second metal cup clipped to the edge of your palette so that you can add a few drops of turpentine to the mixture of paint and linseed oil. This will make the paint even more fluid. The more turpentine you add, the more liquid the paint will become. Some oil painters like to premix linseed oil and turpentine 50-50 in a bottle to make a thinner *painting medium*, as it's called. They keep the medium in one palette cup and pure turpentine in the other. For cleaning your brushes as you paint, pour more turpentine into a jar about the size of your hand and keep this jar near the palette. Then, when you want to rinse out the color on your brush and pick up a fresh color, you simply swirl the brush around in the turpentine and wipe the bristles on a newspaper.

Painting Mediums. The simplest painting medium is the traditional 50-50 blend of linseed oil and turpentine. Many painters are satisfied to thin their paint with that medium for the rest of their lives. On the other hand, art supply stores do sell other mediums that you might like to try. Three of the most popular are damar, copal, and mastic painting mediums. These are usually a blend of natural resin—called damar, copal or mastic, as you might expect—plus some linseed oil and some turpentine. The resin is really a kind of varnish that adds luminosity to the paint and makes it dry more quickly. Once you've tried the traditional linseed oil-turpentine combination, you might like to experiment with one of these resinous mediums. You might also like to try a gel medium. This is a clear paste that comes in a tube.

Palette Layout. Before you start to paint, squeeze out a little dab of each color on your palette, plus a *big* dab of white. Establish a fixed location for each color so that you can find it easily. One good way is to place your *cool* colors (black, blue, green) along one edge and the *warm* colors (yellow, orange, red, brown) along another edge. Put the white in a corner where it won't be soiled by the other colors.

Bristle Brushes. The brushes most commonly used for oil painting are made of stiff white hog bristles. The filbert (top) is long and springy, comes to a slightly rounded tip, and makes a soft stroke. The flat (center) is also long and springy, but has a squarish tip and makes a more precise, rectangular stroke. The bright (bottom) also has a squarish tip and makes a rectangular stroke, but it's short and stiff, digging deeper into the paint and leaving a strongly textured stroke.

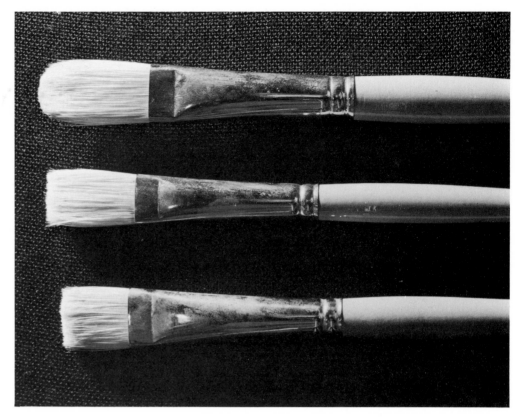

Softhair Brushes. Although bristle brushes do most of the work in an oil painting, it's helpful to have softhair brushes for smoother, more precise brushwork. The top two are sables: a small, flat brush that makes smooth, rectangular strokes; and a round, pointed brush that makes fluent lines for sketching in the picture and adding linear details like a strand of hair or the dark line of a nostril. At the bottom is an oxhair brush, and just above it is a soft, white nylon brush; both make broad, smooth, squarish strokes.

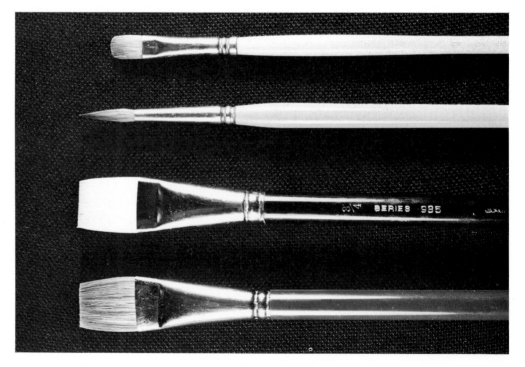

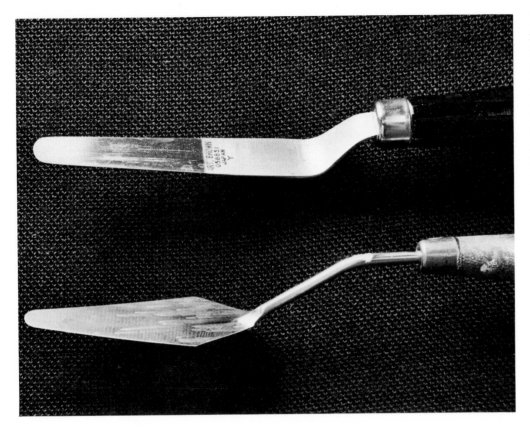

Knives. A palette knife (top) is useful for mixing color on the palette, for scraping color off the palette at the end of the painting session, and for scraping color off the canvas when you're dissatisfied with what you've done and want to make a fresh start. A painting knife (bottom) has a very thin, flexible blade that's specially designed for spreading color on canvas.

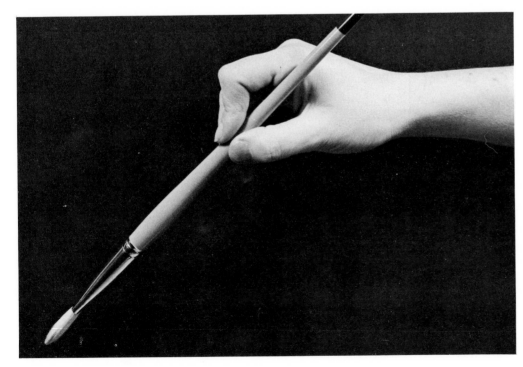

Holding the Brush. Your brushwork will be bold, free, and relaxed if you hold the brush halfway up the handle. As you become more confident, your strokes may become bolder still, and you'll want to hold the brush still further back. There *may* be times when you'll want to hold the brush closer to the bristles in order to paint precise details; but don't get into the habit, or your strokes will become small and constrained.

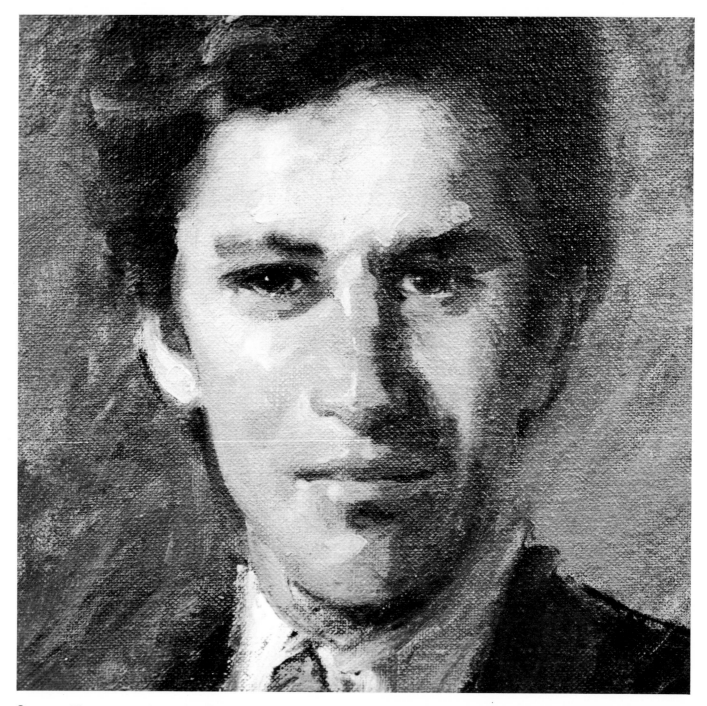

Canvas. The most popular surface for oil painting is cotton or linen canvas. Canvas boards—made of inexpensive fabric covered with white paint and glued to stiff cardboard—are sold in practically every art supply store. You can also buy a pad of special paper that's designed specifically for oil painting; the paper has the same texture as canvas, but it's a lot less expensive. Beginners usually start by painting on canvas boards or on canvas-textured paper. Later on they switch to stretched canvas—canvas nailed to a rectangular wooden framework. The weave of the canvas creates a lovely, slightly irregular texture that softens your brushstrokes and makes it easy to blend the paint. The fibrous surface of the canvas actually softens the strokes, as you can see in the soft edges of the shadows on this strongly lit face. The texture of the canvas generally shows through unless you apply the paint very thickly.

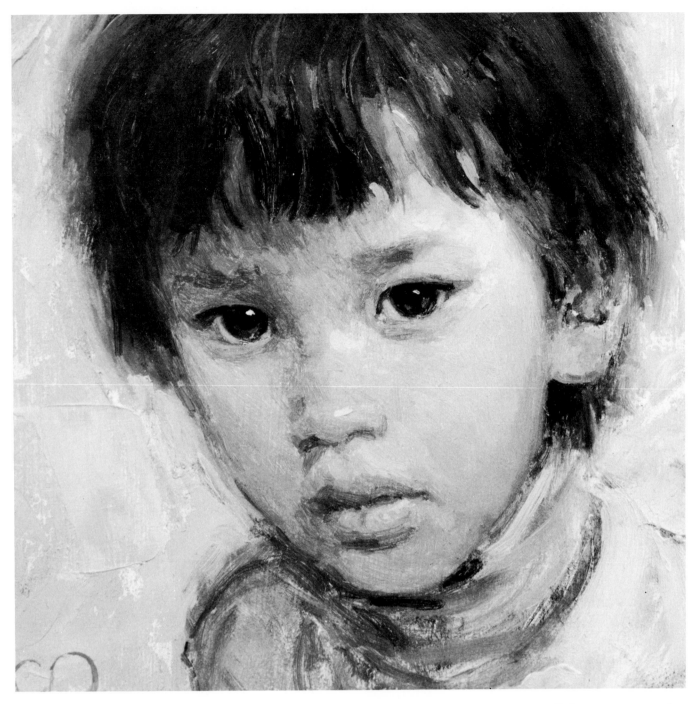

Panel. Some painters prefer to work on the smoother surface of a panel. Today, this is usually a sheet of hardboard that's the modern replacement for the wood panels used by the old masters. Like canvas boards and stretched canvas, the panel is coated by the manufacturer with a layer of white oil paint or white gesso. It's easy and inexpensive to prepare your own panels. Most art supply stores stock acrylic gesso, a thick, white paint that you brush onto the hardboard with a nylon housepainter's brush. As it comes out of the jar or the can, the gesso is thick. For a smooth painting surface, thin the gesso with water to a milky consistency and then apply several coats. If you like a rougher painting surface, apply the gesso undiluted or add just a little water; your nylon brush will leave delicate grooves in the gesso. The brush glides more smoothly over a panel than it does over canvas, so the whole painting looks a lot smoother. Because there's no canvas texture to soften and blur the stroke, the marks of the brush are often more distinct. You can see the difference in the brushwork if you compare the clearly defined brushwork in this little boy's hair with the softer, more blurry brushwork of the man's hair on the facing page. Or compare the smooth texture of the little boy's cheek with the rougher texture of the face painted on canvas.

EQUIPMENT

Easel. A wooden studio easel is convenient. Your canvas board, stretched canvas, or gesso panel is held upright by wooden grippers that slide up and down to fit the sides of the painting. They also adjust to match your own height. Buy the heaviest and sturdiest you can afford so that it won't wobble when you attack the painting with vigorous strokes.

Paintbox. A paintbox usually contains a wooden palette that you can lift out and hold as you paint. Beneath the palette the lower half of the box contains compartments for tubes, brushes, knives, bottles of oil and turpentine, and other accessories. The lid of the palette often has grooves into which you can slide two or three canvas boards. The open lid will stand upright—with the help of a supporting metal strip, which you see at the right—and can serve as an easel.

Palette. The wooden palette that comes inside your paintbox is the traditional mixing surface that artists have used for centuries. A convenient alternative is the paper tear-off palette: sheets of oilproof paper that are bound together like a sketchpad. You mix your colors on the top sheet, which you then tear off and discard at the end of the painting day, leaving a fresh sheet for the next painting session. This takes a lot less time than cleaning a wooden palette. Many artists also find it easier to mix colors on the white surface of the paper palette than on the brown surface of the wooden palette, since the paper is the same color as the white canvas.

Palette Cups (Dippers). These two metal cups have gripping devices along the bottom so you can clamp the cups over the edges of your palette. One is for turpentine or mineral spirits (white spirit in Britain) to thin your paint as you work. The other cup is for your painting medium. This can be pure linseed oil; a 50-50 blend of linseed oil and turpentine that you mix yourself; or a painting medium which you buy in the art supply store—usually a blend of linseed oil, turpentine, and a natural resin such as damar, copal, or mastic. Be sure to clean your palette cups at the end of the painting day or they'll get gummy.

Brush Washer. To clean your brush as you paint, rinse it in a jar of turpentine or mineral spirits. To create a convenient brush washer, save an empty food tin after you remove the top; turn the tin over so the bottom faces up; then punch holes in the bottom with a pointed metal tool. Drop the tin into a wide-mouth metal jar—with the perforated bottom of the tin facing up. Then fill the jar with solvent. When you rinse your brush, the discarded paint will sink through the holes to the bottom of the jar, and the solvent above the tin will remain fairly clean.

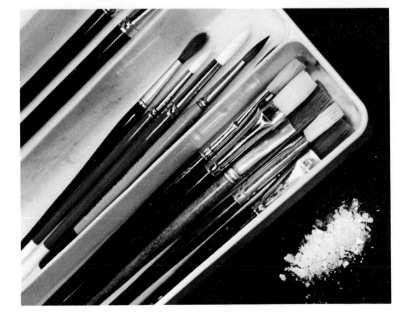

Storing Brushes. If you don't use brushes regularly, it's wise to store them in a shallow box—or a silverware tray like this one—and put them in a drawer with moth-killing crystals. Professionals, who use their brushes almost every day, store them in a jar, bristle end up. Of course, you can also store the brushes in your paintbox—but don't forget to add the moth crystals.

Step 1. If you want to stretch your own canvas, buy wooden stretcher bars at your art supply store. These are wooden strips with slotted ends that fit together to make a rectangular frame. You'll need four bars, one for each side of the frame. The best nails for stretching canvas are 3/8″ or 1/2″ (9-12 mm) carpet tacks.

Step 2. When you assemble the slotted stretcher bars, they should fit together tightly without the aid of nails or glue. Check them with a carpenter's square to make sure that each corner is a right angle. If the corners aren't exactly right, it's easy to adjust the bars by pushing them around a bit.

Step 3. Cut a rectangle of canvas that's roughly 2″ (50 mm) larger than the stretcher frame on all four sides. As it comes from the store, one side of the canvas will be coated with white paint and the other side will be raw fabric. Place the sheet of canvas with the white side down on a clean surface. Then center the stretcher frame on the fabric.

Step 4. Fold one side of the canvas over the stretcher bar and hammer a single nail through the canvas into the edge of the bar—at the very center. Do exactly the same thing on the opposite stretcher bar, pulling the canvas tight as a drum and hammering a nail through the canvas into the edge of the bar. Then repeat this process on the other two bars so you've got a single nail holding the canvas to the centers of all four bars.

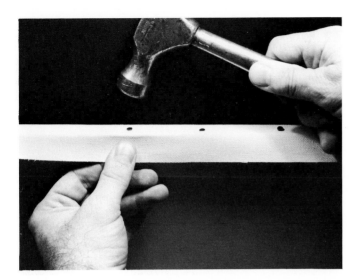

Step 5. Add two more nails to each bar—one on either side of the original nail, about 2″ (50 mm) apart. Working with the back of the canvas facing you, pull the canvas tight with one hand while you hammer with the other. Repeat this process on all four sides. Keep adding pairs of nails to each side, gradually working toward the corners. Pull the canvas as tight as you can while you hammer. At first, you may have trouble getting the canvas tight and smooth. Don't hammer the nails all the way in; let the heads stick up so you can yank the nails out and try again.

Step 6. When you get to the corners, you'll find that a flap of canvas sticks out at each corner. Fold it over and tack it to the stretcher as you see here.

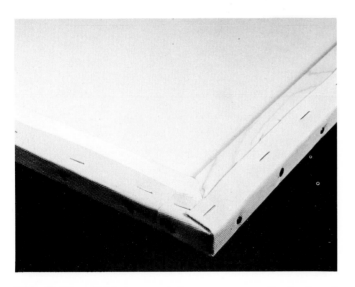

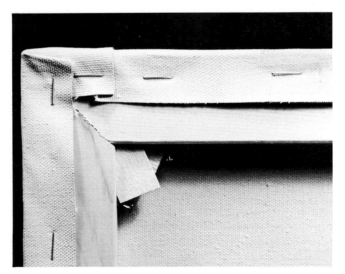

Step 7. Then fold the remaining canvas over the backs of the stretcher bars and staple it down to make a neat job. Speaking of staples, you might like to try using a staple gun for the whole job—instead of tacks or nails.

Step 8. Here's a close-up of the corner, seen from the back, showing the canvas all neatly folded and stapled down. Inside the corner of the stretcher bars you can see the ends of triangular wooden keys, which you hammer into the slots to stretch the canvas tighter if it's not absolutely smooth. Your art supply store will give you the keys when you buy the stretcher bars. Hold the keys in place by hammering small tacks behind them. If the canvas starts to loosen and get wavy later on, just hammer in the keys a little further.

Buying Brushes. There are three rules for buying brushes. Buy the best you can afford—even if you can afford only a few. Buy big brushes, not little ones; big brushes encourage you to work in bold strokes. And buy brushes in pairs, roughly the same size. For example, if you're painting the light and shadow planes of a face, you can use one big brush for the shadows, but you'll want another big brush, unsullied by dark color, to paint the skin in bright light.

Recommended Brushes. Begin with a couple of really big bristle brushes, about 1″ (25 mm) wide for painting your largest color area. Try two different shapes: possibly a flat and a filbert, one smaller than the other. Then you'll need two or three bristle brushes about half this size; again, try a flat, a filbert, and perhaps a bright. For painting smoother passages, details, and lines, three softhair brushes are useful: one that's about 1/2″ (12 or 13 mm) wide; one that's about half this wide; and a pointed, round brush that's about 1/8″ or 3/16″ (3-5 mm) thick at the widest point.

Knives. For mixing colors on the palette and for scraping a wet canvas when you want to make a correction, a palette knife is essential. Many oil painters prefer to mix colors with the knife. If you like to *paint* with a knife, buy a painting knife with a short, flexible, diamond-shaped blade.

Painting Surfaces. When you're starting to paint in oil, you can buy inexpensive canvas boards at any art supply store. These are made of canvas coated with white paint and glued to sturdy cardboard in standard sizes that will fit into your paintbox. Another pleasant, inexpensive painting surface is canvas-textured paper that you can buy in pads, just like drawing paper. (Many of the demonstrations in this book are painted on canvas-textured paper.) Later, you can buy stretched canvas—sheets of canvas precoated with white paint and nailed to a rectangular frame made of wooden stretcher bars. You can save money if you buy stretcher bars and canvas and assemble them yourself. If you like to paint on a smooth surface, buy sheets of hardboard and coat them with acrylic gesso, a thick, white paint that you can thin with water.

Easel. An easel is helpful, but not essential. It's just a wooden framework with two "grippers" that hold the canvas upright while you paint. The "grippers" slide up and down to fit larger or smaller paintings—and to match your height. If you'd rather not invest in an easel, you can improvise. One way is to buy a sheet of fiberboard about 1″ (25 mm) thick and hammer a few nails part way into the board so that the heads of the nails overlap the edges of the painting and hold it securely. Prop the board upright on a tabletop or a chair. Or you can just tack canvas-textured paper to the fiberboard.

Paintbox. To store your painting equipment and to carry your gear from place to place, a wooden paintbox is convenient. The box has compartments for brushes, knives, tubes, small bottles of oil and turpentine, and other accessories. It usually holds a palette and you can fit canvas boards inside the lid.

Palette. A wooden paintbox often comes with a wooden palette. Rub the palette with several coats of linseed oil to make the surface smooth, shiny, and nonabsorbent. When the oil is dry, the palette won't soak up your tube color and will be easy to clean at the end of the painting day. Even more convenient is a paper palette. This looks like a sketchpad, but the pages are nonabsorbent paper. You squeeze out your colors on the top sheet. When you're finished, you just tear off and discard the top sheet. Paper palettes come in standard sizes that fit into your paintbox.

Odds and Ends. To hold turpentine, linseed oil, or painting medium, buy two metal palette cups (or "dippers"). Make a habit of collecting absorbent, lint-free rags to wipe mistakes off your painting. Paper towels or old newspapers (a lot cheaper than paper towels) are essential for wiping your brush after rinsing it in turpentine.

Furniture. Be sure to have a comfortable chair or couch for your model. Not many people have the stamina to *stand* for hours while they're being painted! If you're working at an easel, you're probably standing while the model sits or sprawls—which means that the model is below your eye level. That's why professional portrait and figure painters generally have a model stand. This is just a sturdy wooden platform or box about as high as your knee and big enough to accommodate a large chair or even a small couch. If you're handy with tools, you can build it yourself. (Of course, you can always work sitting down!) Another useful piece of equipment is a folding screen on which you can hang pieces of colored cloth—which can be nothing more than old blankets—to create different background tones.

Lighting. If your studio or workroom has big windows or a skylight, that may be all the light you need. Most professionals really prefer natural light. If you need to boost the natural light in the room, don't buy photographic floodlights; they're too hot and produce too much glare. Ordinary floor lamps, tabletop lamps, or hinged lamps used by architects will give you softer, more "natural" light. If you have fluorescent lights, make sure that the tubes are "warm white."

PART ONE

PORTRAITS
IN OIL

Portraits in Oil. More portraits are painted in oil than in any other medium. For hundreds of years, oil paint has been the favorite medium of portrait painters—and the key to its popularity lies in the unique character of the paint itself.

What is Oil Paint? Like every other kind of artists' colors, oil paint starts out as dry, colored powder, called pigment. The pigment is then blended with a vegetable oil called linseed oil—squeezed from the flax plant, whose fibers are also used to make linen. Together the pigment and oil make a thick, luminous paste that the manufacturer packages in metal tubes. It's the oil that produces the buttery consistency that makes oil paint so easy to push around on the canvas. And the oil takes a long time to dry on the painting surface, giving you so much time to work on the picture, to experiment, and to change your mind as often as you like. The linseed oil is called the *vehicle*. But there's another liquid that's equally important in oil painting: a *solvent* that will make the paint thinner and more fluid and then evaporate as the paint dries. This solvent is usually turpentine, though some painters use mineral spirits (or white spirits, as it's called in Britain), which works the same way and is worth trying if you're allergic to turpentine. Oil painters usually add a bit of linseed oil *and* a bit of turpentine to the tube color to make it more brushable.

Handling Oil Paint. The rich, oily consistency of the color is what oil painters treasure most. The paint is a thick, semi-liquid paste as it comes from the tube, but when you add just a bit of linseed oil and turpentine, the color takes on a creamy consistency that's ideal for the delicate modeling of a face. It's a great delight to blend the lighted front of the forehead into the shadow side of the brow or add a hint of darkness in the hollow of the cheek with just a few soft strokes. The paint handles like warm butter, so pliable that you can blend one stroke or one color smoothly into another, producing beautiful gradations like colored smoke. If you add still more linseed oil and turpentine, the paint becomes fluid enough to paint crisp lines and precise details, such as strands of hair curling down over the ear or the highlight in the eye.

Drying Time. The gradual drying time of oil paint is one of its greatest advantages. The turpentine (or mineral spirits) evaporates in minutes, but the oil remains and takes days to dry solid. Actually, the oil never really evaporates, but simply solidifies to a tough, leathery film. Although some colors tend to dry faster than others, your painting does remain moist long enough for you to produce effects that aren't possible in any other medium. You can keep blending fresh color into the wet surface until you get the exact hue that you want. You can go over a passage with the brush, stroke after stroke, until you produce exactly the rough or smooth texture you want. And, if anything goes wrong, you can easily scrape off the wet color with a knife or wipe it away with a rag and turpentine.

Basic Techniques. Before you begin to paint complete portraits in color, it's important to study the human head. So after a quick review of the colors, mediums, and painting tools you'll need to paint portraits in oil, this book analyzes the proportions of a typical head and the placement of the features. Then noted portrait painter George Passantino paints a series of step-by-step demonstrations in black-and-white. First he paints a complete head to show you the basic procedure. Then he shows you how to paint close-ups of the eye, the mouth, the nose, and the ear. These black-and-white demonstrations are important because they show you how the basic forms of the head and features are revealed by the pattern of light and shadow. Study these demonstrations carefully and try painting some heads entirely in black-and-white. This is good practice before you go on to paint in color.

Painting Demonstrations. Following these black-and-white demonstrations, Passantino goes on to demonstrate how to paint ten different portrait heads in color. In these demonstrations, you'll find a wide range of hair and skin colors. You'll learn how to paint the pale skin tones of blond and redhaired sitters; the darker skin tones that are typical of sitters with brown and black hair; the deep tones of black skin and hair; and the oriental sitter's lovely contrast of golden skin and black hair. Each demonstration will show you how to execute the first monochrome brush drawing on the canvas; how to mix and apply all the colors; how to blend the colors and model the forms; and how to add the final touches that give so much vitality to the completed portrait.

Composing, Lighting, Drawing. Following the painting demonstrations, you'll find suggestions about how to direct and pose the sitter. You'll see some typical mistakes in composition—and how to avoid them. You'll study the different ways of lighting a portrait. And you'll watch Passantino demonstrate how to draw portraits in pencil, charcoal, and chalk—and how to make an oil sketch. When you're not painting, devote as much time as you can to drawing. Buy yourself a sketchpad of good, sturdy drawing paper and draw faces whenever you have a spare moment—friends, family, strangers. Drawing is not only fun in itself, but it's the best way to study the most fascinating and varied of all subjects: the human head.

Front View. Memorize the proportions of a "classic" head. Although no two heads are *exactly* alike, most heads are slight variations of this basic scheme. Seen from the front view, the "classic" head is taller than it is wide. The eyes are about midway between the top of the head and the chin. The underside of the nose is about midway between the eyes and the tip of the chin, while the edge of the lower lip is roughly midway between the tip of the nose and the tip of the chin. At its widest point, usually halfway down the head, the head is "five eyes wide." The space between the eye and the ear is the width of one eye. So is the space between the eyes.

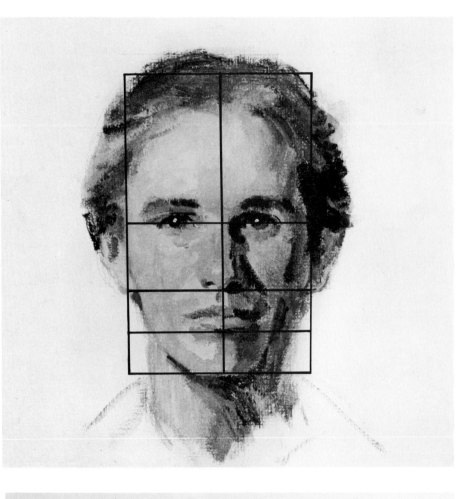

Profile View. Seen from the side, the "classic" head reveals the alignment of the features. The corner of the eye lines up with the top of the ear. The underside of the nose lines up with the lower edge of the earlobe. The lower lip lines up with the squarish corner of the jaw. Measuring from top to bottom and from front to back, the height and the width of the head are roughly equal in this side view. Without the neck the entire head would fit quite neatly into a square box.

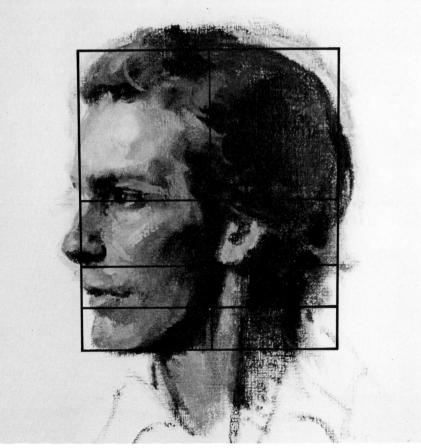

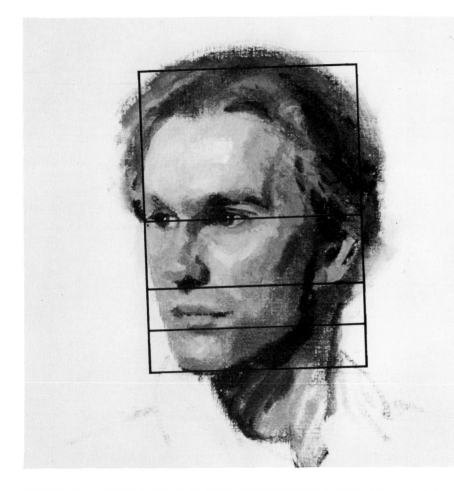

3/4 View. Even when the head turns slightly—so it's no longer a front or side view—the proportions remain essentially the same. The eyes are still halfway down the head and they line up with the top of the ear. The bottom of the nose is still midway between the eyes and the chin, aligning with the lower edge of the earlobe. And the lower lip still falls midway between the tip of the nose and the tip of the chin, lining up with the corner of the jaw.

3/4 View. This is also a 3/4 view, but now the head is seen from slightly above. The proportions are fundamentally the same, but you'll discover some very subtle differences if you look closely. The most obvious difference is that you see more of the top of the head. If you draw a line through the corners of the eyes, that line will slant downwards slightly from right to left. So will all the lines that are parallel with the line of the eyes. The dark, diagonal line of the jaw also has a slightly steeper slant. From this angle the nose looks just a bit longer, and you see less of the tops of the eyes. In painting a portrait note these subtle differences, but never lose sight of the essential proportions of the head.

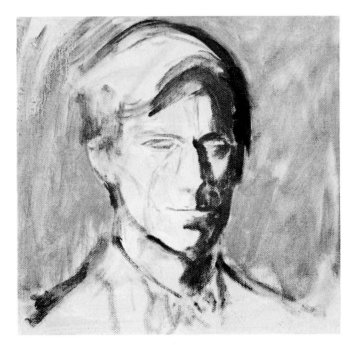

Step 1. A round, softhair brush defines the shapes and proportions of the head. Tube color is thinned with turpentine to the consistency of watercolor. The face is defined as an oval. Just a few lines locate the features. Notice the vertical center line that divides the face symmetrically and helps you to place the features more accurately.

Step 2. Next, a bristle brush defines the shapes of the shadows with broad strokes. The light comes from the left, so there are shadow planes on the right side of the hair, forehead, eye socket, cheek, lips, jaw, chin, and neck. Now there's a clear distinction between light and shadow. The face already looks three-dimensional.

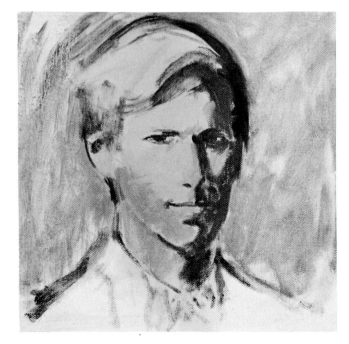

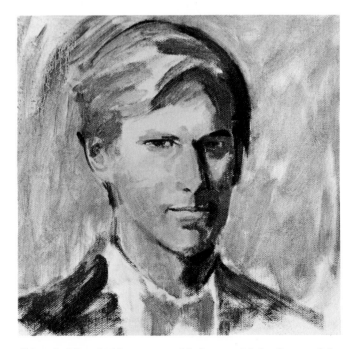

Step 3. A bristle brush covers the lighted area of the face—the forehead, brow, ear, cheek, nose, upper and lower lips, and the lightstruck patch on the cheek that's in shadow. Now the brush begins to add some halftones (lighter than shadows, but darker than lights) on the cheek, jaw, chin, and neck. Dark strokes begin to define the eyes and ear.

Step 4. More halftones are added to model the forms of the hair, ear, eyes, nose, mouth, and chin. A bristle brush begins to blend darks, lights, and halftones together. Dark strokes sharpen the edges of the features, and some touches of darkness bring the shoulders forward.

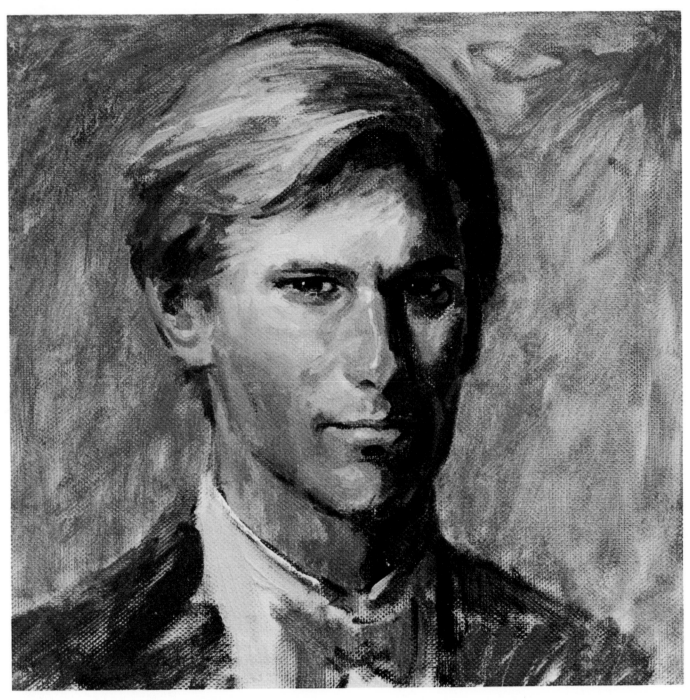

Step 5. In this final stage, a bristle brush strengthens the darks and the lights, blends the tones together, and adds the last touches of detail. Bristle brushes add darker strokes to deepen the shadows and the halftones, then pick up pale color to brighten the lights on the forehead, brow, cheeks, lips, and chin. These tones are brushed together with soft, back-and-forth strokes that blur the transitions between light, halftone, and shadow. The tip of a round softhair brush adds the dark lines of the eyebrows, eyes, nostrils, lips, and ear. This same round brush adds highlights to the eyes and touches of light along the nose and lips. A bristle brush suggests the texture of the hair with swift, spontaneous strokes that follow the direction of the hair. The background is darkened and the portrait is complete. Re-member the sequence of operations. The preliminary brush drawing defines shapes and proportions. The darks establish the light and shadow planes of the face. Lights and halftones come next. Darks, lights, and halftones are amplified and brushed together. Finally, the darks, lights, and halftones are further defined and adjusted—and the painting is completed with crisp touches of dark and light that define the features. You may have noticed that the background tone appears early in the development of the picture and is then modified in the final stage as the head is completed. A professional always remembers that the background is part of the picture—not an afterthought—and he works on the background as he works on the head.

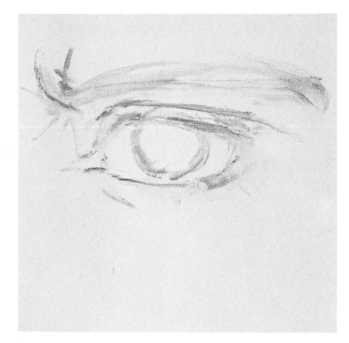

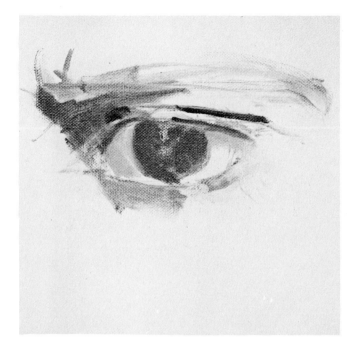

Step 1. A round softhair brush sketches the lines of the eyebrow, the lid, and the eye itself. Memorize the subtle contours of the lids. Starting from the outer corner, the top lid follows a long, flat curve, turning downward at the inside corner. The lower lid does the opposite, starting from the inside corner as a long, flat curve, then turning upward at the outside corner.

Step 2. A bristle brush scrubs in the darks: the shadow of the inside corner of the eye socket, the tone of the iris, and the shadow lines within the upper lid. Then a paler tone is brushed in to suggest the delicate shadow on the white of the eye and the shadow beneath the lower lid.

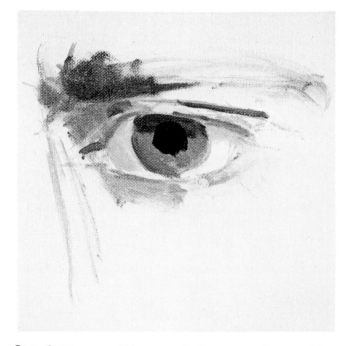

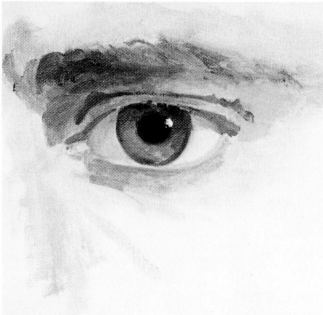

Step 3. The upper lid casts a shadow across the top of the iris—and this tone is added by a flat softhair brush. This same brush adds the dark pupil. The tip of a round softhair brush adds the shadow line in the corner of the eye and then paints a slender strip of light along the edge of the lower lid. A bristle brush begins to scrub in the hair of the eybrow.

Step 4. The tip of a round softhair brush strengthens and refines both the shadows within the upper lid and the shadow cast on the white of the eye. This same brush sharpens the rounded shape of the iris and the pupil, adding a brilliant white highlight. The shadows in the eye socket are strengthened. The round brush extends the eyebrow with delicate, linear strokes.

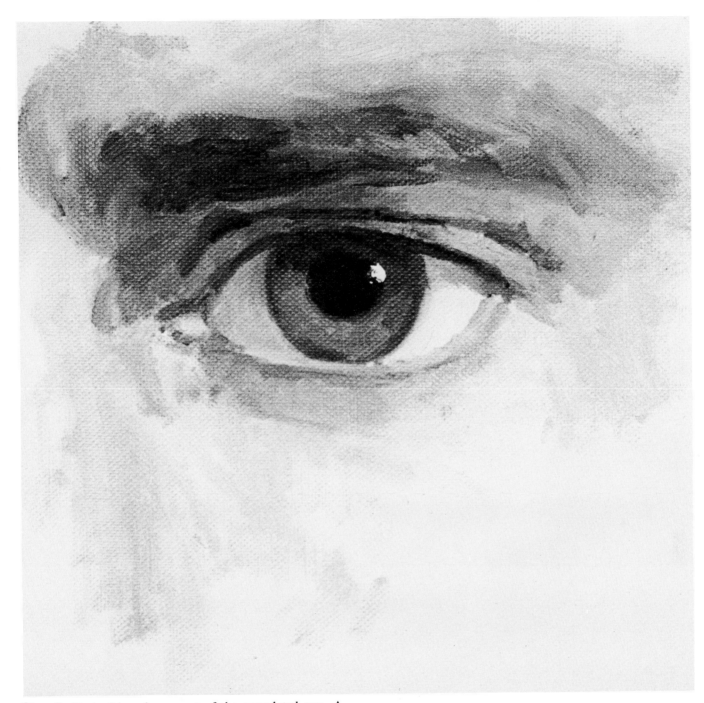

Step 5. Study this enlargement of the completed eye. A bristle brush has added more shadow beneath the brow to make the eye socket look deeper. A round softhair brush has strengthened the shadow lines within the upper lid. Notice the modeling of the lights and shadows on the eye itself. The eye is a rounded form, after all, so the lights and shadows should emphasize its curving shape. Thus the white of the eye is brightly lit at the right but curves gradually into shadow at the left. The three-dimensional form of the eye is emphasized by the strip of shadow that's cast by the upper lid and curves over the ball of the eye. The sequence of painting operations is the same sequence you've already seen in the step-by-step demonstration of the head: brush lines for form and proportion; broad masses of darks, halftones, and lights; final darks, lights, and details.

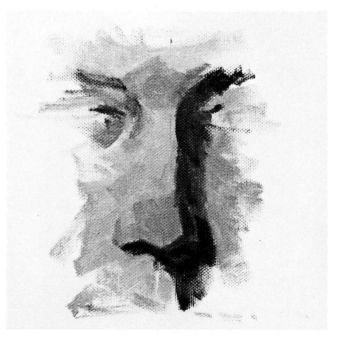

Step 1. The brush drawing not only defines the bridge of the nose and the nostrils, but also suggests such surrounding structures as the eye sockets and the center line of the upper lip. The lines also make a clear distinction between the shape of the tip of the nose and the "wings" of the nostrils.

Step 2. A bristle brush adds the darks. The light comes from the left and from slightly above, creating deep shadows in the corner of the eyesocket, beside the bridge and the tip of the nose, alongside the nostril "wing," beneath the nose, and on the side of the upper lip. The brush also indicates a halftone for the brow above the bridge of the nose.

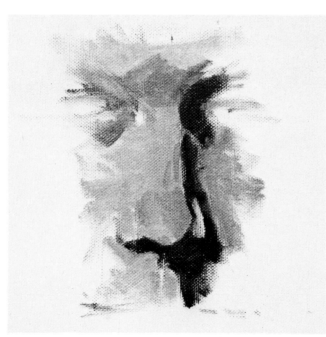

Step 3. The halftones and the lighter tones come next. The rounded corner of the eye socket on the lighted side of the face is modeled with a halftone. The nose and the cheeks are painted with lighter tones that are distinctly paler than the surrounding darks.

Step 4. The lights and halftones are strengthened, so you can now see a sharper distinction between the lighted bridge of the nose and the darker tones of the brow, eye socket, and tip. The darks are strengthened with strokes that define the contours of the nose more clearly, shape the "wings" of the nostrils, and indicate the darks of the nostrils themselves.

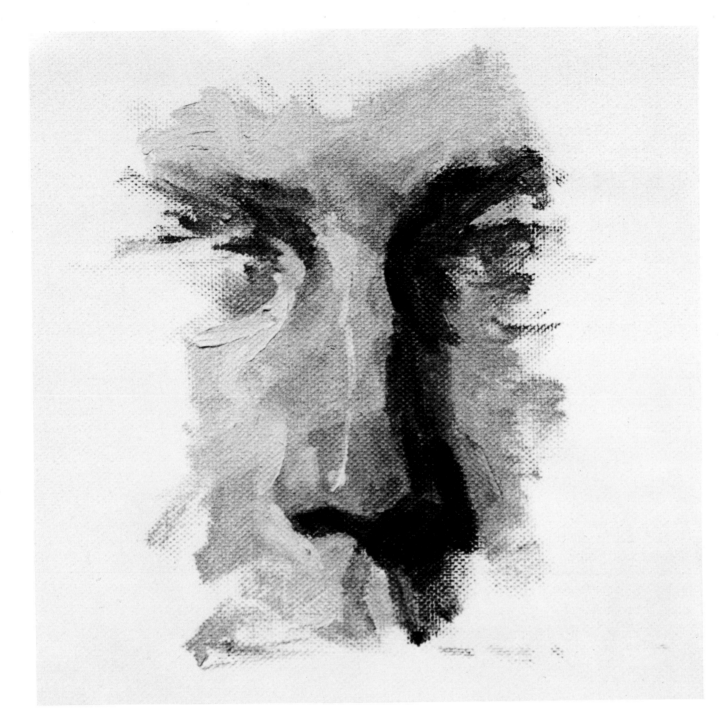

Step 5. In this final stage, the lighted bridge of the nose and the lighted cheek are adjusted with paler color. Additional dark strokes model the eye sockets and strengthen the shadow that's cast by the tip of the nose across the upper lip. Where the darks, lights, and halftones meet, they're gently brushed together to create soft transitions. You can see this most clearly in the tip of the nose, which now looks softer and rounder than in Step 4. Wherever shadow meets light or halftone, there's a soft, slightly blurred transition—except at the bridge of the nose, where a hard, dark edge suggests the sharp contour of the bone. With all the broad tones completed, a small softhair brush moves over the face to strike in touches of light such as the highlights on the nose and the light strokes where the nostril "wing" meets the cheek and upper lip. These final touches of light give luminosity to the skin.

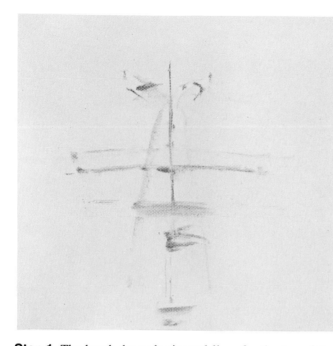

Step 1. The brush draws horizontal lines for the top of the upper lip, the division between the lips, and the bottom of the lower lip. It's important to visualize the mouth in relation to the nose and the chin, which are also indicated with quick touches of the brush. A vertical center line divides the face into equal halves and helps you to place the features symmetrically.

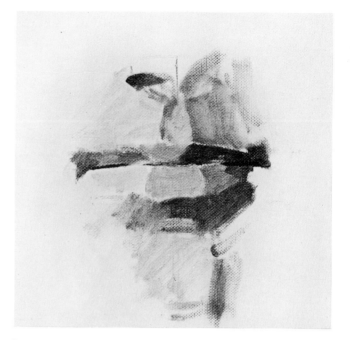

Step 2. The darkest notes are placed first—the underside of the upper lip, the shadow beneath the lower lip, and a nostril. Halftones define the planes above and below the lips, including the concave valley that joins the nose and the upper lip. The lightest tones are placed within this valley, at the center of the upper and lower lip, and at the center of the chin.

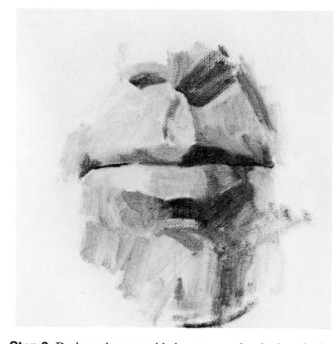

Step 3. Dark strokes are added to suggest the shadow that's cast by the corner of the nose plus the shadow on the side of the chin. Halftones are added around the lips and chin. The brush begins to blend these tones together with casual strokes that merge darks, halftones, and lights.

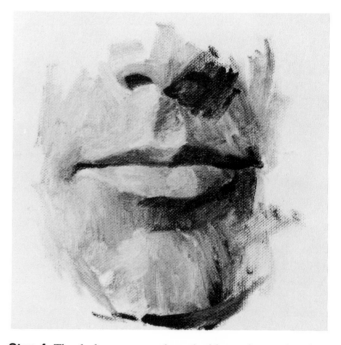

Step 4. The darks are strengthened with precise strokes that sharpen the contours of the lips, nose, and chin. The light planes are made still lighter to emphasize the contrast between light and shadow, making the face look more three-dimensional. A pointed brush sharpens the dividing line of the mouth, deepens the shadow beneath the lower lip, and adds the nostrils.

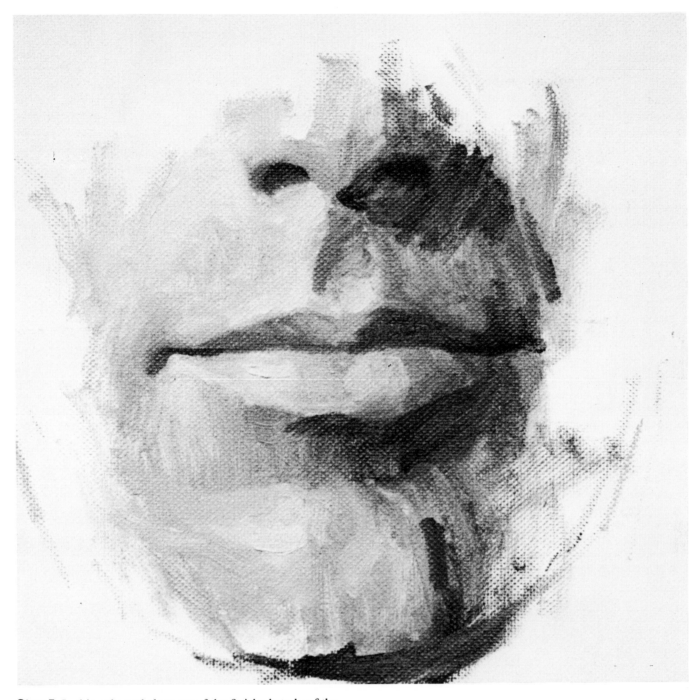

Step 5. In this enlarged close-up of the finished study of the mouth, you can see how the tones have been softened and blended to make the face look rounder and more lifelike. The brush has blurred the edges of the darks to make the nostrils and the lips look softer and rounder. Much of the scrubby brushwork around the mouth has been softened to make the strokes flow together more smoothly. Soft, blurry strokes of light have been added to the lower lip and the chin, which now come forward more distinctly. Notice how the corner of the mouth at the left has been darkened and softened. As you paint the mouth, you'll notice that the upper lip is usually in shadow, while the lower lip tends to catch the light. Beneath the lower lip there's another pool of shadow. As the chin curves outward, it catches the light and then moves back into shadow as it curves inward at the very bottom.

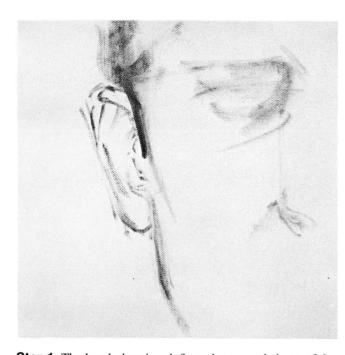

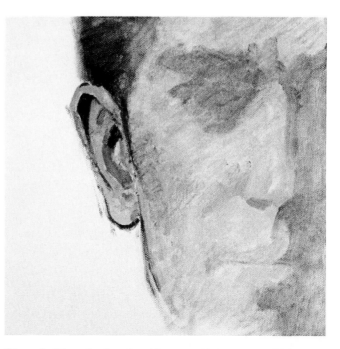

Step 1. The brush drawing defines the general shape of the ear and then locates the ear in relation to the eye, nose, cheek, and jaw. The curve of the cheek comes right next to the ear. The top of the ear aligns with the corner of the eye, while the lobe lines up with the nose. The angular corner of the jaw is well below the ear and level with the mouth.

Step 2. Dark strokes define the two deep shadows within the ear, the shadow beneath the lobe, the shape of the hair, and the dark edge of the jaw, which continues up past the lobe. With just these few dark touches, the ear already begins to look three-dimensional.

Step 3. The two pools of shadow within the ear are carried downward with strokes of halftone. The rest of the ear is covered with a pale tone that represents the light. Now the planes of the ear are clearly defined in three distinct tones: darks, halftones, and lights. So far, only the major planes of the ear have been defined.

Step 4. Now the brush adds more lights and halftones to define the smaller forms of the ear. A single stroke suggests the valley that appears just below the top rim—and a touch of light appears where the rim shines against the hair. Small strokes of halftone make the lobe look rounder where the ear joins the jaw.

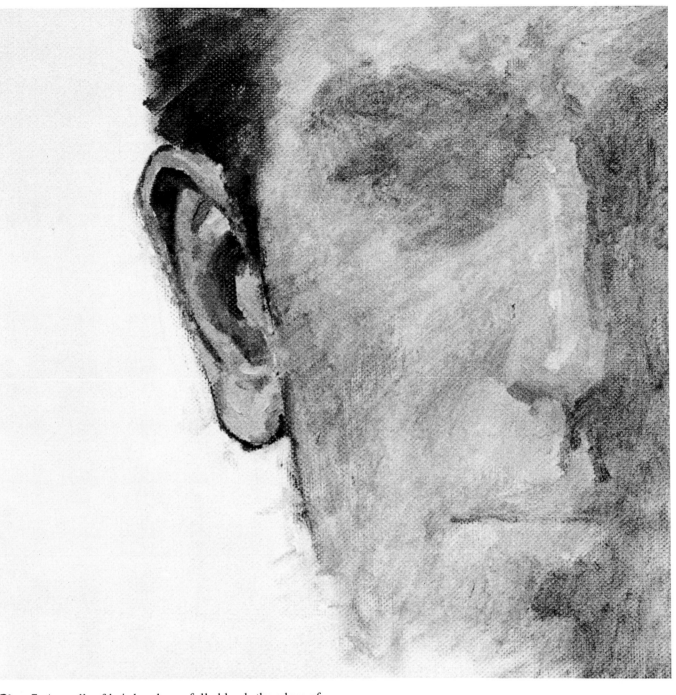

Step 5. A small softhair brush carefully blends the edges of the darks with the halftones and the lights. You can see this most clearly in the two pools of shadow, which are softened and blurred to make the tones flow together more smoothly. The point of the brush adds touches of darkness beneath the rim, within the hollow of the ear, and at the corner of the lobe. Then this same brush adds touches of light within the ear and the lobe. Now there's a much sharper contrast between the lights and shadows, although they flow softly together to make the forms of the ear look round and solid.

Preliminary Brush Drawing. In the demonstrations that follow, you'll see that George Passantino normally starts with a preliminary brush drawing in a single color—on a toned painting surface. He begins by selecting (or mixing) some color that will harmonize with the final painting, diluting this color with lots of turpentine, and scrubbing it casually over the canvas with a rag. This toned painting surface has two important functions. First, by quickly covering the canvas with color, you subdue that glaring white canvas—which beginners often find so intimidating that they're afraid to touch it with a brushload of paint. Now you can dive right in and start painting! Second, when you start to apply color on top of that toned canvas, you can see how your colors look in relation to an undertone that bears some resemblance to the final painting—instead of working on bare, white canvas that looks *nothing* like the final painting. The brush drawing is made with a darker version of this undertone, containing less turpentine. The drawing establishes the overall shape of the head, neck, and shoulders; the placement of the features; the general shapes of the features; and sometimes the broad pattern of lights and shadows.

Lights and Shadows. Using the preliminary brush drawing as a guide, but never hesitating to cover the original brushstrokes, Passantino then goes on to block in the shadows with thicker, richer color, diluted with painting medium rather than turpentine. Now the paint is more like the consistency of thin cream, in contrast with the original brush drawing, which is like watercolor. As soon as a few strong shadow shapes appear, the head suddenly begins to look three-dimensional. Next, Passantino usually turns to the lighter side of the face, covering the lights with broad strokes. Even at this early stage, the face beings to look "real" because there's a clear contrast between the lighted planes of the head and the planes that are in shadow. The paint is applied broadly and flatly, without any blending or detail. The purpose is to define the lights and shadows quickly and simply.

Halftones. Between the lights and the shadows are subtle tones that the professionals call *halftones*. When you look carefully at the head, you see that there isn't a sudden shift from light to shadow, but a transitional tone that connects the brightest and the darkest areas of the face. This transitional tone—or halftone—is darker than the lights but paler than the shadows. Halftones appear throughout the head in those areas which are neither light nor dark, but fall somewhere between these two extremes. Generally, Passantino applies the halftones next and then begins to blend the edges where the lights, darks, and half-

tones meet. The brushwork is still broad and free, with no precise details.

Blending, Refining, Heightening, Finishing. Having placed the lights, darks, and halftones where they belong, Passantino continues to blend these tones together—although you'll see that he doesn't overdo it. He doesn't "iron out" his tones to a smooth, mechanical finish, but handles the brush loosely, allowing the strokes to show. This is the stage at which forms and contours are modified to make the drawing more accurate. Shadows are strengthened and colors are enriched. The brush moves over the face, heightening the tones with touches of light and color. Finally, the artist focuses on a few details: the dark shapes of the nostrils and the pupils of the eyes; the line between the lips; a few strands of hair.

Summary of Painting Operations. That sequence of operations is worth remembering: toned canvas, preliminary brush drawing in one color, darks, lights, halftones, blending, refining, heightening, and final details. However, don't regard that as a fixed set of "rules." There's no law that says you've got to follow that sequence of operations rigidly every time. As you'll discover when you study the demonstrations, Passantino often varies his sequence of painting steps to suit the subject. Furthermore, in the excitement of painting, a lot of things start to happen by themselves and a lot of these operations begin to overlap. Ultimately, you'll find *your own* way of working. However, nearly all professional portrait painters agree that it's usually best to begin with big brushes and broad strokes—setting down the pattern of lights, shadows and halftones as simply as possible—and save the refinements, the details, and the small brushes for the very end.

Tips About Color Mixing. Above all, think before you mix. Don't wander around the palette, poking your brush into various colors at random, hoping that the mixture will turn out right. Decide on the exact hue you're hoping to mix and then pick the tube colors that look like they'll do the job. Remember that two or three colors, plus white, should give you just about any color mixture you need. More than three colors (not including white) usually produce mud. To keep your color fresh and clean, keep your brushes and knives as clean as possible. Before you pick up a new color, rinse your brush in turpentine and wipe off most of the turpentine on a sheet of newspaper or a paper towel. Pure tube color is generally too thick for lively, fluent brushwork, so get into the habit of adding enough painting medium to produce the rich, creamy consistency.

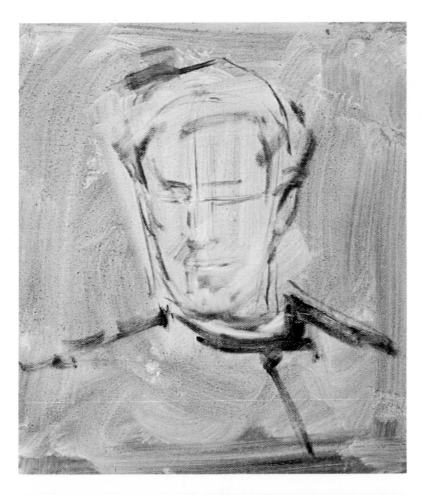

Step 1. A good way to start any portrait is to cover the white canvas with a tone. Against this tone the lights of the face will stand out more clearly, and you'll find it easier to decide how dark to make the darks. This portrait begins with a mixture of raw umber and ultramarine blue thinned with lots of turpentine and rubbed over the canvas with a rag. It's not important for the tone to be smooth; actually, the tone is more interesting if it's rough and irregular. The area of the face is lightened with a clean rag that removes most of the tone, but not all of it. A small bristle brush picks up the same mixture of raw umber and ultramarine blue—diluted with somewhat less turpentine—and sketches the outer shape of the head and hair. A vertical center line is drawn down the middle of the face to help locate the features on either side of the line. The brush establishes the location of the eyes, nose, and mouth with a few horizontal lines, making no attempt to draw the actual shapes of these features. The sketch is completed with several broad strokes for the shoulders and the collar.

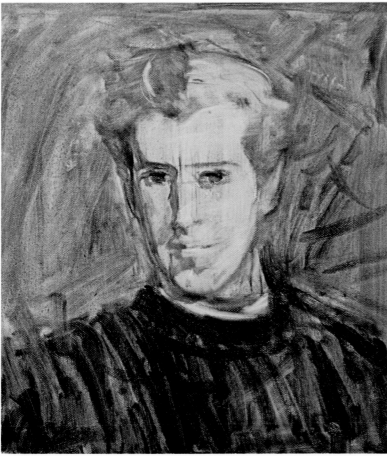

Step 2. More ultramarine blue is added to darken the original mixture, which is still diluted only with turpentine. A small bristle brush draws the shadows on the sides of the brow, cheek, jaw, chin, nose, and lips. One eye socket is filled with shadow. A round softhair brush draws the shadows under the eyelids and the dark shape of the iris. A big bristle brush blocks in the shadow planes of the hair; darkens the background with free, scrubby strokes; and darkens the sweater. A rag, wrapped around a finger, wipes away the light areas of the face and hair, leaving only a faint hint of the undertone applied in Step 1. This monochrome "block-in" establishes the shapes of the face and features, as well as the pattern of light and shadow, before you start to think about color.

Step 3. A big bristle applies the first casual strokes of background color: cobalt blue softened with raw umber and lightened with a touch of white. A small bristle brush goes over the shadows with a rich, warm mixture of raw sienna and Venetian red, diluted with painting medium to a liquid consistency. The brush picks up a thick mixture of raw umber, raw sienna, a touch of cadmium yellow, and white—diluted with just a touch of painting medium—and paints the shadow planes of the hair with short, thick strokes. More cadmium yellow and white are blended into this mixture for the lighted area of the hair, which is painted with curving strokes that suggest the sitter's curls. A few strokes of the cool background tone are brushed over the sweater. More white is added to this tone for the curving stroke of the shadow under the collar. A single curving stroke of white suggests the lighted edge of the collar. Notice that both eye sockets are now in shadow; but the socket on the lighted side of the head is slightly paler than the socket on the shadow side.

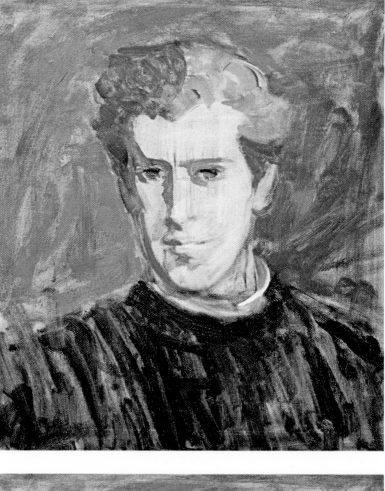

Step 4. A large bristle brush covers the lighted areas of the face with broad strokes of raw umber, cadmium orange, and white, diluted with painting medium to a creamy consistency. These pale strokes are placed right next to the shadows, but the lights and shadows are not blended together at this stage. They're just flat tones. A slightly darker version of this mixture—containing less white—appears on the cheek.

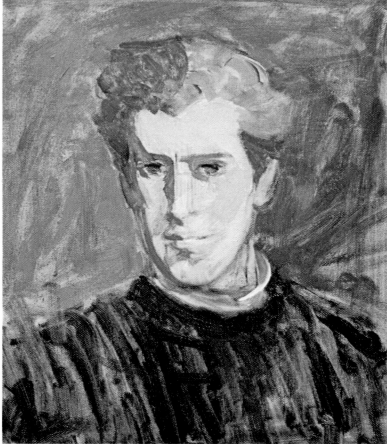

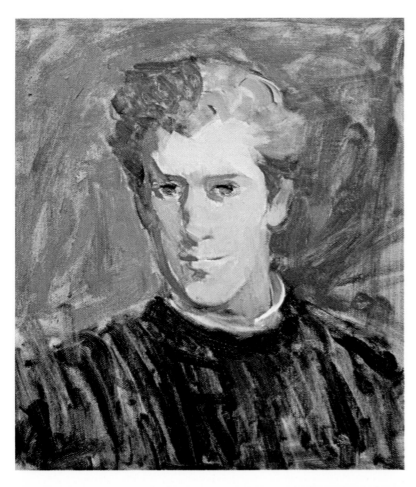

Step 5. Now some halftones begin to appear in the lower half of the face. These tones are darker than the brightly lit forehead, but distinctly lighter than the shadows. The tone on the lighted side of the face is raw umber, cadmium orange, and white. The tone on the shadow side of the face is darker, containing more raw umber and less white. This same mixture is brushed between the eyes to suggest the shadow of the brow; it's brushed into the corners of the eye sockets to make them look deeper and rounder; and it's carried down over the neck. The original shadow tone—raw sienna, Venetian red, and a little white—suggests the hollow of the ear. Here and there the brush blends the light and shadow planes together. You can see this most clearly where the brush has softened the meeting of light and shadow on the forehead and along the side of the nose.

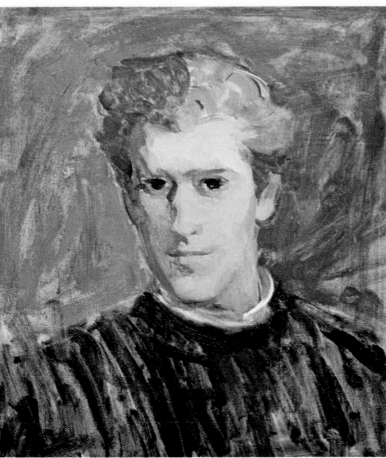

Step 6. Now it's time to refine the drawing. The brush adds more lights and halftones to the cheeks, jaw, and chin. These are brushed softly together to give a sense of roundness to the face. The tip of a round softhair brush strengthens the darks of the eyes with ultramarine blue and burnt umber, then strengthens the shadowy hollow beside the nose with a single stroke of Venetian red and ultramarine blue. The small brush redraws the dark line of the upper lip with the original shadow mixture of raw sienna, Venetian red, and white, using this same mixture to sharpen the shadows around the eyesockets. A single stroke of raw umber, cadmium orange, and white emphasizes the shadowy edge of the lighted cheek at the right.

Step 7. Small brushes move over the face, enriching and deepening the colors and defining the features more strongly. The shadows on the forehead, cheek, jaw, chin, nose, and lips are deepened with a darker mixture of raw umber, Venetian red, and a little white. The shadows beneath the eyebrows are darkened and blended. The darks and halftones of the lower lids are strengthened to make the eyes look rounder. The tip of a round softhair brush draws the dark lines of the eyebrows and the upper lids. The darks of the lips are strengthened with this small, pointed brush. A bristle brush picks up more of the pale mixture of raw umber, cadmium orange, and white to strengthen the light on the forehead, cheek, nose, and chin—then blends this tone softly into the shadows. The tone of the forehead is blended softly into the hairline. Working with the original mixture of raw umber, raw sienna, cadmium yellow, and white, a small bristle brush begins to refine the shape of the hair. A big bristle brush covers the sweater with strokes of burnt umber and ultramarine blue.

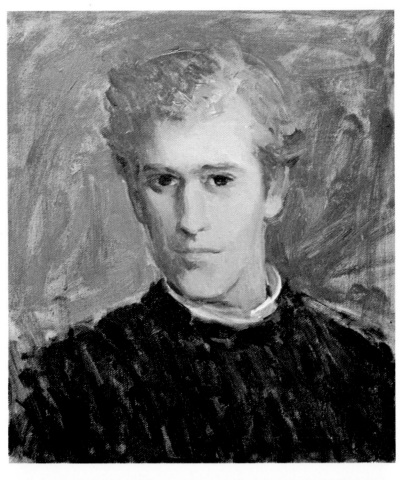

Step 8. Small brushes continue the process of refining and sharpening the forms. The tones within the eye sockets and the lines around the eyes are darkened and drawn more precisely with the tip of a round brush. The whites of the eyes are strengthened with a touch of white delicately tinted with a speck of cobalt blue. Some cobalt blue is also blended into the darks of the iris. Working with raw umber, Venetian red, and a little white, the round brush strengthens the darks around the bridge of the nose, beneath the tip of the nose, and around the mouth. A single stroke of this mixture defines the nostril on the lighted side, deepens the shadow under the chin, and adds a touch of shadow under the lighted earlobe. Thick strokes of raw umber, cadmium orange, and lots of white brighten the forehead, cheeks, and chin. Working with the original hair mixture, a bristle brush darkens and solidifies the shadows of the hair and then begins to define the texture with short, distinct strokes.

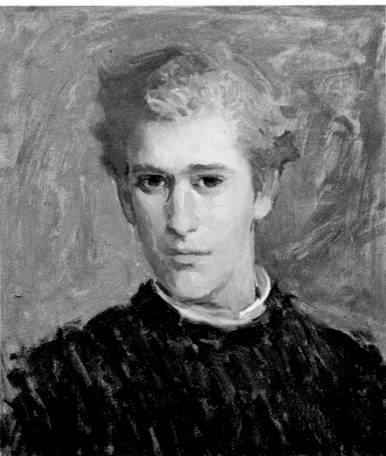

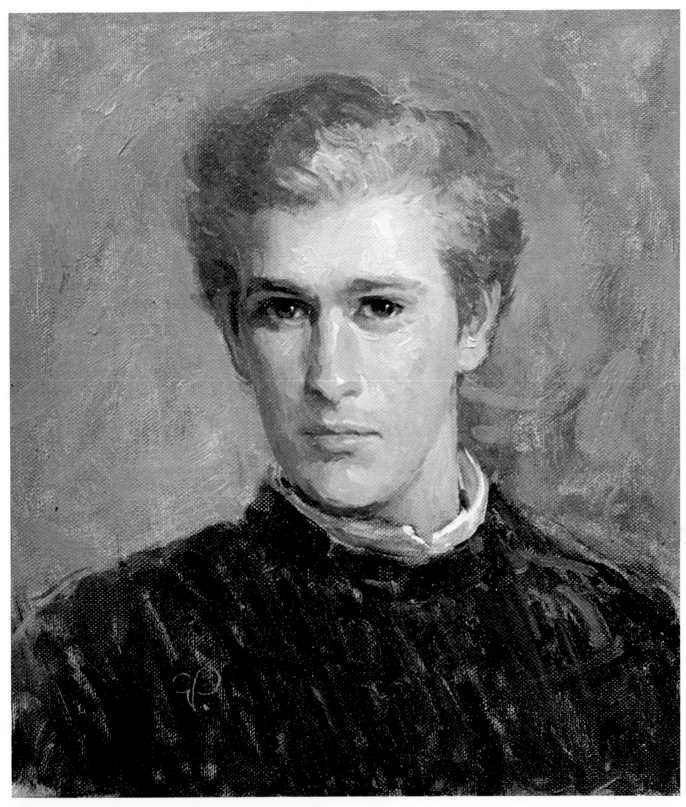

Step 9. The last crisp touches of light and dark—as well as the richest color notes—are saved for this final stage. Thick strokes of cobalt blue, raw umber, and white are freely brushed around the head, while touches of the same mixture are added to the dark sweater. This cool tone heightens the warm hues of the face and hair. Then small bristle and soft-hair brushes travel delicately over the face, enriching the shadows with raw umber and Venetian red; strengthening the lines of the eyebrows, eyes, nostrils, lips, and chin with burnt umber and ultramarine blue; drawing the ear more precisely; adding highlights of pure white to the eyes; and adding luminous strokes of *almost* pure white (tinted with the slightest touch of raw umber and cadmium orange) to the lighted side of the face. A hint of warmth is blended into the lighted cheek. A round brush adds a few strands of hair.

Step 1. A rag picks up a fluid mixture of raw umber and a little cadmium yellow diluted with plenty of turpentine. This mixture is scrubbed lightly over the canvas, leaving the area of the face untouched. A round softhair brush sketches the lines of the face, hair, and shoulders with burnt umber and ultramarine blue, thinned with turpentine to the consistency of watercolor, so the lines flow smoothly. First the brush draws the oval shape of the head, the vertical lines of the hair and neck, and the angular lines of the shoulders. Then a vertical line is carried down the center of the face, and the features are placed on either side of this line with just a few strokes. The purpose of this sketch is simply to establish the shape and proportions of the head, and the locations of the features.

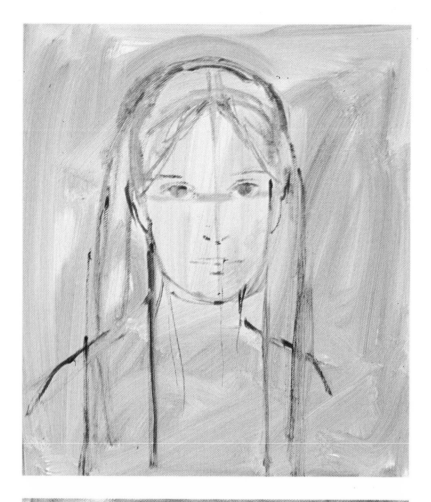

Step 2. A large bristle brush darkens the background with broad, scrubby strokes of burnt umber and yellow ochre. The shadows on the face and neck are delicately brushed in with soft strokes of raw umber, yellow ochre, and white, thinned with painting medium to a fluid consistency. A darker version of this same mixture is scrubbed around the head and down over the shoulders to suggest the hair. A clean rag is wrapped around a fingertip to wipe out the lights of the face and the lighted side of the hair. The tip of a round brush begins to draw the dark lines of the eyelids, the dark shapes of the eyes, the shadowy underside of the nose, and the shadowy lines of the lips. A few strokes of the dark background tones suggest the sitter's jacket.

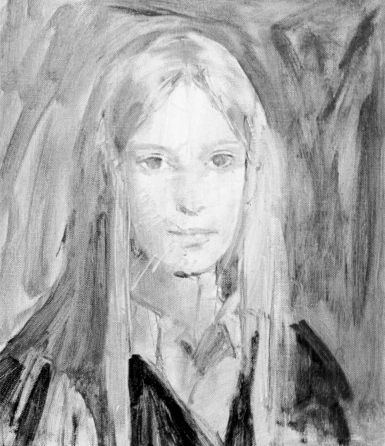

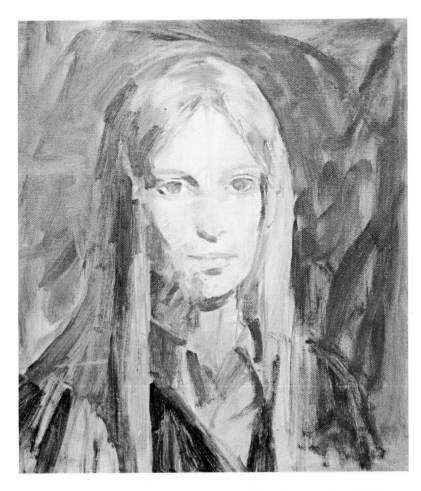

Step 3. A large bristle brush darkens the shadows on the hair and face with rough strokes of raw umber and cobalt blue, warmed with a touch of cadmium red and diluted with painting medium. Notice how a few carefully placed strokes of this mixture deepen the shadows of the eye sockets, the tip of the nose, the lower lip, and the chin. The big brush darkens the background with burnt umber and ultramarine blue to strengthen the contrast between the brightly lit head and the surrounding darkness. The cool shadow of the sitter's collar is indicated with a few straight strokes of cobalt blue, alizarin crimson, and white.

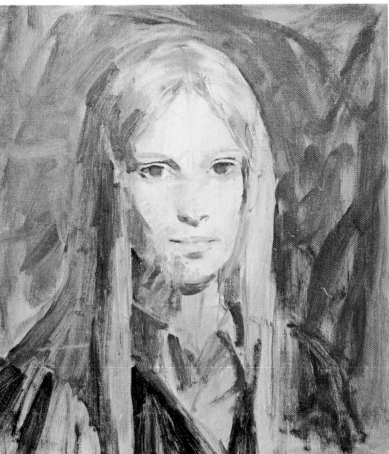

Step 4. The tip of a round brush draws the lines of the eyelids with raw umber and yellow ochre and adds touches of this mixture to define the shadow beneath the nose, the nostrils, and the corners of the mouth. The tip of a small bristle brush adds a touch of cobalt blue and raw umber to the eyes. Just these few notes of darkness make the face look rounder, more solid, and more lifelike.

Step 5. The few strong darks on the face have been clearly stated and now it's time to begin work on the lights. The pale, delicate skin tone of the blond sitter is mixed with raw umber, cadmium red, cadmium orange, and a great deal of white. This is brushed over the forehead, while a slightly darker version of this mixture is brushed over the cheeks, nose, and neck. The light planes of the hair are begun with broad strokes of yellow ochre, raw umber, and white. The first light tones of the blouse are just a few strokes of white tinted with alizarin crimson and cobalt blue.

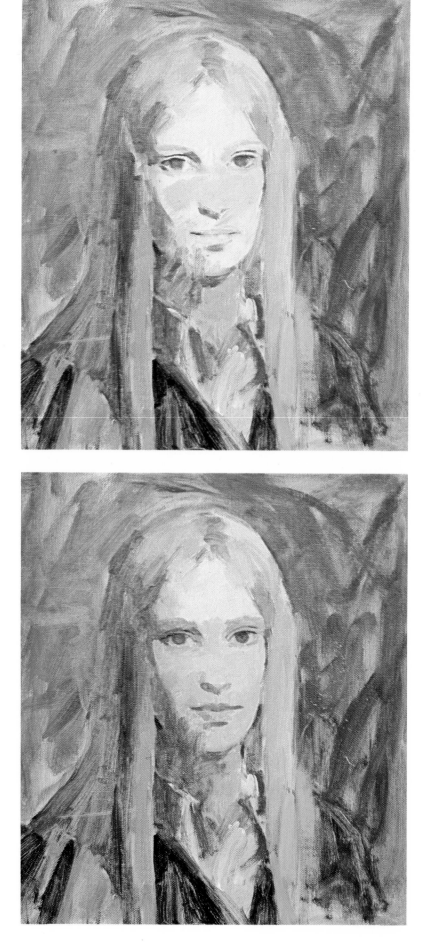

Step 6. The lights are completely covered with a pale mixture of raw umber, cadmium red, cadmium orange, and white. Then the brush mixes the first delicate halftones by adding more raw umber to the mixture. These tones are brushed beneath the eyebrows, between the eyes, and beneath the cheek, where the rounded form turns toward the shadow. A small round brush picks up the original shadow mixture to darken the corners of the eyes and strengthen the underside of the nose. More cadmium red is added to the flesh mixture to begin work on the lips. The lower lip, which catches the light, containes more white. The shadow side of the face is darkened with the original shadow mixture, while touches of this tone darken the corners of the mouth.

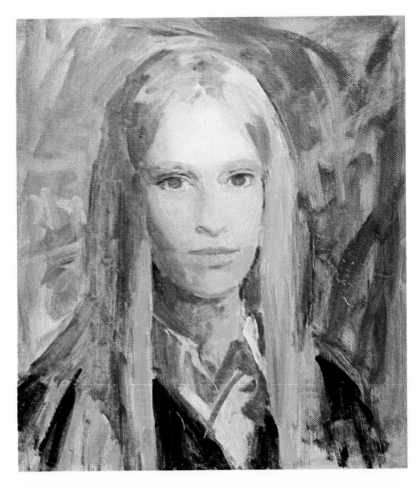

Step 7. The halftones on this face are extremely subtle—almost invisible—and you must look closely to see them. A little more raw umber is added to the flesh mixture, and this tone is brushed in where the light and shadow planes meet at the side of the face; along the side of the nose; and at the sides of the chin, where the jaw turns away from the light. The brush begins to blend the lights, darks, and halftones, which now fuse softly together. The color of the cheeks is heightened with just a little cadmium red. The edges of the lips are softened and blurred into the surrounding tone. The lights and darks of the sitter's blouse are carried further with ultramarine blue, alizarin crimson, and white—more white in the lighted areas. Dark strokes are added to the jacket with burnt umber and ultramarine blue.

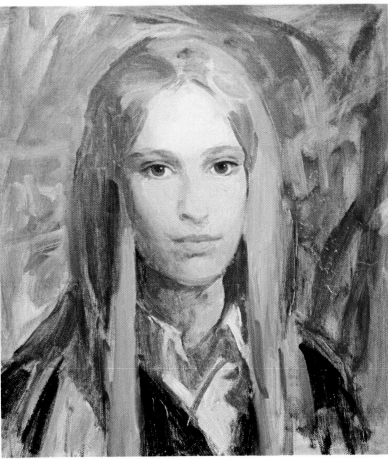

Step 8. The shadow planes of the hair are more clearly defined with big, decisive strokes of a bristle brush carrying raw umber, yellow ochre, and a hint of Venetian red to add warmth. More white is added to this mixture, and the brush strengthens the tones of the lighted planes of the hair. The tip of a round brush sharpens the dark lines of the eyelids and adds the pupils with burnt umber and ultramarine blue. It then adds the whites of the eyes and the highlights with white faintly tinted with raw umber. The eyebrows and the eye sockets are darkened with the original shadow mixture. Additional strokes of the light skin tone are added to the face and blended into the edges of the shadows.

Step 9. Small, flat brushes strengthen the shadows on the cheeks, jaw, nose, and eye sockets. The shadow beneath the chin and the dark tone on the neck are deepened with this mixture. The lower lids are darkened to make the eyes more prominent. The lips are enriched with more cadmium red and white and then brightened with a highlight on the lower lip. Notice how a touch of the rag wipes away some color from the jaw and from the shadow side of the hair to suggest reflected light. The lighted side of the hair is solidified with thick touches of raw umber, yellow ochre, and lots of white. A few cool strokes of cobalt blue, raw umber, and white are scrubbed over the warm tone of the background, which becomes more subdued and is less likely to compete with the luminous tones of the hair and face.

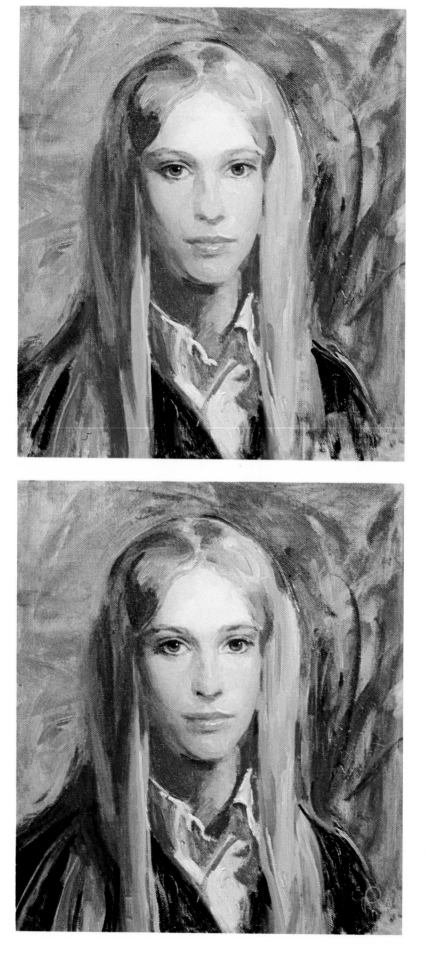

Step 10. The hair is developed with thick, creamy strokes of yellow ochre, raw umber, a hint of cadmium orange, and white, diluted with just enough painting medium to make the color flow smoothly. The wet strokes of the shadows—which obviously contain more raw umber than the lights—are placed side-by-side with the lighter strokes. The strokes overlap slightly and blend as the brush moves. The hair at the top of the head is painted with curving strokes, while the hair at the sides of the face is painted with straight, vertical strokes. The tip of a round brush continues to darken the corners of the eyes very gradually; darkens the brows; and adds two dark touches for the nostrils. The color of the cheeks is graduall heightened by blending in cadmium red and white. The dark tones of the jacket are completed with ultramarine blue and burnt umber.

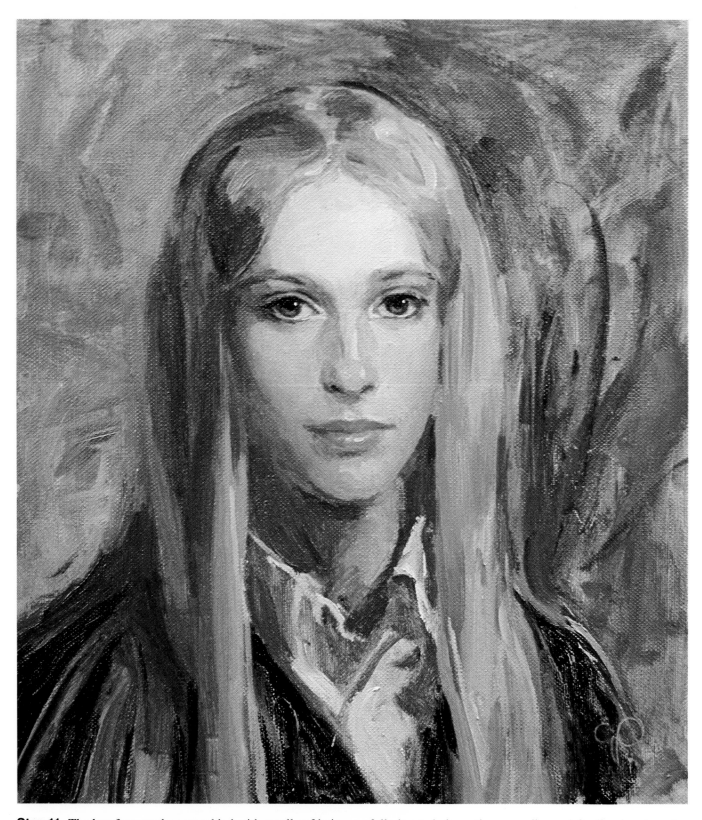

Step 11. The last few touches are added with small softhair brushes that soften the edges of the eyes, sharpen the contours of the lips, and strengthen the lines of the nose. Highlights—pure white tinted with a little flesh tone—are carried down from the bridge of the nose, placed at the tip, carefully located above the upper lip, and finally placed on the chin. Pale strokes are added to the inner corners of the eyes to make the lids look more luminous. A big bristle brush adds more strokes of the cool background tone; by contrast, these strokes heighten the golden tone of the hair.

Step 1. Burnt umber and a little cadmium orange are blended on the palette, diluted with turpentine, and scrubbed over the canvas with a rag. A small bristle brush picks up the same mixture—diluted with less turpentine, to draw the outer contours of the face, head, and neck. Then the tip of a round softhair brush draws the vertical center line of the face and the horizontal guidelines that locate the features. (These lines are very light and will quickly disappear as the painting progresses.) Then a softhair brush quickly indicates the features with a few heavier lines. The features are not drawn precisely. It's their location—and the general proportions of the head—that are most important.

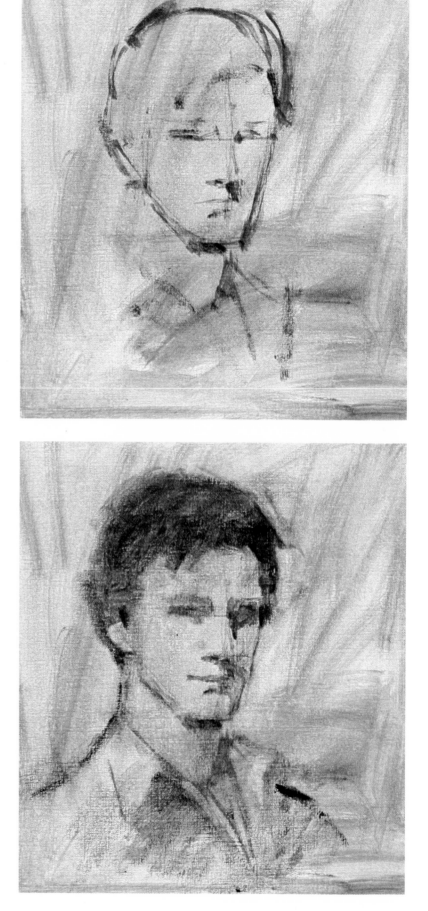

Step 2. A bristle brush blocks in the dark tone of the hair and then goes on to suggest the pattern of light and shadow on the face. The eye sockets are filled with shadow. The brush carries dark strokes down one side of the nose, from the lower edge of the nose down to the upper lip, beneath the upper and lower lips, and beneath the chin. A single dark stroke indicates the hollow of the ear. And the brush scrubs some lighter tones over the forehead, down the shadow side of the face and neck, and beneath the collar. The brush is still working with the original mixture of burnt umber, cadmium orange, and turpentine. The preliminary sketch is completed.

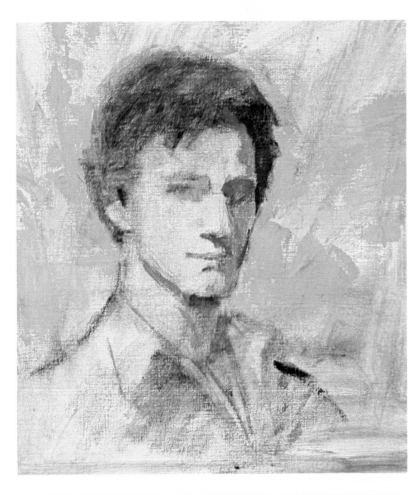

Step 3. Now a bristle brush begins to work with richer color. The shadow side of the head is painted with a mixture of raw umber, raw sienna, Venetian red, and white. This color runs from the brow down to the chin and reappears on the neck. Notice that the lighted side of the head is now paler than in Step 2; it's been wiped with a rag wrapped around a finger. The first background tones are broadly applied with a painting knife, carrying a mixture of burnt umber, yellow ochre, and lots of white. You can see this tone just above the shoulders, beside the dark cheek, and behind the neck. By placing the first strokes of background color side-by-side with the cheek, the artist can determine how dark to make the shadow side of the cheek and how light to make the background. Always start work on the background early; never save it for the very end.

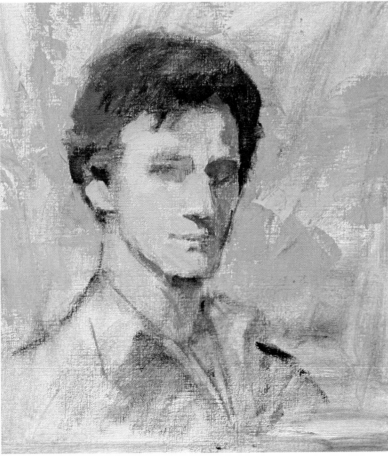

Step 4. A bristle brush covers the lightest areas of the face with a mixture of raw umber, raw sienna, Venetian red, and white. This is the same mixture used for the shadow side, but here it contains more white. Notice that a patch of forehead has been left untouched; this is where the biggest halftone will appear. Just above the ear the brush begins to place some solid color on the hair—a mixture of burnt umber, cadmium orange, and white. Look closely at the lower part of the face and you'll see that the color of the cheek is warmed with an extra touch of Venetian red.

Step 5. Next come the halftones that fall between the lights and shadows. Working with the same mixture of raw umber, raw sienna, Venetian red, and white, a bristle brush covers the patch on the forehead. Then the brush moves into the eye socket on the lighted side of the face and adds halftones to the nose, lips, chin, and neck. You can see clearly that these halftones fall right between the lights and shadows painted in Steps 3 and 4. The tones are simply flat patches of color; they're not blended together yet. A few strokes of white and raw umber suggest the brightly lit collar.

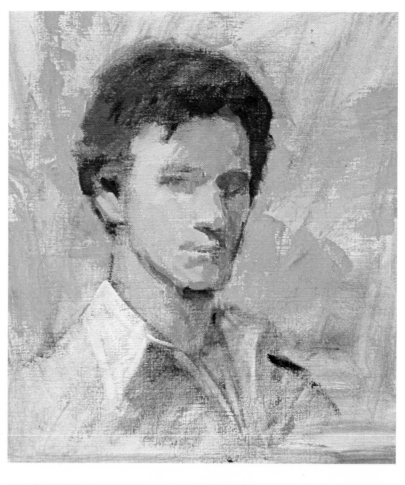

Step 6. The tip of a small brush places a few strokes of burnt umber and ultramarine blue, lightened with just a hint of white, to indicate the eyebrows, the shadow lines of the upper lids, and the dark patches of the eyes themselves. Working with the light and halftone mixtures—raw umber, raw sienna, Venetian red, and varying amounts of white—the tip of a small bristle brush defines the shape of the mouth. Now you can see the dark plane of the upper lip and the lighted plane of the lower lip more clearly. It's easy to see the three basic *values*, as they're called: darks, halftones, and lights. And the face really comes alive as the brush places those few strokes that transform the shadowy eye sockets into eyes.

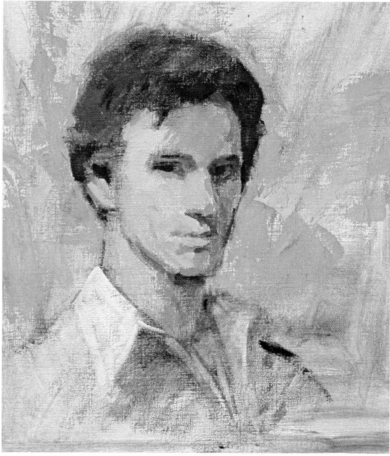

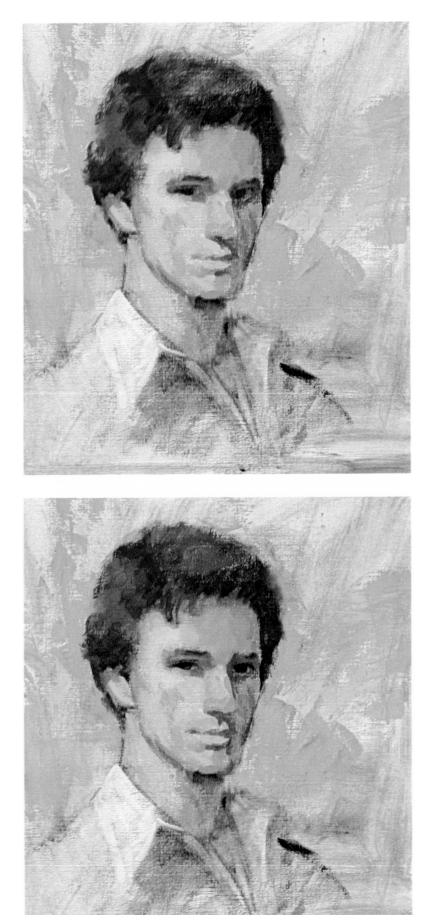

Step 7. Now the brush begins to blend some of the tones. With back-and-forth strokes the brush joins the darks, halftones, and lights on the forehead. More halftones are added to the nose and lower lip, plus the cheek and jaw on the lighted side of the face. A touch of cadmium red, softened with plenty of white, adds a ruddy tone to the cheek. The shape of the eye socket, on the lighted side of the face, is strengthened with short, decisive strokes of shadow tone. A shadow is added where the hair overlaps the ear. A round softhair brush strengthens the darks of the hair with short, curving strokes of burnt umber, ultramarine blue, and a little white.

Step 8. Round and flat softhair brushes continue to sharpen the features with small, precise strokes. On the shadow side of the face the eye socket is filled with tone, and a line of shadow redefines the side of the nose. Dark strokes clarify the shapes of the tip of the nose, the nostril, the upper lip, and the shadow side of the jaw. A touch of halftone is scrubbed into the shadow side of the face, which now looks more luminous. The bristle brush now scrubs in the lighter tones of the hair with burnt umber, ultramarine blue, and more white.

Step 9. A small bristle brush moves back into the shadow areas to enrich them with thick strokes of rich color. These strokes are the original mixture of raw umber, raw sienna, Venetian red, and white. You can see variations in the color of these strokes, which are sometimes lighter, sometimes darker, sometimes warmer, and sometimes more subdued. These variations are produced by very slight changes in the proportions of the mixture—such as adding an extra touch of Venetian red to the warm tone on the brow or an extra touch of raw umber to strengthen the darks of the eye sockets. As the shadow side of the face is strengthened, the brush defines the contours of the cheek and jaw more precisely. The shadow tones on the neck and chest are also covered with thick, rich color. A few touches of light color begin to define individual locks of hair. The tip of a round brush suggests the whites of the eyes.

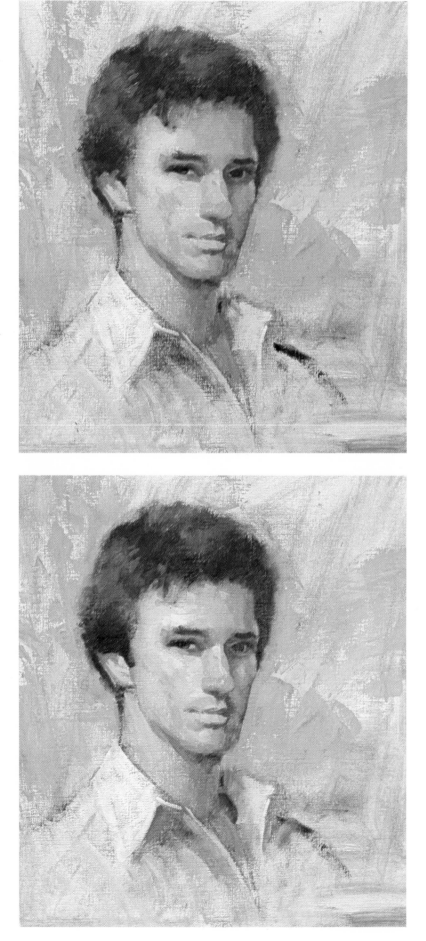

Step 10. More white is added to the flesh mixture, and this pale, bright tone is blended into the lighted side of the face. These strokes make the skin more luminous and heighten the contrast between light and shadow. The pale tones are not smoothly blended, but individual strokes are allowed to stand out; you can see them on the forehead, just above the eye; on the cheek, just below the eye; on the side of the nose; and on the chin. The tip of a round brush begins to sharpen the details of the eyes. The cool shadows beneath the collar are quick, broad strokes of cobalt blue, raw umber, and white.

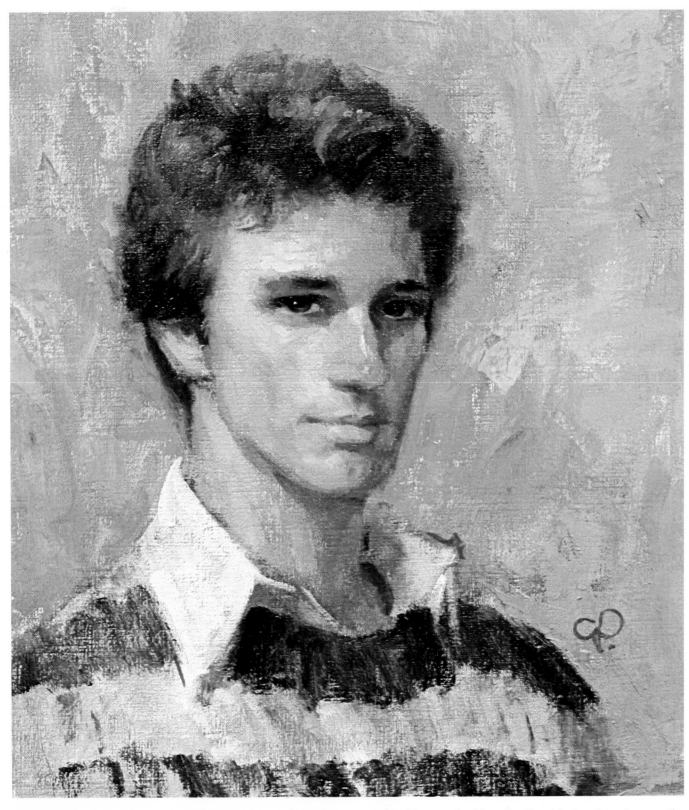

Step 11. A big bristle brush enriches and completes the background with rough strokes of raw umber, raw sienna, cadmium orange, and white. Notice that the background tone is strongest around the face. A round softhair brush completes the hair with pale strokes of raw umber, raw sienna, and white, and darker strokes of burnt umber, ultramarine blue, and white. Small sable brushes sharpen the details of the features. The curves of the eye sockets are darker and more precise. Now you can see the pupils of the eyes and tiny highlights in pure white. The stripes of the sweater are suggested with broad, casual strokes of the same mixture that appears in the hair.

Step 1. The overall tone of this portrait will be cool, so a rag picks up a mixture of cobalt blue, raw umber, and turpentine to cover the bare canvas. This same mixture is used to draw the outlines of the head, hair, neck, shoulders, and dress. A vertical center line divides the face. The eyes are carefully placed on either side of this line, while the nose and mouth are placed right on the line.

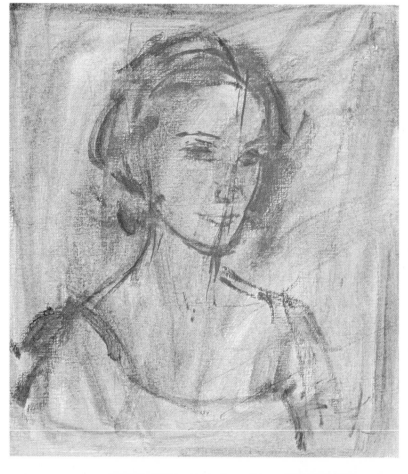

Step 2. The dark background is covered with quick, rough strokes of cobalt blue, raw umber, and white. Now the paint is thick and creamy, thinned with medium instead of turpentine. The dark, warm tone of the hair is suggested with a few strokes of raw umber, cobalt blue, and a little white. Some white is added to the background tone—and this mixture is used to scrub in a few strokes that suggest the dress.

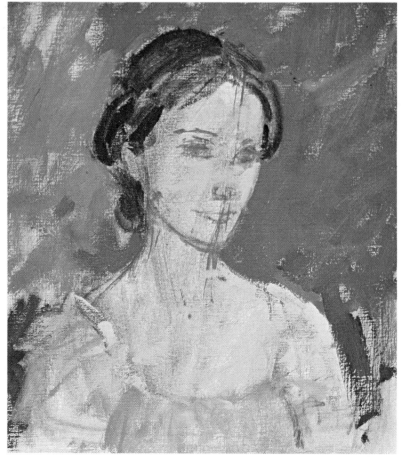

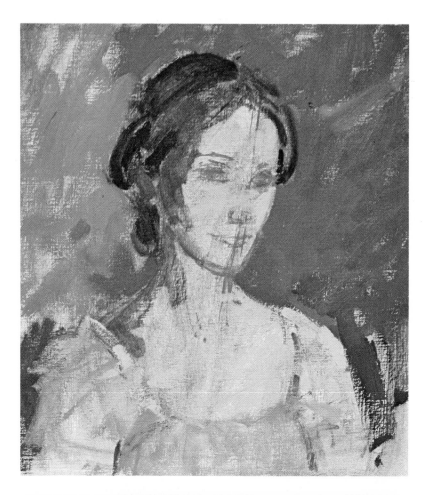

Step 3. The shadow side of the head, neck, and shoulder are suggested with just a few broad strokes of a big bristle brush. The shadow tone is a mixture of raw umber, cobalt blue, a touch of cadmium red, and white. Notice how these strokes overlap the hair. Then the first few hints of pale flesh tone are brushed across the face and chest—a delicate mixture of raw umber, cadmium red, cobalt blue, and lots of white. Now the portrait has clearly defined planes of light and shadow.

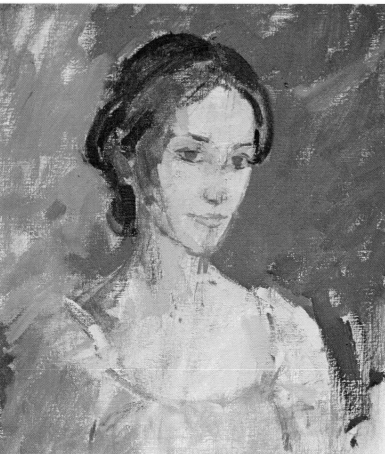

Step 4. The lighted planes of the face are strengthened with heavier strokes of the pale mixture that first appeared in Step 3. The pale tones of the forehead, cheeks, shoulder, and chest are now clearly defined. Soft halftones are brushed between the lights and shadows. These halftones are the same mixture as the lights— raw umber, cadmium red, cobalt blue, and white—but they contain less white and less cadmium red. These halftones are so subtle that they're only a bit darker than the lights. You can see them most clearly on the brow, cheek, chin, and neck. A small softhair brush blends more cobalt blue into the shadow tone and adds darks to the eyebrows, the eyes, and the underside of the nose. An extra touch of cadmium red is blended into the flesh mixture to suggest the warmth of the lips. A touch of white is blended into the dark background mixture to paint the shadow side of the dress with broad strokes of a big bristle brush.

Step 5. A flat softhair brush begins to blend the whites, halftones, and shadows with delicate, back-and-forth strokes. As the pale tones are brushed into the darks, the shadow side of the face becomes softer and paler. The lighted planes of the face and chest are strengthened with thicker strokes of the original flesh mixture; these strokes are brushed out smoothly. The shape of the hair is solidified with heavier strokes of raw umber, yellow ochre, a little cobalt blue, and white. A round softhair brush picks up the hair mixture to sharpen the lines of the eyebrows and the eyelids. The round shapes of the iris are carefully redrawn, as are the shape of the nostril and the dark line that divides the lips.

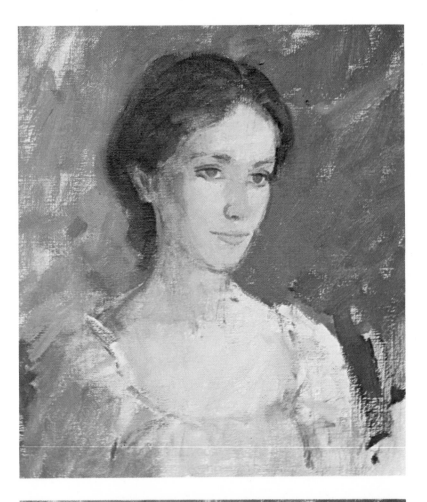

Step 6. Flat softhair brushes continue to blend the lights, halftones, and shadows. Now the darker tones of the neck and shoulder flow softly into the paler tones of the chest. There's also a softer transition between light and shadow on the brow and jaw. The contours of the eyes are darkened; the dark pupils appear. A single pale stroke defines the lighted front plane of the nose, and a highlight is added to the tip. The nostril and the side of the nose are drawn more precisely. The upper lip is darkened, while more distinct shadows appear beneath the lower lip and the chin.

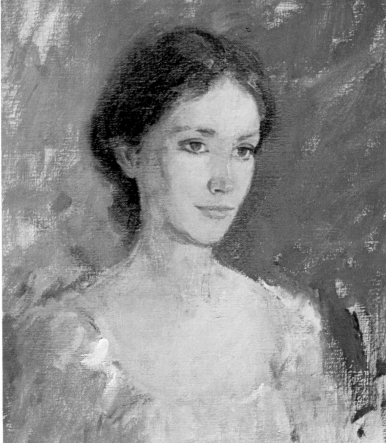

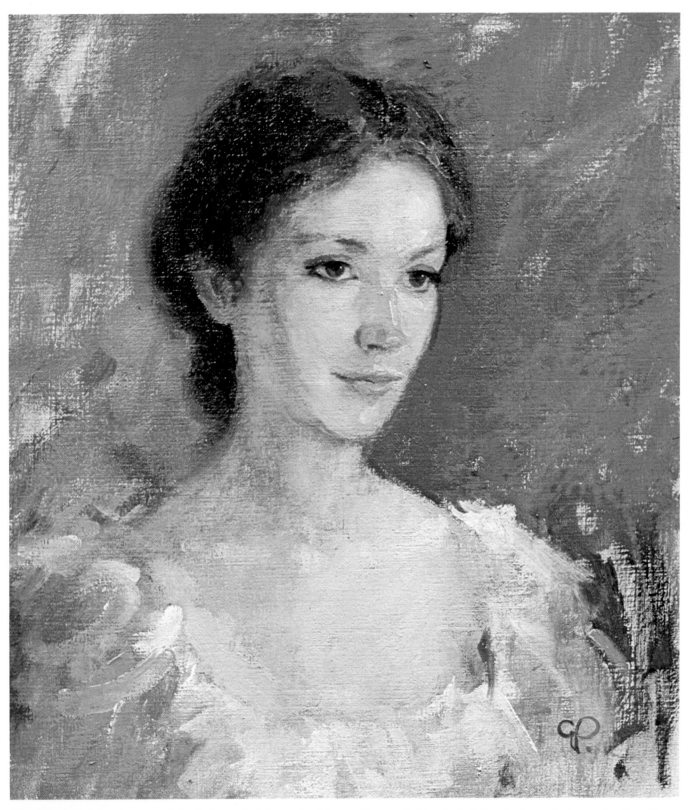

Step 7. The lighted areas of the hair are heightened with the original mixture plus a bit more white, while the background is darkened to emphasize the lighted side of the face. Thick strokes of the palest skin tone make the face, neck, and chest more luminous. More white is added to this tone for the highlights that appear on the forehead, nose, lips, and chin. A dark line is drawn between the lips. Some halftone is lightly rubbed into the shadow side of the face, which now becomes more delicate and transparent. The lighted areas of the dress are completed with rough strokes of white tinted with background color.

Step 1. The canvas is toned with a rag that carries raw umber diluted with turpentine. A clean corner of the rag wipes out the lighted area of the face, neck, shoulder, and chest. Then the preliminary sketch is completed with raw umber. It's instructive to compare this sketch with the preliminary brush drawing for Demonstration 4. Because the painting of the brown-haired woman has very little contrast between light and shadow, the brush drawing simply defines the shapes and then stops. In this painting of a red-haired woman, there are very clearly defined light and shadow planes, which are carefully rendered in the brush drawing.

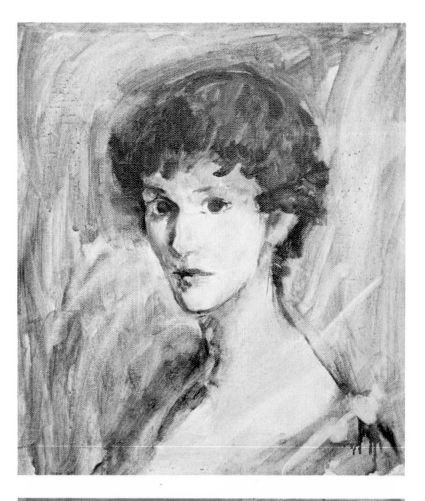

Step 2. The background color is blocked in with broad strokes of viridian, ultramarine blue, burnt umber, and white. This tone completely surrounds the head and establishes the sharp contrast between the dark background and the brightly lit skin. A small bristle brush adds the shadows with a mixture of raw umber, burnt umber, cadmium red, and white. Two variations of the same mixture are used to paint the hair with short, squarish strokes: the dark strokes contain more burnt umber and the light strokes contain more cadmium red. The dark at the center of the eye is the same dark tone that appears in the hair. The color of the dress is quickly scrubbed in with broad strokes of cobalt blue, alizarin crimson, and white.

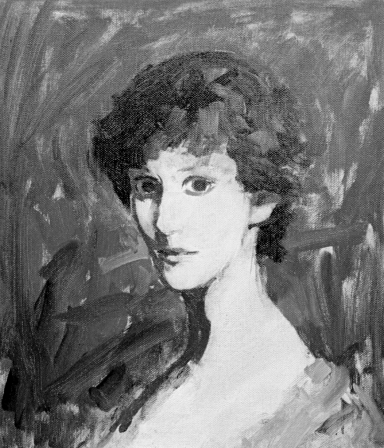

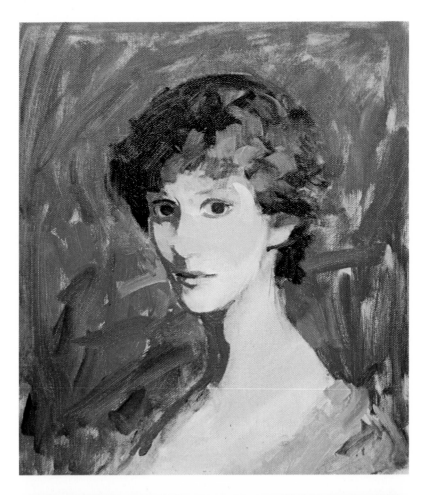

Step 3. The lighted tones of the skin are brushed in with a creamy mixture of raw umber, burnt umber, cadmium red, and white—actually the same mixture as the hair, but with much more white and diluted with painting medium to make the color flow smoothly. The strokes across the center of the face contain a little more cadmium red to heighten the tone of the cheeks and nose. Notice that the brush leaves the halftone areas of the face untouched—the forehead and lower jaw.

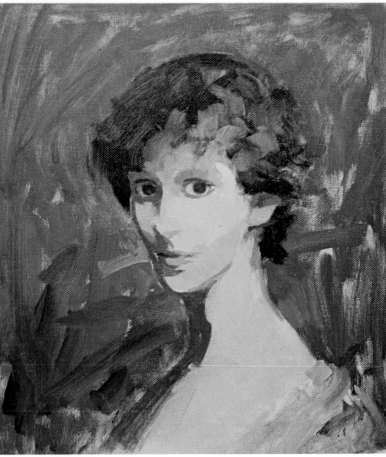

Step 4. A slightly darker version of the flesh tone—containing less white—is brushed across the forehead, the underside of the nose, the undersides of the cheeks, and the lower jaw. These are the subtle halftones that fall between the lights and the shadows. A little more white is added to this halftone mixture, which is then brushed downward over the neck and chest. The eye socket on the lighted side of the face is darkened. This same tone is carried down the back of the neck where the form turns away from the light. More cadmium red is added to the halftone mixture for the color of the lips. As usual, the upper lip is darker because it's in shadow.

Step 5. A flat softhair brush blends together the lights, halftones, and shadows on the face. Now the head begins to take on a soft, rounded quality. Notice how the edges of the hair are blurred so that the dark areas of the hair seem to melt away into the dark background. The softhair brush travels down the neck and chest to blur the meeting of light and shadow. Compare the flat patches of color in Step 4 with the soft, blended tones of Step 5. A round softhair brush moves carefully around the eyes to darken the lids and then adds the whites to the eyes with pure white faintly tinted with the pale fleshtone. The dark hair is carried down the back of the neck and softly blended into the skin.

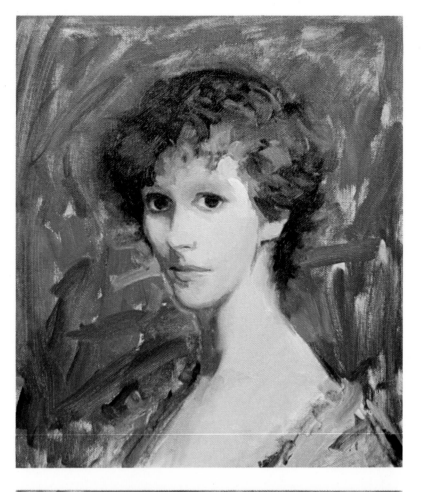

Step 6. The tip of the round softhair brush continues to define the eyes with the same mixture used for the dark areas of the hair. Crisp lines are drawn for the shadows of the lids, and the eyebrows appear for the first time. A mixture of ultramarine blue, viridian, burnt umber, and a little white is blended into each iris. The small brush also sharpens the shapes of the lips and adds some of the lip tone to the cheek. The shadow on the side of the nose is darkened along with the shadow beneath the lower lip. More white is blended into the pale flesh mixture, and this tone is carried over the lighted areas of the face with thick, creamy strokes.

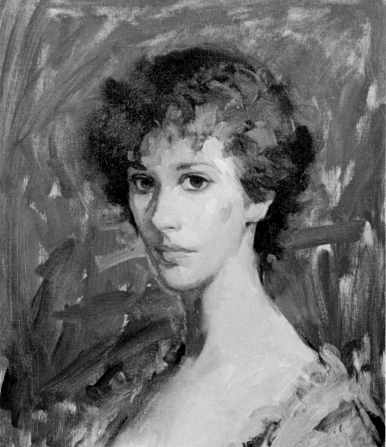

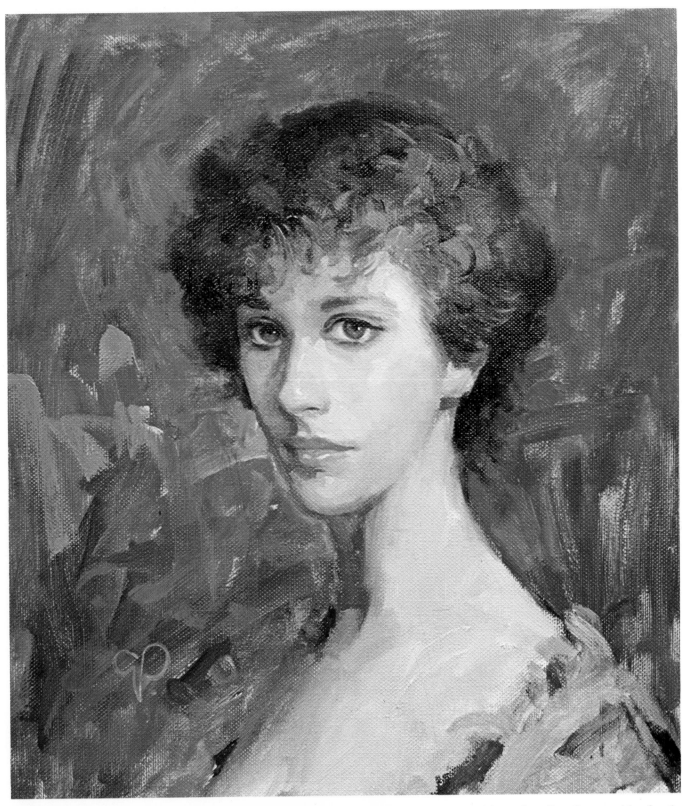

Step 7. More white is blended into the background mixture, and a large bristle brush travels over the background to soften the distracting strokes. With short, curving strokes the tip of a round brush suggests individual locks of hair. The pupils of the eyes are added with burnt umber and ultramarine blue, followed by a tiny dot of pure white for the highlight. A flat softhair brush blends the lighted side of the face, neck, and chest to soften the thick strokes applied in Step 6. And the tip of the round brush applies highlights to the nose, cheek, lips, and chin.

Step 1. The canvas is toned with a mixture of burnt umber and cadmium red diluted with turpentine to the consistency of watercolor. The shape of the face is drawn with the tip of a round softhair brush, which then indicates the features. This is done with burnt umber and ultramarine blue. A small bristle brush uses the same mixture to draw the hair with free strokes, and then the brush adds a few touches of shadow to the brow, cheek, nose, upper lip, and chin. The bristle brush picks up the background mixture to suggest the shoulders and the collar with a few big strokes.

Step 2. A bristle brush blocks in the shadows with a thicker, creamier mixture of raw umber, a little raw sienna, and white diluted with painting medium. You can now see solid shadow tones on the forehead, cheek, jaw, eye socket, nose, lips, and ear. The shadow planes of the hair are also brushed in with burnt umber and ultramarine blue, a combination which makes a beautiful dark tone which is more colorful than black. The head is strongly lit from the left; this accounts for the shadow cast by the nose. A thicker version of the background color—burnt umber, cadmium red, and white—is scrubbed in around the head. It's important to do this early so you can see how the colors of the head relate to the background tone.

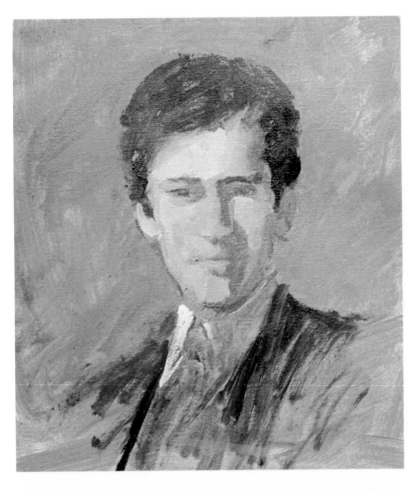

Step 3. A bristle brush lays in the lights with a thick, creamy mixture of raw umber, raw sienna, Venetian red, and plenty of white. The halftones—made with the same mixture but with less white and more raw umber—are placed between the lights and shadows. You can see these halftones most clearly on the forehead, next to the shadow; in the eye socket on the lighted side of the face; on the bridge of the nose; underneath the cheek on the lighted side of the face; and on the chin. The dark area of the hair is now completely covered with rough strokes of burnt umber and ultramarine blue. The same color suggests the jacket. A few strokes of white faintly tinted with raw umber indicate the lighted planes of the collar, while the shadow areas are suggested with cobalt blue, raw umber, and white. More white is added to the original background mixture, and this tone is carried over most of the background with a big bristle brush.

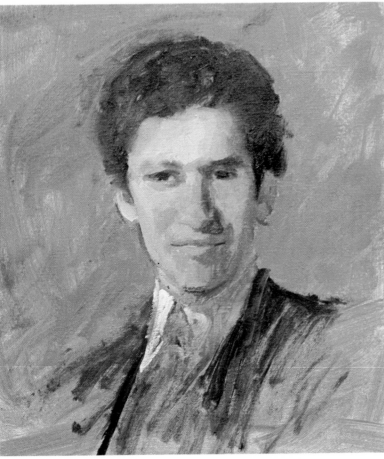

Step 4. A bristle brush begins to blend the lights, halftones, and shadows. The shadows around the eyes, nose, and mouth are strengthened with strokes of raw umber, raw sienna, Venetian red, and white. The halftones on the nose, cheek, and chin are also strengthened with this mixture, but with more white and less raw umber. A small softhair brush deepens the lines of shadow around the eyes, adds the dark notes within the eyes, and strengthens the darks of the eyebrows. These darkest notes are simply the hair mixture. The shadowy tone of the upper lip is redrawn, and then a dark shadow line is drawn between the lips. Work also continues on the background, which is now enriched with a warmer, deeper mixture of burnt umber, cadmium red, and white.

Step 5. A small bristle brush continues to solidify the shadows with a creamy mixture of raw umber, raw sienna, Venetian red, and white. This tone is applied with direct, simple strokes that move down the shadow side of the face, starting with the eye socket and then moving on to the nose, the shadow cast by the nose on the upper lip, the upper and lower lips, and finally the jaw and chin. A slightly paler version of this tone darkens the eye socket on the lighted side of the face and strengthens the shadow on the lower lid. A few thick touches of light are added to the lighted areas of the forehead and cheeks. Compare this step with Step 4 and you'll see that the shapes of the shadows are now more solid and distinct. You can also see the first touches of light on the hair.

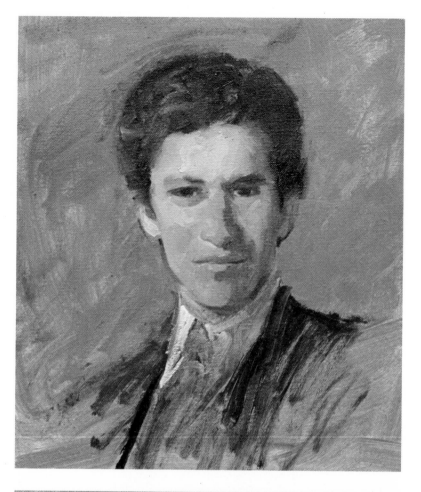

Step 6. Small brushes begin to build up the lights on the face, adding thick, creamy strokes to the forehead, cheeks, nose, lips, and chin. This pale tone is still the basic flesh mixture of raw umber, raw sienna, Venetian red, and white—but the mixture is now *mostly* white. More white is added to the hair mixture, and this tone is blended into the lighted side of the hair. A small brush darkens the corners of the lips and strengthens the darks at the corners of the eyes. Then the tip of a round softhair brush draws the dark lines of the eyelids more precisely, adds the dark pupils (with the hair mixture) and finally adds the whites of the eyes and the highlights on the pupils with pure white tinted with a minute touch of skin tone.

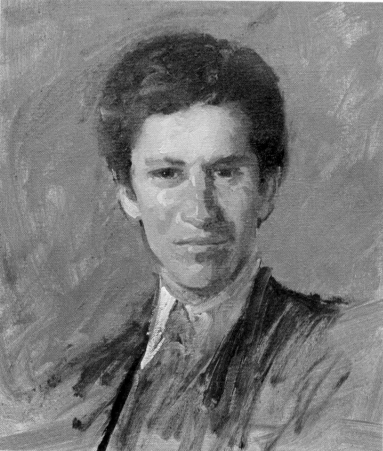

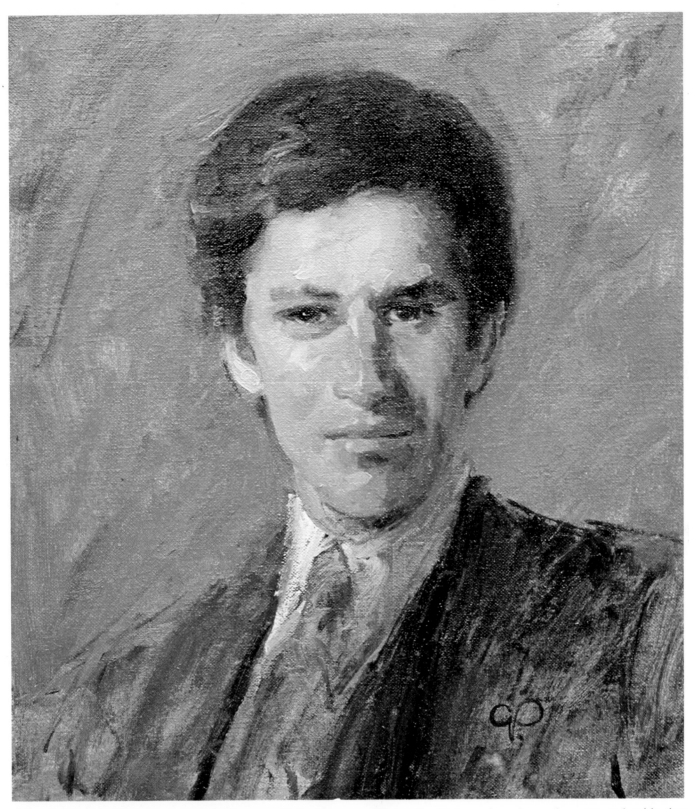

Step 7. Small brushes move over the face to add the last *accents* of light and dark that make the portrait more vivid and alive. Extra touches of darkness are added to the eyebrows, the corners of the eyes, the nostrils, and the corners of the lips. These darks are the same mixture as the hair tone, with just a little Venetian red. Extra dashes of shadow are carefully placed between the lips, beneath the lower lip, and beneath the chin. Thick, juicy touches of light are added with thick strokes above the eyes and with tiny strokes around the lips. More strokes of light are blended into the hair, while the hair mixture is used to complete the jacket. Touches of cobalt blue, raw umber, and white suggest the tie—without painting it completely. And the corners of the background are darkened with raw umber to make the head seem surrounded by a warm glow.

Step 1. A rag tones the canvas with a mixture of ultramarine blue, burnt umber, and white diluted with plenty of turpentine. A darker version of this same mixture, but with less turpentine and no white, is used to make the preliminary brush drawing. The outer contours of the face are drawn first, and then the brush indicates the loose curls with quick, scrubby strokes. The eyes of the sitter are particularly magnetic, and they're drawn with greater care than one would normally take in a preliminary drawing. A few strokes define the nose and mouth. The brush begins to indicate the shadows on the face and neck with very light tones—diluted with a great deal of turpentine—and the light areas of the face are wiped away with a rag wrapped around a fingertip. Just a few strokes define the shoulders and the neckline.

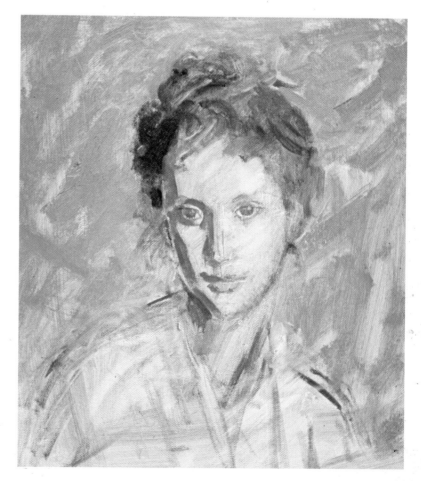

Step 2. A big bristle brush covers the background with a thicker version of the original mixture: ultramarine blue, burnt umber, and white, diluted with painting medium—not just turpentine. A smaller bristle brush places the shadows on the brow, cheek, jaw, chin, neck, eye socket, nose, and lips. This shadow tone is a mixture of raw umber, cobalt blue, and white. Study the eye socket on the shadow side of the face: the upper eyelid catches the light, while the lower eyelid is in shadow. Conversely, the upper lip is in shadow because it turns away from the light, while the lower lip turns upward and catches the light. The dark side of the hair is indicated with a dark mixture of burnt umber and ultramarine blue.

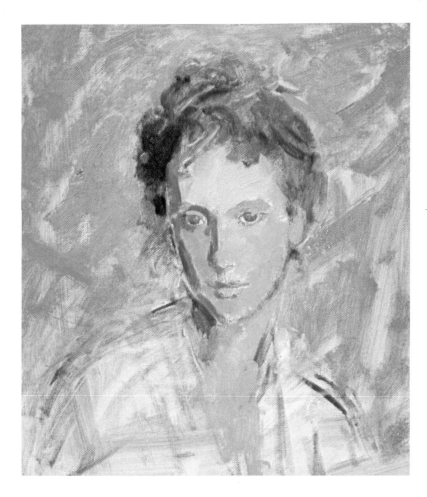

Step 3. The light planes of the face are covered with broad strokes of raw umber, Venetian red, raw sienna, and white. Notice that the lower half of the face is a bit darker than the forehead; these darker tones contain slightly less white. The first halftones begin to appear in the eye sockets, along the lower jaw, and beneath the chin. These halftones are a slightly darker version of the flesh mixture—to which a minute quantity of the background color has been added. The light tone is carried down the neck and over the chest. A halftone is placed directly beneath the chin. Some background color is also brushed into the hair. Observe how these light areas all grow slightly darker where the rounded edges of the forms turn away from the light.

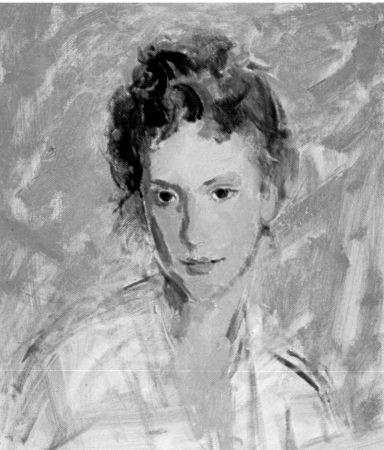

Step 4. Working with a slightly darker version of the original flesh mixture, stronger halftones are added on the front of the nose and chin and along the lighted edge of the face next to the ear. The eye sockets are darkened, and then the tip of a round brush adds the dark lines of the eyelids. The darks within the eyes are added with the original hair mixture of burnt umber and ultramarine blue. Cadmium red is added to the flesh tone to block in the tones of the lips. A slightly paler version of this color suggests the ear on the shadow side of the face. And a big bristle brush begins to indicate the curls of the sitter's hair. A round brush begins to add linear details like the eyebrows and the dark corners of the mouth.

Step 5. A big bristle brush works on the lighted top and side of the hair with ultramarine blue and burnt umber, lightened with just a touch of white. On the shadow side of the face—particularly on the cheek—the halftones are enriched with more raw umber and Venetian red. This warm color is also brushed into the lighted cheek. The halftones are strengthened beneath the eyes, within the eye sockets, and along the lighted jaw. The darks of the eyelids are also deepened, and the pupils are added with touches of pure black warmed with burnt umber. The brush begins to blend the lights, halftones, and shadows on the cheeks. So far, the lighted ear is nothing more than a patch of pale color for the lobe and rim, plus a dark patch for the hollow.

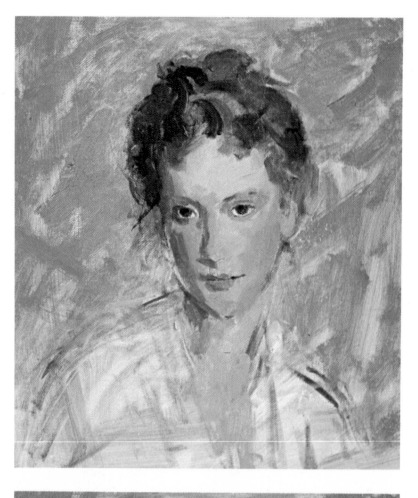

Step 6. A flat softhair brush blends the darks and halftones on the shadow side of the face and then darkens the eyelids with the shadow mixture. The lips are shaped more carefully, darkening the upper lip and placing a shadow beneath the lower lip. The shadow beneath the nose is carried downward to the lip. A pointed brush begins to add details like the eyebrows, the dark lines of the upper lids, the whites of the eyes, and the dark contours of the nostrils. A shadow is added where the hair overhangs the forehead. The shadow on the neck is pulled downward, and the chest is darkened to a halftone. In addition to the original components of the flesh mixture, all these darker notes contain a small quantity of the background color.

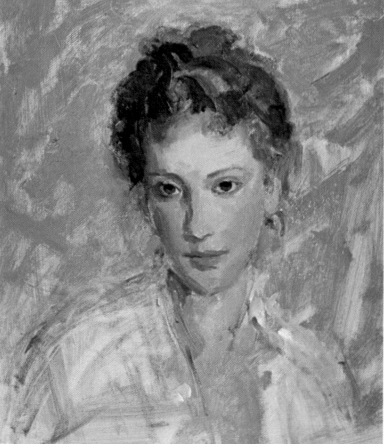

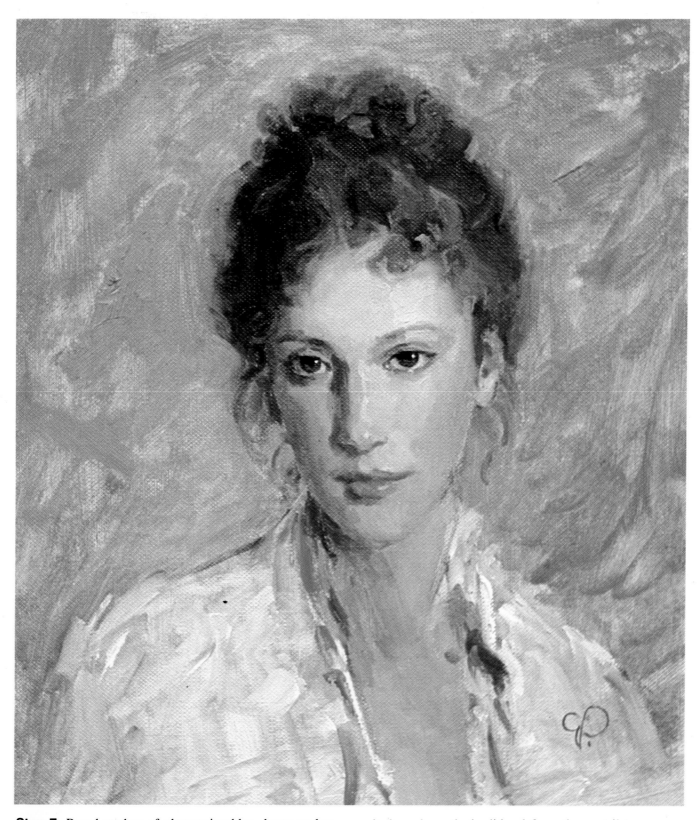

Step 7. Broad strokes of ultramarine blue, burnt umber, and white cover the background. A small, round brush suggests individual curls and then adds highlights to the hair with ultramarine blue, just a little raw umber, and white. More white is added to the flesh mixture to build up the lights on the forehead, cheeks, and chin. A round brush picks up this mixture to add highlight to the nose and lips. The same brush lightens the upper lids and darkens the shadows beneath the lids; defines the nostrils more precisely; and then softens the lines of the lips. A flat softhair brush moves gently over the face, softening such contours as the eye socket and the lower lip; blending lights and half-tones; adding hints of warm color to the chin and the hollow of the ear; and blurring the shadow on the neck. Strokes of white tinted with background color complete the blouse.

Step 1. A mixture of cobalt blue and just a hint of raw umber diluted with plenty of turpentine is wiped over the canvas with a rag. Then the preliminary brush drawing is made with pure cobalt blue diluted with enough turpentine to make the paint handle like watercolor. This brush drawing is interesting because it emphasizes broad patches of light and shadow. The domelike shape of the hair is a solid tone. The dark eye sockets are also filled with tone, as are the shadow planes beneath the nose, lower lip, and chin; the dark planes where the cheeks and jaw turn away from the light; and the shadow cast by the chin on the neck. Now work begins on the darks of the hair just above the ears with a mixture of ivory black, ultramarine, and burnt umber.

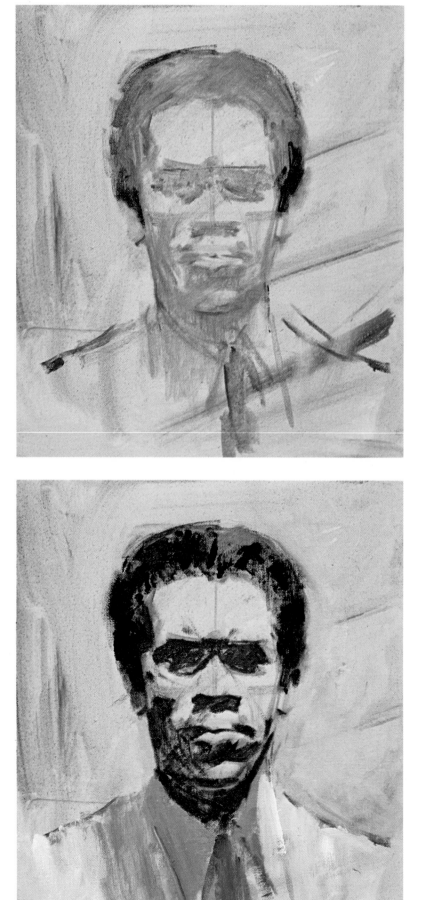

Step 2. The hair is the darkest note in the portrait, so the tones of the hair are placed first with ivory black, ultramarine blue, and burnt umber. Now it will be easier to determine all the other tones in the portrait, since even the darkest of these tones must be lighter than the hair. The darks of the face—first indicated in Step 1—are now solidified with heavier strokes of burnt umber, ultramarine blue, a little cadmium orange, and white. These rich darks contrast beautifully with the lighted planes of the face. The head already looks boldly three-dimensional. Thicker background color—cobalt blue, raw umber, and white diluted with medium—is brushed in above the shoulders and around the face. The collar and tie are suggested with a darker version of this color containing less white. A stroke of white is placed on the lighted side of the collar.

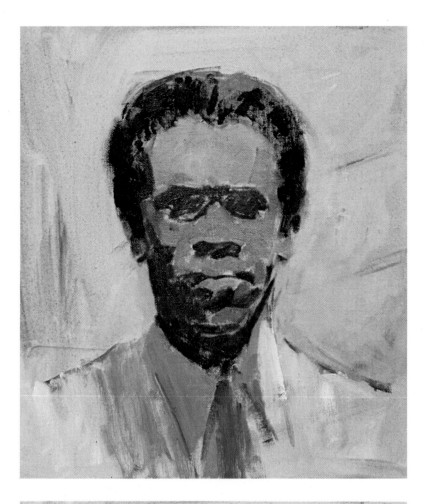

Step 3. The lighted planes of the face are placed beside the darks. These lights are a blend of burnt umber, ultramarine blue, cadmium orange, and white. The forehead receives the strongest direct light, so this plane is a little paler than the lower half of the face. A warmer shadow tone is brushed over the darks, which become richer and more solid. The shadow mixture is also burnt umber, ultramarine blue, cadmium orange, and less white. These shadow shapes are very carefully designed to reveal the form. Study how the shadow runs down the side of the face, curving in with the brow, cutting under the cheek and into the corner of the mouth, and then moving under the lip and chin. On the brightly lit forehead, notice how the color darkens slightly at the curving edge of the form.

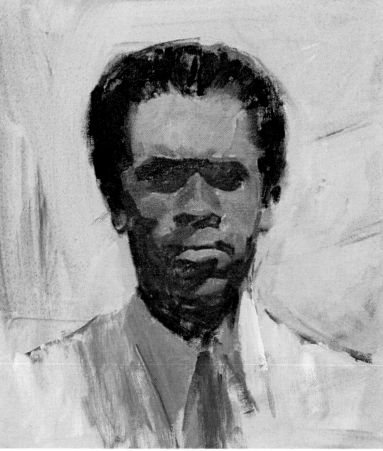

Step 4. More white is blended into the shadow tone to produce the halftone mixture. Then halftones are added between the light and shadow—along the lower edge of the brow, on either side of the nose, on the cheeks, and on the lips. The brush begins to blend the edges of the halftones where they meet the light. In this boldly painted head, all the work is done with bristle brushes. Just as softhair brushes add delicacy to a female face, bold strokes of a bristle brush can accentuate the strength of a masculine face.

Step 5. More white is blended into the basic flesh mixture of burnt umber, ultramarine blue, cadmium orange, and white. Just enough medium is added to make this mixture rich and creamy. Then a bristle brush begins to emphasize those areas that catch the most light—the forehead, cheek, bridge of the nose, and upper and lower lips. Another brush blends the edge where the lighted forehead meets the dark shape of the hair; some cool background color is blended in at this point.

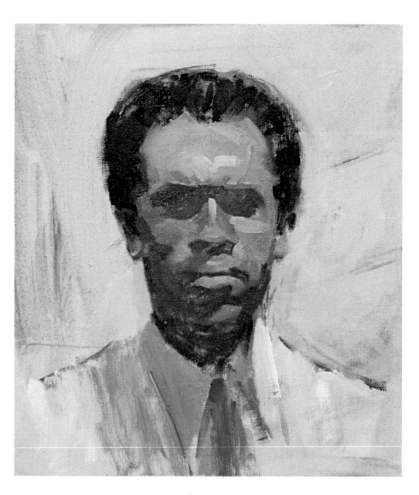

Step 6. The dark strokes of the hair are fused into one soft, continuous tone. The outer edge of the hair is blended softly into the background. Stronger lights are added to the forehead, cheek, nose, and lower lip with thick strokes. The brush begins to blend the edges of the shadows, which now melt softly into the halftones; you can see this most clearly around the eye socket, on the shadowy cheek, and around the mouth. A small brush begins to add details such as the whites of the eyes—which are almost as dark as the halftones—and the darks of the eyes, which are the shadow mixture. A softhair brush blends a touch of Venetian red into the shadows to add a hint of warmth beneath the nose and on the jaw. The shadow on the neck is blended into one continuous tone.

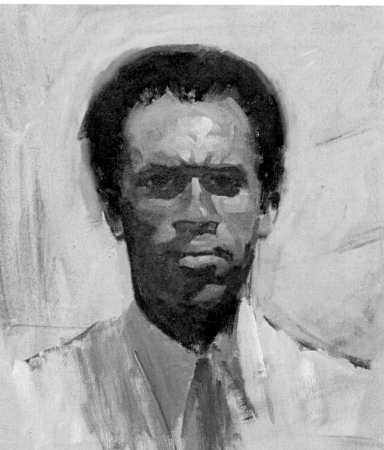

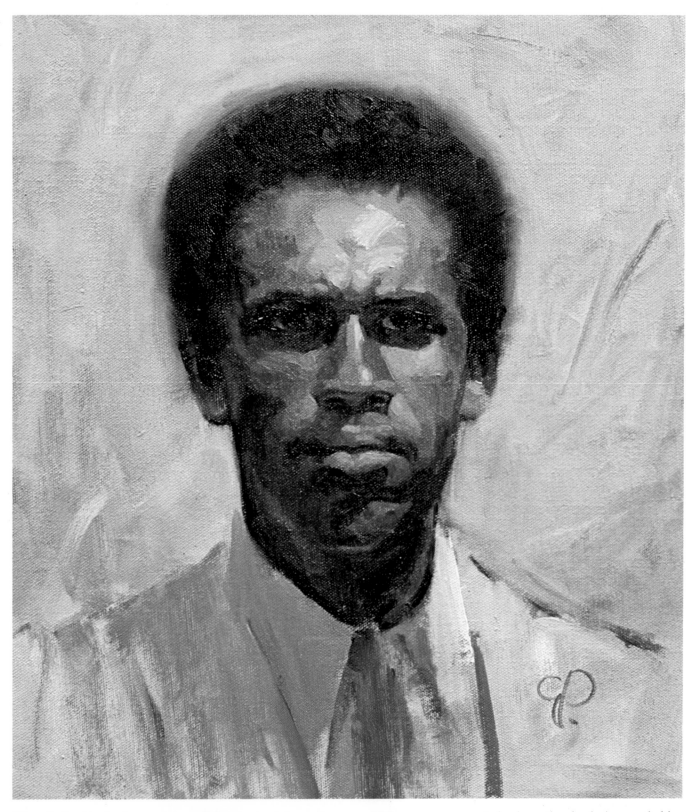

Step 7. In this final stage, a small brush strengthens the darks around the eyes, ears, nose, and mouth with a mixture of ultramarine blue and burnt umber. The eyebrows, the nostrils, the hollows of the ears, and the line between the lips are all sharpened with precise strokes of this mixture. The shadows are warmed with touches of Venetian red, which you can see most clearly on the cheek, jaw, and chin. Touches of cool background color are also blended into the shadows beneath the eyes, nose, and lower lip. The portrait captures the beautiful interplay of warm and cool color which is typical of black skin.

Step 1. The canvas is toned with a blend of raw umber and raw sienna that creates a warm, golden tone that harmonizes with the sitter's skin. The same mixture, but containing more raw umber and less raw sienna, is used for the brush drawing of the head. The brush draws the curving outline of the oval face, the curves of the neck and shoulders, and the dark shape of the hair. Then the eyes are located with dark touches; the nose is indicated with a single stroke that travels down the shadow side, plus quick touches for the nostrils; and the lips are suggested with broad, horizontal strokes. The shadow on the neck is lightly scrubbed in, and then the light areas of the neck are wiped away with a rag wrapped around a fingertip. The background is darkened with the same tone that's used for the brush drawing.

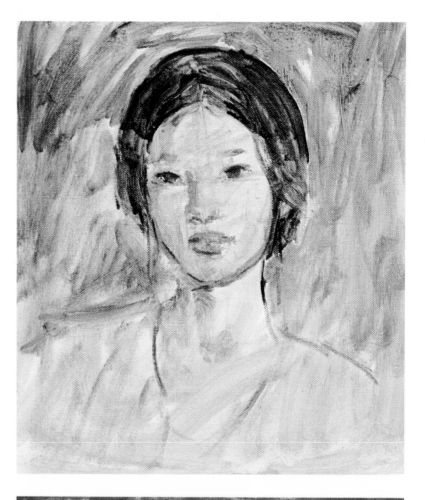

Step 2. The background is roughly covered with broad strokes made by a big bristle brush. The brush carries a mixture of cobalt blue, raw umber, raw sienna, and white. This cool tone will contrast nicely with the golden tone of the sitter's skin. It's important to establish this color scheme in the early stages of the portrait so you can judge the skin mixtures more accurately.

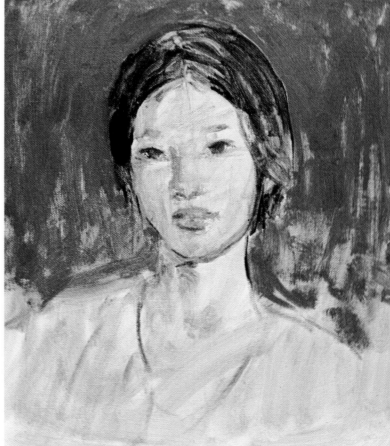

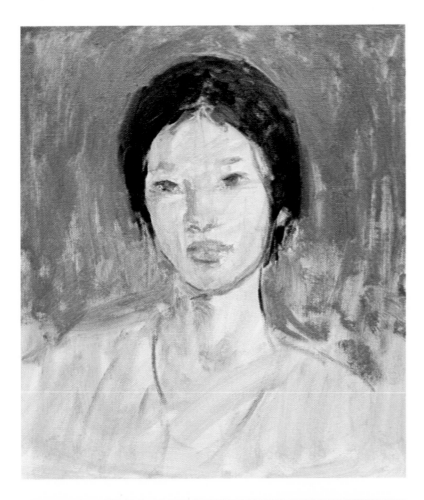

Step 3. The rich, dark shape of the hair is covered with strokes of ivory black, ultramarine blue, and a hint of burnt umber. A slight touch of light is suggested on the hair by adding more ultramarine blue and white to this blackish mixture. A rag wipes away some tone from the lighted side of the face.

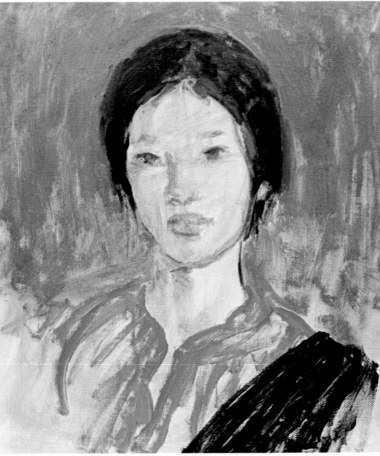

Step 4. Now the brilliant color of the dress is begun with strokes of cadmium red and alizarin crimson—which yield a particularly vibrant red—softened with a touch of cobalt blue and white. The dark fabric, draped over the sitter's shoulder, is painted with strokes of the hair mixture: ivory black, ultramarine blue, and burnt umber. Now the face is surrounded by all the colors which will contrast with the skin tones. This will make it easier to mix the skin tones and judge them accurately as they're placed on the canvas.

Step 5. The darks of the eyes are carefully painted with the tip of a round softhair brush that carries the hair color. Because the contrast between light and shadow—in the final portrait—will be particularly subtle, the artist starts work on the lights and shadows at the same time. The lighted side of the face is covered with a pale mixture of raw sienna, cadmium yellow, cadmium red, and white. The shadows on the brow, eye socket, nose, lips, and neck are painted with small touches of raw sienna, burnt umber, and white. At this early stage the face already contains a suggestion of the lightest and darkest notes that will appear in the finished portrait.

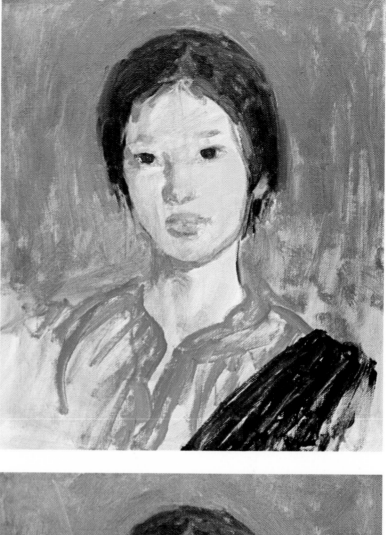

Step 6. Most of the face is just slightly darker than the light areas painted in Step 5. The forehead, nose, chin, and the shadow sides of the face and neck are covered with broad strokes of the same flesh mixture that appears in Step 5: raw sienna, cadmium yellow, cadmium red, and white. But now the mixture contains less white and more raw sienna. The dark drapery on the shoulder is distracting, and it's covered with a more delicate mixture of cobalt blue, alizarin crimson, and white, scrubbed on with rough strokes of a big bristle brush. A few strokes of this mixture appear on the opposite shoulder. Work continues on the background, where the original strokes are blended and brushed more evenly over the entire area. At the same time a few hints of the clothing mixtures are blended into the background above the shoulders. The area of the red dress is broadened with more color.

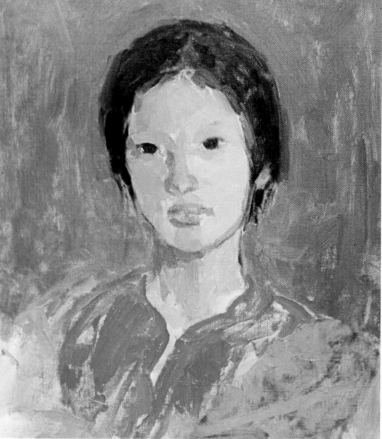

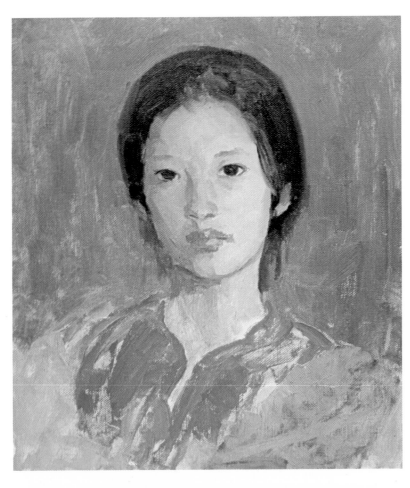

Step 7. Shadows and adjacent halftones are carried down the shadow sides of the brow, cheek, jaw, chin, nose, and lips. These "dark" notes are really not much darker than the lighter skin tones painted in Step 6. The components of the mixture, once again, are raw sienna, cadmium yellow, cadmium red, and white—with more raw sienna and less white. More cadmium red is blended into this mixture to add color to the lips. Patches of light and shadow are added to the ears. A pointed brush begins to darken the eyebrows and the shadowy edges of the eyelids. A flat, softhair brush blends the strokes of the hair into one continuous tone and softens the edges of the hair where they meet the background color. A pointed brush picks out a few strands of hair next to one ear.

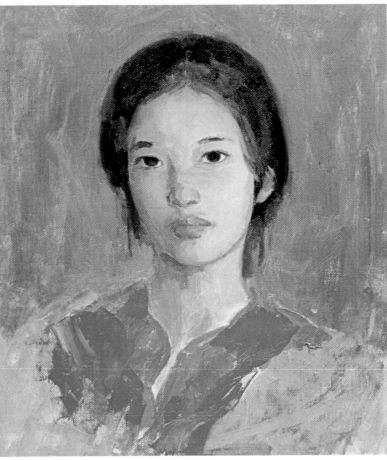

Step 8. A flat softhair brush begins to blend lights, halftones, and shadows. As these tones flow smoothly together, the face becomes rounder and more luminous. The shadow beneath the chin is carried down the length of the neck, and a touch of darkness is added just beneath the chin. The tip of a round brush continues to sharpen the eyebrows with the hair mixture and then darkens the upper lids. Notice how the hair is carried down the side of the shadowy cheek, which now stands out more distinctly. The tip of the brush sharpens the contours of the nostril wings, the nostrils themselves, and the lips.

Step 9. Flat softhair brushes begin to accentuate the darks and the lights. Creamy strokes build up the lights on the forehead, cheek, chin, and neck. The darks are strengthened on the shadow sides of the brow, nose, upper lip, and jaw. The contours of the lips are modeled more precisely. The eyebrows are thickened and the rims of the eyes are darkened. The whites of the eyes are added with *almost* pure white tinted with a minute amount of flesh color. The pupils are painted with pure black and the highlights are added with touches of pure white. A darker background tone is mixed on the palette with cobalt blue, raw umber, and less white; this is brushed over the background, concentrating the heaviest tones around the head and simplifying the shape of the hair by eliminating the hanging strands that appear in Step 8.

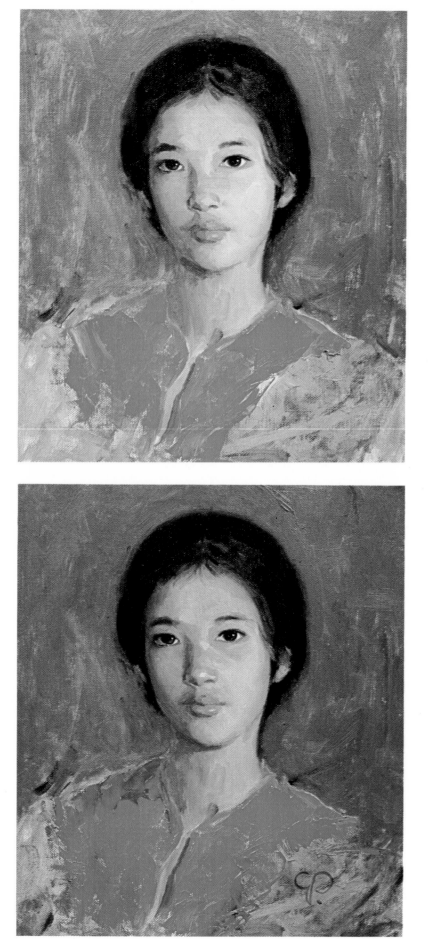

Step 10. Work continues on the background tone, which grows darker and more uniform, although hints of warmer colors still shine through. Softhair brushes continue to darken the shadows and strengthen the lights with touches of thick, creamy color. The face grows darker, richer, and more luminous as the strokes contain more cadmium yellow, more raw sienna, and less white. The shape of the mouth becomes more rounded as the small brush strengthens the shadows and sharpens the drawing. The dark beneath the chin is sharpened to make the chin come forward more distinctly.

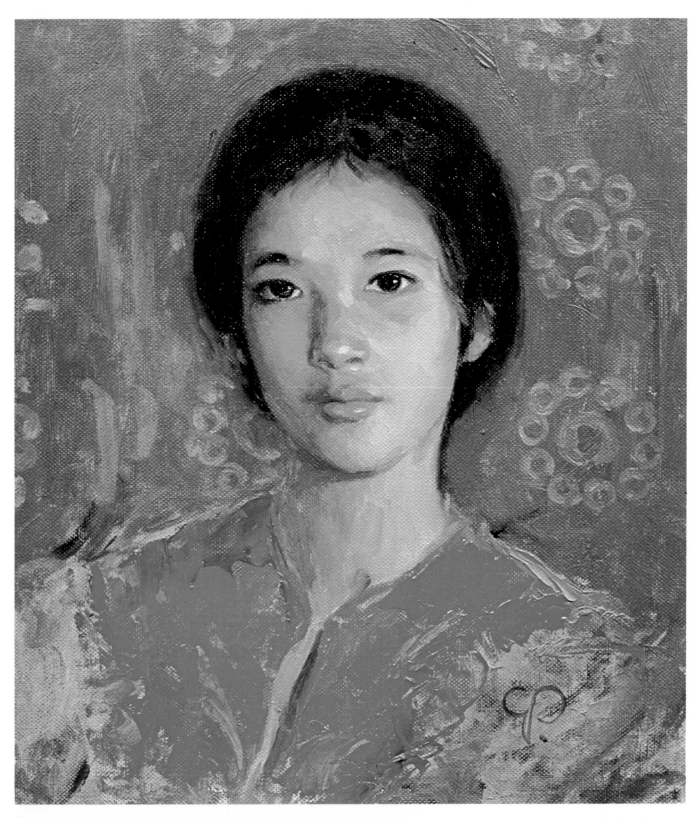

Step 11. The final stage shows how the shadows and half-tones have been enriched with the golden tones of raw sienna and cadmium yellow, lightened with white. Golden highlights of this mixture—with lots of white and painting medium—brighten the bridge of the nose, the tip of the nose, and the lips. Notice how the cadmium red in the shadows adds brilliance and transparency. The background mixture is lightened on the palette with white; this tone is drawn into the wet background with the tip of a small bristle brush to suggest the pattern of a fabric behind the sitter's head. Despite the blending action of the softhair brushes, it's important that the flesh tones aren't absolutely smooth; they still retain the marks of individual brushstrokes.

Step 1. The canvas is toned with raw umber. Then some Venetian red is blended into the raw umber on the palette for the brush drawing. The preliminary brush drawing is quite complete, delineating the features with great care and roughly indicating the shapes of the shadows. A rag wipes away some of the wet undertone on the lighted side of the face, neck, and scarf. Rough strokes suggest the pattern of the sitter's jacket. The background behind the head is darkened with free strokes of raw umber slightly darkened with ultramarine blue.

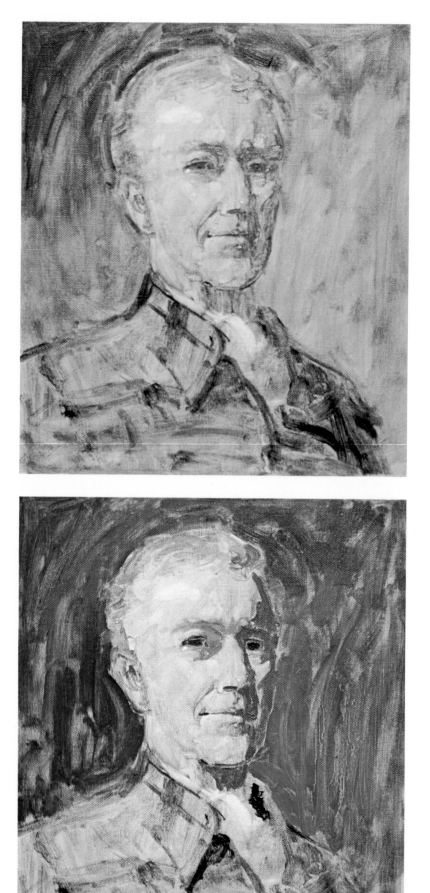

Step 2. A big bristle brush darkens the background with rough strokes of raw umber, ultramarine blue, a touch of viridian, and white. This dark tone silhouettes the head and defines the contours more sharply. A small bristle brush blocks in the shadows with raw umber, Venetian red, and white. As always, the eye socket on the lighter side of the face is lighter than the eye socket on the shadow side of the face. The tip of a round softhair brush places slender lines of shadow beneath the upper eyelids, between the lips, and inside the ear. The same brush adds the darks of the iris with burnt umber, ultramarine blue, and viridian. Work begins on the hair with strokes of burnt umber, ultramarine blue, and white. The first dark notes of ultramarine blue and burnt umber are placed inside the collar.

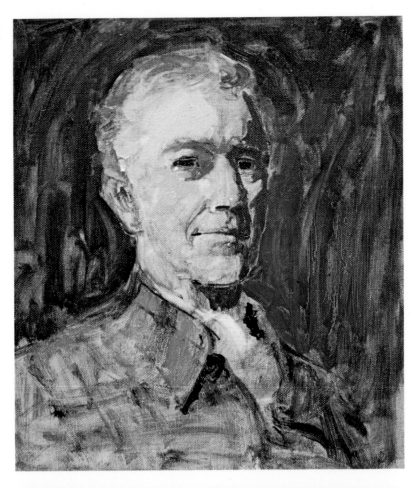

Step 3. At this stage work begins on the lightest areas of the skin. A bristle brush scrubs on a pale mixture of raw umber, cadmium red, and lots of white. The first strokes are placed on the most brightly lit area—the forehead—and then the mixture darkens very slightly as the brush moves down to the cheek. In general, it's worthwhile to remember that the greatest amount of light falls on the upper half of the head, and the tones tend to darken gradually as the brush moves down the face. You can see that the shadow beneath the chin is darker than the shadow on the cheek. More pink is added to the flesh mixture for the lighted edge of the ear. Cadmium red is softened with raw sienna, and the first touches of color are placed on the shirt.

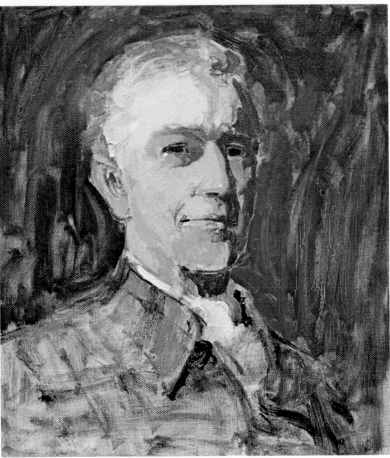

Step 4. The light areas of the face are now completely covered. It's important to notice that the lights are not one continuous tone, but are several different mixtures—starting out with a pale mixture on the forehead, then growing darker on the cheek, and becoming darker still on the jaw, chin, and neck. The ear is darker too. So are the lights on the shadow side of the face. The lighted cheek is raw umber, cadmium red, and white. The slightly darker tones are raw umber, raw sienna, Venetian red, and white. This mixture is used to place a halftone between the lights and shadows in the eye socket on the lighted side of the face, down the front of the nose, and along the underside of the nose. The edge of the jaw is darkened with more raw umber. A few strokes of white, softened with raw umber, appear on the scarf, alongside a touch of cobalt blue softened by raw umber and white.

Step 5. Halftones are brushed in with a lighter version of the shadow mixture—raw umber, Venetian red, and more white. You can see a broad halftone between the light and shadow planes of the forehead, plus varied strokes of halftone around the mouth, chin, jaw, and neck. A small bristle brush begins to blend the halftones into the shadows on the dark side of the face and inside the eye sockets. A whisper of cadmium red is added to this mixture to paint the warm hollows of the ear; the warm corners of the eye, nose, and mouth on the lighted side of the face; and the warm edges of the jaw and chin. Hints of this warm tone also appear on the shadowy cheek. More cadmium red is added to the pale flesh mixture to warm the lighted side of the nose and cheek.

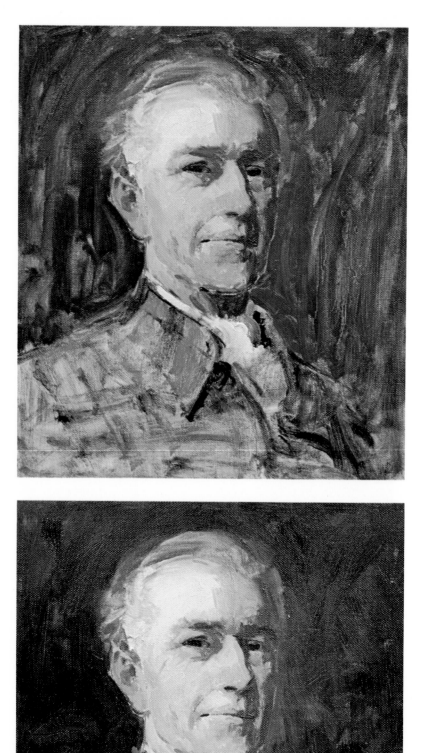

Step 6. The background is covered with a more uniform dark tone of burnt umber, ultramarine blue, viridian, and just enough white to "bring out" the color. Now there's a much stronger contrast between the dark background and the lighted side of the face, which emerges more dramatically from the darkness. The edges of the hair are blended softly into the background, while more lights are added to the hair with ultramarine blue, burnt umber, and white. The brush continues to blend the lights, halftones, and shadows on the dark side of the face. The warm stripes of the shirt are painted with various mixtures of cadmium red, raw sienna, and raw umber, in varying proportions as the stripes grow brighter or more subdued. More raw umber is added to this mixture for the muted stripes, the dark spots, and the shadow side of the shirt. The pointed handle of a brush scratches some pale lines into the wet paint.

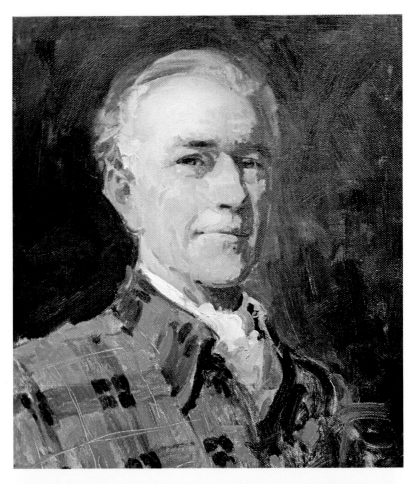

Step 7. A small bristle brush adjusts the colors of the face with crisp, distinct strokes that express the weathered character of this handsome head. More white is added to the basic flesh mixture to build up the lights on the forehead, cheek, nose, upper lip, and chin. For the warmer, darker touches, more raw umber and Venetian red are added to the mixture. The lights and darks of the eye sockets are more clearly defined. If you look carefully, you can see where hints of cool color appear within the shadows and on the lighted lower jaw; these are delicate strokes of cobalt blue softened with raw umber and white. The eyebrows are darkened with burnt umber and ultramarine blue. A small brush warms and softens the corners of the mouth and the line between the lips.

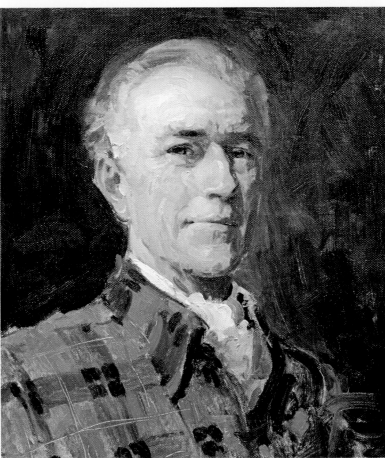

Step 8. A small bristle brush continues to build up the lights with thick, creamy color diluted with just enough painting medium to produce a buttery consistency. You can see the thick strokes at the corner of the forehead, where the form receives the most light; along the bony edge of the nose and further down on the nostrils; on the lighted areas of the cheeks; around the lips and chin; and on the ear. These touches seem to bring the form forward into the light and make the head look more three-dimensional.

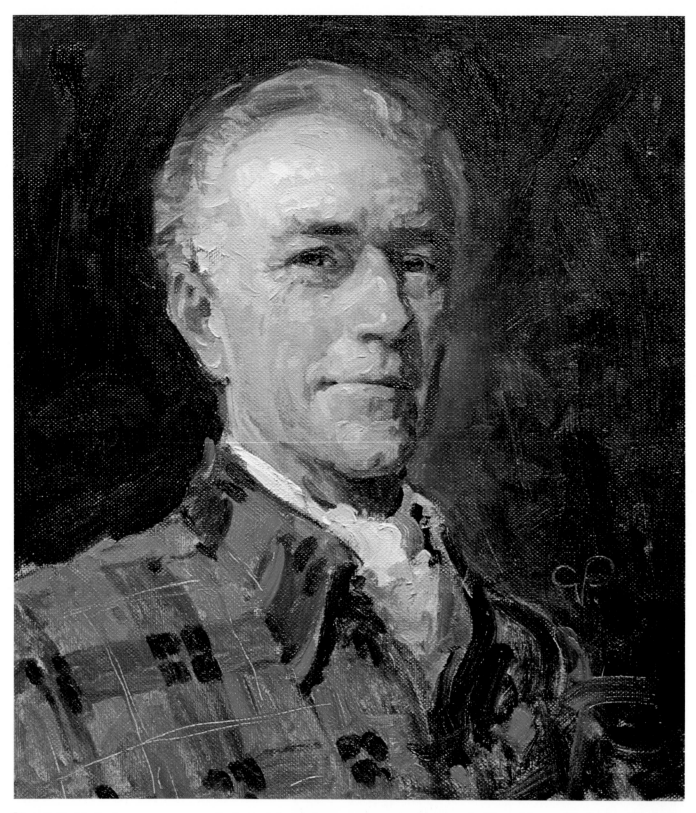

Step 9. In this final stage you can see the last subtle touches that enrich and complete the portrait. The whites of the eyes actually contain cobalt blue and so do the dark tones around the pupils. There are other suggestions of this cool tone in the shadows and halftones. Thick, juicy highlights add luminosity to the brow, the lighted corner of the eye socket, the tip of the nose, the lips, and the chin. These highlights are pure white tinted with a whisper of flesh tone. The background is darkened on the light side of the head to heighten the luminosity of the flesh color. But the background is then lightened on the dark side of the head, making the shadow curve softly into the darkness. Touches of Venetian red add warmth to the shadows, which are as colorful as the lights.

Deciding the Pose. All the painting demonstrations you see in this book are what the professionals call a "head-and-shoulders." This is what you might call the "basic" portrait. It's also the most intimate kind of portrait because it's essentially a close-up of the sitter's face. At first glance, it may seem easy to establish the pose for such a simple portrait—but there are more possibilities than you might think. Above all, try to find a pose that looks *active*, not static. Ask the sitter to lean his head to the left or right. Have the sitter turn—or you walk around him—until you find the most flattering angle. Some sitters will look (and feel) most natural if they slouch or lean in the chair, while others will prefer to sit upright.

Finding the Flattering View. Portrait sitters usually want to be shown at their best. They want you to emphasize their most attractive features and minimize their least attractive ones. Some portrait painters don't hesitate to reduce the size of a big nose, enlarge a small chin, or square up a weak jaw. Other painters consider this "dishonest." Whether you want to flatter your sitter—by redesigning his face—is your decision. However, another method is to try to find the most flattering *view* of the sitter. A big nose looks even bigger if you paint the head from slightly above—but tends to get smaller if you ask the sitter to tilt his chin upward so that you're painting him from slightly below. That same nose may look unattractive in a profile or three-quarter view, but may become strikingly handsome when the sitter faces you head-on. If a sitter is particularly proud of her luxuriant hair, paint her from slightly above so you can see more hair; this view also emphasizes the eyes and de-emphasizes the chin.

Relaxing the Sitter. The whole painting will go more smoothly if you can keep the sitter relaxed and entertained. Watching television, listening to a radio broadcast, or hearing a record will not only reduce the tedium of sitting for a portrait but will make the sitter look alive and alert. After all, if your sitter is tired and bored, it's difficult to keep that feeling out of the portrait. If you can carry on a natural, relaxed conversation with the sitter—without making it obvious that you're trying too hard—that's an excellent way to keep the sitter entertained. The sitter will look at you with an animated expression which will enliven the portrait. Many professionals place a large mirror behind them so the sitter can see how the portrait is coming along—a process more fascinating than *any* television show!

Experimenting With Lighting. The most common portrait lighting is called 3/4 lighting. The light does not hit the face from the front, but hits it slightly from one side; thus *most* of the face is in light, but the angle of the light creates clearly defined shadow planes on one side of the brow, cheek, jaw, and nose. This is often called "form lighting" because it emphasizes the three-dimensional quality of the face. Women often like "form lighting" because it makes a round face look rounder, while men often like it because they feel that the strong contrast between light and shadow makes them look more masculine. On the other hand, there are times when you want to emphasize the softness and delicacy of the face by using frontal lighting. When the light strikes the face head-on, rather than from the side, shadows tend to melt away, softening harsh features and de-emphasizing wrinkles. Move the sitter around—place him or her close to the light, further away, facing the light, facing away—to see how different kinds of light affect each sitter's face.

Making Preliminary Drawings. As you study different poses, angles, and kinds of lighting, it's helpful to make quick pencil sketches of all these possibilities. These don't have to be elegant, finished drawings, or even a good likeness. The drawings simply record all the different options. Spread out the drawings and choose the one that represents the best approach to the final portrait. Having chosen the sketch that looks best, some artists dive right into the painting, while others like to make some more drawings of the sitter—or perhaps a quick oil sketch—before they begin the actual painting. This may seem like extra work, but many professionals consider it a shortcut. As he makes these studies, the artist gets to know the contours of the face so intimately that he can execute the final painting without hesitation.

Some Final Do's and Don'ts. Female sitters often insist on going to the hairdresser just before they come to the studio. The fresh hairdo may have a tight, artificial quality that's much less attractive than the sitter thinks. Ask her to go to the hairdresser a day or two before the sitting, so there's time for the hair to soften and become more natural. If she shows up with a hairdo that's just an hour old, tactfully ask her to soften it slightly with her fingers or with a comb. Ask the sitter to dress simply, preferably in solid colors or clothes with a subdued pattern. Urge the sitter to avoid ornate jewelry and violent colors that distract attention from the face. Never tell a sitter to smile; no one can hold a smile long enough for you to paint it. And be sure to let the sitter take a break—for a walk, a rest, a snack—every twenty or thirty minutes.

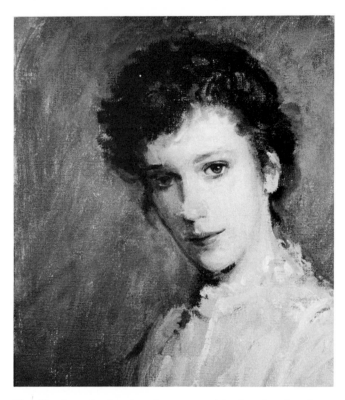

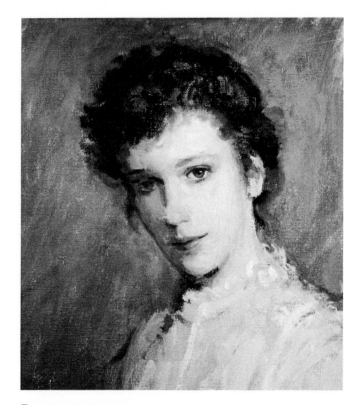

Don't place the head so far to one side that there's a huge space in front of the head and just a little space behind.

Do place the head so the space in front is just a *little* greater than the space behind. It's effective to place the head slightly off center, but not too far to one side of the canvas.

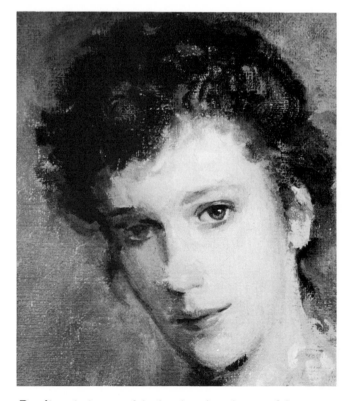

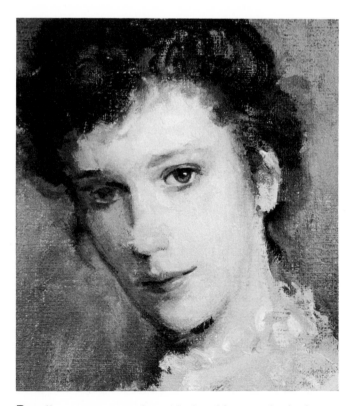

Don't push the top of the head against the top of the canvas and rest the chin against the lower edge of the canvas when you paint a close-up. Such close-ups can be handsome, but the head should never look as if it's crowding the edges of the canvas.

Do allow more space beneath the chin—not hesitating to chop off a bit of hair at the top of the canvas. Now the head is just as big, but the portrait seems more spacious.

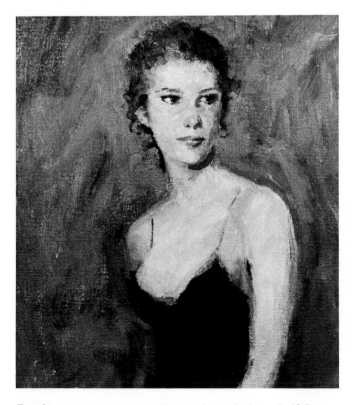

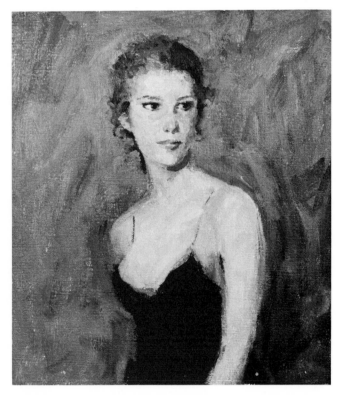

Don't crowd the canvas when you're painting a half figure. Once again, the head is too close to the top edge of the canvas and too close to the right side, allowing too much space at the front of the figure.

Do allow enough space above the head and provide a better balance of space on either side of the figure. Now the space in front of the figure is only slightly greater than the space behind.

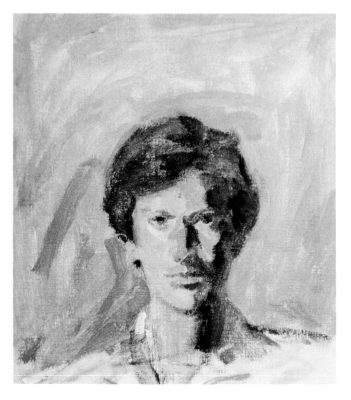

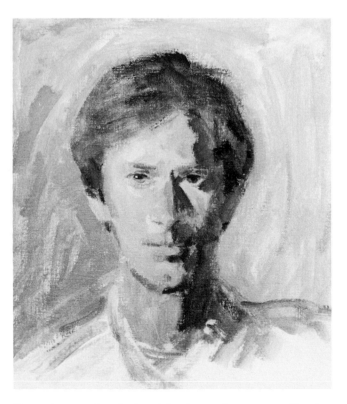

Don't drop the head too far down from the top of the canvas, allowing too much space at either side. In this portrait the space, not the head, dominates the painting.

Do make sure that the head dominates the canvas, allowing a *reasonable* amount of space at the top and the sides.

3/4 Lighting. Sometimes called *form lighting*, this is the favorite lighting of most portrait painters. The light comes from one side and from slightly in front of the face. As you stand at the easel, facing this sitter, the light is coming from somewhere beyond your left shoulder, illuminating roughly three quarters of the head and creating strong shadows on one side of the nose, lips, brow, cheek, jaw, chin, and neck. The shadow side of the face isn't *completely* dark, but catches a certain amount of light on the cheek and jaw. Portrait painters like this kind of lighting because the light and shadow planes are clearly defined, making the forms look solid. Like the face, the hair also has distinct planes of light and shadow.

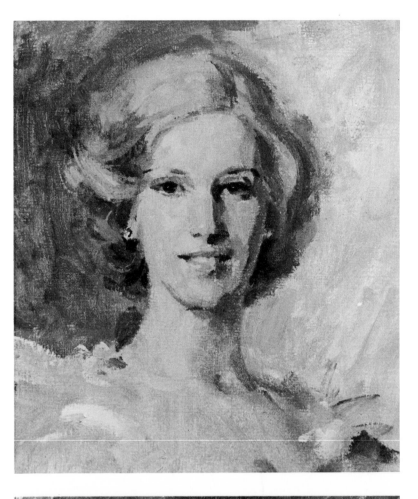

3/4 Lighting. Here's another example of 3/4 lighting, but this time the light comes from your right side. The light source is slightly further to the side, creating deeper shadows on the dark side of the head. In contrast with the woman's head above, the eye sockets are darker, and there are broader shadows on the side of the nose, mouth, and chin. On the lighted side of the face, the eye socket is also in shadow, but the shadow isn't as deep as the tone that fills the eye socket on the dark side of the face. These strong shadows can be particularly flattering to a male sitter. Compare these with the slender shadows that are more flattering to the female sitter.

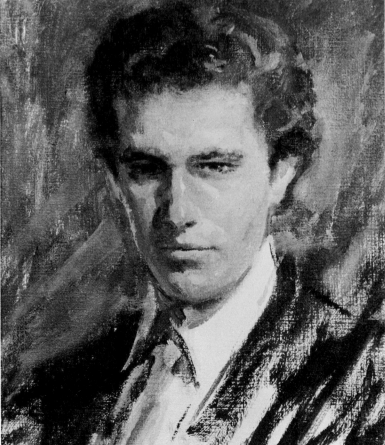

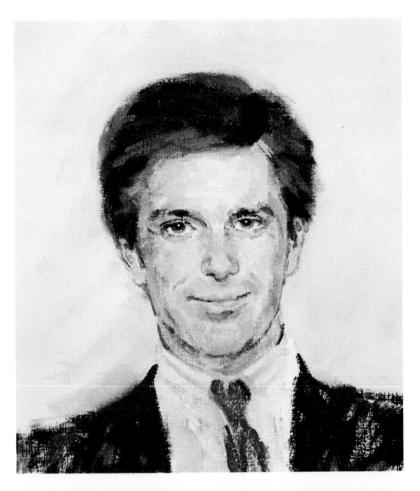

Frontal Lighting. When the light hits the sitter in the center of his face, this is called frontal lighting. As you stand at the easel, facing the sitter, it's as if the light source were your own face, pointing straight at him. Frontal lighting bathes the face in a smooth, even light that minimizes shadows. The shadow planes of the head are only slightly darker than the light planes. The darks tend to be the features themselves: eyebrows, eyelids, eyes, nostrils, and the lines of the lips. Frontal lighting is particularly effective when you want to minimize wrinkles and other surface irregularities in the sitter's face.

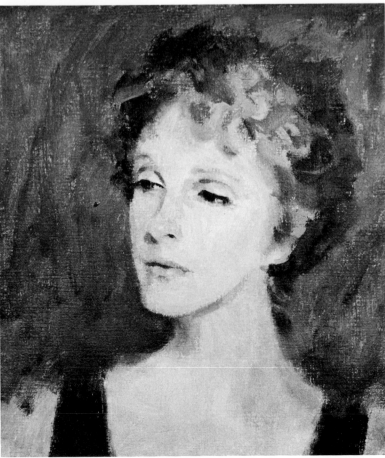

Frontal Lighting. When the sitter turns, frontal lighting may produce slightly more shadow. Hints of shadow appear in the eye sockets, beside the nose, around the lips, and beneath the chin. These shadows, however, are still inconspicuous and not much darker than the lights. The face still looks bright, smooth, and evenly lit. Frontal lighting can be particularly flattering to a female sitter, emphasizing her smooth, soft complexion. The dark background heightens the luminosity of her skin.

Side Lighting. When the light comes directly from the side—as if the sitter is next to a window—the face tends to divide into equal planes of light and shadow. For this reason side lighting is sometimes called half-and-half lighting. In a head-on view of the sitter, the dividing line tends to be the nose: on one side of the nose the face is in bright light; on the other side the face is in deep shadow. A suggestion of light sometimes creeps into the cheek on the shadow side of the face, as you see here. Side lighting will dramatize a sitter who has a strongly cut head and bold features.

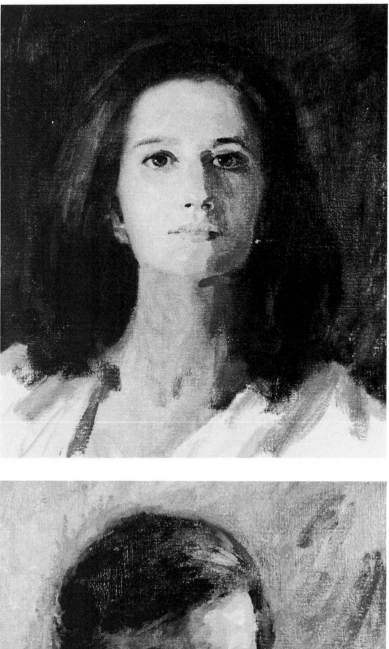

Side Lighting. As the head turns, the distribution of light and shadow may change. Here the dividing line is still the nose, but there's more shadow on the forehead, chin, and neck. In fact there's more shadow than light on this face. Within the deep shadow, there are still subtle variations in tone: patches of darkness around the eyes, nose, and mouth; and a suggestion of reflected light on the cheek. Light sometimes bounces off a reflecting surface such as a white wall, adding luminosity to the shadow side of the head.

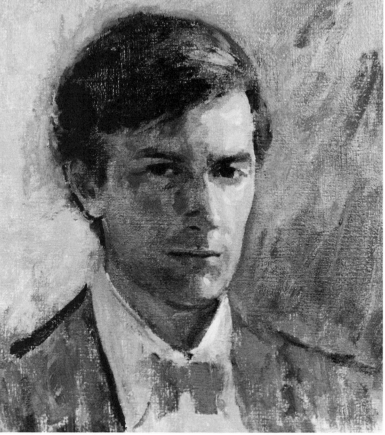

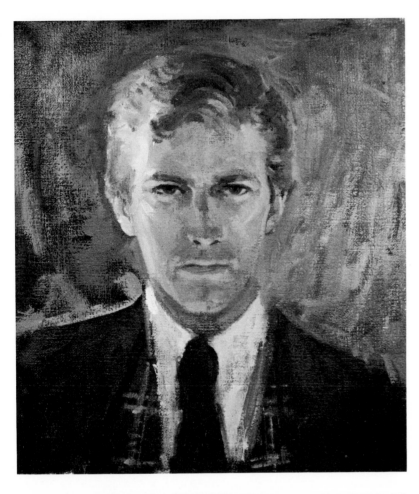

Rim Lighting. When the light source is behind the sitter's shoulder, most of the face is apt to be in shadow. Some of the light, however, usually creeps around one side of the face, which is why it's called rim lighting. Here, the light catches only the very edge of the brow, cheek, ear, and jaw. The rest of the face is in shadow, but this doesn't mean that the front of the face is pitch black. On the contrary, there are still tonal variations that define the features. In rim lighting the lights and shadows may appear in unexpected places, so you have to study the head carefully. This head surprises you by picking up reflected light from below. This means that the lower lids, the underside of the nose, and the upper lip catch the light—which is the reverse of the "normal" distribution of lights and shadows. Rim lighting has a theatrical quality that lends an air of mystery to the sitter's face.

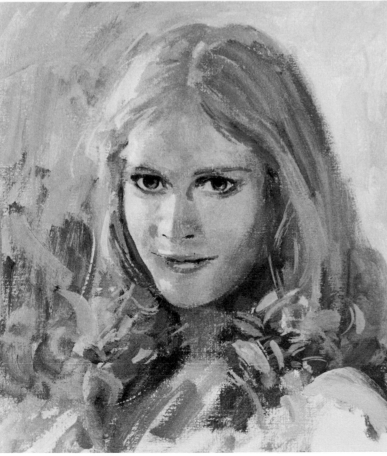

Rim Lighting. As the sitter's face turns toward the light source, the rim lighting may extend beyond the edge of the face to catch the nose, upper lip, and chin. Nor does rim lighting have to be somber and serious, as it is on the male head above. This lighting effect can also be soft and delicate if there's only a slight contrast between the planes of light and shadow. Delicate rim lighting can be particularly flattering to the female head. Here the only strong darks are the eyes and mouth, which look particularly magnetic in contrast with the pale shadow tone that covers most of the face.

Step 1. A pencil portrait begins with a few strokes for the outlines of the head, hair, neck, and shoulders. A vertical center line divides the head. Horizontal lines are drawn across the center line to locate the eyes, nose, and mouth. A few shorter lines begin to define the features.

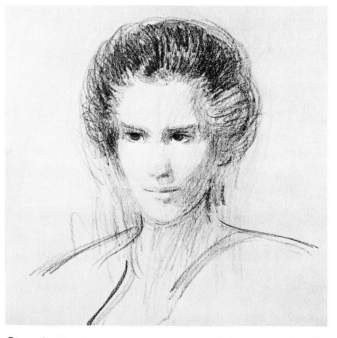

Step 2. Working with pale, parallel lines, the pencil indicates the tones of the hair and the shadows. The eye sockets are filled with shadows. The shapes of the eyes are carefully drawn. Shadows are suggested beneath the nose, beside the nostril "wing," and beneath the upper and lower lips. One broad shadow tone is carried down the side of the head and neck.

Step 3. Still working with parallel strokes, the pencil glides lightly over the paper to darken the hair and the shadows very gradually. The pencil begins to define the darks of the eyes, the nostrils, and the dark line of the mouth. Additional lines sharpen the shoulders and the shape of the dress:

Step 4. Curving strokes continue to darken the hair. The pencil sharpens the contours of the eye sockets with darker strokes, defining the lines of the eyebrows, the lids, and the dark pupils within the eyes. The pencil point darkens the lines between the lips and strengthens the lines of the cheek, jaw, neck, shoulders, and dress. A single line defines the earlobe.

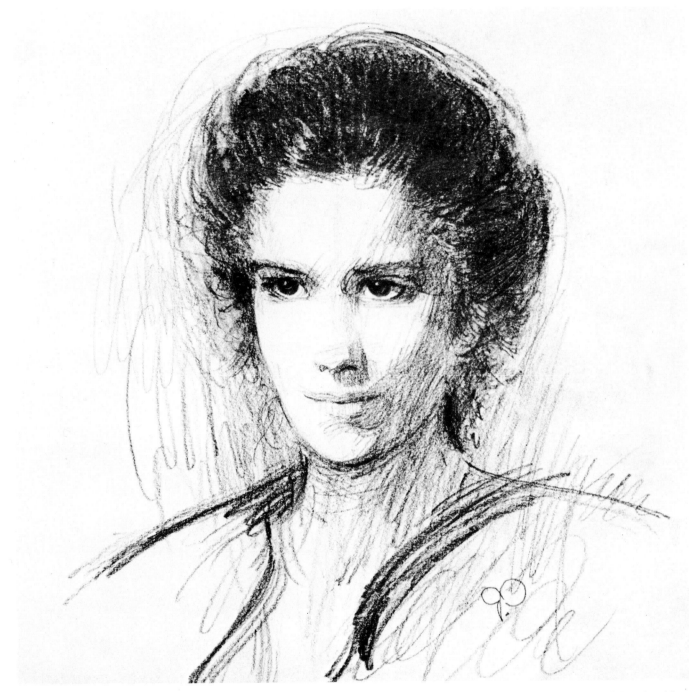

Step 5. In this final stage the pencil presses harder and harder, strengthening and solidifying the darks. The dark strokes of the hair merge to form a continuous tone—within which you can see individual strands. The point of the pencil sharpens and darkens the eyebrows and the eyelids. The sharp corner of a rubber eraser picks out the highlights in the eyes. The pencil point darkens the nostrils and strengthens the shadow at the corner of the nose; the point then moves down to darken the lines of the lips and to strengthen the shadow at the side of the lower lip. Still working with scribbly, parallel lines, the pencil deepens the shadows on the side of the face and carries this tone down to the neck.

The tip of the chin is sharpened. The lines of the shoulders and dress are reinforced with multiple strokes. A light tone is scribbled around the head to suggest a background. This method of pencil drawing is particularly interesting because all the tones are made with strokes that follow the form. The strokes of the hair follow the short curves of the sitter's dark curls. The strokes on the face follow the curves of the brow, cheek, jaw, and neck. Although it's *possible* to create tones by smudging the marks of the pencil with a fingertip, all *these* tones are made by building up a network of parallel lines.

Step 1. The strokes of a charcoal pencil are particularly effective on the textured surface of charcoal paper. This charcoal portrait begins with light, curving lines that define the outer shape of the head and hair. A vertical center line divides the head; then horizontal lines locate the features.

Step 2. Pressing harder against the paper, the charcoal pencil strengthens the outer contours and then draws the shapes of the features. A diagonal shadow runs from the nose to the jaw; another shadow curves down over the brow, cheek, and jaw. These shapes are carefully drawn and then filled with parallel strokes.

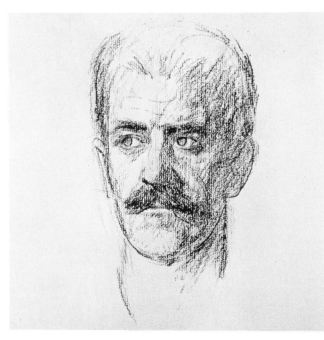

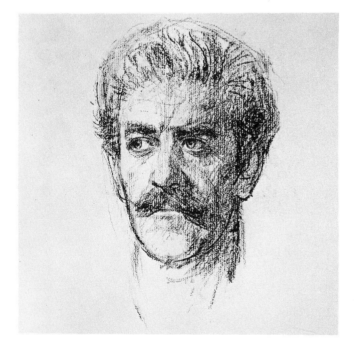

Step 3. Moving back and forth over the textured paper, the charcoal pencil gradually darkens the shadows, eyebrows, and mustache. The textured drawing surface tends to produce a ragged stroke. The point continues to sharpen the contours and the features: the eyes, ears, nose, and mouth are more distinct.

Step 4. The point of the charcoal pencil draws some strands of hair and darkens the lines of the features. Now the eyelids are more distinct and you can see the pupils. The details of the ears and nostrils appear. Parallel strokes continue to darken the shadow side of the face and neck.

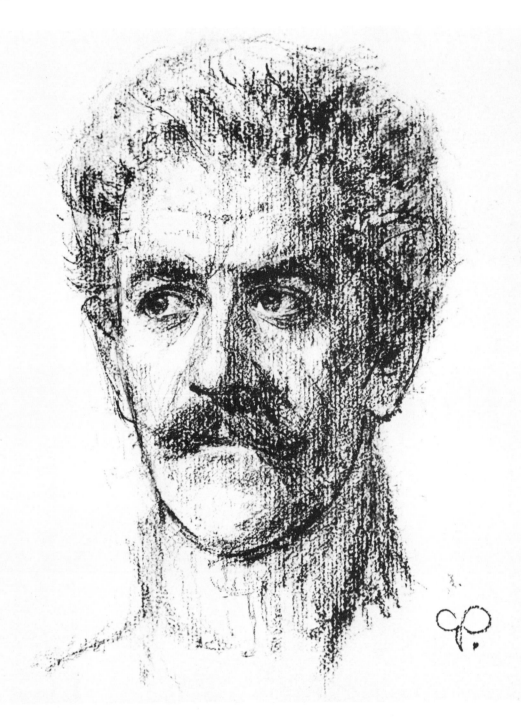

Step 5. Until now all the work has been done with the tip of the charcoal pencil. But the charcoal inside the pencil is actually a broad cylinder, and you can create rich, heavy strokes by working with the side of the charcoal. Now the side is scribbled over the hair and the shadows, which become darker and rougher as these broad, ragged strokes appear. The collar of the turtleneck sweater is executed by this method. The eyebrows, the mustache, and the shadow of the nose are deepened with broad strokes. And the tip of the charcoal adds the last few dark lines that strengthen the contours of the eyes, nose, mouth, and jaw. Charcoal, like pencil, can be smudged with a fingertip to behave more like paint. But a charcoal drawing is more powerful if you avoid smudging and work with decisive strokes.

Step 1. A chalk drawing can be particularly rich if you work on gray paper with two pieces of chalk, one black and one white. This portrait begins without the usual guidelines for the features. With enough practice you should be able to draw the outer contours of the head and then just strike in a few lines to locate the features, as you see here.

Step 2. The broad side of the chalk begins to surround the head with heavy strokes of darkness. Then the white chalk scribbles in the first suggestion of the light that falls on one side of the face. The bare, gray paper becomes the shadow side of the face.

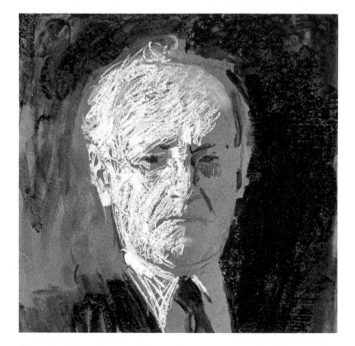

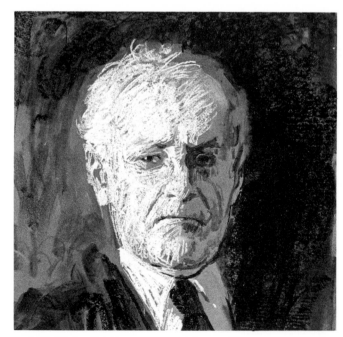

Step 3. The white chalk continues to cover the lighted side of the face with parallel, diagonal strokes, leaving gaps of gray paper for the shadowy eye sockets, the hollow of the ear, and the dark lines of the features. The black chalk continues to surround the head with darkness, scribbles in dark tones for the shoulder and necktie, and then reinforces the features with small strokes.

Step 4. The sharp tip of the black chalk delineates the eyebrows, eyes, nose, wrinkles, mouth, and chin with quick, decisive strokes. A touch of white chalk places a single highlight on one eye. A fingertip smudges the strokes of the white chalk to produce a softer, more continuous tone, but doesn't obliterate the individual strokes.

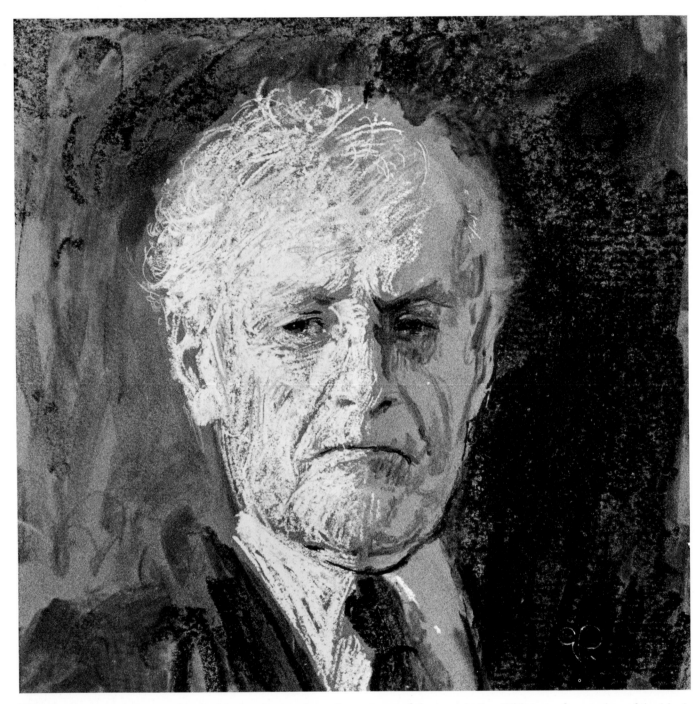

Step 5. The portrait is completed with the sharp points of both chalks. The white chalk adds a few more strands of hair and some touches of white to the eyes. The dark chalk strengthens the shadow lines on the dark side of the face. The "strategy" of this chalk portrait is worth remembering. It's essentially a portrait in three tones. The white chalk creates the lights. The black chalk creates the darks. And the paper provides a middletone that falls midway between the tones of the two chalks. With just a few strokes of the black chalk, the paper becomes the shadow side of the face. Like charcoal, chalk can be used in different ways. The tip can draw distinct lines, while the broad side of the chalk can make wide strokes like a big bristle brush. Working with black and white chalk on gray paper—or with brown and white chalk on tan paper—you can produce a portrait that has a tonal range as rich as a painting.

Step 1. To *paint* a preliminary sketch simply mix black and white on the palette to produce a variety of grays—diluted with turpentine. Casual strokes begin by suggesting the background; the dark patches of the hair, beard, and mustache; the shadow side of the face; and the dark eye socket on the lighted side.

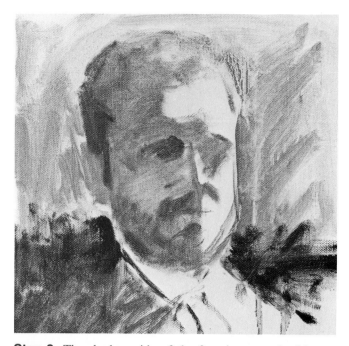

Step 2. The shadow side of the face is covered with one continuous tone. On top of this tone the darker patches are scrubbed in for the hair, beard, mustache, and eye sockets. Another patch suggests the eye socket on the lighted side of the face. Scrubby strokes suggest the shoulders and a landscape background.

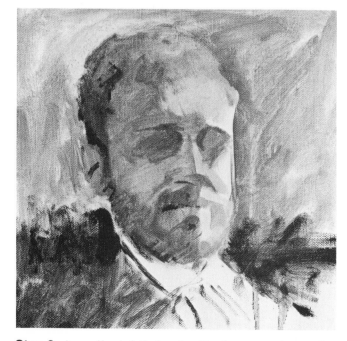

Step 3. A smaller bristle brush adds sharper strokes to define the hairline, ear, jaw line, brows, nostrils, and the dark line of the mouth. Halftones are added to the lighted side of the face—on the forehead, cheek, and jaw. The background is darkened to accentuate the face.

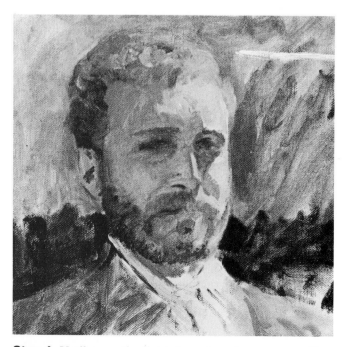

Step 4. Until now, the lights have been bare canvas. Now they're covered with thick, juicy strokes that define the lighted planes of the forehead, cheek, nose, and jaw. The brush begins to blend the brushstrokes on the shadow side of the face. Dark strokes define the features more distinctly and add texture to the beard.

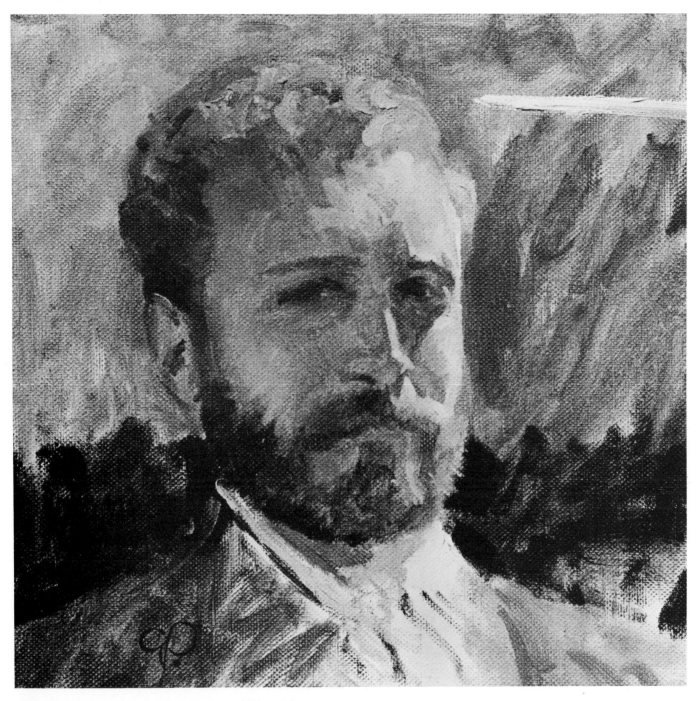

Step 5. The tip of the brush adds the whites of the eyes, sharpens the lighted side of the nose and cheek, and adds details to the lighted side of the beard. Short, thick strokes suggest the texture of the hair. Compare this stage with Step 3 to see how softly the rough strokes on the shadow side of the head have been blended to produce a continuous tone. A rag wipes away some color from the dark cheek to suggest reflected light. Dark color has been scrubbed on the background next to the lighted cheek to accentuate the bright contour. The entire sketch is composed of broad areas of light and shadow, with very little attention to detail. The oil sketch may, in fact, be an excellent likeness—which proves how little detail you need to create a successful portrait, as long as the broad shapes are correct.

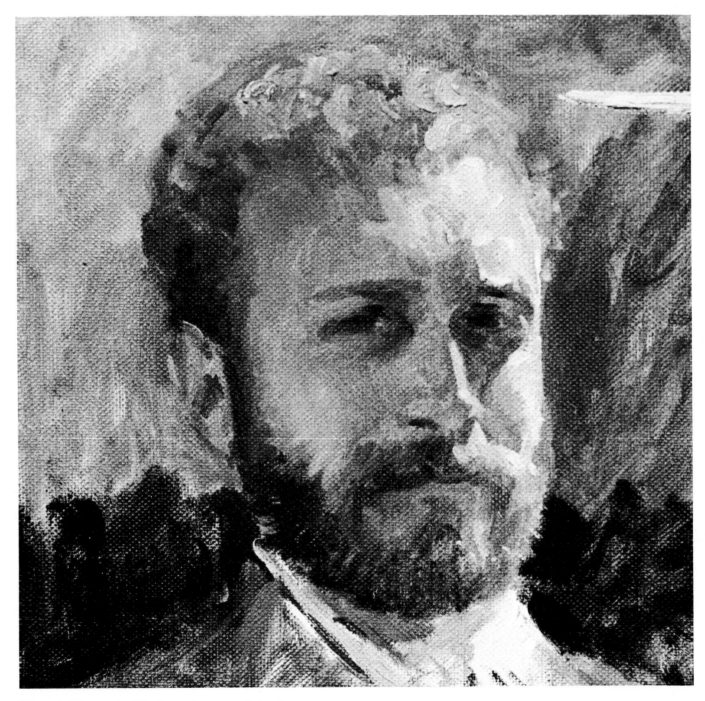

Step 6 (Close-up). Here's a close-up of the final stage, showing the last few refinements in the tones. The corners of the eye sockets are darkened to make them look deeper. Thick highlights are added to the forehead. A few more dark strokes add texture and suggest detail in the mustache and beard. On the lighted side of the forehead, small strokes suggest individual locks of hair caught in the light. The nostril is darkened and the tip of the nose is wiped lightly with a rag to suggest reflected light within the shadow. The artist *could* go on refining the tones and adding more details—perhaps adding color—until the sketch is transformed into a finished portrait. But a successful oil sketch *is* a complete work of art in itself. So it's best to stop here.

PART TWO

CHILDREN'S PORTRAITS IN OIL

Painting Children's Portraits. The faces of children—sensitive, animated, and colorful—are the favorite subjects of many portrait painters around the world. Most children are wonderful portrait sitters. They look natural and relaxed because they're not consciously trying to look glamorous or important. They're open about their feelings, so their faces are full of tenderness and vitality. They're usually fascinated by the process of painting, full of questions, and easy to talk to. They're fun to be with *and* fun to paint.

Painting Children Step By Step. In the next few pages, you'll see a series of demonstrations painted in black and white. The distinguished portrait painter, George Passantino, starts by showing you the basic steps in painting a girl's head, from the preliminary brush drawing on the canvas, through the buildup of the tones, to the final touches and details. Then Passantino repeats the process, showing you the steps in painting a boy's head. Having seen two demonstrations of the steps in painting a complete head, you'll then find step-by-step demonstrations that show you how to paint each of the features: the eye, nose, mouth, and ear. Study these black-and-white demonstrations carefully before you go on to the demonstrations in color. It's important to learn how to visualize the head and its features in black-and-white because it's light and shadow that actually mold the forms. In fact, it's good practice to squeeze out a gob of black and a gob of white on your palette, mix them to produce a variety of grays, and paint a series of black-and-white portrait studies *before* you begin to work in color. When you've learned how to visualize the head as a pattern of lights, shadows, and halftones—halftones are those subtle tones that are darker than the lights but lighter than the darks—you're well on your way to painting an effective portrait.

Color Demonstrations. Following these black-and-white demonstrations, Passantino goes on to demonstrate how to paint ten different children's heads in color. These demonstrations cover a wide range of ages, from very young children to teenagers. You'll also find a great variety of hair and skin colors. First, you'll watch Passantino paint a girl with dark brown hair and pale, delicate skin, followed by a boy whose hair is a softer brown, but whose skin is darker. You'll learn how to paint a red-haired girl with freckled skin. Then you'll watch painting demonstrations that show how to render the delicate skin and hair tones of a

blond girl and a blond boy. Dark-haired sitters can also have a variety of hair and skin tones, and you'll see how these are handled in demonstration paintings of a young boy and a teenaged girl. You'll see how to paint an oriental boy with black hair and pale skin. And finally, you'll watch two demonstration paintings of black children: a girl with soft, coffee-colored skin, and a boy whose skin is a ruddy brown. Above all, you'll discover that there are no formulas for painting different racial and ethnic types: each sitter has his or her own unique combinstion of hair and skin color—as unique as the sitter's personality.

Proportions, Lighting, Drawing. Children change rapidly, as you know, so it's particularly important to study the differences in children of different age groups. Following the color demonstrations, you'll find a series of sketches that analyze the head proportions of seven different children of various ages: two, five, seven, nine, eleven, twelve and thirteen. You'll study four different ways of lighting children's portraits. And you'll watch a series of step-by-step demonstrations in which Passantino shows you how to draw portraits in pencil, charcoal, and chalk—and how to make an oil sketch.

Studying Children. Children have enormous energy, and it's often difficult for *young* children to sit still for very long while you're working on a portrait. It's always important for a portrait painter to be quick and decisive—but this is doubly important when you're painting children. The secret, of course, is *practice.* Make a habit of drawing children at every opportunity. If there are children in your own household, ask if they'll sit for a quick sketch after dinner, while they're relaxing with a book or a magazine, or while they're in front of the television set. Invite the neighbors' kids in for a quick sketch. A brief drawing session each day will fill your sketchpad with information and rapidly develop your powers of observation. At the end of a year, you'll have a stack of sketchpads filled with drawings, and all the information will also be stored inside your head. It's also worthwhile to make lots of quick sketches in color. Buy a pad of light gray or tan drawing paper and a small box of colored chalks. Now these quick studies can begin to capture the colors of hair and skin. With hundreds of such sketches behind you—and stored in your "memory bank"—you'll be far more decisive and self-confident when you're standing at the easel.

Step 1. A round softhair brush draws the contours of the head and then locates the features with tube color thinned with turpentine to the consistency of watercolor. A flat bristle brush picks up this color and begins to suggest the shadows on the hair, forehead, cheek, jaw, and neck; it also adds touches of shadow within the eyesockets.

Step 2. Working with darker color—color diluted with less turpentine—a small bristle brush darkens the shadows on the hair, forehead, cheek, jaw, chin, and neck. The shadow is indicated alongside the nose. More darks are added to the eyes. The brush begins to darken the hair and the background. A round brush sharpens the lines of the nose and mouth.

Step 3. The color is diluted with painting medium to the consistency of thin cream. Now a large bristle brush paints the darks as big, flat shapes. Another bristle brush paints the big lighted patches on the front of the face. A small bristle brush begins to add the halftones—those subtle tones that are lighter than the shadows but darker than the lights.

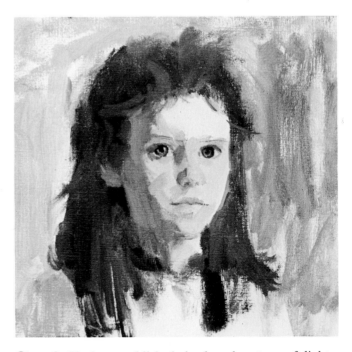

Step 4. Having established the broad pattern of lights, shadows, and halftones, the large bristle brush begins to adjust these tones. Paler mixtures are brushed over the hair and into the shadow side of the face and neck. Stronger darks are added to the shadow side of the nose. Small brushes strengthen the tones and details of the eyes, nose, and lips.

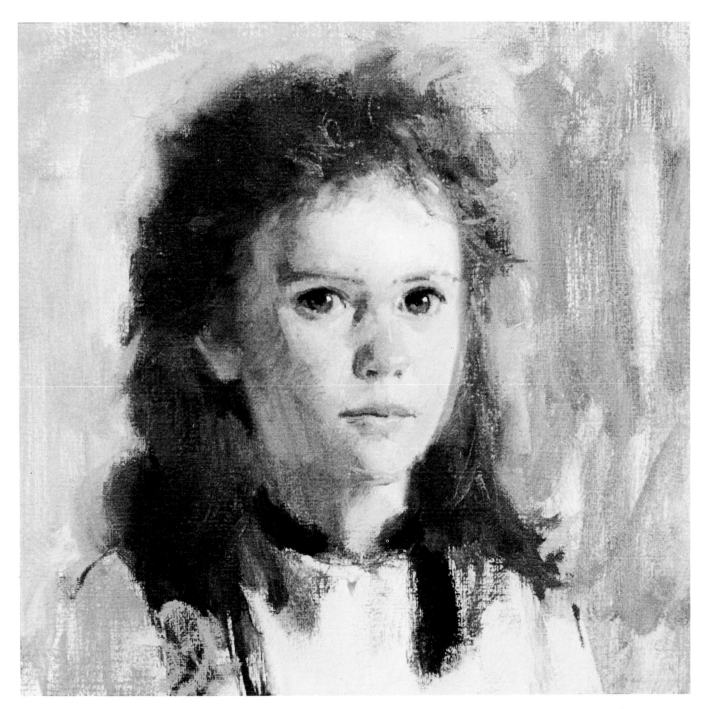

Step 5. The blending of the lights, shadows, and halftones is saved for the final stages. Now a flat brush—which can be either a bristle or a softhair—softens the areas where lights, halftones, and shadows meet. The brush, however, doesn't "iron out" the original strokes, but allows the lively, casual brushwork to remain. You can see this most clearly on the shadow side of the cheek and jaw. A big bristle brush moves over the hair, blending the strokes, softening the tones, and roughening the edges of the hair where it melts away into the background. At the left the big bristle brush blends and smoothes the background tone to contrast with the rough brushwork of the hair; the original background strokes, however, remain untouched at the right. The final touches and details are saved for the very end. The tip of a round softhair brush completes the eyes and the eyebrows and then moves down to sharpen the contours of the nose and mouth. The small brush doesn't overdo these details. One nostril is more distinct than the other. The dark line between the lips fades away at the right. The tip of the small brush adds just a few highlights to the eyes, the nose, and the lower lip. Observe how the outer contours of the face remain soft and slightly blurred. This is produced by free, casual brushwork that's particularly suitable for the softness of a young girl's face.

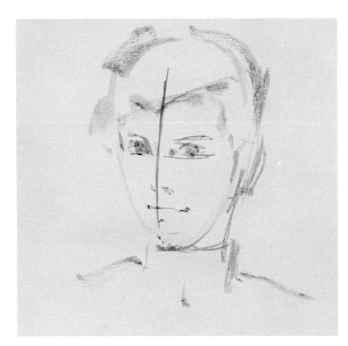

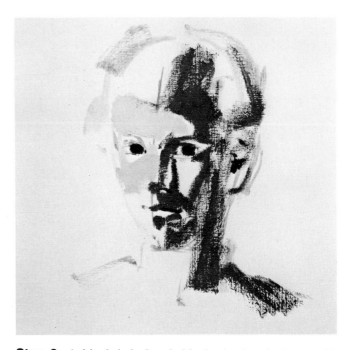

Step 1. The portrait begins with a brush drawing in tube color diluted with turpentine. A round softhair brush draws the oval shape of the face, the curves of the hair, and the lines of the neck, collar, and shoulders. To place the features accurately, the brush draws a vertical center line through the face. The eyes are placed on either side of that line, while the nose and mouth cross it.

Step 2. A big bristle brush blocks in the shadows with color that's diluted with painting medium to the consistency of thin cream. The brush also locates dark patches within the eyes and ear. Another bristle brush begins to cover the lighted patches of the face. The brush moves quickly to establish the broad pattern of lights and shadows—it's not important to cover the canvas evenly.

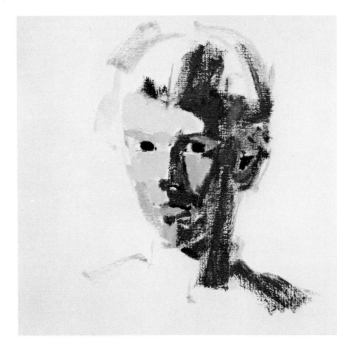

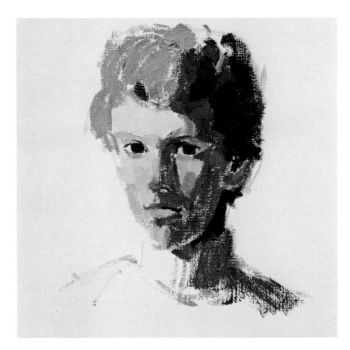

Step 3. A bristle brush completes the tonal pattern of the face by adding the halftones that appear within the eye sockets, between the eyes, and on the cheeks, lower lip, and chin. The lights, halftones, and shadows are as flat and simple as a poster.

Step 4. Now a big bristle brush begins to adjust the tones. First the brush completes the shadow side of the hair, darkens the back of the neck, and covers the lighted plane of the hair. Then the brush adds more halftones to the eyes, nose, cheeks, and chin. The tip of a round brush begins to refine the contours of the eyelids and mouth. The brushwork is still broad and flat.

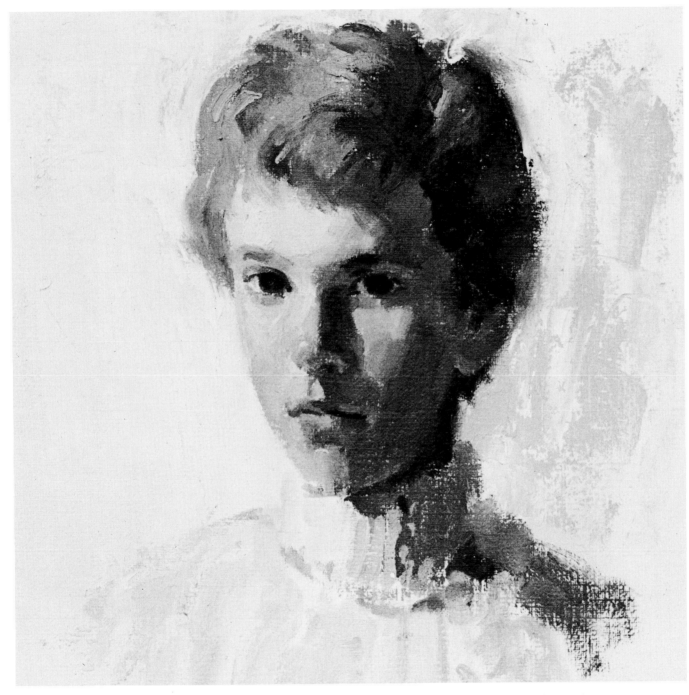

Step 5. The face and hair are now completely covered with tone, and a bristle brush begins the job of softening and blending. The brush moves over the areas where light, shadow, and halftone meet, softly brushing them together to make the face look round and three-dimensional. You can see these soft transitions most clearly where the shadow meets the light on the forehead, cheek, and chin. Notice that the shadow doesn't meet the light abruptly; there's always a suggestion of halftone that forms the bridge between the shadow and the light. A small bristle brush also adjusts the tones, darkening the shadow on the side of the nose, filling the eye sockets with more tone, and strengthening the contours of the lips. Compare Step 4 and Step 5 to see how the hard line of the jaw is now blurred softly into the dark shadow of the neck. Having made these necessary adjustments in the tones, the small bristle brush then moves over the hair to pick out individual locks with light and dark strokes. As always the precise brushwork is saved for the very end, when the face is completed with the last touches of detail. The tip of a round brush sharpens the lines of the eyelids, strengthens the eyebrows, and defines the line where the lips meet. Scan the entire head and you'll see that this is the only precise brushwork in the portrait. Everywhere else the strokes are broad and rough.

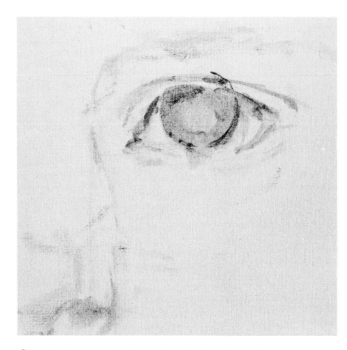

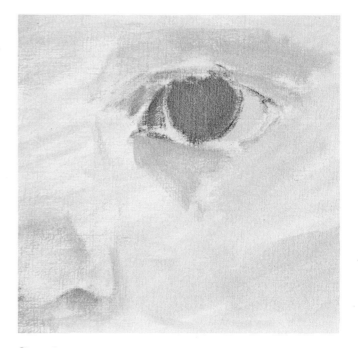

Step 1. The preliminary brush drawing defines the outer shape of the eye, the line of the upper lid, and the circle of the iris, which is overlapped by the upper lid. (Remember that you almost never see the full circle of the iris.) A hint of tone suggests the darker color of the iris plus the shadow that's cast by the upper lid on the iris and on the white of the eye.

Step 2. A very soft tone is brushed above and below the eye to suggest the delicate shadows within the eye sockets. The iris is covered with a flat tone. Some of this tone is added to the shadowy inner corner of the eye. A paler tone is brushed over the white of the eye.

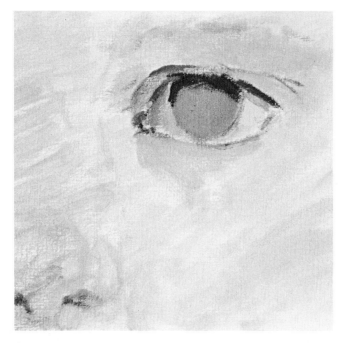

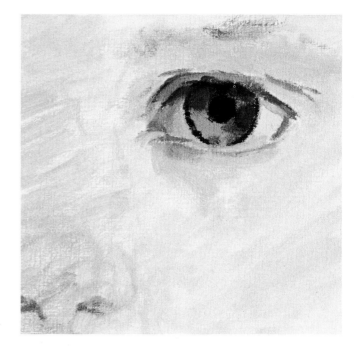

Step 3. The tip of a round brush adds the slender shadow lines that appear along the edges of the lids. The brush also adds the curving shadow that the upper lid casts on the iris and on the white of the eye, which you can see most clearly at the right. The shadowy inner corner of the eye is blended with a softhair brush.

Step 4. The shadowy upper lid is darkened slightly. Then the iris is darkened too, and the pupil is added at the center. The tip of a round brush traces the dark edge of the iris. The same round brush strengthens the outer contours of the eye and blends the shadow that's cast by the upper lid.

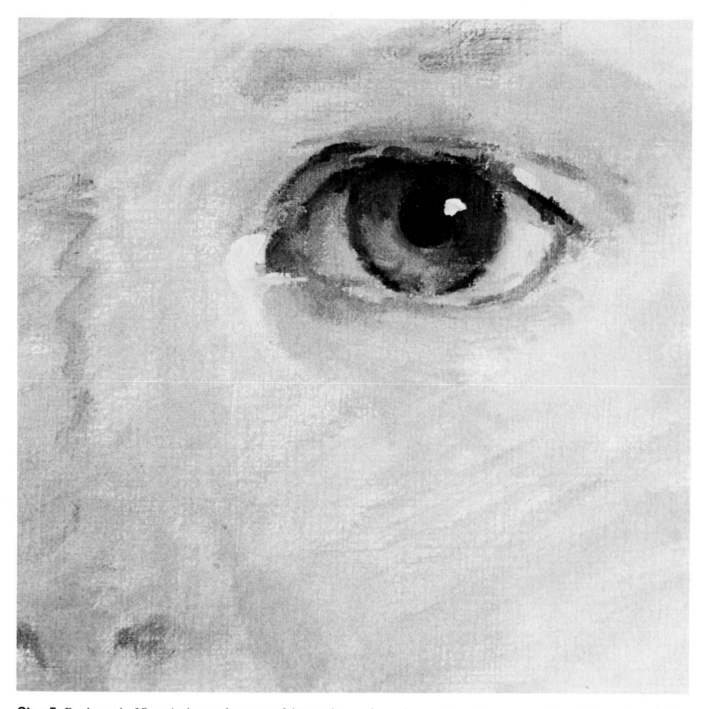

Step 5. By the end of Step 4, the tonal pattern of the eye is completely established. Now the tip of a round softhair brush makes the final adjustments, blends the tones, and adds the last details. The dark and light areas of the iris are blended softly together, while the dark edge is softened and blurred. The tip of the brush darkens the shadowy edges of the lids and strengthens the shadow at the inner corner of the eye. A crisp shadow line is added beneath the upper lid at the outside corner of the eye. A single bright highlight is added to the pupil—not at the center, but off to one side. A few pale, scrubby strokes suggest the child's eyebrow without actually drawing a single hair. Study the shape of the eye carefully. Notice that the top is a flat curve that turns sharply downward toward the inner corner. Conversely, the lower edge of the eye is a flat curve that turns sharply upward at the outer corner. It's rare to see deep shadows within a small child's eye sockets. The strong contrasts of light and shadow generally occur within the eye itself, not beneath the eyebrow or around the lids, which tend to be pale and smooth.

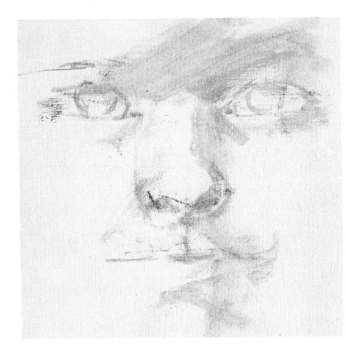

Step 1. A round softhair brush draws the contours of the nose at the same time as all the other features. The brush indicates the shadow above the bridge of the nose, the shadow on one side of the nose, the nostrils and the shadowy underside of the nose, the valley beneath the nose, and the diagonal shadow that's cast by the nose downward to the upper lip.

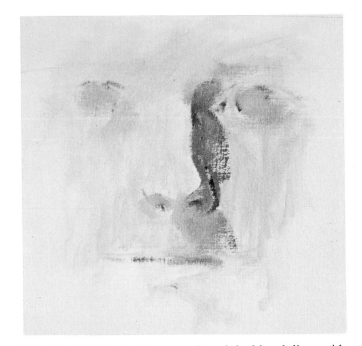

Step 2. A bristle brush covers the original brush lines with solid tones. Now there's a strong shadow on one side of the nose, leading from the eye socket down the bridge of the nose to the nostril. The shadowy underside of the nose is indicated by a soft tone that's carried diagonally downward over one side of the upper lip.

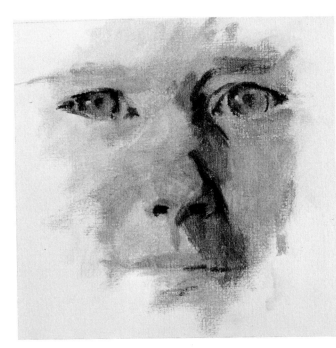

Step 3. A big bristle brush adds the lights and halftones on the nose and the surrounding cheeks, brow, and upper lip. A smaller bristle brush strengthens the darks on the shadow side of the nose, indicates the nostrils, and solidifies the shadow that's cast by the nose over the upper lip. At the same time, work continues on the other features.

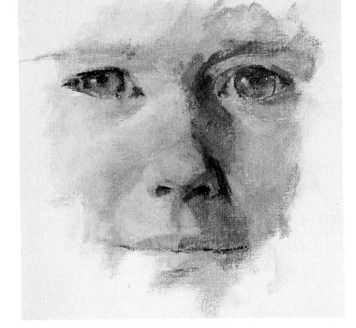

Step 4. It's time to begin adjusting the tones. The brush solidifies the big shadow on the side of the nose into one continuous tone and then softens and lightens the harsh shadow strokes that appear in Step 3. The lighted planes of the nose, cheeks, and upper lip also become softer and paler. The tip of a round brush begins to define the nostrils more precisely.

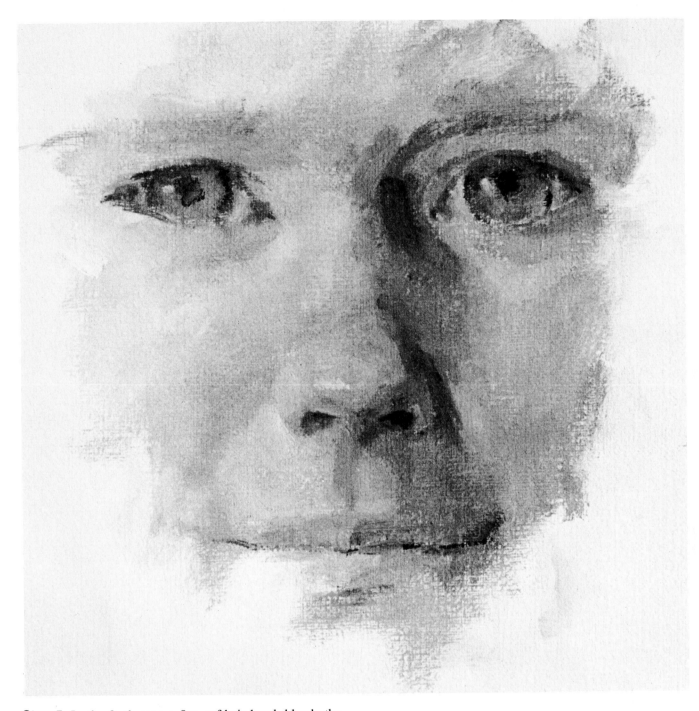

Step 5. In the final stage a flat, softhair brush blends the shadow side of the nose delicately into the lighted cheek at the right. This same brush softens the meeting place of the lighted front of the nose with the shadow side. The blending action of the softhair brush makes the underside of the nose look rounder and then blurs the cast shadow on the upper lip. The shadow side of the nose is strengthened in only one place; the flat softhair brush adds a single dark where the bridge of the nose meets the corner of the eye socket. Then the tip of a round softhair brush completes the job by sharpening the dark shapes of the nostrils and adding a highlight at the tip of the nose. Throughout the child's face the softhair brush carefully blurs all harsh lines except for the edges of the eyelids, the darks of the nostrils, and the slender line where the lips come together.

Step 1. A round softhair brush begins by drawing the outer contours of the jaw and chin. The brush draws a vertical center line and then draws the horizontal lines that locate the nose and lips. With these guidelines the brush lightly draws the upper lip, darkens the line between the lips, and suggests the shadow beneath the lower lip.

Step 2. A small bristle brush fills the upper lip with a solid tone and then repeats this tone *beneath* the lower lip. The upper lip is usually in shadow, while the lower lip is usually brighter. The brush also suggests a touch of shadow at the corner of the nose alongside the upper lip as well as the shadow under the chin.

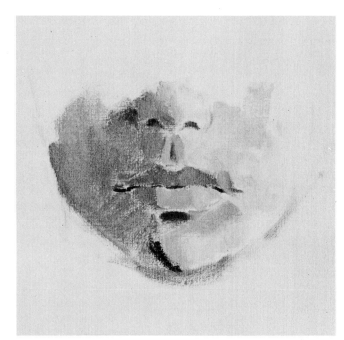

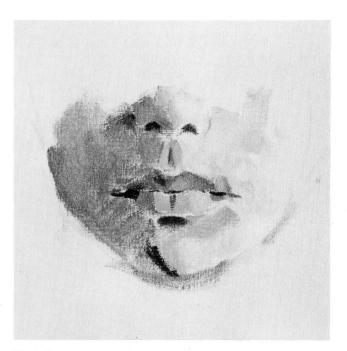

Step 3. A big bristle brush covers the shadow side of the face with a broad, continuous tone. A smaller bristle brush paints the shadowy side plane of the lower lip and then adds the lighted areas. A big bristle brush covers the lighted planes of the face above and below the lips. The shadow beneath the lower lip is strengthened, and a touch of shadow is added to the chin.

Step 4. The round brush continues to define the light and shadow planes of the lips, which are more complex than they might seem at first glance. The corners of the lips are darkened. A shadowy cleft divides the lower lip, and a touch of shadow is added to accentuate the central curve of the upper lip.

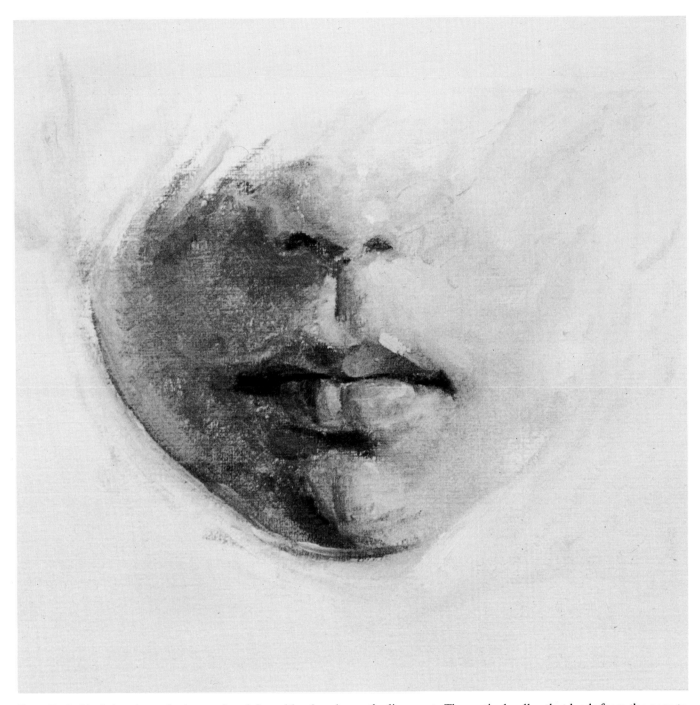

Step 5. Softhair brushes—both round and flat—blend and modify the tones and add the final details. The shadow sides of the upper and lower lips (at your left) are darkened and blended softly into the surrounding skin so that there's no harsh dividing line. The shadow beneath the lower lip is darkened and then blurred softly into the surrounding skin. The lighted areas of the lips are brightened with paler color. The dark corners of the mouth are blurred, and then the tip of the round brush strengthens the dark dividing line where the lips meet. The vertical valley that leads from the nose to the upper lip is clearly divided into a light plane and a shadow plane. There's a dark, distinct stroke where these planes meet. There's a similar valley at the center of the lower lip. All the forms are now quite distinct, but the lights and the shadows blend softly into one another. The tone of the lips blends delicately into the tone of the surrounding skin.

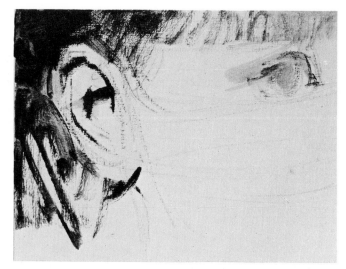

Step 1. The preliminary brush drawing defines the outer and inner contours of the ear. Adding more turpentine to produce a liquid wash something like watercolor, the brush adds a few broad, dark strokes that suggest the hair behind the ear and the pool of shadow within the ear. A pale guideline indicates that the top of the ear lines up roughly with the top of the eye.

Step 2. The brush surrounds the ear with dark hair to accentuate the pale tone of the skin. Then the brush traces the shadowy edges of the rim within the ear and the shadowy underside of the lobe. Finally, the brush adds a pool of shadow within the center of the ear.

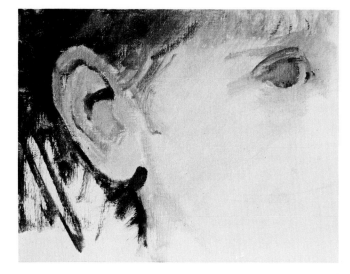

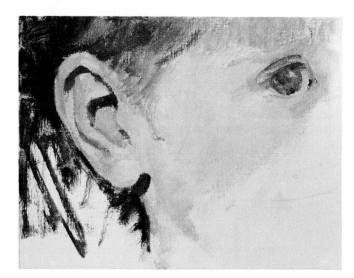

Step 3. The lighted areas of the ear are painted with color that's diluted with painting medium to the consistency of thin cream. The lines of shadow begin to disappear under these pale tones—but the darks will be re-established soon. The lighted contours of the ear are now clearly separated from the dark hair and the background.

Step 4. The tip of a round brush reinforces the pool of shadow beneath the upper rim of the ear and strengthens the other shadow lines within the ear. Notice the subtle halftones that make the lobe look rounder and that deepen the depression at the center of the ear.

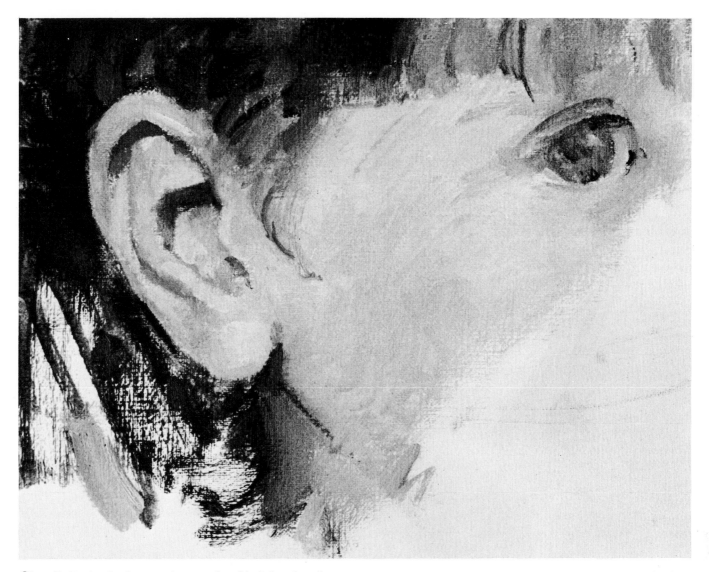

Step 5. In the final stage the round softhair brush refines some of the forms and intensifies the lights. Compare Step 4 and Step 5 to see how the shadow at the corner of the ear-lobe is reshaped. Within the ear the curving pools of shadow are softened and blurred as the dark shapes move downward toward the lighted skin. The tip of the brush adds touches of light along the rim, within the bowl of the ear, and along the thick, curving ridge at the center of the ear. It's important to study the contours of the ear carefully. It's not just an ellipse with a dark hole in the middle—as to many beginners paint it—but a complex pattern of shapes. The outer contour is composed of a series of short lines, many of which are surprisingly straight, until you get to the curving top of the ear. Discipline yourself by drawing the ear again and again until you memorize the form.

Beginning with Broad Strokes. There's a famous portrait painter who always tells his students to start out with brushes that "look just a bit too big for the job." His strategy is to train his students to begin a portrait with big, broad strokes—and to discourage beginners from starting a portrait with small, timid strokes. In the early stages of the portrait, your task is to cover the head with broad planes of flat color to establish the shapes of the lights and shadows. Between these two tones, you place the halftones, which are darker than the lights but lighter than the shadows. These three basic tones—lights, shadows, halftones—should be placed on the canvas with your largest bristle brushes. At this stage, the brushstrokes can be broad, simple, and quite rough. Don't worry about rendering the contours of the face precisely. And don't be too concerned with the exact shapes of the features. Save all the precise brushwork for later on. Start out by visualizing the painting as a kind of "poster" with big masses of flat colors.

Finishing with Precise Brushwork. Save your small brushes and your more exact brushwork for the later stages of the portrait. When the entire painting is covered with broad masses of flat color, then you can begin to blend the areas where lights, halftones, and shadows meet. You can do some of this blending with the big bristle brushes you started out with. But now you can also bring in the smaller bristle brushes and the flat softhair brushes. However, don't overdo the blending—don't keep "brushing out" the paint until the surface is so smooth that all the brushstrokes disappear. Even when you're working with smaller brushes, try to make bold, decisive strokes. And save your smallest brushes—particularly the round softhair brushes—for the very last stages of the painting. You'll need these small brushes for details such as the eyes and the eyebrows, the nostrils, the line between the lips, and the hair. But be very selective about these final, small strokes. Don't paint every strand of hair—just pick out a few. Don't try to paint every eyelash. And don't paint the nostrils so precisely that they look like dark holes in the canvas; paint them with free strokes and soften the edges of the nostrils so they become part of the surrounding skin. And when you place those last few highlights with small strokes, don't cover the face with shining dots that make the sitter look like he's perspiring: just pick out a few of the bigger highlights and then stop.

Working from Thin to Thick. Thin color is a lot easier to handle than thick color. So professional portrait painters generally do most of their work with fairly thin color, saving their thicker strokes for the very end. It's best to do the preliminary brush drawing with tube color that's diluted with turpentine to the consistency of watercolor. This color is so thin that you can easily wipe away a mistake with a clean rag and then correct the drawing with fresh strokes. For blocking in the lights, darks, and halftones, it's best to dilute your color mixtures with painting medium—not just turpentine—to a consistency somewhat like thin cream. This consistency makes it possible for you to work quickly and decisively, moving the brush across the canvas with broad, sweeping strokes. When you've established the broad pattern of lights, darks, and halftones, you'll begin to enrich the surface of the painting by blending in smaller strokes of richer color. Now you can add a little less painting medium so that these strokes of richer color are the consistency of *thick* cream. Professionals generally save the thickest color for the highlights, which are sometimes pure tube color—undiluted with painting medium—but more often contain just a touch of painting medium to produce a thick, rich consistency like warm butter. Of course, for those last touches of precise detail—eyes, nose, mouth, hair—it's important to add quite a lot of painting medium. These final touches are usually placed on the canvas by a small, round softhair brush that needs fluid color for precise, linear strokes.

Mixing Skin Tones. Every portrait painter has his own favorite mixtures for skin tones. George Passantino has a very simple method that you'll see in the demonstrations that follow. He generally begins his skin mixtures with white and a subdued brown called raw umber. The darker the skin tone, the more raw umber he adds. Then he adds one or two warmer hues to establish the precise skin color. For very pale skin, he starts with raw umber and white, then adds cadmium red and a hint of cadmium orange. For pinkish skin, he adds cadmium red and a bit of alizarin crimson. For brownish skin, he adds Venetian red and a touch of raw sienna. When he paints black skin, Passantino often substitutes burnt umber for raw umber, beginning with raw umber and white, then adding Venetian red, cadmium red, cadmium orange, and alizarin crimson or ivory black, depending upon the sitter. When he paints oriental skin, Passantino likes to add a touch of raw sienna to his basic mixture of raw umber and white; then he'll modify this with Venetian red and perhaps a touch of cadmium orange. When you turn to the demonstrations, you'll see that Passantino doesn't always follow these procedures too rigidly. But they *are* useful guidelines to keep in mind when you start to paint portraits. Later on you may discover your own favorite skin mixtures. Experiment and find the mixtures that work best for *you*.

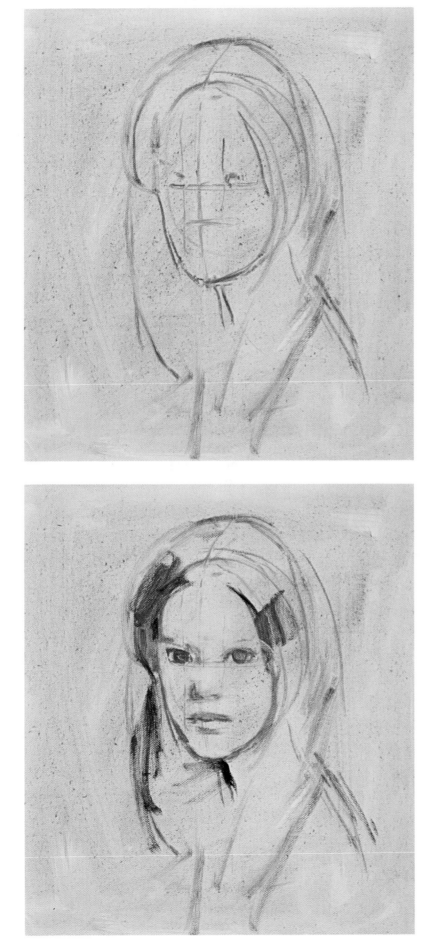

Step 1. Ultramarine blue and raw umber are blended on the palette and diluted with turpentine to the consistency of watercolor. A clean rag picks up this mixture and wipes it over the canvas. Then a round, softhair brush picks up this same mixture—but with less turpentine—to make the preliminary brush drawing. The drawing begins with the curved lines of the head and the surrounding hair, the straighter lines of the hair falling across the shoulders, and the lines of the neck and shoulder. The brush draws a vertical center line through the face and then places another vertical line on either side of that center line. Across these vertical guidelines, the brush carries horizontal lines to locate the eyes and the underside of the nose. In Step 2 you'll see how these guidelines work.

Step 2. Working with this same mixture of ultramarine blue, raw umber, and turpentine, the tip of the round brush draws the outer contours of the face more precisely, paying particular attention to the shapes of the jaw and chin. Then the artist refers to the vertical and horizontal guidelines to place the features. Now you can see that the purpose of these guidelines is to establish the relationships of the features. In this particular view of the face—which is turned slightly to the left—the center line shows that the corner of one eye socket lines up (approximately) with the tip of the nose and the center of the lips. The vertical guideline at the left shows that the iris is directly above the corner of the mouth. The vertical guideline at the right shows that the corner of the eye falls above the corner of the mouth. Whenever you begin to draw a head, look for these vertical alignments—which change radically as the head turns. At the end of Step 2 a bristle brush begins to add the dark tone of the hair.

Step 3. A bristle brush completes the preliminary sketch by covering the hair with rough strokes of ultramarine blue, raw umber, and turpentine. The strokes actually follow the direction in which the hair wraps around the head and falls over the shoulders. Notice that the sketch also records the very delicate shadows within one eye socket, on one side of the nose, on the upper lip, and beneath the lower lip. A few scribbly background strokes suggest the irregular background texture that will begin to appear in the next step.

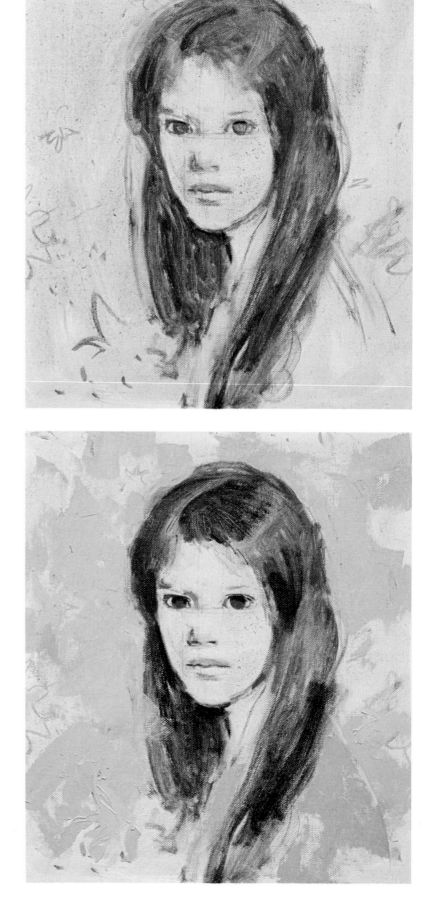

Step 4. A large bristle brush picks up a mixture of raw umber, cadmium orange, and a touch of ultramarine blue to begin the dark color of the hair. A round softhair brush picks up this same mixture to darken the eyes and strengthen the lines of the eyes, eye sockets, nose, mouth, and jaw. It's always important to begin work on the background as early as possible; so now a painting knife blends ultramarine blue, raw umber, and white on the palette and then surrounds the head with broad, flat strokes.

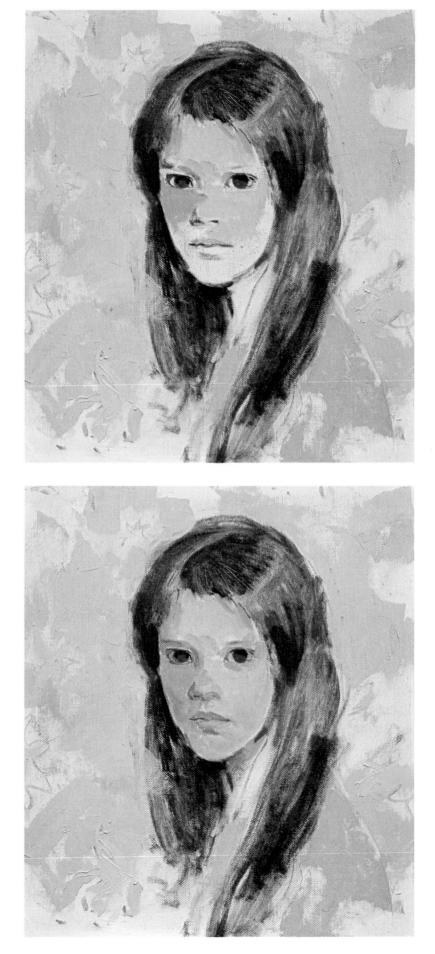

Step 5. A bristle brush begins to lay in the flesh tones with various mixtures of raw umber, Venetian red, raw sienna, and white, diluted with painting medium. The forehead receives the strongest light, and therefore the flesh mixture contains the most white. Starting with the tone between the eyes, the lower half of the face is distinctly darker. The shadow side of the face is only slightly darker than the lighted cheek. But this gradual change from light to dark is important because it gives the face a feeling of roundness. If this head had a strong, distinct pattern of light and shadow, the artist would begin with the darks and *then* block in the lights. But here the lights and darks are so similar to one another that the artist works on them all at the same time.

Step 6. The bristle brush covers the entire lower face and neck with color, continuing to work with various mixtures of raw umber, Venetian red, raw sienna, and white. The lighted side of the face contains more white. There's more Venetian red in the warm shadows within the eye sockets, along the shadow side of the nose and cheek, within the lips, and on the neck. The shadows are all very soft. Notice how the tone of the eye socket on the lighted side of the face is only *slightly* darker than the lighted cheek below. This same very soft shadow tone appears beneath the nose and within the vertical valley that leads from the nose to the upper lip. At first glance the entire face seems to be in light, but there's definitely a shadow side—and you can also see some halftones where the lights and shadows meet, such as the bridge of the nose. A little more Venetian red is added to the flesh mixture for the color of the lips.

Step 7. Having covered the face with lights, halftones, and shadows, the brush begins to blend them together. Now the face has a softer, rounder look. The lighted cheek is warmed by adding a little cadmium red to the mixture. Still more cadmium red is added to enrich the tone of the lips—though the artist carefully avoids a harsh "lipstick red." Blending more raw umber into the flesh mixture, the brush adds shadows where the hair overhangs the forehead and blends some of this tone into the hair where it parts at the left. A small bristle brush sharpens the contour of the shadow side of the face, where it meets the hair. Adding more raw umber to the flesh mixture, a round brush sharpens all the features. Then this brush paints the darks of the eyes more precisely with burnt umber and ultramarine blue.

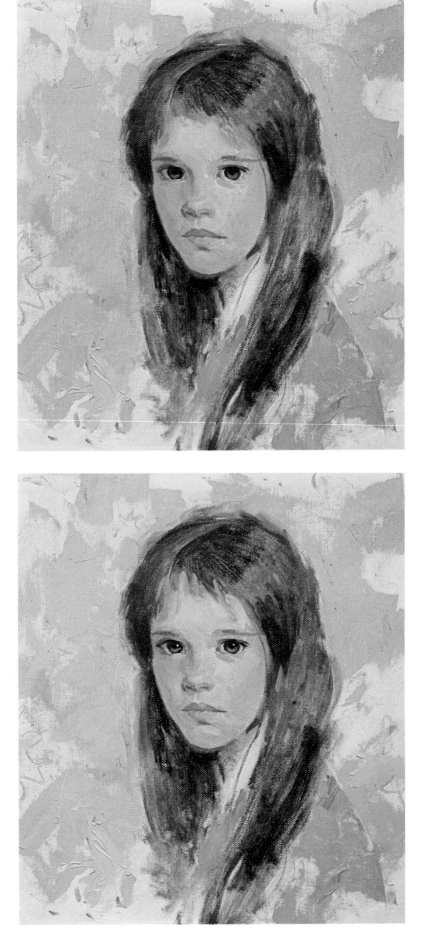

Step 8. Blending more white into the flesh mixture, a small bristle brush builds up the lighted areas on the forehead and cheek, the tip of the nose, the upper lip, and the chin. Now there's a stronger contrast between the lights and the shadows. You can see this most clearly when you look at the shadowy lower lid of the eye on your right, which now contrasts more strongly with the lighted cheek beneath. In the same way there's a stronger contrast between the shadowy underside of the nose and the lighted upper lip. A bristle brush blends more shadowy skin tone into the surrounding hair. A round brush continues to sharpen the lines of the eyes with burnt umber and ultramarine blue, adding highlights to the pupils with pure white tinted with flesh tone. The whites of the eyes are actually a very pale skin tone.

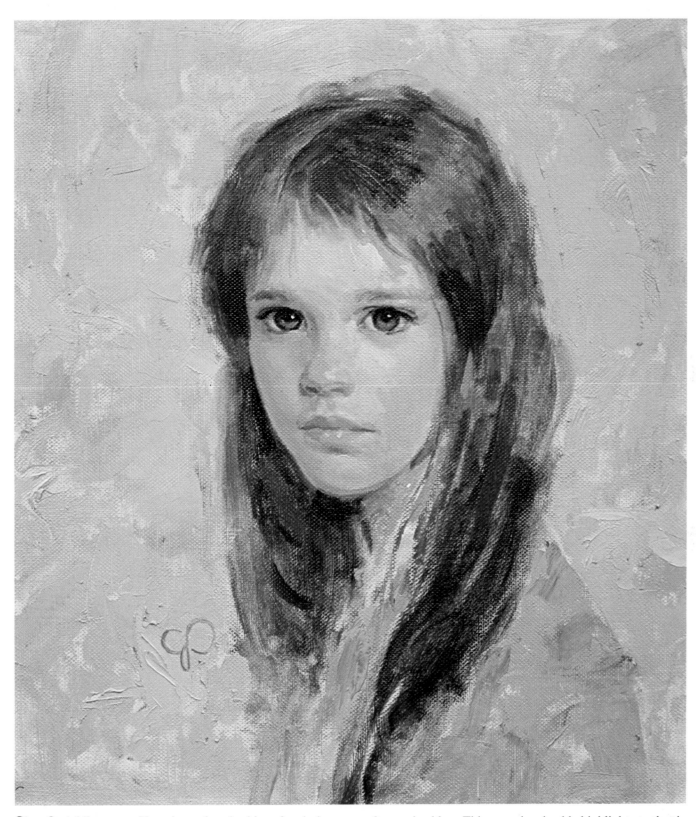

Step 9. Adding more Venetian red and a hint of cadmium red to the flesh mixture, a flat softhair brush enriches the flesh tone, blending these soft strokes into the lights that were added in Step 8. A softhair brush blends other contours, such as the shadow side of the nose, the pool of shadow beneath the lower lip, and the shadowy lower lid on the lighted side of the face. A round brush defines the eyelids and then darkens the eyebrows with burnt umber and ultramarine blue. This same brush adds highlights to the tip of the nose and the lower lip with quick touches of the palest flesh tone. A big bristle brush sweeps long strokes of Venetian red, ultramarine blue, burnt umber, and white over the hair. A round brush picks out a few individual strands of hair. The background and the dress are completed with broad brush and knife strokes of ultramarine blue, raw umber, and white.

Step 1. A rag wipes the canvas with a pale mixture of raw umber, ultramarine blue, and lots of turpentine. A big bristle brush picks up a slightly darker version of this mixture—containing less turpentine—and covers the face and chest with this tone to indicate the darkest areas of the picture. Then a round softhair brush begins the preliminary brush drawing with this same combination of colors diluted with turpentine. The brush draws the outer shapes of the face and hair; draws two vertical center lines, which will help to locate not only the features, but the shadow on one side of the nose; and draws horizontal guidelines for the features. A single touch of the brush locates the center of each eye. These horizontal lines also help to locate the ears.

Step 2. Still working with ultramarine blue, raw umber, and plenty of turpentine, the round softhair brush continues to develop the preliminary drawing. A cloth wipes away some excess lines, and then the brush defines the shapes of the hair, ears, cheeks, jaw, and chin more precisely. The neck is visualized as a simple cylinder. Following the guidelines drawn in Step 1, the brush fills the eye sockets with tone; indicates the darks of the eyes; and darkens the underside of the nose, the upper lip, and the shadow beneath the lower lip. A rag wipes away the lights on the face.

Step 3. The round brush draws the contours of the face with precise lines that capture the squarish character of the jaw and chin. The tip of the brush draws the eyes more precisely, refines the contours of the nose and lips, and fills the shadow side of the nose with a tone that follows the two vertical guidelines that first appeared in Step 1. A flat brush fills the shadow side of the face with tone and moves swiftly over the hair to solidify its shape. A scrubby tone suggests the dark shape of the scarf. Unlike the girl's head in Demonstration 1, this head has a strong pattern of light and shadow, which is important to capture in the preliminary brush drawing.

Step 4. A big bristle brush covers the lighted area of the hair with broad, curving strokes of burnt umber, raw sienna, ultramarine blue, and a little white. The shadow areas of the hair are painted with this same mixture with less white. The cool, dark tone of the scarf is quickly scrubbed in with cobalt blue, alizarin crimson, and white. Now the canvas contains the two strongest darks that will appear in the portrait. Work begins on the background with cobalt blue, alizarin crimson, and lots of white. From this point on, all mixtures are diluted with painting medium.

Step 5. A round softhair brush begins to strengthen the shadows by adding crisp touches of darkness, beginning with the features. Working with a mixture of raw umber, Venetian red, and a little white, diluted with painting medium, the tip of the brush darkens the contours of the eyes and adds a strong shadow to one eye socket, darkens the underside of the nose and the line of the mouth, and sharpens the forms of the ears. The brush also adds strong touches of shadow on one cheek and on the side of the neck.

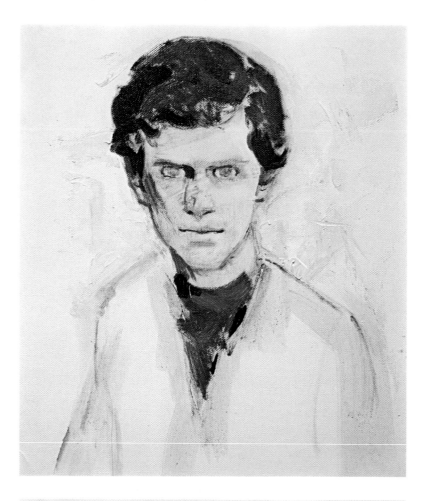

Step 6. A small bristle brush completes the pattern of shadows with raw umber, raw sienna, Venetian red, and white, diluted with painting medium. The brush works downward, beginning with the shadow that's cast by the hair over the forehead and then moving on to the brow, cheek, jaw, chin, and neck on the dark side of the face. The brush also fills the eye sockets with tone. Adding more Venetian red and raw umber the brush darkens the iris of each eye; adds rich, warm shadows to the cheek and the side of the nose; and warms the color of the ear in shadow. A round brush paints the shadowy upper lip and the pool of shadow beneath the lower lip. Now all the shadow areas are clearly defined.

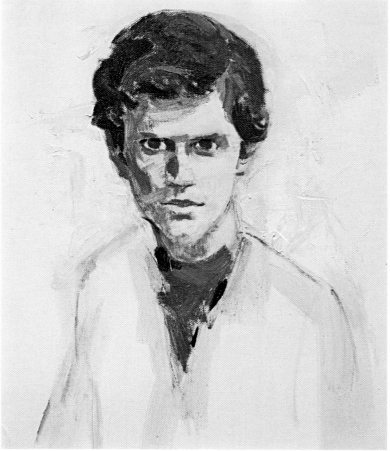

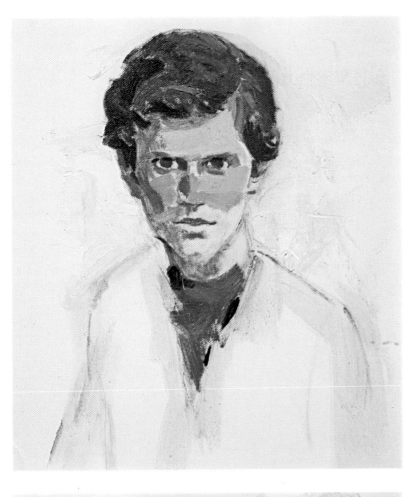

Step 7. Moving on to the lighted areas of the face, a bristle brush covers the forehead with raw umber, Venetian red, raw sienna, and plenty of white. This same mixture—with less white—is carried over the lighted cheek. Then more Venetian red is added to paint the nose, the underside of the lighted cheek, and the patch of light that appears on the opposite cheek. As usual the upper half of the face is brightest, while the lower half of the face grows gradually darker.

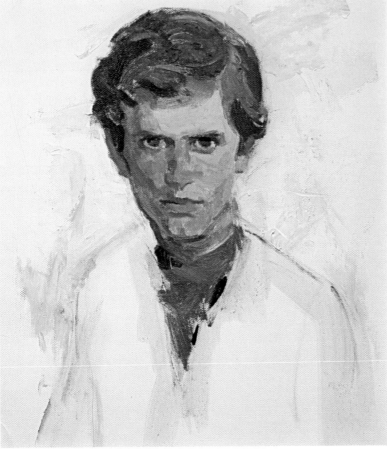

Step 8. A bristle brush completes the lower half of the face, still working with various mixtures of raw umber, Venetian red, raw sienna, and white. The warm tones—such as those on the shadow side of the head—contain more Venetian red and raw sienna. The more muted tones—such as those on the chin, beneath the nose, and on the jaw beneath the lighted cheek—contain more raw umber. More Venetian red is added to the flesh mixture to produce the warm tone of the lips. Thie whites of the eyes are painted with the palest flesh tone— never with pure white straight from the tube. Notice the halftones where the lights and shadows meet at places like the brow and the chin. The tone of the hair is enriched with strokes of raw umber, raw sienna, and white.

Step 9. A small, flat brush—either bristle or softhair—begins to blend the areas where lights, halftones, and shadows meet. Compare the cheeks in Step 8 with those in Step 9 to see how the original harsh brushstrokes melt away into soft, continuous tones. The tip of a round brush defines the shapes of the eye sockets more precisely with raw umber, raw sienna, a little Venetian red, and white, and then moves downward to sharpen the underside of the mouth and the lips with this same mixture. The lines of the chin and jaw are sharpened too. Notice how the warm tones of the cheeks and lower lip now blend softly into the surrounding skin. A small brush begins to pick out individual locks of hair with raw umber, raw sienna, and white. A few strokes of cobalt blue, alizarin crimson, and white enrich the background and define the shoulders.

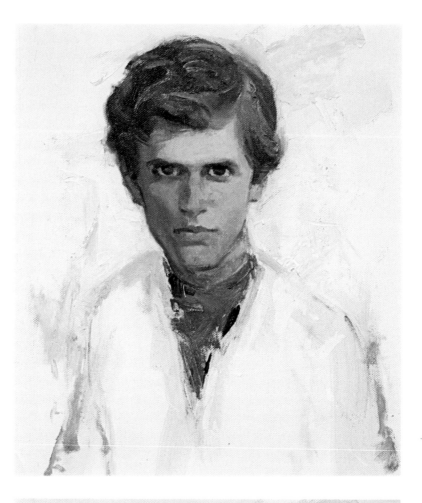

Step 10. Adding still more white to the original flesh mixture, a small bristle brush builds up the lights on the forehead, the upper lip, and the very top of the cheek on the lighted side of the face. At the same time another flat brush enriches the shadows and the halftones with a warmer flesh mixture that contains more Venetian red and raw sienna. Thus the lights become brighter, while the shadows and halftones become darker, warmer, and richer. The tip of a round brush sharpens the lines of the eyes and adds the pupils with ultramarine blue and burnt umber. A round brush adds highlights to the eyes, the tip of the nose, and the lower lip.

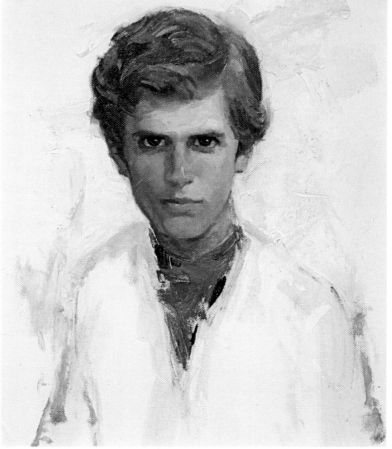

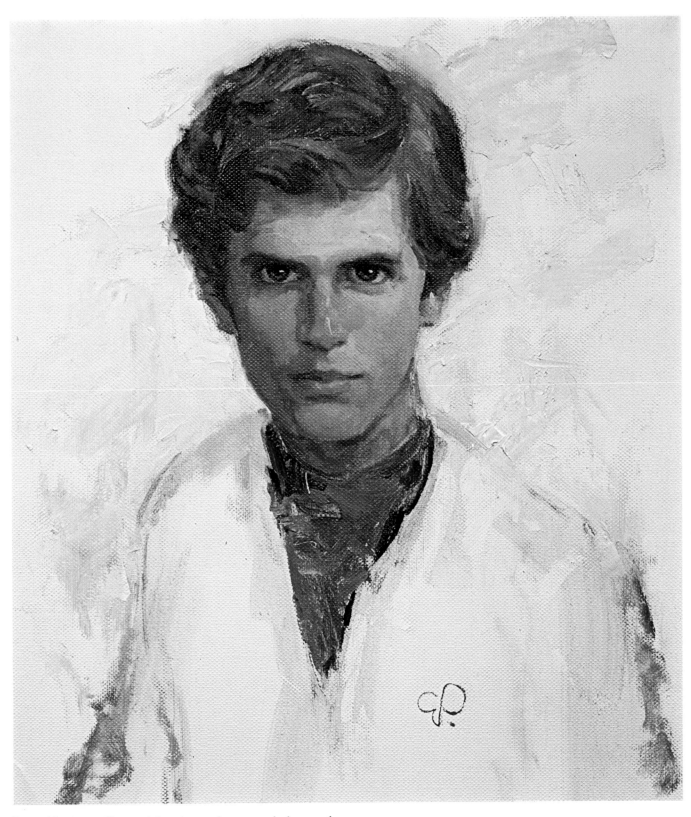

Step 11. A small round brush continues to darken and sharpen such details as the eyebrows, the nostrils, the dark line of the lips, and the shadow beneath the lower lip. More highlights are added to the nose, lips, and ear with pure white tinted with a little flesh tone. A bristle brush picks out more clusters of hair with raw umber, raw sienna, and white. A single dark stroke of ultramarine blue and raw umber defines the shadowy edge of the collar.

Step 1. A big bristle brush tones the canvas with raw umber and turpentine, darkening the lower area to suggest the sitter's dress. A round softhair brush scrubs in the curving top of the sitter's hair and the straight lines of the hair hanging down on either side of the head. Then the tip of the brush draws the oval shape of the face and the lines of the neck and shoulder. After placing a vertical center line, the brush draws horizontal lines to locate the features and adds a single dark touch for one eye.

Step 2. The tip of the round brush adds the dark patches of the eyes, the dark nostrils, and the dark corners of the mouth. The brush also sharpens the shapes of the cheeks, jaw, and chin. A cloth wipes away some of the excess guidelines.

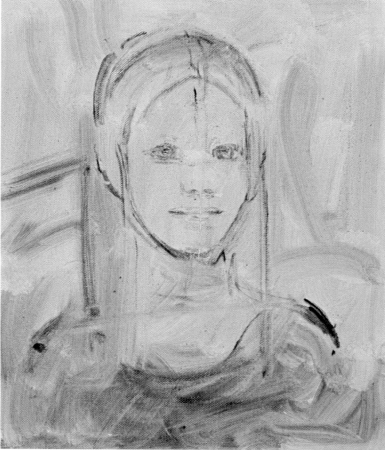

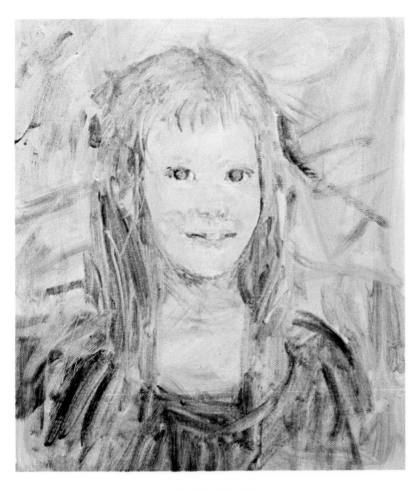

Step 3. A rag wipes away the lighted areas of the face and eliminates the last remaining guidelines. The tip of a round brush draws the shapes of the eyes more precisely and places the darks of the irises. There's no strong pattern of lights and shadows, but the brush indicates some delicate tones between the eyes, along the undersides of the cheeks and nose, and beneath the chin. A bristle brush suggests the tone of the hair and darkens the dress. The entire preliminary brush drawing is executed in raw umber and turpentine.

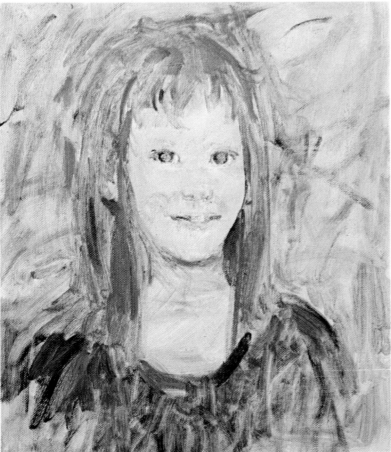

Step 4. A bristle brush begins to suggest the color of the hair with raw umber, raw sienna, Venetian red, and white, diluted with lots of painting medium so the paint is still fairly thin. The background tone is suggested with a few strokes of ultramarine blue, viridian, raw umber, and white. The green dress, which will contrast so nicely with the sitter's red hair and pink skin, is begun with viridian, burnt umber, and white.

Step 5. A small brush fills the dark irises with cobalt blue, a little raw umber, and white. The darks between the lips are raw umber, Venetian red, and white. A big bristle brush begins to cover the face with the palest flesh tones—a mixture of raw umber and lots of white, warmed with the slightest hint of cadmium red and alizarin crimson. The darker tones between the eyes and beneath the cheeks obviously contain less white. Work continues on the background and dress.

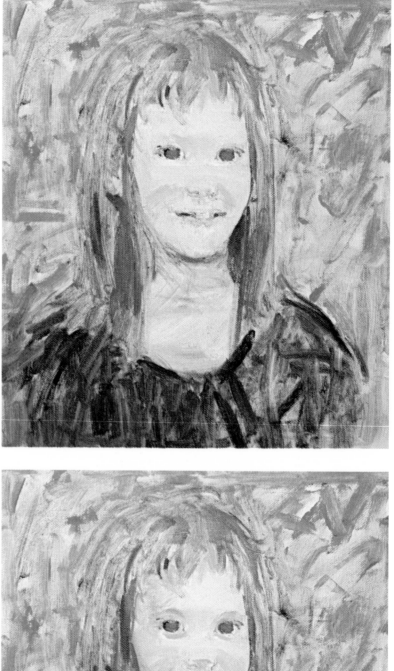

Step 6. The bristle brush continues to lay in the flesh tones with the same mixture, which gradually grows darker on one side of the forehead as well as the cheeks, jaw, and chin. A little more raw umber is added for the shadow on the neck; the skin below is the same pale mixture that appears on the forehead. An extra touch of cadmium red is added for the lips, but the color is still pale, soft, and natural. Now the face is completely covered with lights, halftones, and shadows, all of which are extremely pale.

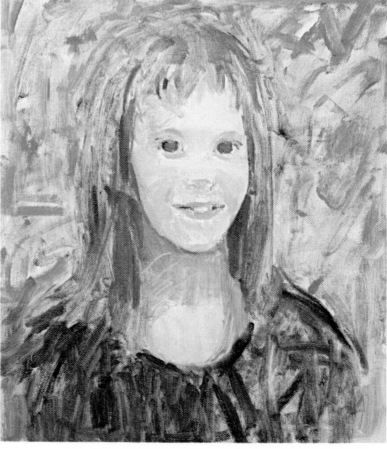

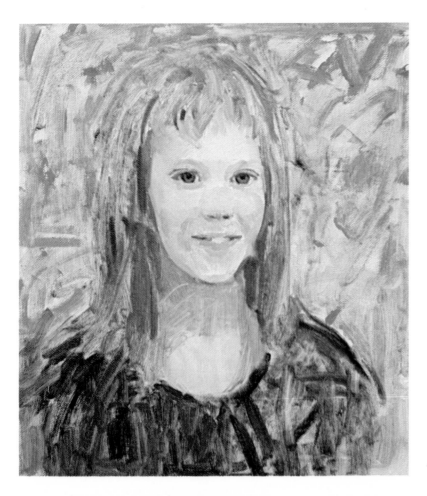

Step 7. The tip of a round brush defines the dark lines of the eyelids with raw umber, raw sienna, a touch of Venetian red, and white. The dark lines around the irises and the darks of the pupils are carefully drawn with cobalt blue and raw umber. The whites of the eyes are painted with a very pale version of the flesh mixture. The nostrils are sharpened with the same mixture that's used for the lines of the eyelids. Adding a little more cadmium red and alizarin crimson to the flesh mixture, a small bristle brush begins to darken the eye sockets, nose, cheeks, and chin.

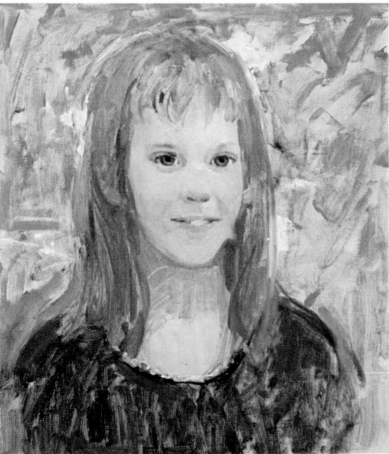

Step 8. A flat softhair brush starts to blend the tones to create softer transitions between lights, halftones, and shadows. Compare Steps 7 and 8 to see how the tones on the forehead, cheeks, nose, and chin flow softly together now. A small brush also darkens the underside of the nose. The teeth are not painted with pure white, but with a very pale version of the flesh mixture, similar to the tone used to paint the whites of the eyes. A big bristle brush goes over the hair with thicker strokes of raw umber, raw sienna, Venetian red, and white, which grow darker and brighter toward the bottom. The tone of the dress is solidified with more strokes of viridian, burnt umber, and white.

Step 9. Adding just a little more white to the pale flesh mixture, a flat brush brightens the lightest planes of the forehead, cheeks, nose, upper lip, chin, and chest. Another flat brush strengthens the darks ever so slightly—you can see this on the shadowy undersides of the cheeks—and blends the shadow on the neck. A small round brush sharpens the lines of the eyes and adds highlights to the pupils with pure white tinted with a whisper of cobalt blue. The lighted top of the hair is painted with quick, ragged strokes of raw umber, cobalt blue, a little Venetian red, and lots of white; this mixture is carried downward over the hair on the forehead. The tone of the hair is warmed with strokes of raw sienna, a little cadmium yellow, and white. Work continues on the background and on the dress.

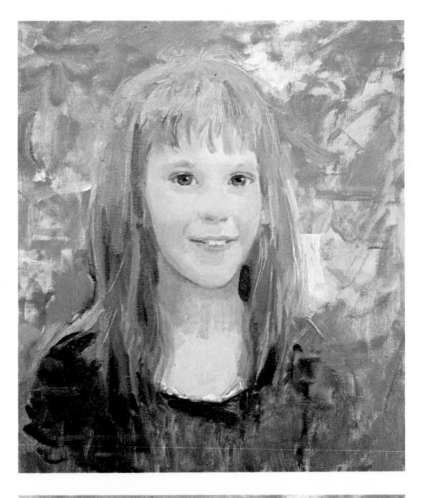

Step 10. The artist begins to concentrate on the smaller forms and details. The tip of a round brush adds more strands of hair—and the sharp end of the brush handle scratches some bright lines into the wet color. The eye sockets, cheeks, and chin are darkened just a little more. The tip of the round brush adds some freckles to the face and chest with raw umber, raw sienna, and white. A dimple is added to one cheek. By now the background and dress are finished. The darks of the dress are viridian and burnt umber, with no white.

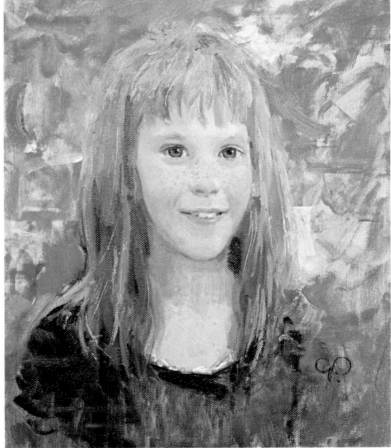

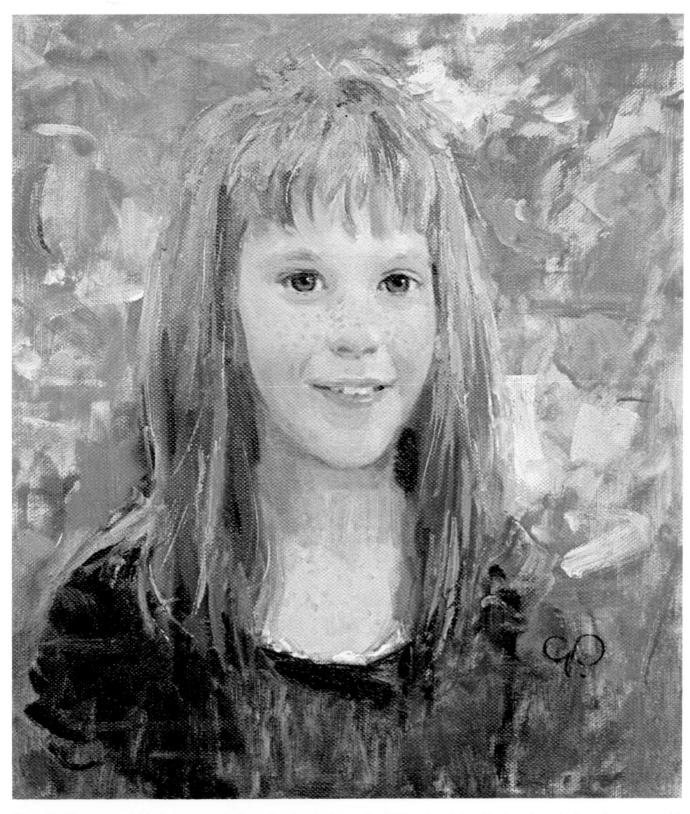

Step 11. The tones of this face are so delicate that the final touches are almost invisible, but they're important as always. The tip of a round brush darkens the shadow lines that are cast over the eyes by the upper lids. A flat softhair brush blurs the edges where the dark tone of the lips meets the surrounding skin. (Always avoid a harsh line around the lips!) The tip of the chin is softened where it merges with the shadow beneath. More strokes of raw sienna, cadmium yellow, and white brighten the hair—and a little hair tone is blended into the background. The corners of the mouth are darkened to accentuate the brightness of the sitter's teeth. A few more freckles are added—and the portrait is complete.

Step 1. Because the finished picture will be generally pale, only the area of the head is toned with cobalt blue, a touch of raw umber, and turpentine. Then a clean corner of the rag wipes away the lighted areas of the face, and the preliminary brush drawing is executed with the same mixture with less turpentine. The brush drawing suggests the wide, loose shape of the hair, the contours of the face, the darks of the eyes, the big shadow that runs down the side of the head and neck, and the small shadows that define the shapes of the features.

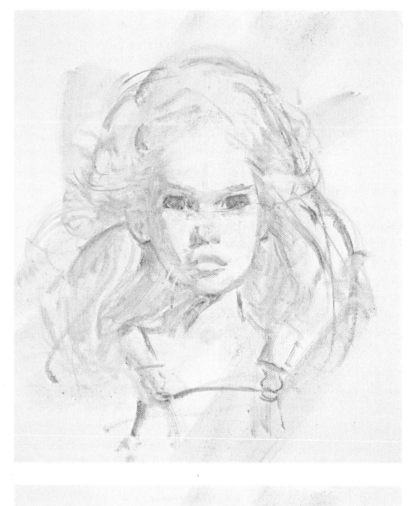

Step 2. A bristle brush paints the big shadows on the side of the face and neck with raw umber and white warmed with a touch of cadmium red and then subdued with a hint of cobalt blue. This same mixture is placed in the eyes and in the shadows of the lips. The lighted planes of the face, neck, and chest are painted with raw umber, white, and a touch of cadmium orange. A wisp of cadmium red is added to this mixture for the warm tone on the cheeks and nose. More white is added to the shadow tone to paint the dress. At this stage the mixtures contain a great deal of painting medium, and the color is applied very thinly.

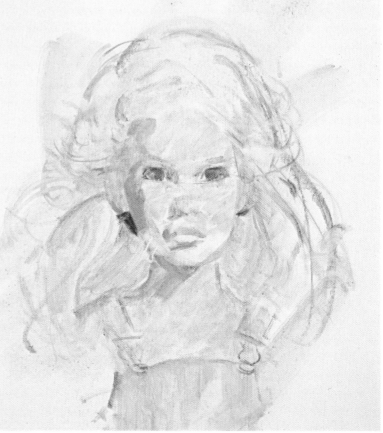

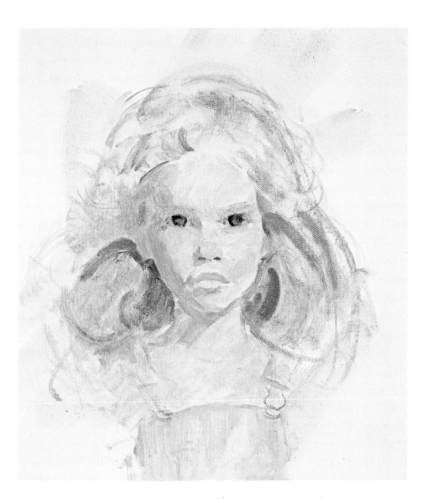

Step 3. A big bristle brush surrounds the face with the darker tone of the hair—a mixture of raw umber, raw sienna, and white, with less white in the darker areas that surround the lower face. Another bristle brush gradually builds up the color on the face. First the shadow tone on the side of the face is completed and the shadows are strengthened within the eye sockets, on the side of the nose, and around the mouth and chin. Then more color is added to the lighted areas of the face. Warmer, richer tones—containing a little more cadmium red and cadmium orange—appear on the nose, cheeks, and chin. The dark edges of the irises are defined by a small round brush that carries a mixture of cobalt blue and raw umber.

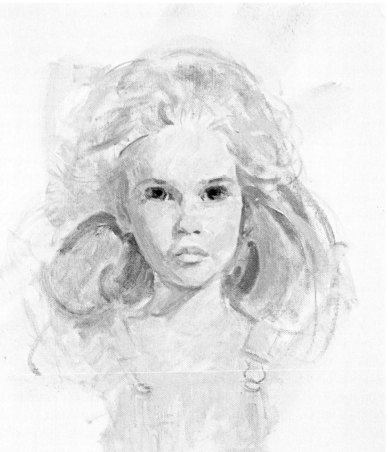

Step 4. The small round brush continues to sharpen the features. The shadows around the eyes are darkened with the same mixture that appears in the hair: raw umber, raw sienna, and white, with the slightest touch of cobalt blue. The corners of the eyes are darkened, and the eyebrows are brushed in. This same mixture darkens the shadow at the side of the nose, defines the lines between the lips, darkens the shadow beneath the lower lip, and darkens the shadow under the chin to bring the head forward. A stroke of this mixture sharpens the edge of the cheek at the right. A few more strands of hair are added above the forehead.

Step 5. A flat softhair brush starts to blend the brushwork on the face to create smoother, more continuous tones. The brush adds more white to the flesh mixture and begins to build up the lights on the forehead and the bridge of the nose. As the brush blends and smoothes the shadow side of the face, it darkens the inner edge of the shadow with a little more raw umber, cobalt blue, and white. The shadow on the neck is darkened with this mixture. The tip of a round brush sharpens the lines of the eyes, nose, lips, and chin with raw umber, raw sienna, a touch of Venetian red, and white. Work continues on the hair, which is now fuller and more distinct. A few broad strokes of cobalt blue, raw umber, and white are added to the background.

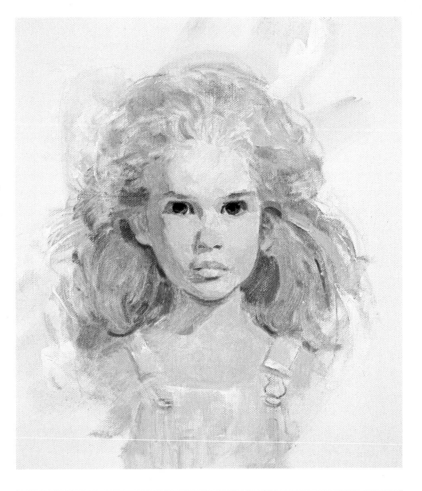

Step 6. The tip of a round brush concentrates on the eyes, which are the darkest notes in the painting. The whites of the eyes are painted with a very pale version of the flesh mixture. The dark edges of the irises and the dark notes of the pupils are carefully drawn with a mixture of raw umber and cobalt blue, which is also used to draw the shadowy lines beneath the upper lids. The highlights on the pupils are placed with pure white tinted with flesh tone. A little more cadmium red is blended into the lips, and the forms are more precisely drawn. The shapes of the earlobes are sharpened with lines of the hair mixture—and the details of the hair begin to appear.

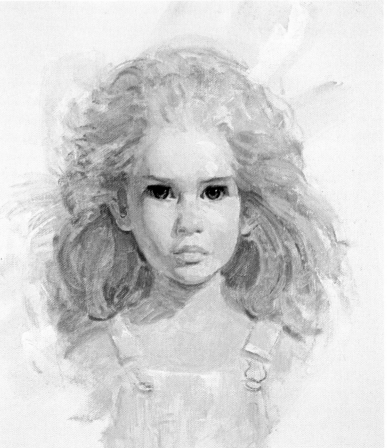

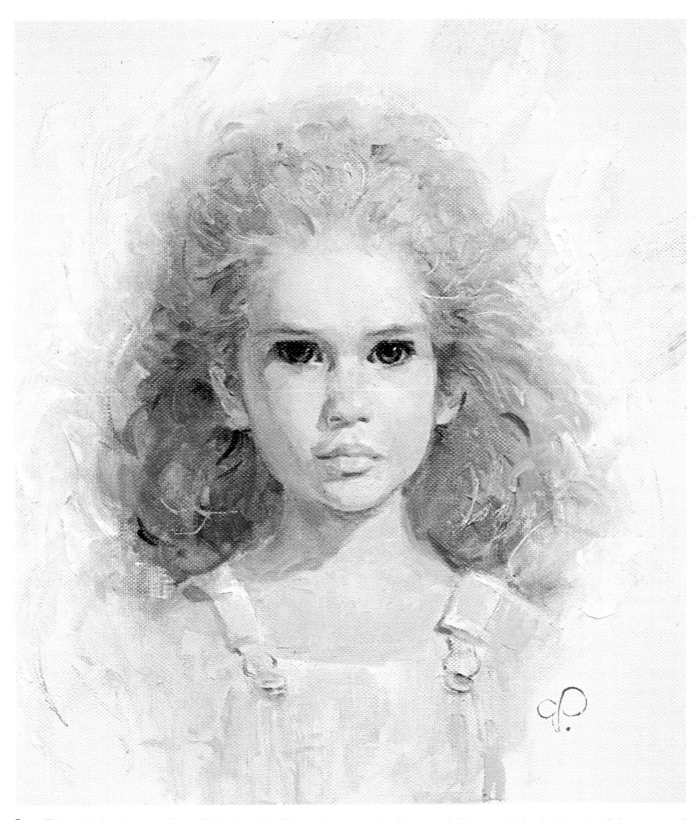

Step 7. In this final stage a flat softhair brush builds up the lights on the forehead, cheeks, nose, chin, and chest with the original flesh mixture and still more white. The nostrils and the line between the lips are sharpened. Subtle highlights are added just above the eyebrows, on the bridge and tip of the nose, and on the lips and chin. The background is completed with very pale strokes of cobalt blue, raw umber, and white—and this tone is blended into the lighter areas of the hair, which now merge softly with the background. Some of this mixture is blended into the shadowy hair around the neck. A small brush picks out individual strands of light and dark hair; the lighter strands are scratched away by the pointed end of the brush handle.

Step 1. The canvas is toned with a pale wash of cobalt blue and turpentine. A round softhair brush draws the head with the same mixture, and then a clean cloth wipes away the lighted areas of the skin. The shadow side of the face is only a bit darker than the lighted side. There are also very pale shadows within the eye sockets, beneath the nose, and within the lips. The brush indicates only one very strong shadow—beneath the chin. Then a big bristle brush surrounds the head with a much darker tone and carries this tone over the sitter's jacket. A rag wipes away the pale tone of the sweater inside the jacket.

Step 2. The round brush defines the dark edges of the forms on the shadow side of the face—the brow, cheek, nose, lips, jaw, chin, and neck. At the same time the brush darkens the shadow lines of the upper eyelids and the underside of the earlobe. These darks are a mixture of raw umber, Venetian red, cadmium orange, and a little white. Then a flat bristle brush adds a great deal of white and painting medium to this same mixture and begins work on the lighted areas of the face. The cheek contains slightly more Venetian red. The first touches of background color are placed around the head—a mixture of cobalt blue, raw umber, and white.

Step 3. Working with the same mixture of raw umber, Venetian red, cadmium orange, and white, the flat bristle brush covers the entire face and neck. The shadow side of the face, the eye sockets, the nose, and the lips contain less white and just a bit more Venetian red. Notice that the lower half of the face is distinctly darker and warmer than the forehead. The neck is darker still. The dark shadow beneath the chin is the same mixture used for the darks in Step 3. A few strokes of raw umber, a hint of cadmium yellow, and white suggest the color of the sweater.

Step 4. A large bristle brush starts to indicate the tones of the hair with raw umber, raw sienna, and white. More white is added to the lighted area of the hair. The short strokes suggest the curly texture that will become more apparent later on. The darks of the irises are strengthened with cobalt blue and white. The pupils are located with a single touch of cobalt blue and raw umber.

Step 5. A big bristle brush darkens the entire background with rough, irregular strokes of cobalt blue, raw umber, and white. These strokes don't completely cover the underlying blue tone, which still shines through. The same brush covers the jacket with a dark mixture of cobalt blue and raw umber; there's a little white in the lighted areas, but no white in the shadows. The sweater is brushed in with strokes of raw umber, cadmium yellow, and white, with some burnt umber in the shadows. A smaller bristle brush begins to build up the tones of the hair with the same mixtures that first appeared in Step 4. And the flat bristle brush begins to blend the strokes of the face into smoother, more continuous tones. A round brush adds more darks to the shadow side of the face.

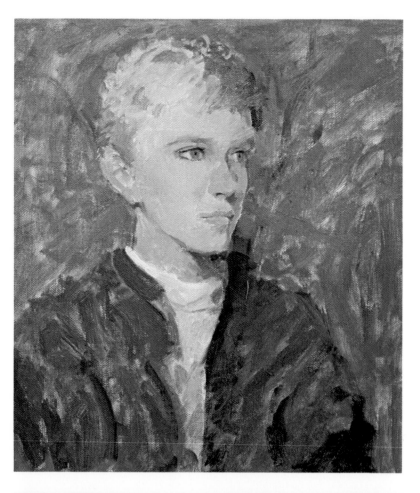

Step 6. A small bristle brush adds more white to the basic flesh mixture and builds up the lighted areas with thicker color. You can see that the forehead, the cheeks, the upper lip, and the chin are more luminous than Step 5. Some of this light tone is also blended into the neck. A small bristle brush sharpens the shapes of the nose and the lips. The tip of a round brush strengthens the dark lines of the upper eyelids.

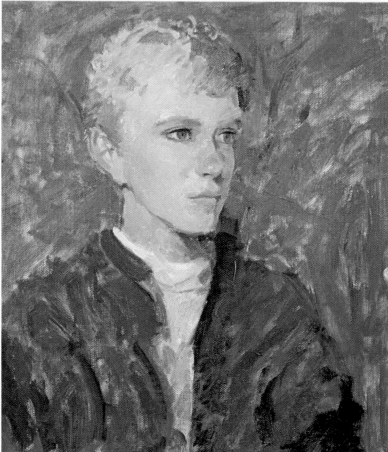

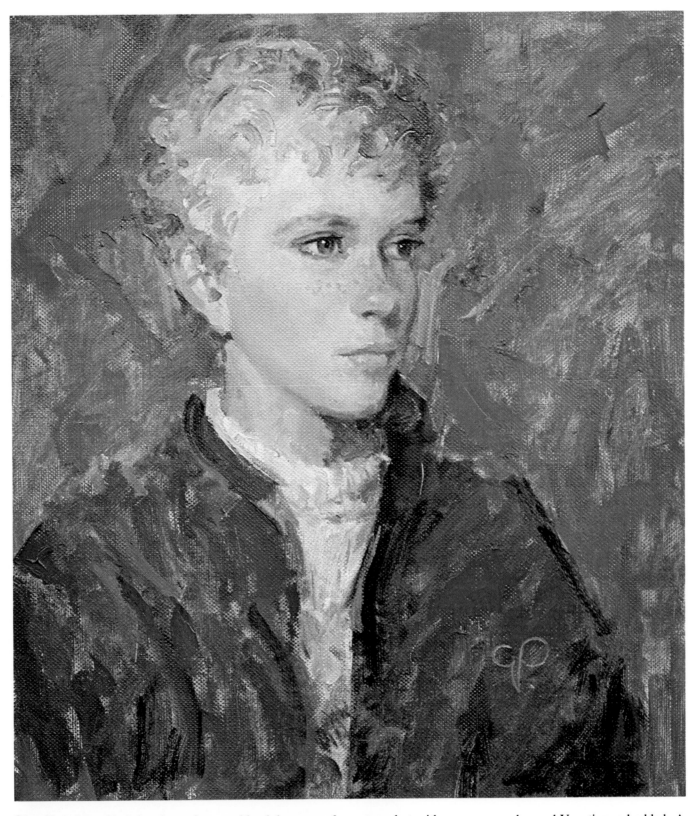

Step 7. A flat softhair brush continues to blend the tones of the face, which are now soft and smooth. The brushwork on the neck remains a bit rougher. The tip of a round brush darkens the lines of the upper eyelids, and strengthens the pupils with cobalt blue and raw umber, and then places highlights on the pupils with pure white tinted with the slightest touch of cobalt blue. A few more darks are blended into the shadow side of the face with the original skin mix-ture, but with more raw umber and Venetian red added. A round brush adds some freckles with this mixture. The eye-brows are completed with soft, blurry strokes of the same mixture that appears in the hair: raw umber, raw sienna, and white. Dark curls are added to the hair with this mixture. More white is added for the brighter curls. The short, curv-ing brushstrokes emphasize the lively texture of the blond hair.

Step 1. A rag tones the canvas with raw sienna, a little ultramarine blue, and turpentine. The preliminary brush drawing is executed with this same mixture, emphasizing the strong darks of the sitter's hair and eyes. The brush drawing also emphasizes the dark shadow on the side of the nose and indicates the shadow sides of the forehead, cheek, jaw, chin, and neck. A few dark strokes beneath the chin suggest the dark tone of the bow tie. A rag wipes away some tone from the lighted planes of the face.

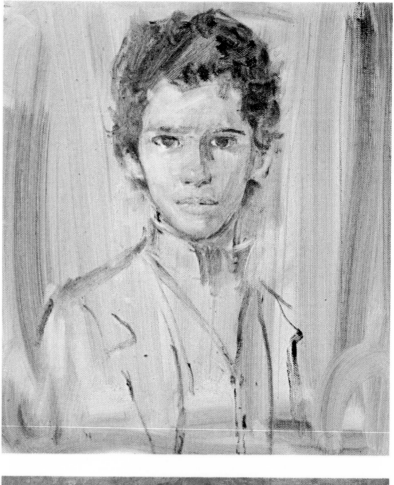

Step 2. A big bristle brush covers the background with broad strokes of ultramarine blue, burnt umber, and white, leaving some gaps for the warm undertone of the canvas to shine through. The sitter's dense, curly hair is begun with short strokes of burnt umber, ivory black, a touch of alizarin crimson, and some white. There's more black in the shadow strokes. The shadow side of the face and nose as well as the dark ear are painted with raw umber, Venetian red, a little raw sienna, and white. A pointed brush sharpens the lines of the features with this mixture. Then a bristle brush adds more white to this mixture to paint the lighted planes of the face. The shirt and bow tie are painted with cobalt blue, a little alizarin crimson, and lots of white—with less white in the bow tie, of course. More alizarin crimson is added to this mixture for the dots on the bow tie.

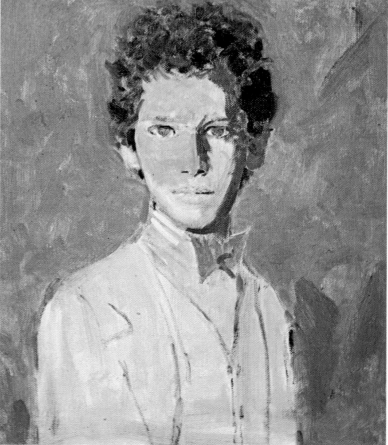

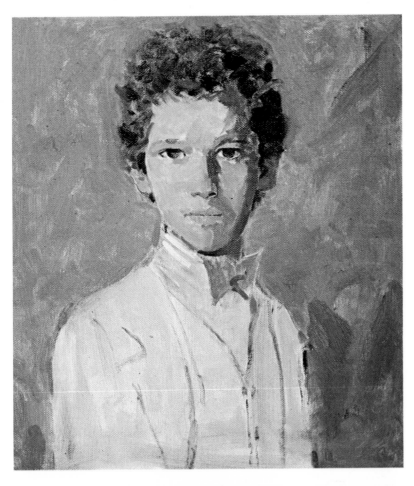

Step 3. A big bristle brush covers the lighted areas of the face with various mixtures of raw umber, Venetian red, raw sienna, and white—gradually darkening the strokes as the brush moves downward over the lower half of the face. The darks are strengthened on the shadow sides of the mouth and chin. Halftones are added within the eye sockets, around the eyes, and where the light meets the shadow on the dark side of the face. The eyes are darkened with burnt umber, ivory black, and white. The tip of a round brush sharpens the lines of the eyelids, nose, and lips, adding the dark hollow of the ear that's in shadow. A single dark stroke beneath the chin makes the chin come forward.

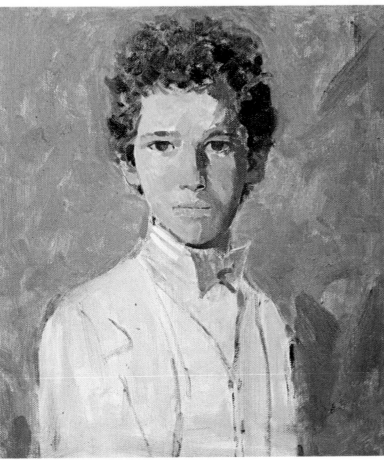

Step 4. A flat brush begins to blend the tones of the face. You can see that the lighted cheek and jaw are now smoother where the brushstrokes have begun to merge. The tip of a round brush continues to darken the eyes with burnt umber and ivory black. The brush then darkens the lines of the upper lids and the corners of the eyes with this mixture, adding a few strokes to strengthen the eyebrows. Notice that the lighted cheek is distinctly paler than the lighted patch of the cheek on the shadow side of the face. In the same way the eye socket on the lighted side of the face is paler than the eye socket on the shadow side.

Step 5. A flat brush continues to blend the tones of the face: the rough brushwork gradually melts away into smooth, continuous tones. A small bristle brush darkens the hair with ivory black, burnt umber, and a little alizarin crimson, adding some white to the lighted areas. Now the artist is concentrating on the smaller forms. The whites of the eyes are painted with pure white tinted with a little flesh tone. The pupils are added with burnt umber and ivory black. The tip of a round brush carefully draws the lights and shadows of the valley that leads from the nose to the upper lip. The lips are painted more precisely, adding an extra touch of Venetian red to the shadowy flesh mixture.

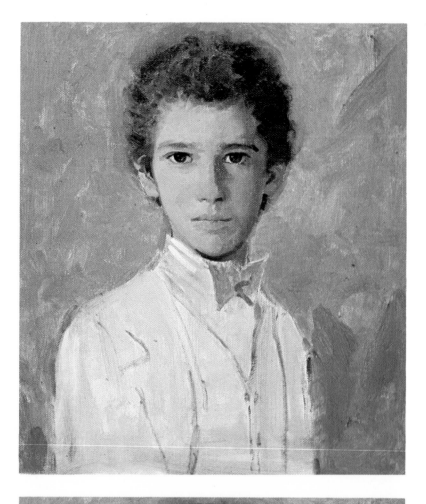

Step 6. Adding more white to the palest flesh tone, a bristle brush builds up the lighted areas of the forehead, cheek, nose, and chin. The tip of a round brush picks up this mixture to place the highlights on the eyes. A small bristle brush moves down the dark side of the nose, hardening the shape of the shadow to emphasize the bony structure of the bridge and the shape of the tip. A big bristle brush covers the suit with raw sienna, a little raw umber, and lots of white. The shadows on the suit contain somewhat more raw umber.

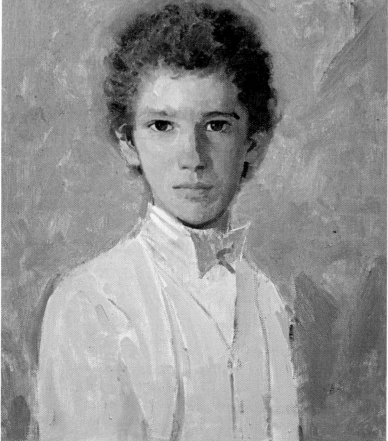

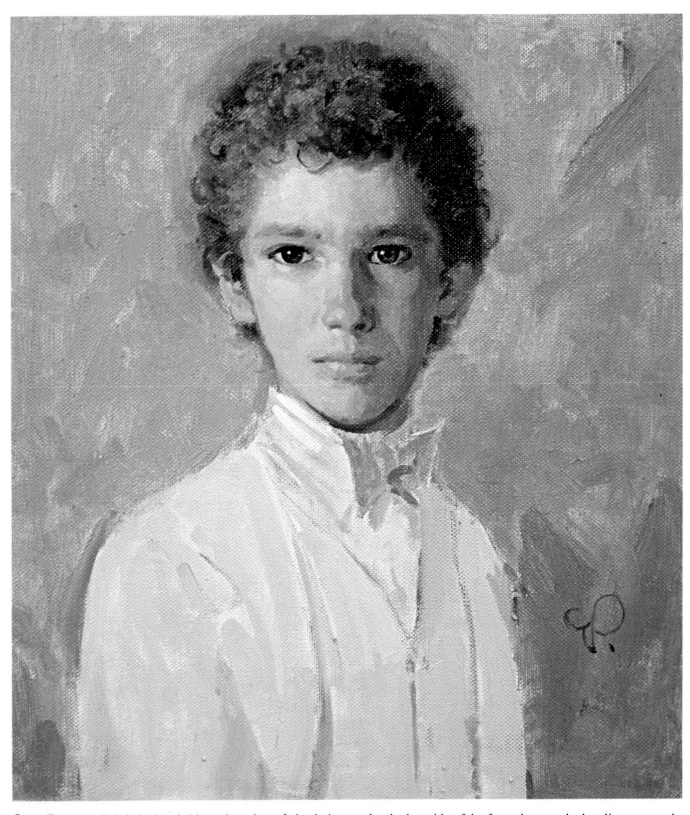

Step 7. A small bristle brush blurs the edge of the hair where it melts away into the background and then adds individual curls with quick dabs of the tip of the brush carrying burnt umber, ivory black, a little alizarin crimson, and white. The tip of a round brush adds a few individual strands of hair and then darkens the lines of the eyes with this same mixture. The round brush blurs the eyebrow on the shadow side of the face, draws a shadow line next to the nostril, and darkens the corners of the lips and the shadow beneath the lower lip. The last touches are the thick highlights—white and just a little flesh tone—beside the bridge of the nose, on the tip of the nose, beside and beneath the lighted nostrils, and on the lower lip. One more highlight is added to the lower eyelid on the lighted side of the face.

Step 1. A rag tones the canvas with raw umber and turpentine warmed with just a touch of burnt umber. A small bristle brush begins the preliminary drawing with rough masses of tone for the hair, the eye sockets, the shadowy underside of the nose, the lips, and the big shadow that runs down the side of the face and under the chin. A cloth wipes away the lighted areas on the front of the face. The artist works with broad patches of tone to emphasize the strong pattern of light and shadow on this head.

Step 2. The tip of a round softhair brush draws the contours of the brow, cheek, jaw, chin, and neck more precisely. Then the brush defines the features, adding sharp lines for the eyebrows, eyelids, nostrils, and lips. A flat bristle brush strengthens the shadow on the cheek, jaw, and neck, and then darkens the hair and indicates the tone of the sitter's coat. The entire brush drawing is executed in raw umber, a little burnt umber, and turpentine.

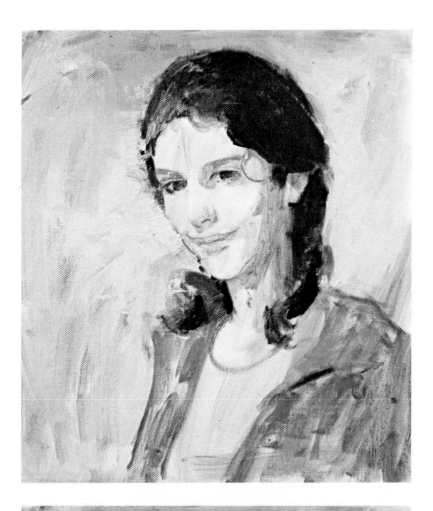

Step 3. A big bristle brush covers the hair with a solid tone of burnt umber, ivory black, a little alizarin crimson, and a touch of white to brighten the color. A big brush covers the background with loose strokes of alizarin crimson, cobalt blue, raw sienna, and lots of white. The warm tone of the coat is suggested with casual strokes of alizarin crimson, burnt umber, and white.

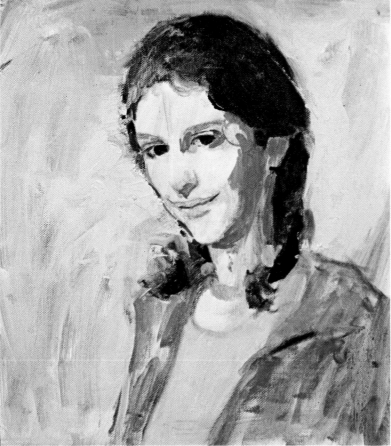

Step 4. A bristle brush paints the strong shadow on the side of the face with raw umber, raw sienna, just a little Venetian red, and white. This tone moves around under the chin and re-appears on the ear and neck. A round brush picks up this tone to darken the eye sockets, the underside of the nose, and the line of the lips.

Step 5. A big bristle brush covers the brightly lit forehead with raw umber, raw sienna, Venetian red, a speck of alizarin crimson, and plenty of white. Adding more Venetian red and alizarin crimson to this mixture, the brush moves down over the cheeks and nose, which are darker and warmer than the forehead, as usual. A few strokes of flesh tone are added to the chest, and then the blouse is painted with raw sienna, raw umber, and white.

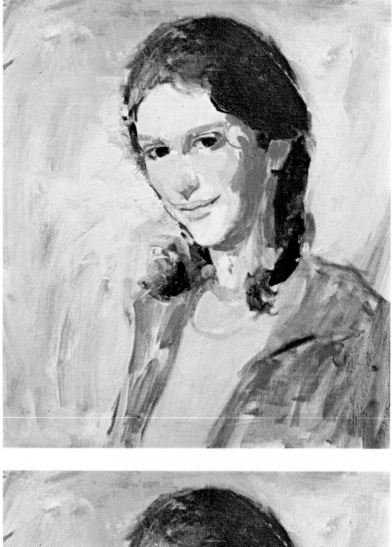

Step 6. A big bristle brush completes the job of covering the lighted area of the face with raw umber, raw sienna, Venetian red, a touch of alizarin crimson, and white. A little more raw umber and Venetian red are added to this mixture to paint the halftones that appear in the eye sockets, on the side of the nose, and along the edge of the big shadow on the side of the face. The basic mixture is heightened with a little extra alizarin crimson to paint the lips. As always the upper lip is darker because it's in shadow, while the lower lip is brighter because it turns upward to catch the light.

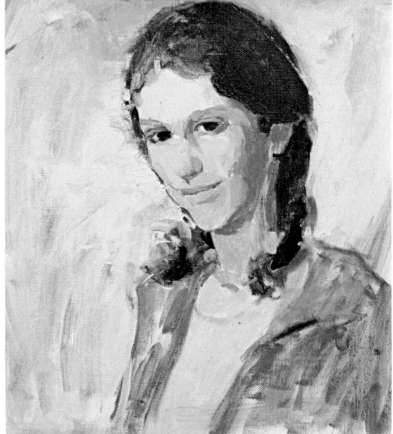

Step 7. A flat brush blends the lights, halftones, and shadows on the face. The individual brushstrokes, which stood out so clearly in Step 6, now fuse into soft, continuous tones. The tip of a round brush darkens the eyes with burnt umber and ivory black, sharpening the lines of the upper lids and strengthening the eyebrows. An extra touch of Venetian red is blended into the halftone where the light and shadow meet on the side of the face. Pale, delicate shadows are placed beneath the nose and lower lip.

Step 8. The eyes become more lively and expressive as a round brush adds the pupils with ivory black and just a little burnt umber, using the same mixture to darken the edges of the upper eyelids. Tiny highlights are placed on the pupils with pure white tinted with flesh tone. The shadow on the side of the nose and the shape of the underside are strengthened. More white is blended into the hair mixture to soften and blur the lighted side of the hair.

Step 9. Adding more white to the basic flesh mixture of raw umber, raw sienna, and Venetian red, a bristle brush builds up the lights with thick strokes. You can see these strokes on the forehead, beneath the eye and on the cheek at the right, around the mouth, and on the chin. A single stroke indicates the dark hollow of the ear. Then the bright earring is painted with cadmium red, alizarin crimson, a little raw umber, and a touch of white for the highlight. The contour of the hair at the top of the head is sharpened and darkened. The whites of the eyes are painted with a very pale flesh tone, and then the corners of the eyes are darkened with burnt umber and ivory black.

Step 10. A flat softhair brush blends these thick strokes of light—applied in Step 9—into the surrounding flesh tones. You can see this most clearly in the forehead, which is now brighter, smoother, and rounder. A small brush adds highlights of pale flesh tone to the nose and cheek. More Venetian red is added to the shadow mixture to suggest a warm reflected light along the jaw. The background is completed with thick strokes of the original mixture: cobalt blue, alizarin crimson, raw umber, and white. Alongside the forehead, some dark strokes of hair are blurred into the background.

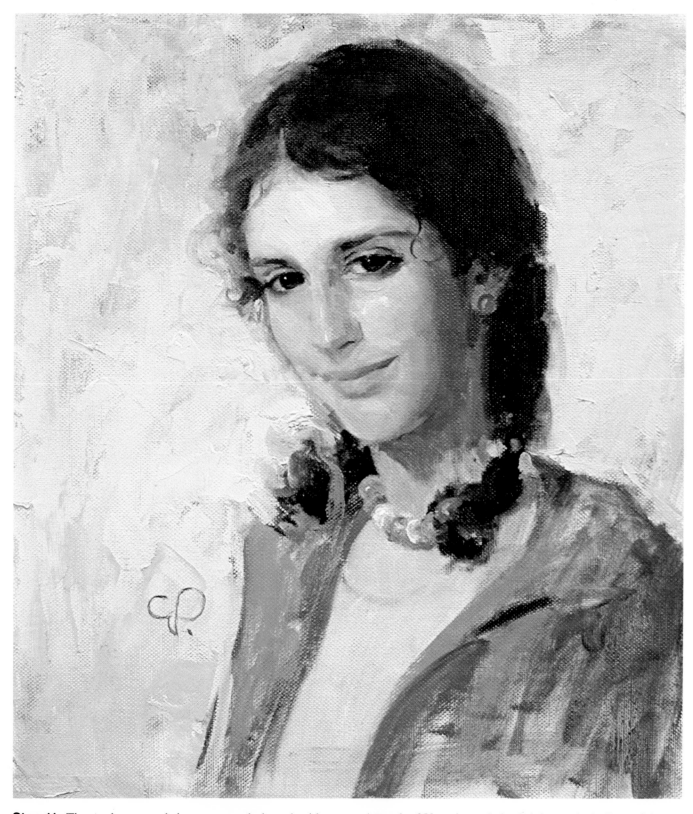

Step 11. The eyebrows and the eyes are darkened with a few final strokes of burnt umber and ivory black. The tip of a round brush uses the same mixture to add a few extra strands of hair. A bristle brush travels around the contour of the hair, blending the dark tone softly into the pale background. More Venetian red is blended into the shadow beneath the jaw, and this bright tone is extended onto the chin.

A touch of Venetian red also brightens the hollow of the ear and the underside of the nose. The red beads are painted with the same mixture as the earring, but with a little more white. The other beads are cobalt blue and white. The strokes of the coat are various mixtures of cadmium red, alizarin crimson, burnt umber, and white.

Step 1. This portrait is painted on a gesso panel rather than on canvas. A sheet of hardboard is brushed with several coats of acrylic gesso diluted with water to the consistency of thin cream. The gesso is allowed to dry overnight, and then the surface is toned with a rag dipped in raw umber and turpentine. The preliminary brush drawing is executed with this same mixture. The drawing emphasizes the two strongest darks: the hair and the eyes. A subtle wash of raw umber and turpentine, as thin as watercolor, indicates a shadow that's cast by the hair over the forehead and the bridge of the nose. This same soft tone appears on the shadow side of the face to the left—only slightly darker than the lighted side of the face.

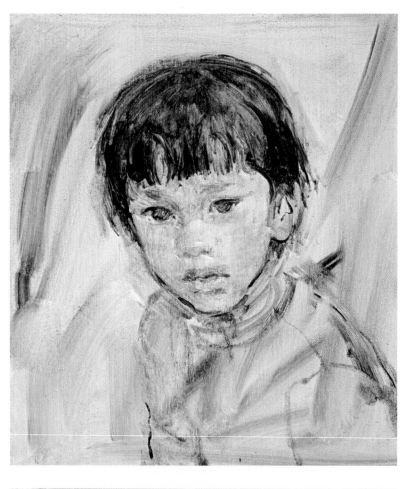

Step 2. The background is covered with knife strokes of cadmium orange, raw umber, and white. A big bristle brush places casual strokes of color on the blouse: cadmium yellow softened with raw sienna, raw umber, and white. Another bristle brush begins work on the hair with raw umber, ultramarine blue, and a little white at the top; the brush doesn't carry too much color, so the bristles make a ragged, scrubby stroke that suggests the wispy texture of the hair. A round brush places the darks of the irises with burnt umber and ivory black. The first strokes of flesh tone are raw umber, raw sienna, a little Venetian red, and white, diluted with painting medium.

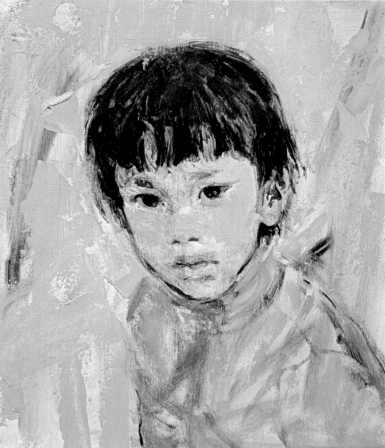

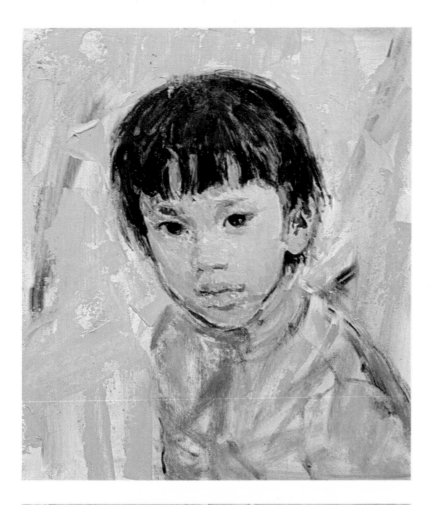

Step 3. A bristle brush finishes the job of covering the face with various mixtures of raw umber, raw sienna, Venetian red, a speck of cadmium red, and white. The strokes contain more raw sienna and raw umber on the shadow side of the face, between the eyes, on the side of the nose, and in the shadowy areas beneath the nose and lower lip. A bit more Venetian red is added to the lighted areas of the cheeks. Notice how extra touches of Venetian red and cadmium red warm the chin, nostrils, lips, and ear. The whites of the eyes are painted with white tinted with raw umber. The dark irises are warmed with tiny touches of Venetian red and raw sienna.

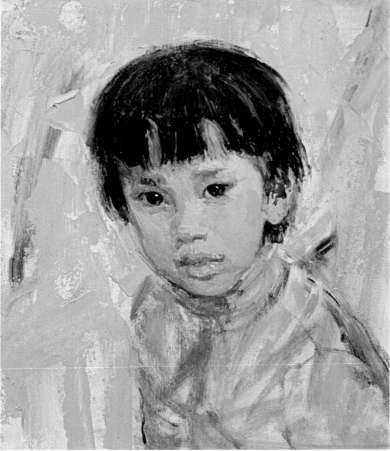

Step 4. A flat softhair brush begins to blend the brushstrokes of the face together to produce a smoother, more delicate tone. The shadows are strengthened in the eye sockets, on the nose and cheek, and alongside the jaw. Blending more Venetian red and cadmium red into the shadowy flesh mixture, a round brush paints the shapes of the lips with curving strokes. The shadow on the forehead is darkened by adding a little more raw umber to the flesh mixture. The shape of the hair is solidified with heavier strokes of ultramarine blue and raw umber. A pointed brush sharpens the lines of the eyes, adds the pupils with this same dark mixture, and then adds tiny highlights with pure white tinted with flesh tone.

Step 5. The painting knife covers the background with thicker strokes of the original mixture: cadmium orange, raw umber, and white. Softhair brushes continue to work on the face, building up the light on the cheeks, upper lip, chin, and earlobe. At the same time the lips are darkened and blended to look warmer and rounder. A flat softhair brush blends the strokes on the forehead, nose, chin, and shadowy cheek. The blended paint has a particularly smooth, delicate character on the smooth surface of the gesso panel, which enhances the tender quality of the little boy's skin.

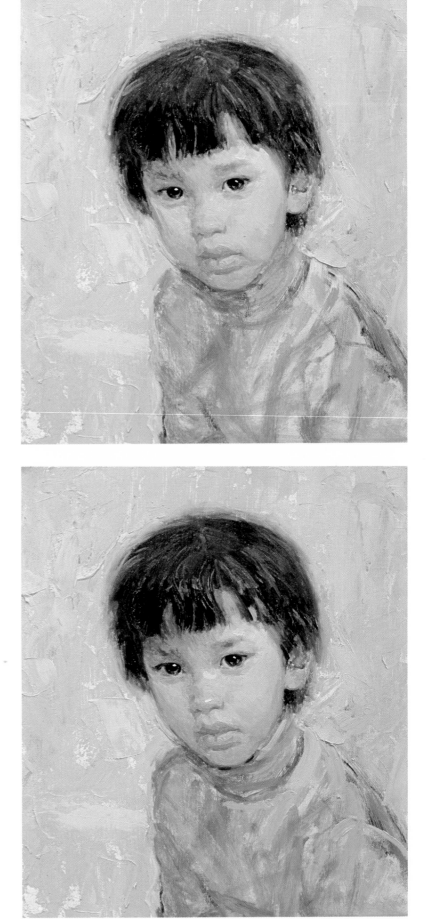

Step 6. The tone of the blouse is enriched with heavier strokes of cadmium yellow, raw sienna, raw umber, and white. The tip of a round brush adds the lighter tones of the hair with raw umber, ultramarine blue, and white, picking out individual strands and blending the edges of the hair softly into the pale background. The tip of a round brush modifies the contour of the shadow side of the face with strokes of warm flesh tone containing more Venetian red. These strokes are blended softly into the skin, leaving a dark edge where the cheek turns away into the shadow. The entire shadow side of the face is darkened slightly and blended more smoothly.

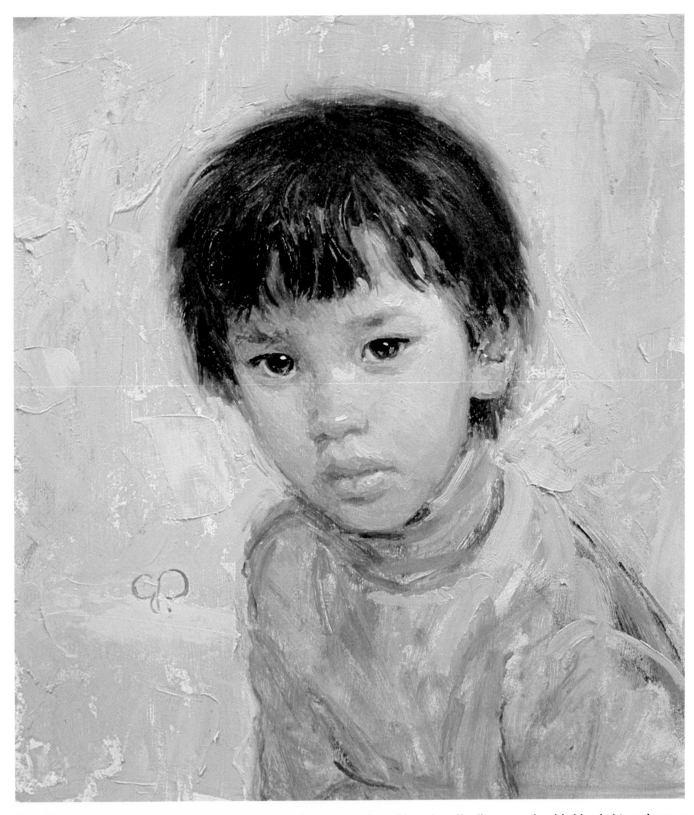

Step 7. Blending more white into the palest flesh mixture, a small brush adds thick touches of light to the brow above the eye on the lighted side of the face, the lighted cheek, the bridge and tip of the nose, just above the upper lip, and the side of the lower lip. The eyebrows and the dark lines of the upper eyelids are the same mixture as the hair: ultramarine blue and raw umber. The dark line on the side of the face in Step 6 has virtually disappeared as it's blended into the tone of the flesh. A few small strokes of flesh tone are carried upward from the forehead into the hair to suggest bright skin shining through the dark locks. On the gesso panel, which lacks the rough weave of canvas, the only texture is the texture of the paint itself—rough where the paint is applied roughly, smooth where the strokes are softly blended.

Step 1. The canvas is toned with burnt umber and turpentine. The warm tone of this mixture already begins to suggest the color of the sitter's skin. You can see where vertical and horizontal guidelines have been brushed over the face and then wiped away as the brush drawing proceeds. The brush indicates the dark shape of the hair, the darks of the eyes, the shadows within the eye sockets, the shadowy underside of the nose, the dark upper lip, and the shadow beneath the lower lip. The shadow side of the face, at the left, is suggested with a fluid wash of burnt umber and turpentine, while the lighted side of the face is wiped away with a cloth.

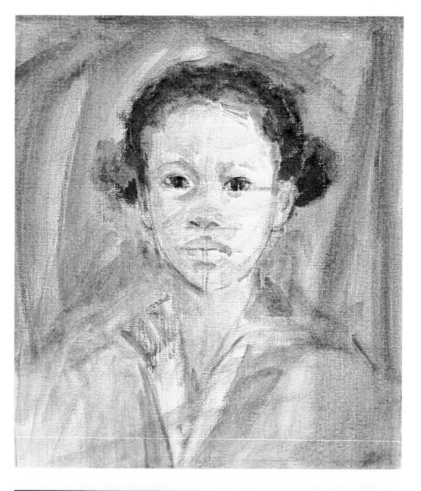

Step 2. A large bristle brush covers the face with several different mixtures of raw umber, cadmium orange, Venetian red, and white—with a touch of ivory black in the strongest darks. The warm, dark background is painted with thick strokes of burnt umber, alizarin crimson, and ivory black, plus a touch of white. This same mixture, without the white, darkens the hair and the eyes. At this stage, the colors are all simple, flat shapes that will be blended later on.

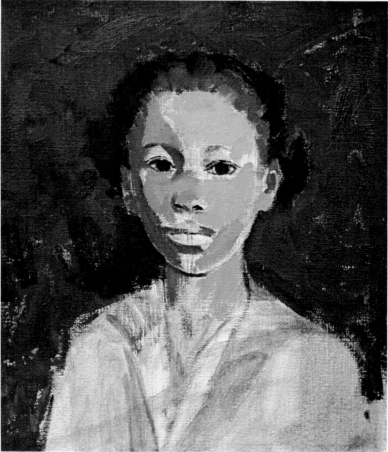

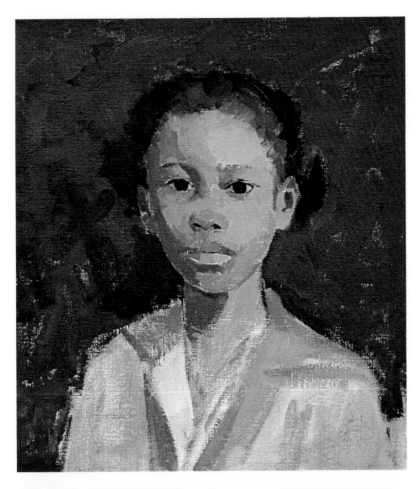

Step 3. The entire face and neck are now covered with flesh tones. The brightest skin tone appears on the forehead on the lighted side of the face. Notice how the jaw darkens as it curves away from the light. The tip of the nose is slightly darker than the bridge. Notice how the rounded eye socket curves from dark to light. Observe how the lower lip is painted as three separate planes of color: dark, halftone, and light. The dress is painted with the same mixtures as the skin, warmed with a little more Venetian red and brightened with more white.

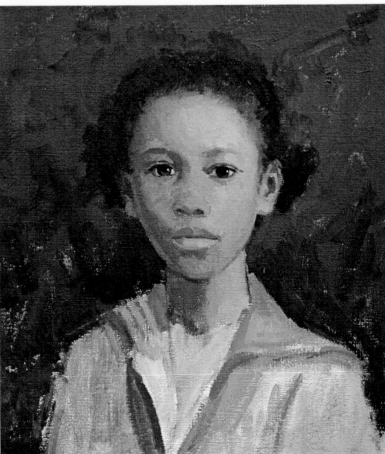

Step 4. Blending more white into the flesh mixture, a bristle brush gradually builds up the lighted area of the forehead, the lighted cheek, the nose, the lower lip, and the lighted side of the neck. Then a flat brush begins to blend all the tones together to make the face look more rounded and lifelike. The eyebrows are darkened. The dark lines of the lids and the dark patches of the pupils are painted with burnt umber and ivory black. The whites of the eyes and the highlights next to the pupils are pure white, tinted with a speck of raw umber.

Step 5. Still more white is added to the palest flesh tone to build up the lights. Until now the skin has looked rather drab, but now it begins to glow as luminous touches are added to the brow, eye sockets, nose, and lips. A small brush darkens the shadow areas of the eye sockets, sharpens the contours of the eyes, draws the nostrils and the underside of the nose more precisely, and blends and softens the lips and chin.

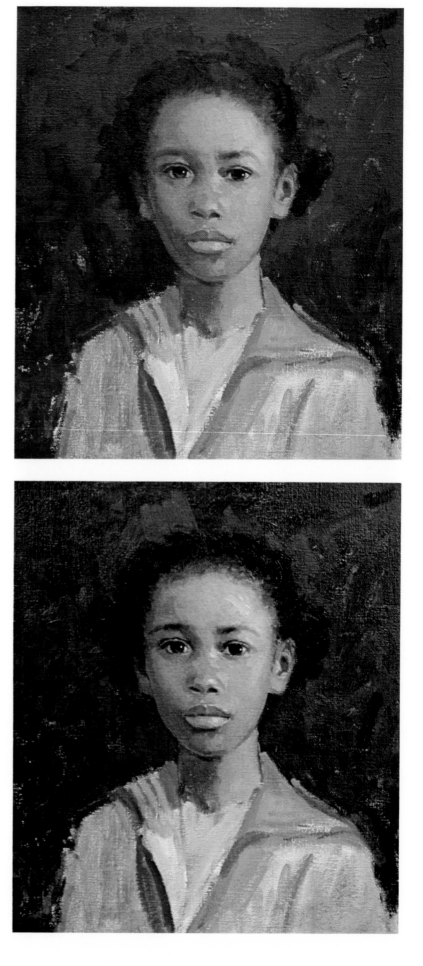

Step 6. Thick touches of light are now added to enrich the lighted sides of the forehead, brow, cheek, nose, and lips. A touch of light is added to the ear on the lighted side of the face. A small round brush darkens the contours of the lips and strengthens the tone of the eyebrows. The hair is darkened with burnt umber and ivory black, and then the edges of the hair are blurred softly into the dark background.

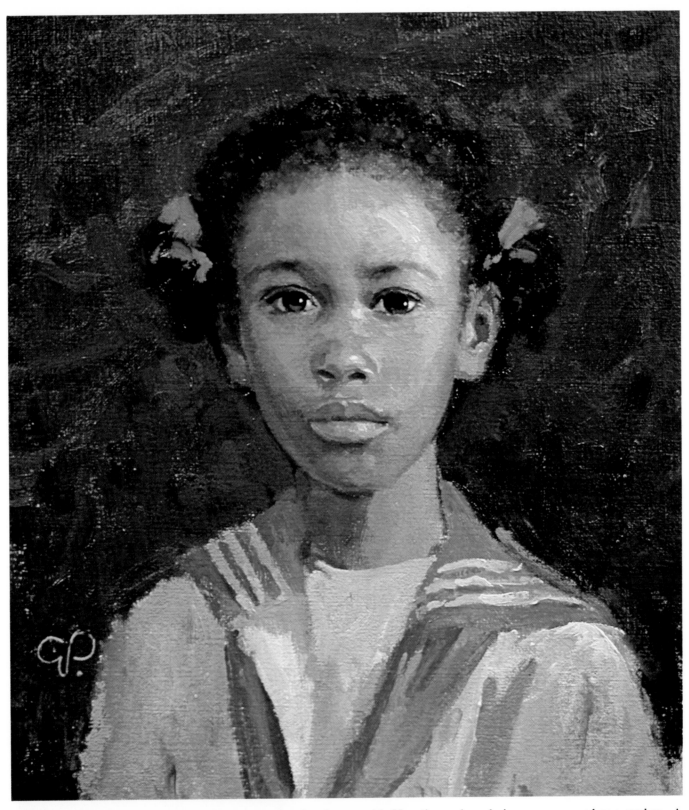

Step 7. In the final stage touches of Venetian red and cadmium orange are blended into the shadow mixture to add subtle, warm notes to the shadow side of the face. At the same time, cool notes are added to the eye socket and the forehead on the shadow side of the face with ivory black, raw umber, and white. Warm notes are added to the eyes with Venetian red, cadmium orange, and raw umber. A small round brush scribbles some strokes over the hairline to suggest individual curls of hair. The cool shadows on the blouse are ivory black, raw umber, and white. The portrait is completed by a few quick strokes for the ribbons: cadmium orange, burnt umber, Venetian red, and white.

Step 1. A rag tones the canvas with burnt umber diluted with lots of turpentine to a very pale tone. The preliminary brush drawing is also executed in burnt umber diluted with less turpentine. The dark tone of the hair is scrubbed on with a bristle brush and so is the tone of the sweater. A round softhair brush draws the contours of the face and features. Then a bristle brush carries the shadow tone down the dark side of the face and adds a few touches of shadow on the dark sides of the features.

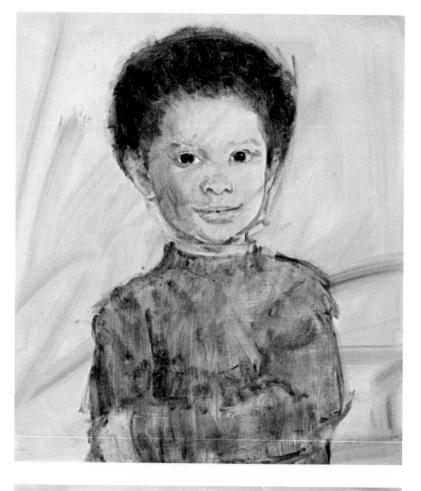

Step 2. A big bristle brush covers the hair with ivory black and ultramarine blue and then darkens the eyes with this same mixture. A round brush picks up this dark tone to draw the lines of the eyelids, the nostrils, and the line between the lips. The bright color of the sweater is a single stroke of alizarin crimson and cadmium red softened with a touch of raw umber. Cobalt blue, raw umber, and white are brushed loosely over the sweater. A pale tone of raw umber and white is brushed over the background.

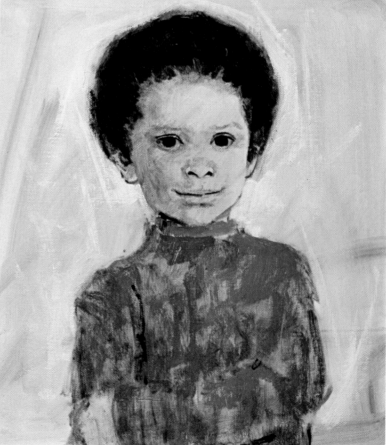

Step 3. The dark tone on the shadow side of the face is blocked in by a big bristle brush that carries a mixture of burnt umber, raw sienna, and cadmium orange. Notice how this mixture is carried over the ear, into the eye socket, and into the pool of shadow under the lower lip. A single dark stroke of this mixture is placed in the corner of the eye and on the shadow side of the nose.

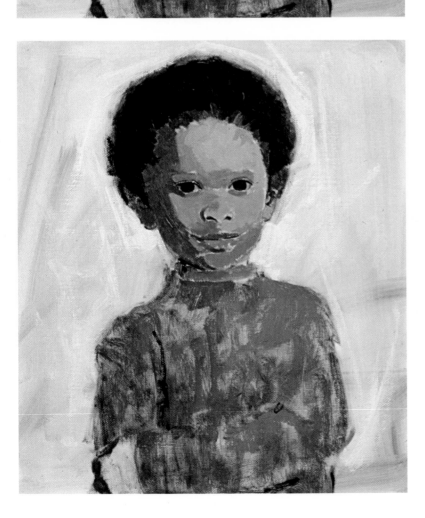

Step 4. The pale tone of the forehead is covered with broad strokes of burnt umber, raw sienna, cadmium red, and white. The darker, warmer tone that falls between the lighted forehead and the shadow side of the face is a mixture of cadmium orange, burnt umber, and white. This mixture, which is really a halftone that falls midway between the light and shadow, is darkened with more burnt umber and cadmium orange as the brush moves down the face to the lips, jaw, and chin. Notice how a single stroke of this mixture defines the shadowy eyelid beneath the eye on the lighted side of the face. Now the entire face is covered with flat tones which will soon be blended.

Step 5. A flat softhair brush begins to blend the flat tones together to create smooth transitions between the lights, halftones, and shadows. The upper lip is darkened and so is the eye socket on the shadow side of the face. Both eye sockets are filled with a warm, soft tone. The tip of a round brush defines the nose and lips more precisely and sharpens the dark lines of the upper eyelids. Subtle touches of ultramarine blue, ivory black, and white add a cool tone to the hair where it overlaps the forehead. The hand is painted with the same colors that appear on the face.

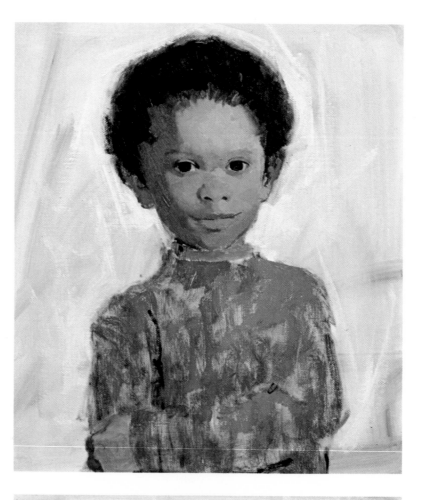

Step 6. A small brush shapes the lips more carefully, darkening the upper lip, the corners of the mouth, and the shadow beneath the lower lip. A flat softhair brush lightens and continues to blend the forehead. The paler hair tone, which was brushed over the edge of the fore-head in Step 5, is now blended softly into the skin. Strokes of ultramarine blue, ivory black, and white are carried over the outer edge of the hair to suggest light falling on the dark mass. Thicker strokes of cobalt blue, raw umber, and white now darken the sweater. The background is lightened with additional strokes of white and raw umber concentrated mainly around the head.

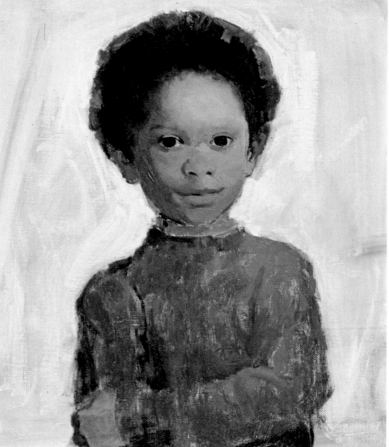

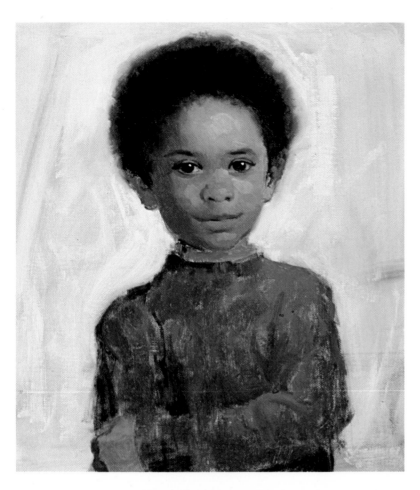

Step 7. The cool pale edge of the hair is blended softly into the surrounding background tone. More white is added to the palest skin tone, and a big bristle brush builds up the lights on the forehead, nose, cheeks, and chin with thick strokes. The whites of the eyes are painted with pure white tinted with raw umber. Highlights are added to the pupils with touches of white also tinted with raw umber. The tip of a round brush draws the dark lines of the eyelids with burnt umber and ivory black. The lower eyelids are warmed and darkened.

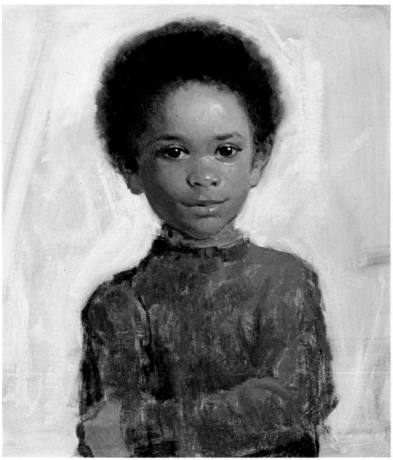

Step 8. The strong touches of light, applied in Step 7, are softly blended into the surrounding skin tones, which grow richer and more luminous. The warm skin tone needs a cool note: the slightest hint of cobalt blue, raw umber, and white is blended into the shadow side of the jaw. Highlights of thick white, softened with a speck of flesh tone, are placed on the forehead, the upper eyelids, the bridge and tip of the nose, just beneath the eye on the lighted side of the face, and on the lower lip.

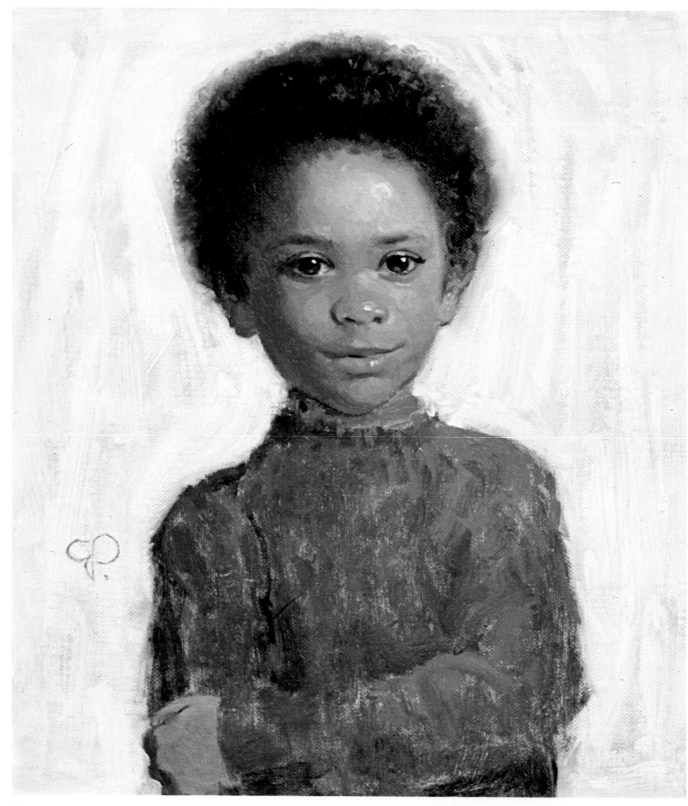

Step 9. The finished painting shows how the lips are warmed with an extra touch of cadmium red. The bright tone of the collar is reflected in the shadow beneath the chin. The whites of the eyes are darkened at the corners to make the eyes look rounder. Small, curving strokes of ultramarine blue, burnt umber, and white pick out individual curls in the hair. Tiny touches of light are added above the eyebrows to dramatize the sitter's eyes. The entire background is lightened with strokes of white and raw umber cooled with a speck of cobalt blue. This cooler background heightens the rich, warm color of the sitter's skin.

Getting to Know the Sitter. When you begin to paint children's portraits, it's best to start with sitters whom you already know—members of your family, friends, neighbors. Since you already know them, your sitters will be fairly relaxed with you. And it's easy to talk to them about how you'd like them to pose, what you'd like them to wear, and how you'd like their hair done. But if the sitter is just a casual acquaintance, or perhaps a stranger, it's a good idea to take some time to get to know the sitter and establish a relaxed, friendly relationship before you begin to paint. When a professional specializes in painting children, he often invites the sitter to the studio a few days before the first painting session—or pays a preliminary visit to the sitter's home, if that's where the portrait will be done. Each professional has his own way of making friends with the sitter. Children are fascinated by the process of painting, and a child may respond with great interest if you show him your paints and brushes, explain how they're used, and perhaps let the child handle them. Other professionals are good at the friendly chitchat that puts a child at ease. To paint children's portraits, you've really got to *like* children—and lots of professionals are perfectly comfortable sitting on the floor, playing with the child and his toys. Some artists make friends with the sitter by using that first session to make some preliminary portrait sketches while the sitter watches, asks questions, and generally enjoys seeing an artist at work. Whether that first session takes place a week before you start to paint or just half an hour before the painting session, it makes the job a lot easier.

Talking to Children. The whole secret in talking to children is to be yourself and to treat the child as a *person*. Small children are *not* amused by "baby talk." Teenagers are *not* impressed when adults pepper their conversations with teenage expressions—which sound natural when a kid uses them, but sound silly and artificial when an adult tries to use them in order to seem like a teenager. Young people of all ages respond to honest, straightforward conversation. Talk simply and openly about yourself, your work, and the portrait. Ask questions and encourage your sitter to ask questions. Don't struggle to make clever conversation or tell lame jokes. The conversation will move along quite naturally if you just talk about how you hope to paint the portrait and how you'd like the sitter to help.

Entertaining the Sitter. When the painting is finally under way, you *will* have to cope with the natural vitality and impatience of children. Whether your sitter is a tiny tot or a teenager, you'll find that children don't like to sit still for very long. That's why professional portrait painters always provide some sort of entertainment to keep the sitter in one place as long as possible. We all know about the hypnotic effect of television—and a television set is probably the most effective device for immobilizing the sitter. For small children, you may want to provide some picture books or toys. Or you can ask the parents to bring along some of the child's own favorite books or toys. Older children may enjoy looking at magazines or at your art book collection. If you have a hi-fi set, you might provide some popular music for a teenage sitter—or suggest that the sitter bring along some favorite records. Be sure to interrupt the pose with frequent rest periods: every fifteen or twenty minutes for a teenager, and more often for a young child. During these rest periods, invite the sitter to look at the canvas and see how the painting is coming along.

Clothing. Always encourage the sitter—or the sitter's parents—to select clothing that's simple, natural, and comfortable. Children don't really like to dress up for a portrait, but prefer loose, casual clothing. Such clothing is not only easier to paint, but the sitter becomes easier to paint because he or she is more relaxed. If possible, discuss the sitter's clothing at least a day before the first portrait sitting so that you can make it clear that the portrait will look best if the sitter's clothes are a solid, subdued color in a simple, unobtrusive style. Explain that a strong color, a blatant pattern, or a dramatic style will distract attention from the sitter's face. If some proud parent insists that the child wear a favorite dress or blouse, ask if you can see it so you can have a chance to say: "Do you have some other favorite that doesn't have such strong stripes?"

Hair. Hair, like clothing, is most "paintable" when it's loose and natural. If a mother insists on sending her child to the hairdresser in preparation for the portrait, ask her to allow a day or two for the hair to loosen up before the painting session. If the hair still looks too tight and artificial when the sitter arrives, you can do a bit of work with a brush or comb. If a boy comes directly from the barber to the studio and his hair looks too neat, hand him a comb and tell him that his hair will look more masculine if he roughens it up a bit.

Preliminary Studies. An adult may be willing to spend as much as two or three hours posing for a portrait, while a teenager will probably begin to fidget after an hour, and a preschooler may start to run around the studio after half an hour. This means that you've got to work quickly when you paint children's portraits. The painting will go more rapidly if you make a number of preliminary sketches in pencil, chalk, or charcoal, before you attack the canvas.

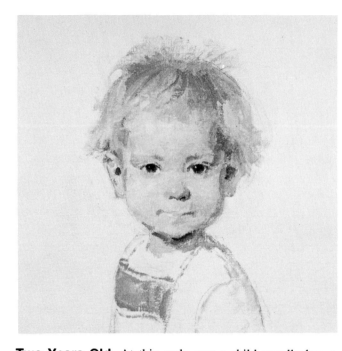

Two Years Old. At this early age a child usually has a very large forehead, round cheeks, and big, bright eyes. On the other hand, the nose, mouth, and chin are small and still undeveloped. The hair is often thin and wispy.

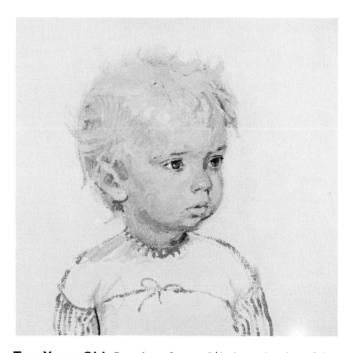

Two Years Old. Seen here from a 3/4 view, the size of the cranial mass—the upper half of the head—is even more obvious. The ear is also quite large in relation to the other features. The nose and lips are tiny and soft. The jaw is round and undeveloped. The neck is slender.

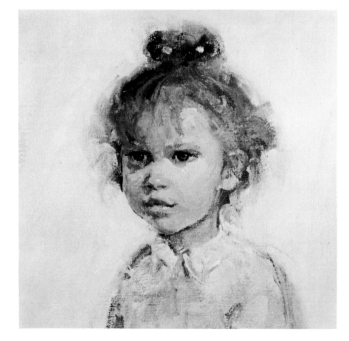

Five Years Old. By the time a child is five years old the forehead and the cranial mass are still large, but they look slightly smaller because the lower half of the face has begun to develop. The contours of the nose and mouth are more pronounced and the jaw has a more distinct shape. The ear is still fairly large in relation to the rest of the features. The neck is still slender and delicate.

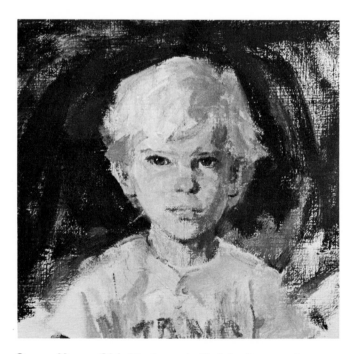

Seven Years Old. The lower half of the face continues to develop. The eyes and ears aren't quite so big in relation to the rest of the face. The bony structure of the nose becomes slightly more apparent. The mouth begins to look more adult. The round cheeks are growing more slender. The bony structure of the jaw becomes firmer and so does the chin.

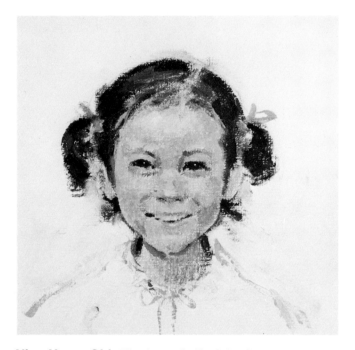

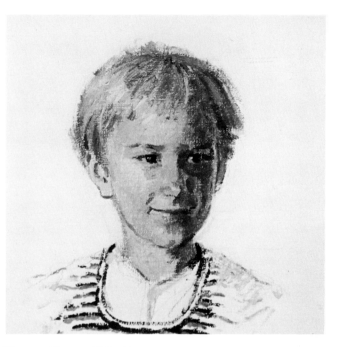

Nine Years Old. The lower half of the face grows more prominent and the features are more sharply defined. The jaw is leaner and the chin is longer and sharper. The mouth grows larger in relation to the other features, while the eyes are a bit less prominent than they were at an earlier age. The ears also look smaller in relation to the other features.

Eleven Years Old. The proportions of the head are very much like those of an adult, although the head is obviously smaller. The head is more elongated and so are the nose and chin. You begin to see the bridge of the nose. The mouth grows more slender, while the lines of the jaw and chin are stronger. The head sits more solidly on the firm cylinder of the neck.

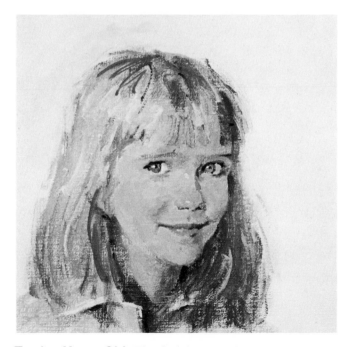

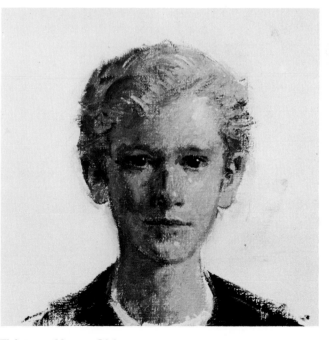

Twelve Years Old. The facial proportions are like those of a mature woman. The line of the brow is sharper. The curves of the cheek, jaw, and chin are more precise. The lines of the mouth are crisp. The eyes are still large and luminous, but they seem smaller in relation to the total head—compared with the five-year-old on the facing page.

Thirteen Years Old. At the beginning of adolescence the face grows longer and leaner. The bony structure becomes more obvious. The nose has a clearly defined bridge. The jaw and chin are firm and solid. The eye sockets grow deeper. The details of the eyelids and mouth are more clearly defined. Yet the face still has a smooth, tender quality because the contours flow softly together.

3/4 Lighting. If you ask portrait painters to choose their favorite type of lighting, most will agree on 3/4 lighting. The light hits one side of the sitter's face, as well as part of the front, throwing the other side of the face into shadow. As you sit at your easel facing this particular sitter, the light is coming diagonally over your right shoulder. The lighted side of the face is at your right, while the shadow side is at your left. One side of the nose is also in shadow. The eye socket on the shadow side of the face is distinctly darker than the socket on the lighted side of the face. The chin casts a shadow on one side of the neck. This is often called *form lighting* because it makes the face look round and three-dimensional.

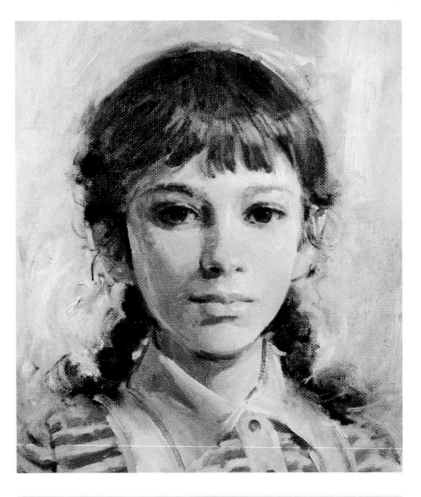

3/4 Lighting. Here's another kind of 3/4 lighting. Now as you sit at the easel facing this sitter, the light moves diagonally over your left shoulder, but the light source is higher—somewhere above your head. The model's face is turned slightly, giving you a three-quarter view instead of the frontal view in the portrait of the girl above. Both eye sockets are in deep shadow, and there's a strong shadow under the nose. One side of the face is in deep shadow, and there's a strong shadow under the chin—but there's only a halftone on the shadow side of the nose. Notice the strong contrast between the light and shadow planes of the hair.

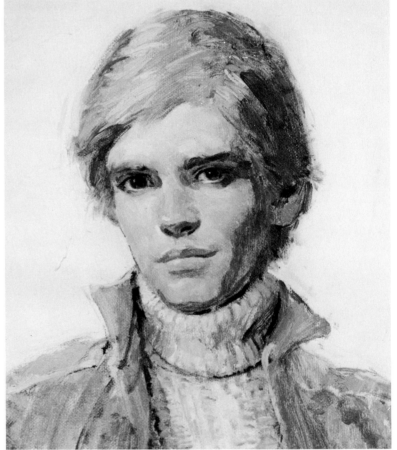

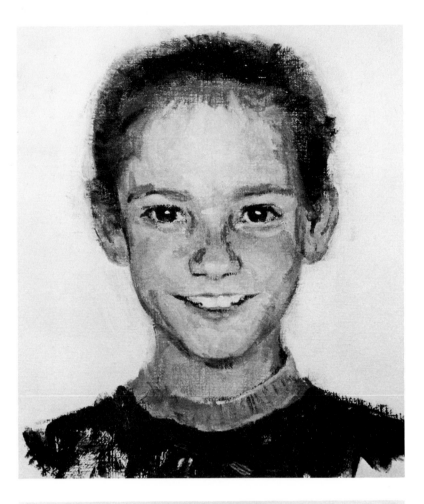

Frontal Lighting. This sitter faces you directly, and the light hits him head-on, as if your own face were the light source. Actually the light is flooding over both your shoulders, and it's equally distributed over the sitter's entire head. There are no big planes of light and shadow. Most of the head is brightly lit, with just a few touches of shadow around the edges of the features, along the cheeks and jaw, and beneath the chin. There are also very soft halftones that lend roundness to the forms of the lower face. Frontal lighting emphasizes the softness and delicacy of the sitter's features.

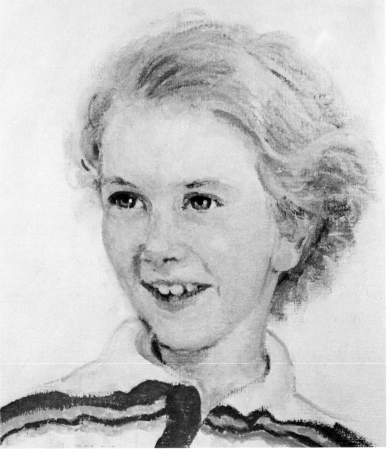

Frontal Lighting. In this example of frontal lighting the sitter has turned slightly. Once again the entire face is evenly lit by light that floods over both your shoulders. The face seems to be one smooth, even tone with slender lines of shadow defining the edges of the features. The curves of the cheeks, jaw, and chin are halftones. This soft, diffused lighting dramatizes the sitter's dark eyes and animated mouth.

Side Lighting. The light comes directly from one side, as if the model is sitting next to a window. The side of the face that's nearest the light source is brightly lit, while the opposite side of the face is in shadow. When you choose this kind of lighting, there's always the danger that the shadow side of the face may be *too* dark. The shadow side of this sitter's face, however, is luminous because she's sitting next to a secondary light source. This secondary source can be nothing more complicated than a white wall or a sheet of white cardboard that reflects the light of the window and bounces some light into the dark side of the face. If you're working with artificial light, place a big light fixture on one side of the head and a much smaller fixture on the other side to provide what photographers call "fill-in" light.

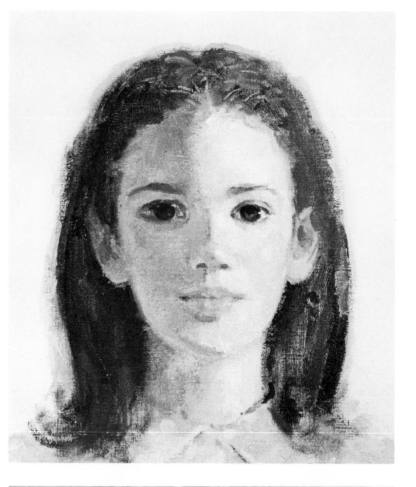

Side Lighting. As the sitter's face turns, the proportion of light to shadow will change. In this case you see more of the shadow side of his face and less of the lighted side. The neck is almost completely in shadow. Once again there's a secondary light source that adds a hint of brightness to the shadow side of the face. Of course, instead of asking the sitter to turn his head, *you* can walk around him to change the proportion of light and shadow.

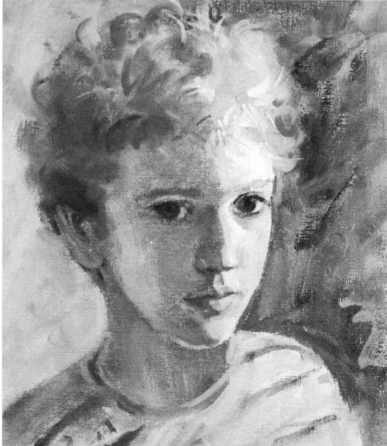

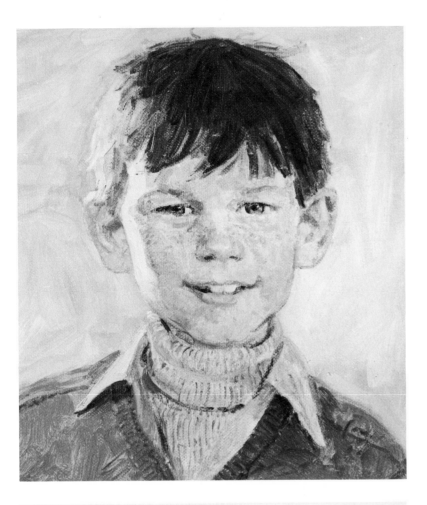

Rim Lighting. When the light source is behind the sitter and slightly to one side, most of the face is in shadow, and there's just a *rim* of light along one side of the brow, cheek, and jaw. This rim of light also appears on his hair and along the edge of one ear. To keep the front of the face from becoming too dark, place a reflecting surface or small lamp where it will lighten the shadows. Now you can see the dark contours of the features more clearly.

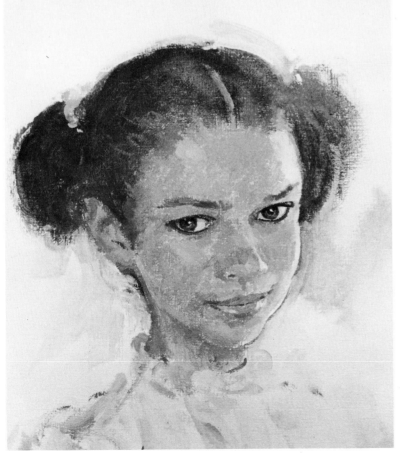

Rim Lighting. As the sitter turns her head toward the light source, a rim of light appears not only on her forehead, cheek, jaw, and chin, but also along the edge of her nose and mouth. The dark side of the face consists mainly of halftones—very much like the effect in frontal lighting. A touch of background shadow is placed next to her cheek to accentuate the lighted edge.

Step 1. The sharpened point of the pencil glides lightly over the paper to define the oval contours of the head, the rounded shape of the hair mass, and the column of the neck, which curves outward toward the shoulders. The pencil draws a vertical center line down the face and horizontal guidelines to locate the features. Then a few lines suggest the eyes, nose, mouth, and ears.

Step 2. The pencil presses slightly harder to produce the darker lines that sharpen the contours of the face, hair, and features. Working with parallel lines, the pencil begins to suggest the shadows within the eye sockets and the larger ear, along the side of the hair and beneath the nose, lower lip, and chin.

Step 3. A kneaded rubber (putty rubber) eraser removes the excess guidelines. Moving lightly over the face the pencil begins to sharpen the features; indicates shadows along the brow, cheek, and jaw; darkens the hair; and suggests the weave of the sweater with quick, scribbly lines.

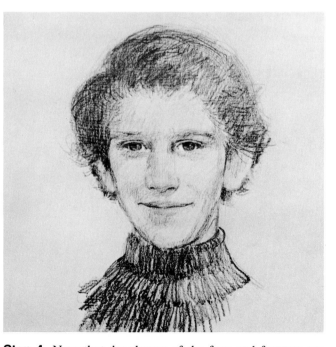

Step 4. Now that the shapes of the face and features are clearly drawn, the pencil presses harder to make darker strokes that define the shapes more strongly. The eyes, nostrils, and mouth are redrawn with darker lines. Moving lightly back and forth, the pencil begins to add halftones to the face and then darkens the hair. The sweater is darkened too.

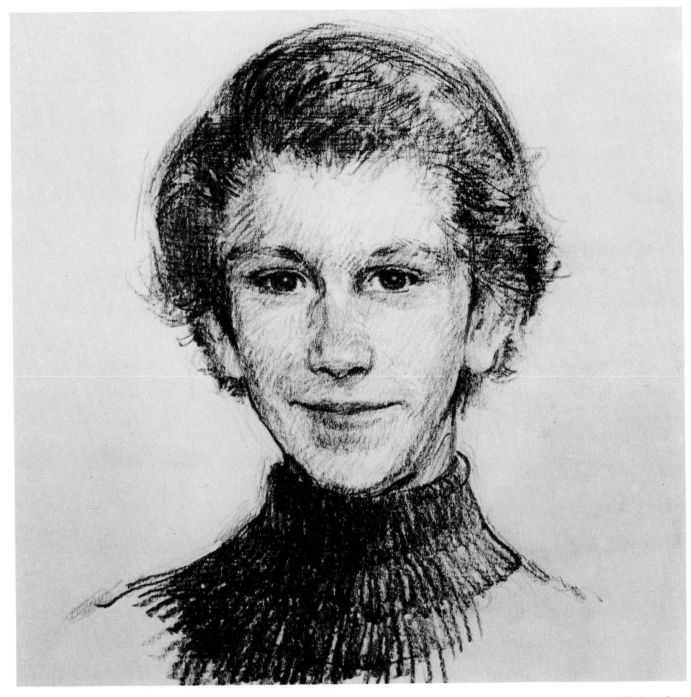

Step 5. The pencil continues to move back and forth, drawing quick parallel lines to complete the shadows and half-tones on the face. The pencil presses down hard to darken the eyes, nostrils, and lips. The eraser cleans away excess lines to lighten the forehead, the cheeks, the chin, and the bridge of the nose. The point of the pencil is used to sharpen the lines of the jaw and chin. Then the *side* of the lead completes the darks of the hair and the sweater with broader, rougher strokes. It's possible to soften and blend the strokes of the pencil with a fingertip, treating the marks of the pencil like wet oil paint. But it's good discipline to leave the pencil strokes intact, starting with lighter strokes and then making the strokes darker and more precise in the final stages of the drawing.

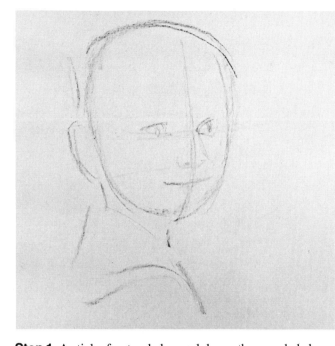

Step 1. A stick of natural charcoal draws the rounded shape of the head with curving lines. A vertical center line aids the placement of the features, which are quickly indicated with a few strokes. The shapes of the ear, neck, and shoulder are suggested with the minimum number of lines. The roughly textured paper is specially made for charcoal drawing.

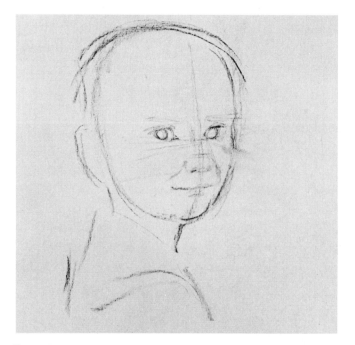

Step 2. Pressing a bit harder to make a darker line, the charcoal stick retraces the contours of the face and draws them more precisely. The features are also defined more clearly. It's easy to wipe away the original lines with a fingertip, a dry cloth, or a cleansing tissue.

Step 3. The tip of the stick is brushed lightly over the shadow sides of the forehead, cheek, jaw, neck, and nose in a series of parallel lines. A fingertip blends some of these lines together to form a soft, continuous tone. Then the charcoal is held at an angle and the side of the stick makes broad strokes around the head to suggest the background. Finally, the eyes are darkened.

Step 4. The background is darkened more to silhouette the lighter shape of the head. The shadows on the face are further developed with light, parallel strokes that are gently blended by a fingertip. The tip of the charcoal stick darkens the contours of the eyes and the details of the nose and the mouth. Heavier strokes suggest the texture of the hair.

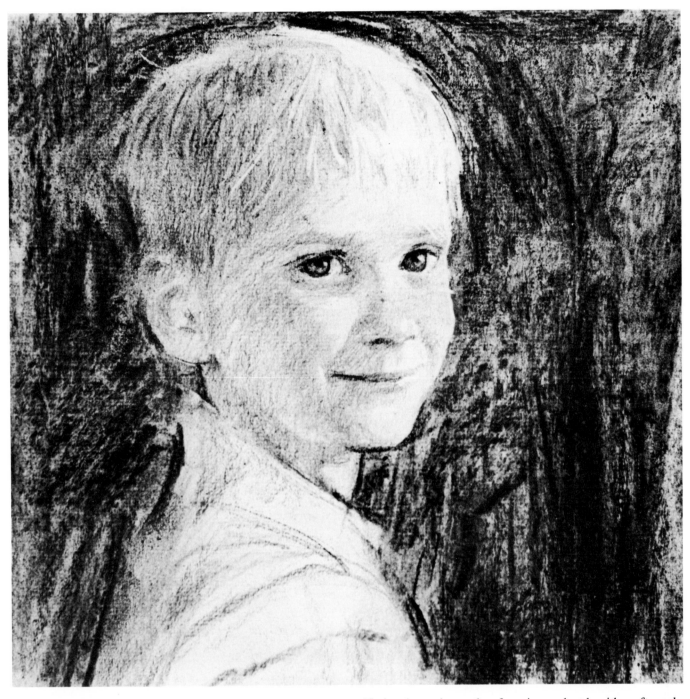

Step 5. Gliding lightly over the face the charcoal stick darkens the shadows very selectively—on the cheek, jaw, chin, neck, and side of the nose. These strokes are left unblended. The sharp tip of the charcoal stick draws the dark lines of the eyes with precise strokes, darkens the nostrils, and strengthens the line between the lips. The side of the stick is used to darken the background with rough, heavy strokes that are left unblended. The tip of the stick picks out a few more strands of hair, and the portrait is complete.

Notice how the entire face is rendered with soft, pale strokes that merge into delicate tones. Only the features are drawn with sharp lines. The texture of the paper roughens the strokes as canvas roughens the mark of the brush. This drawing is made with natural charcoal, which is very dry, soft, and easy to smudge; thus it handles like paint. You can also buy charcoal pencils, which make a firmer line and don't smudge as easily—if you prefer a portrait that looks more like a pencil drawing.

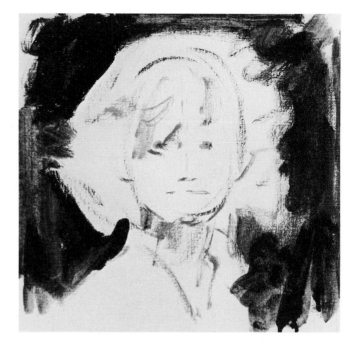

Step 1. The tip of a round softhair brush draws the oval contours of the face, the ragged shapes of the hair, and the first indication of the features with a fluid mixture of tube color and turpentine. Much of the work in this oil sketch will be done with this liquid mixture, which is only a bit thicker than watercolor. The painting surface is canvas-textured paper.

Step 2. A big bristle brush washes in the dark background with fluid strokes of tube color and turpentine. This fluid mixture is darker because it contains somewhat less turpentine. Now the pale tone of the hair is clearly silhouetted against the surrounding darkness.

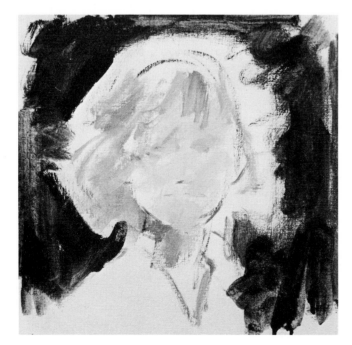

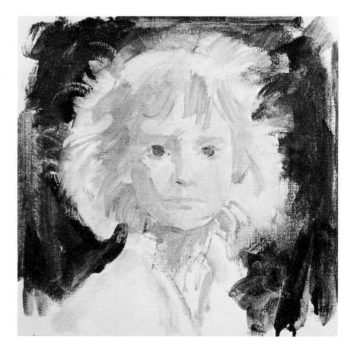

Step 3. The artist *usually* begins by blocking in the shapes of the shadows. But this is a rough, impulsive sketch; he decides on a different approach. The face is quickly covered with a pale tone that represents the lights. A few darker dabs suggest the eye sockets. Then the brush moves swiftly around the face to suggest the shadow tone on the hair and neck.

Step 4. This same shadow is carried swiftly over the darker sides of the head and features, which are now almost complete. Smaller strokes of this tone indicate the dark upper lip, the shadow beneath the lower lip, the underside of the nose, and the lower eyelids. The eyes are placed with two quick touches. And the brush scribbles more shadow strokes over the hair.

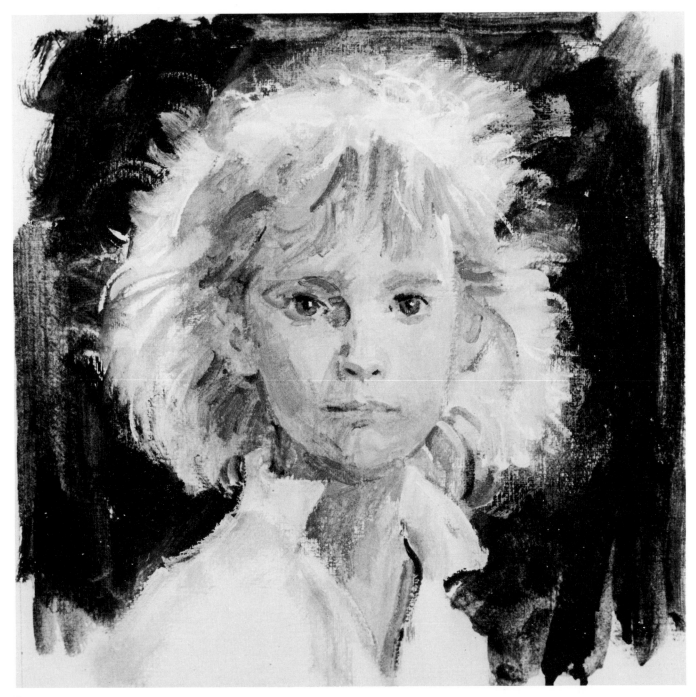

Step 5. Having covered the entire face, neck, and hair with broad strokes of light and shadow in the shortest possible time, the artist finishes the sketch with the last few touches of detail. The tip of a round softhair brush draws the dark lines of the eyes, eyebrows, nostrils, and mouth. A few strokes of shadow darken the corner of the eye socket on the darker side of the face, the corner of the nostril, the underside of the earlobe, the hard line of the jaw, and the line of the chin. The brush scribbles more shadows into the hair that falls over the forehead, over the ear, and behind the neck. Picking up some pale color, the tip of the brush suggests some bright strands of hair that stand out against the darkness. A few rapid strokes indicate the pale color of the blouse and the dark shadow within the collar. The entire sketch is painted with tube color diluted with turpentine to a fluid consistency for rapid brushwork. Such a sketch is often used as a preliminary study for a more finished painting. But the oil sketch has a free, spontaneous quality which is satisfying in itself—and is often just as enjoyable as a more polished painting that takes many more hours of work.

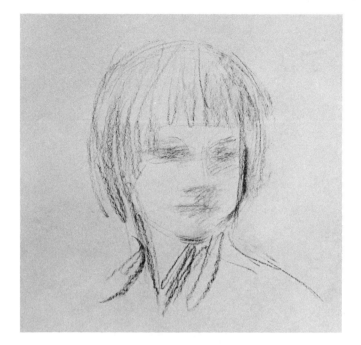

Step 1. The blunt end of a stick of chalk makes a soft, rough stroke. This chalk drawing is made on a sheet of gray paper. The oval shape of the head is drawn first. Then the tip of the chalk is lightly scribbled back and forth to create ragged patches of tone for the features.

Step 2. Still working with free, scribbly strokes, the chalk surrounds the head with hair and indicates the collar and the shoulders. Moving lightly over the face the chalk adds more tone with delicate, parallel lines. Now the eye sockets, the underside of the nose, and the mouth are darker. There's also a suggestion of tone on the shadow side of the face.

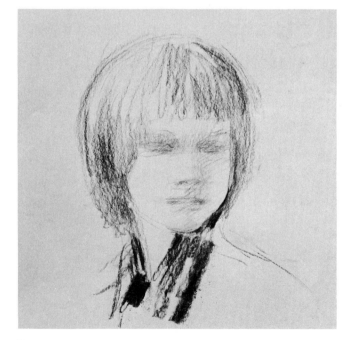

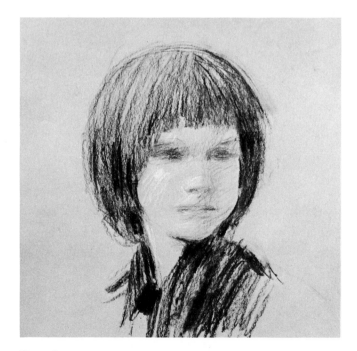

Step 3. The chalk is pressed harder to darken the hair and the collar. A sharp corner of the stick pulls a dark line around the contour of the jaw and chin. Delicate lines begin to define the contours of the eyebrows, the eyes, the nostrils, and the lips. More shadow is added to the eye-sockets.

Step 4. The chalk is pressed down hard to darken the hair and the blouse as well pick out some individual strands of hair. The darks of the eyes begin to appear, while the nose and the lines of the mouth are more sharply defined. A stick of white chalk adds some strokes to the lighter side of the face and the nose.

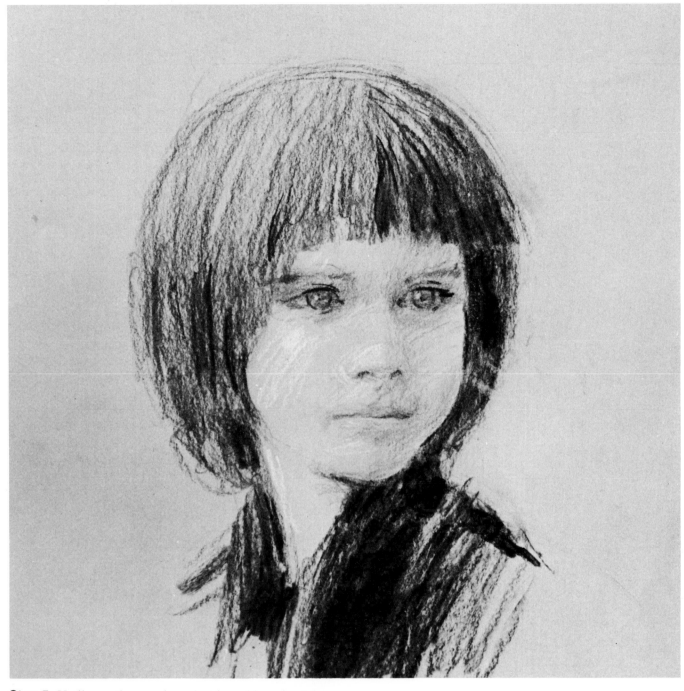

Step 5. Until now the eyes have just been blurred patches of tone. Now a sharp corner of the tip of the chalk draws the precise lines of the eyelids and the iris as well as darkening the softer lines of the eyebrows. The nostrils and the lines between the lips are drawn more precisely. The collar is darkened even more, and this darkness is carried up alongside the cheek to make that round contour more prominent. The sharp corner of the chalk picks out some individual strands of hair at the center of the forehead. More strokes of white chalk are added to the lighted side of the neck, the lighted cheeks, the tip of the nose, the upper lip, and the chin. The drawing is still rather pale. The artist is building up his tone and his details very slowly.

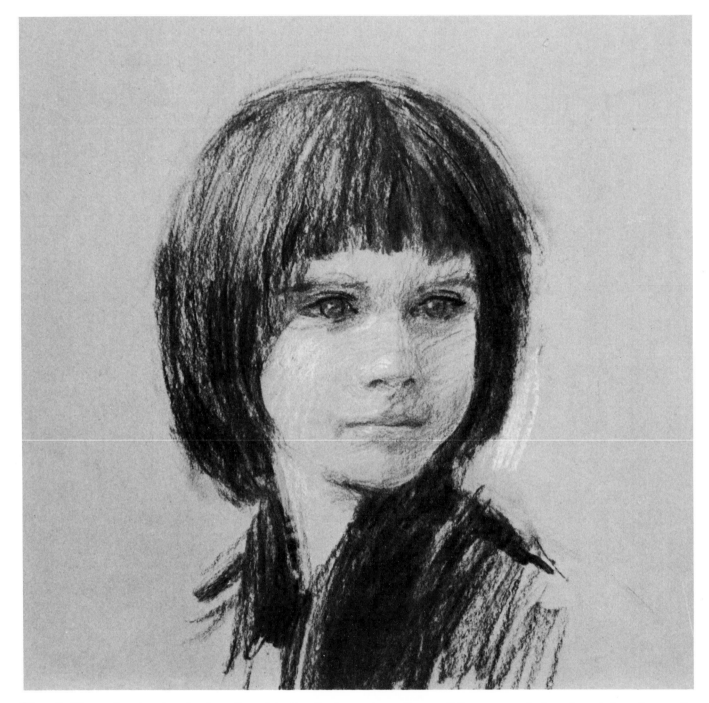

Step 6. The entire drawing is strengthened in the final stages. The chalk is pressed down hard to produce the thick, dark strokes that complete the hair. Notice that the strokes all follow the downward curve of the hair, growing darker toward the bottom where the hair is in shadow. The blouse is darkened too, so now the entire head is framed in darkness. Moving more lightly over the face the chalk works back and forth to deposit small strokes that gradually build up and darken the shadow side of the face, the eye sockets, the tone between the eyes, the underside of the nose, the upper and lower lips, and the chin. The upper lip—which is usually in shadow—is darkened and so is the shadow beneath the lower lip. The corner of the mouth is darkened. The lines of the eyelids are darkened with firm strokes. The inner forms of the eye are darkened, and then the pupils (which first appeared in Step 5) are strengthened. The white chalk adds a few more strokes to the lighted side of the face and to the neck. Then the sharp corner of the white chalk adds a single highlight to each eye, a touch of light to the corner of the eye socket on the lighted side of the face, the highlight alongside the tip of the nose, and a touch of light to the lower lip. Looking at the finished drawing, you can see that most of the work is done with the black chalk. The white chalk is used very selectively—to heighten the lighted side of the face and to add highlights. After you've tried black and white chalks on gray paper, you may enjoy trying dark brown and white chalks on tan paper.

PART THREE

FIGURES IN OIL

Figure Painting in Oil. For thousands of years, artists have painted and sculpted the nude female figure with unending fascination. Famous nudes have been painted of goddesses, wives, lovers, friends, and professional models. Whoever the model might be, the artist regards the nude figure as something sacred—the nude is the vehicle through which artists express their ideal of beauty. Thus, it's not surprising that men and women are equally hypnotized by the great nudes in the world's museums. Nor is it surprising that many of the finest nudes of this century have been painted by women.

Learning About the Figure. In the next few pages, you'll study a series of step-by-step demonstrations in which George Passantino, a noted American painter who's a master of the figure, shows you how to paint the basic forms of the body. First, Passantino shows you the steps in painting a woman's head, beginning with the preliminary brush drawing, continuing through the gradual buildup of the lights and shadows, and concluding with the final details of the head. Then Passantino goes on to paint three views of the torso, step-by-step, showing you how to visualize the torso from the front view, then from a 3/4 view, and finally from the back. And he concludes by demonstrating the steps in painting the arm and the leg. These demonstrations are all in black-and-white oil paint: the artist simply blends black and white paint on his palette to produce a variety of grays. Before beginning to work in color, it's worthwhile to try this yourself. Paint a series of figure studies in black-and-white to learn how the shapes of the figure are revealed by the play of light and shadow over the form. This is very much like "drawing" in oil paint as preliminary practice for working in color.

Color Demonstrations. Next, George Passantino paints a series of ten nudes in color, exploring ten different poses and views of the female figure. You'll also find a variety of indoor and outdoor lighting effects and various combinations of skin and hair colors. The first demonstration is the easiest: a front view of a seated figure in subdued indoor lighting, with a very simple pattern of lights and shadows. This is then followed by a 3/4 view of a standing figure outdoors in bright sunlight; a back view of a seated figure indoors; a side view of a reclining figure in soft, diffused outdoor light; a front view of a standing figure in warm, soft, atmospheric indoor light; a 3/4 view of a seated figure indoors; a back view of a standing figure in a landscape setting; a front view of a reclining figure indoors, with most of the form in shadow; a kneeling figure indoors, with natural light coming through a window and creating strong contrasts of light and shadow; and finally a back view of a reclining figure indoors. Hair colors range from blond to brown to black, while skin tones run the full gamut from pale pink to olive. You'll find detailed instructions for mixing all these different hues—and you'll see how these colors are influenced by both natural and artificial lights.

Proportions, Lighting, Drawing. In painting the nude, it's particularly important to master the proportions of an "ideal" female figure. Even though models will vary considerably in their proportions, these "ideal" proportions are helpful guidelines. So the color demonstrations are followed by a series of oil sketches that analyze the proportions of a standing female figure seen from the front, from the side, from a 3/4 view, and finally from the back. Then you'll find oil sketches of different kinds of lighting that are particularly effective in figure painting. Since figure drawing is essential practice for figure painting—and a great pleasure in itself—Passantino demonstrates how to draw the figure in pencil, charcoal, and chalk. Then he concludes with a demonstration that shows you how to make a black-and-white oil sketch as an end in itself *or* as a study for an oil painting.

Finding Models. As most artists and art students have discovered, people aren't nearly as shy as they used to be. Wives, girl friends, and acquaintances are accustomed to today's revealing beachwear and resort fashions, so they're often flattered by an invitation to pose for a painting. If you prefer to paint a professional model, check your nearest art school, college, or university to see whether they've got a so-called *life class* which you can join. It's common for a school to hire a professional model and provide a studio in which a group of students or serious amateurs can paint for several hours, merely paying a modest admission fee. You can also form your own life class with five or six friends, working in someone's home and sharing the cost of the model among you. To find a professional model for your own life class, you might call your local art school, college, or university to find out where they get their models. Professional artists often find excellent models by contacting dance or drama schools, whose students are willing to model part time in order to finance their professional training for the theater. The important thing is to work from the living figure—not from photographs—and to paint and draw as often as you can. If you join a life class—or form your own—make a habit of going at least once a week. When you go to the beach, take your sketchpad! Never miss an opportunity to draw that miraculous creation, the human figure.

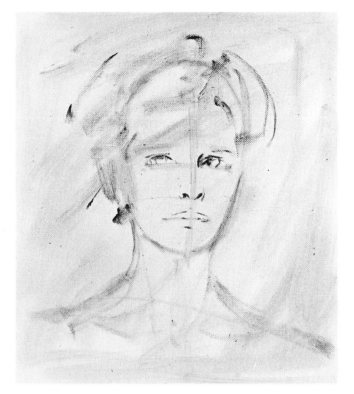

Step 1. A round, softhair brush draws the contours of the head, hair, neck, and shoulders. After placing a vertical center line through the head, the brush draws horizontal guidelines to locate the features.

Step 2. Working with slightly darker color, the brush draws the shapes of the eyes, nose, and mouth.

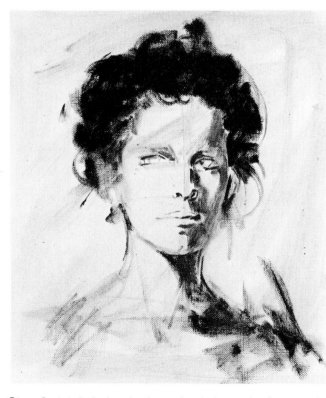

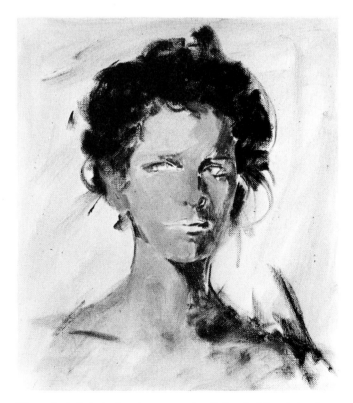

Step 3. A bristle brush places the darks on the face, neck, and shoulder, indicates the darks within the features, and covers the mass of hair.

Step 4. A bristle brush covers the lighted side of the face and the lighted sides of the features with a pale tone. This tone is carried downward over the lighted areas of the neck and shoulder.

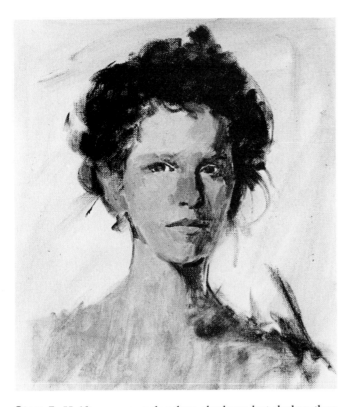

Step 5. Halftones are paler than shadows but darker than the light areas. Now these halftones are placed in the eye sockets, on the nose, and where the lights and shadows meet on the forehead, cheek, and chin.

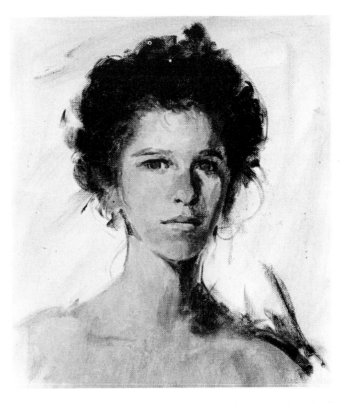

Step 6. The lights, halftones, and shadows are brushed softly together. Now the tones are smoother and more continuous. A small brush darkens the shadows and sharpens the lines of the eyes, nose, and mouth.

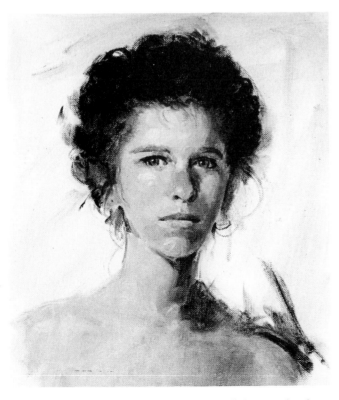

Step 7. A bristle brush strengthens the lights on the forehead, cheek, nose, lips, chin, neck, and chest. These touches of light are blended into the surrounding tones. A small brush begins the details of the eyes.

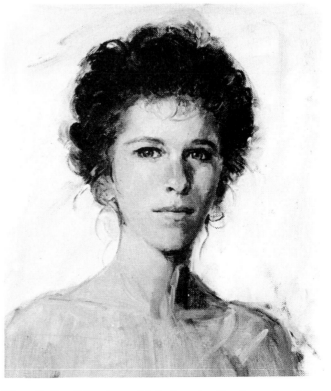

Step 8. Small brushes add the last details: the curls of the hair; the dark lines of the upper eyelids; the contours of the mouth and the dark corners of the lips.

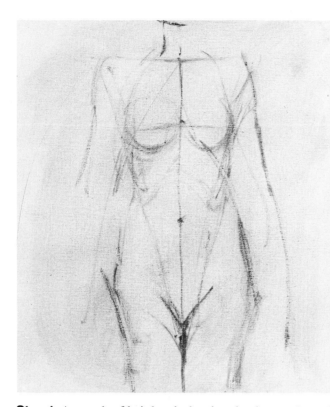

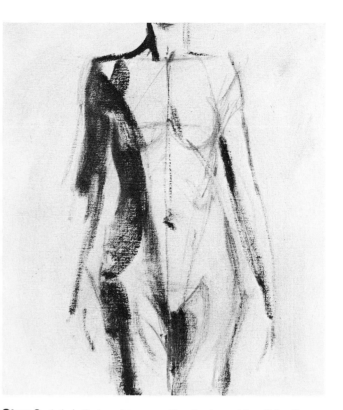

Step 1. A round softhair brush sketches the shapes. A vertical center line aids symmetry; horizontal lines locate the shoulders and the centers of the breasts; diagonals show the alignment of the shoulders, waist, and crotch.

Step 2. A bristle brush covers the shadow side of the figure with broad strokes of dark color. These darks appear not only on the outer edge of the torso, but on such smaller forms as the breast and abdomen.

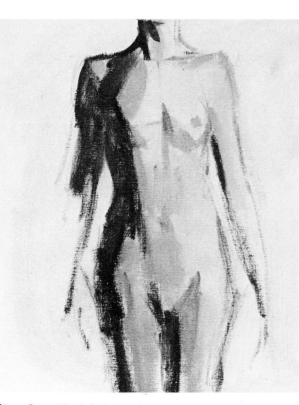

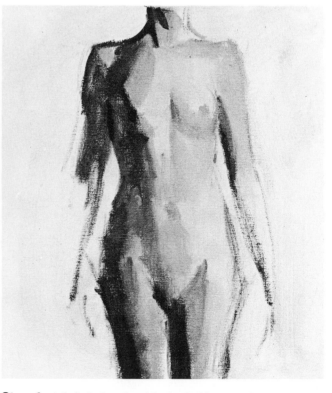

Step 3. A big bristle brush covers the lighted areas of the torso with pale color, obliterating the guidelines that still remain visible in Step 2.

Step 4. A bristle brush adds the halftones where the light and shadow meet. These are most visible in the areas of the waist, hip, and thigh. A halftone is carried down the side of the abdomen.

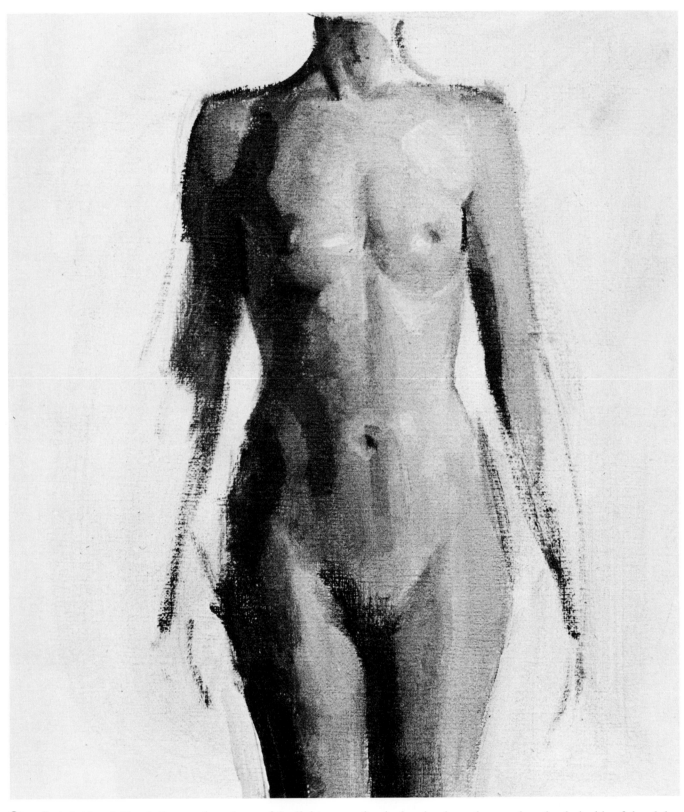

Step 5. A flat brush blends the meeting places of the lights, halftones, and shadows on the dark side of the figure. The shadows are darkened and blended to produce a smoother tone. The lighted areas are strengthened on the chest, breasts, ribs, and abdomen—and these pale strokes are blended softly into the surrounding skin tone. Notice how the shadow has been deepened on the dark side of the abdomen. A small brush places the last touches, darkening the nipples, the division between the breasts, the navel, and the valley that runs down the center of the torso, and adding highlights to the breasts, rib area, and navel.

Step 1. A round brush draws the contours. As the figure turns, the vertical center line follows the convex curve of the body. Other curving guidelines visualize the upper and lower torso as egg shapes.

Step 2. A big bristle brush covers the shadow side of the torso with a single mass of dark color, repeating this tone on the shadow sides of the neck, shoulder, and arm.

Step 3. A large bristle brush covers the lighted front of the torso with a pale tone. Then the brush blocks in the half-tones that fall between the light and shadow areas.

Step 4. A flat brush begins to blend the lights, halftones, and shadows into smoother, more continuous tones. Now the figure looks softer and rounder.

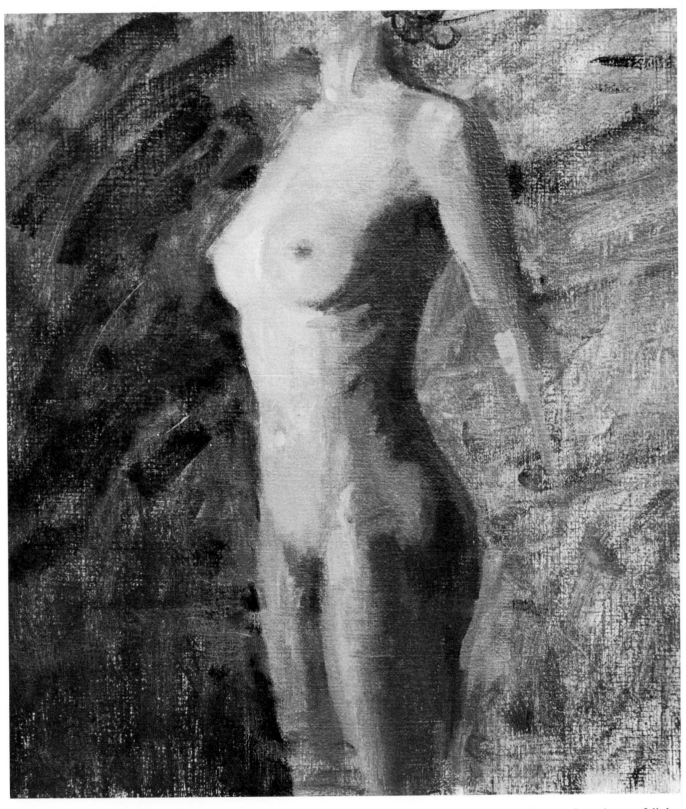

Step 5. A flat brush strengthens the lighted areas on the chest, breasts, rib cage, abdomen, and thighs. To accentuate the lighted planes of the figure, the background is darkened at the left. The shadow side of the figure is also strengthened; note that the background is paler on this side. The brush continues to blend the meeting places of light, shadow, and halftone; compare the thighs in Step 4 and Step 5 to see how this blending makes the forms look rounder and more lifelike. A small brush adds such finishing touches as the nipples and ribs.

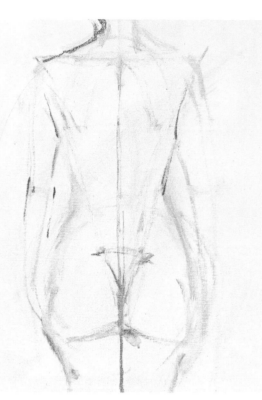

Step 1. The contours of the figure are drawn with the tip of a round softhair brush. A vertical center line aids symmetry, while other guidelines emphasize the diamond shape of the back.

Step 2. A big flat brush covers the shadow side of the figure with broad strokes. Darks also appear on the shoulder blade, in the valley of the spine, and between the buttocks.

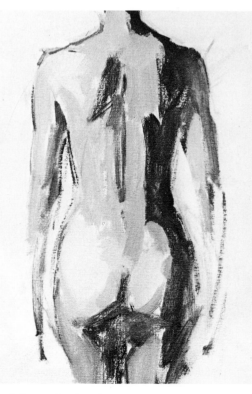

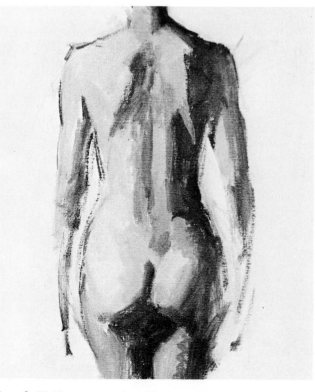

Step 3. A large flat brush covers the lighted areas of the torso. The buttocks are palest because they project outward into the light.

Step 4. Halftones are placed between the lights and shadows. You can see these most clearly on the lower back and the buttocks. The brush begins to blend the lights, halftones, and shadows.

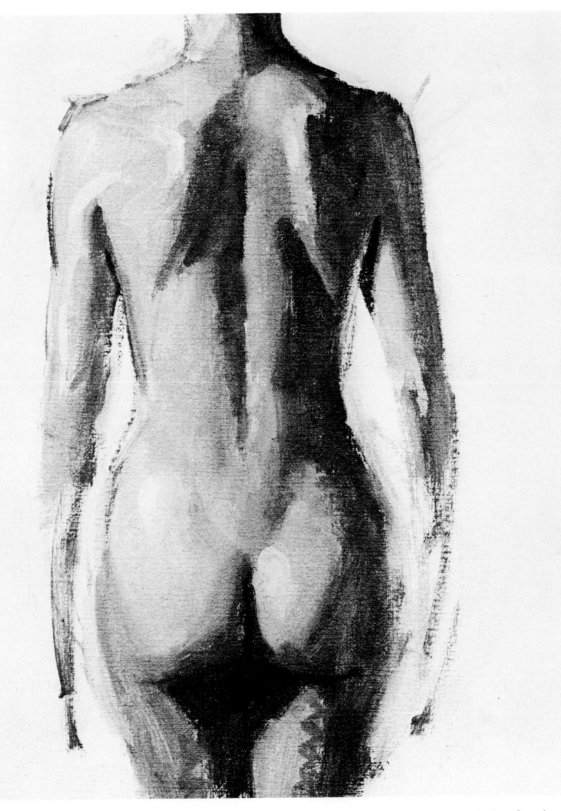

Step 5. A flat brush blends the lights, halftones, and shadows, which now fuse into smooth, continuous tones. The lights are built up selectively on the shoulder blades and the buttocks. The darks are also strengthened—particularly on the shoulder blades, in the valley of the spine, and beneath the buttocks. A small round brush adds the last few details such as the dark line of the spine between the shoulder blades, the shadow lines in the armpits, and the dark line between the buttocks.

Step 1. The tip of the round brush draws the shapes of the upper arm, the forearm, and the hand. A diagonal guideline indicates the meeting place of the upper arm and the forearm, where a shadow will begin. A second, smaller guideline indicates the end of that shadow on the wrist.

Step 2. A small bristle brush carries a dark line of shadow along the undersides of the upper arm and the forearm. A bigger bristle brush blocks in the light and halftone on the upper arm, the shadow on the side of the forearm, and the lighted areas of the hand.

Step 3. The tip of a round brush defines the lighted edge of the forearm and then indicates the intricate pattern of lights, halftones, and shadows on the hand. A flat brush darkens the shadow on the forearm and then adds some pale strokes to suggest reflected light within the shadow. A flat brush begins to blend the lights, halftones, and shadows on the upper arm.

Step 4. A flat brush darkens the underside of the upper arm and then begins to blend the shadowy underside of the forearm. The round brush continues to define the shapes of the hand, brightening the lighted tops of the forms and darkening the shadowy undersides.

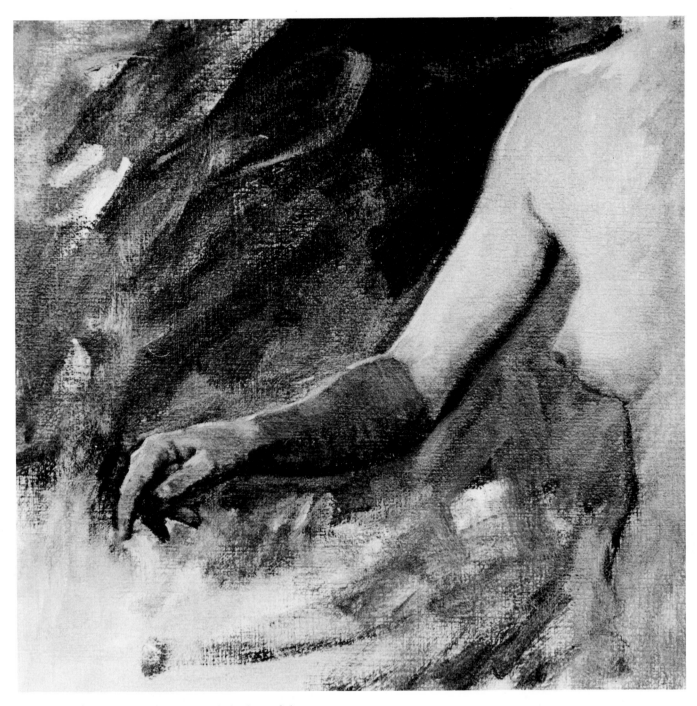

Step 5. Now the light, halftone, and shadow of the upper arm are smoothly blended, although you can actually see each tone quite distinctly. The lighted edge of the forearm is now a single bright line. The shadow side of the forearm is really like a very dark halftone curving around to a line of deep shadow on the underside. The round brush carefully paints the zones of light, halftone, and shadow on the upper half of the hand, the forefinger, and the thumb. The other fingers turn downward and are in shadow. When you paint the arm, it's important to remember that you're not dealing with a single, continuous form, but with a series of forms: the upper arm, the forearm, the upper half of the hand, and finally the fingers. Because each of these forms may move in a different direction, each will have its own specific pattern of light, halftone, and shadow.

Step 1. A round brush draws the contours of the upper and lower legs and the feet. The feet are drawn as simple shapes—the details of the toes are ignored.

Step 2. A large bristle brush paints the shadow sides of the forms in broad, flat tones. A few strokes of dark background are added. These dark strokes make it easier to visualize just how dark to make the shadow sides of the forms.

Step 3. The lighted planes of the lower legs are painted in flat tones. The background is also covered with tone to make it easier to visualize the correct distribution of tones on the legs. A few strokes darken the calf of the near leg.

Step 4. A flat brush begins to blend the light and dark areas of the legs. In the process of brushing the lights and darks together, halftones emerge. (This is another way of creating halftones.) A small brush begins to sharpen the forms of the feet and strengthen the darks.

Step 5. The light comes from the upper left, illuminating the knees and the frontal planes of the lower legs that turn upward toward the light. The shadow areas of the legs, however, are not a uniform dark tone; they seem to be picking up light from a secondary source. Thus, there's a subtle gradation from dark to light within the shadows themselves. The calves are dark just below the knees, growing lighter as they approach the ankles, then darkening again at the ankles and feet. There are no "rules" governing the distribution of lights, halftones, and shadows. You've just got to look carefully and then paint what you see. In this final stage a flat brush makes these subtle adjustments in the tones, adding touches of light and dark, and blending the tones to make the forms look smooth and round. The tip of a round brush finishes the job by sharpening the lines of the feet, adding a few strokes to suggest toes, and placing a shadow where one foot touches the ground.

Drawing the Nude. For centuries, drawing the nude—or *life drawing*, as it's called—has been a basic requirement in art schools. The figure is certainly the most complex of all painting subjects and demands years of study. Professionals agree that the best way to master the figure is to draw the nude as often as you can. This takes discipline, but it's a delightful discipline. Life classes are enormously popular—not only as a means of studying the figure, but for the pure pleasure of drawing the human body. So contact your nearest art school, college, university, or adult education center to enroll in a life class. You'll often find that there are two different kinds of life classes: a class with an instructor, or a sketch group that has no instructor, but simply a monitor who supervises the model. If you're a beginner, it's best to enroll in a class that has an instructor who coaches you as you learn to draw. Later on, when you've more experience, you can join an unsupervised life class for practice and for the pleasure of drawing. If you have time, you can join both.

Quick Studies. Most life classes begin with a series of short poses—one minute, two minutes, five minutes—as a kind of warm-up. You draw as swiftly as you can, doing your best to capture the shapes, the proportions, and the pose with rapid strokes. Try different kinds of quick studies. With a sharp pencil point, simply trace the contours of the figure with thin, wiry lines, paying no attention to the shadows; "contour drawing" will strengthen your feeling for the shapes of the figure. Then switch to a blunt, tonal drawing tool like a stick of charcoal or chalk, a charcoal pencil, or a Conté crayon. Working with broad, rapid strokes, concentrate on the shapes of the shadows. These studies will strengthen your feeling for the three-dimensional form. Using these same broad drawing tools—in contrast with the sharp pencil—make some quick studies with scribbly lines that emphasize the action of the figure. The purpose of all these quick studies is to force you to visualize the figure as rapidly and as simply as possible, paying attention to the biggest forms, the shapes of the lights and shadows, and the action, without worrying too much about detail.

Prolonged Studies. After this series of quick studies, the life class usually switches to longer poses that encourage slower, more careful drawing. The model is apt to hold the same pose for fifteen or twenty minutes, perhaps half an hour. Sometimes the model holds the same pose for the rest of the class session—with a five- or ten-minute break every half hour, allowing both the model and the students to relax. These slow, careful drawings are most often done in charcoal or chalk, which handle somewhat like oil

paint in the sense that you can gradually build up and blend shadows and halftones. The long poses give you a chance to draw and then *redraw* the contours until you get them exactly right. You also have time to develop your tones very gradually and with maximum precision. Charcoal is the most convenient drawing medium for these long studies because corrections are easy to make with a kneaded rubber (putty rubber) eraser; a chamois cloth or any soft cloth; or even a cleansing tissue.

Running Your Own Life Class. If you're lucky enough to have your own model—or if you join with a group of friends to organize your own life class—here are a few suggestions about how to run things. Natural light is always best. If you have a big window or a skylight, place the model where the light will strike her from one side and from slightly in front, producing what's known as 3/4 lighting. This kind of lighting produces the most clearly defined planes of light and shadow: one side of the figure, as well as the front of the figure, will be in the light, while the opposite side of the figure is in shadow. This is often called "form lighting" because it's easiest to see the three-dimensional shapes. It's harder to see the forms if the light comes from directly above, behind, or in front. If you don't have enough natural light, but must depend upon artificial light, place the lighting fixtures where they'll give you the best 3/4 light. Avoid spotlights and photographic floodlights. They exaggerate the contrast between the lights and darks on the figure, producing black murky shadows. Try to find lighting fixtures that will give you a soft, diffused light that looks more like natural light. If possible, paint the room white or very pale gray; the walls will serve as a reflecting surface and fill the room with a soft, diffused light that flatters the model and makes drawing more enjoyable. If you start with a series of short poses, requiring the model to change position frequently, remember that these poses can be tiring; give her a five-minute rest period every fifteen minutes. When you switch to longer poses, she can probably hold a simple, standing pose for twenty minutes before you give her a rest. She can probably hold a reclining pose for twenty minutes or even half an hour. Discuss the sequence and the length of the poses with the model before the class begins so that she knows what to expect and can tell you how long she thinks she can hold a particular pose. The model's comfort is important: keep the studio warm enough; give her a private room somewhere where she can change her clothes in privacy; and encourage her to tell you if a particular pose turns out to be a problem. Halfway through the class, it's traditional to take a coffee or tea break. Be sure to invite the model to join you.

Step 1. A seated pose is easy for the model to hold, and a front view is easy to paint—so this is a good subject for your first figure painting. A rag tones the canvas with ultramarine blue, burnt umber, and turpentine. More burnt umber is blended into this mixture for the preliminary brush drawing, which is executed with a round softhair brush. The purpose of the brush drawing is to define the shapes of the figure with a few simple lines. A rag wipes away the lighted areas of the torso, and then a bristle brush indicates the shadow tones on the face and chest, under the arms, on one side of the torso, and on the abdomen. A darker tone is scrubbed over the hair. Notice the horizontal guideline that aids the artist in aligning the shoulders. Within the face a dark, horizontal stroke suggests the placement of the shadowy eye sockets.

Step 2. The shape of the hair is more sharply defined with dark strokes. Then the brush moves downward to darken the eye sockets and sharpen the curve of the chin by placing a shadow beneath. The shapes of the arms are more carefully defined with slender strokes. A rag wipes away unnecessary strokes within the torso and thighs. Then the tip of the round brush strengthens the outer contours of the torso, shapes the breasts, and places the nipples and navel. The shadows on the torso are darkened with a flat brush. More strokes darken the background, and the sketch is completed.

Step 3. A bristle brush blocks in the shadows with rough strokes of raw sienna, Venetian red, a little ultramarine blue, and white. This tone is carried up over the face. It's important to work on the background as the figure progresses, so a big bristle brush places some background color in the upper left—a mixture of ultramarine blue, burnt umber, a touch of Venetian red, and white. The paler background on the shadow side of the figure is suggested with white tinted with the darker background mixture. The warm tone of the cushion is suggested with a few strokes of ultramarine blue, alizarin crimson, and white. From this point on, all mixtures are diluted with painting medium.

Step 4. A big bristle brush blocks in the lighted areas of the figure with the same mixture—raw sienna, Venetian red, ultramarine blue, and much more white. Then an extra speck of ultramarine blue is added to the mixture to paint the halftones that appear under the breasts and on one side of the ribs. A paler, brighter version of the background color—burnt umber with more ultramarine blue and white—is brushed between the figure and the back of the chair.

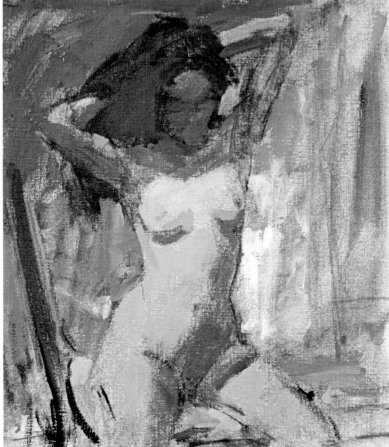

Step 5. The shadows beneath the arms are completed with the same shadow mixture used in Step 3. Then a large bristle brush completes the job of blocking in the halftones with a mixture of burnt umber, Venetian red, ultramarine blue, and white. Working downward from the top of the figure, the brush places the halftones next to the shadows on the arms, chest, breasts, midriff, abdomen, and thighs. Then the shadows are darkened with the same mixture strengthened with a bit more burnt umber and ultramarine blue. You can now see distinct masses of light, halftone, and shadow on the torso.

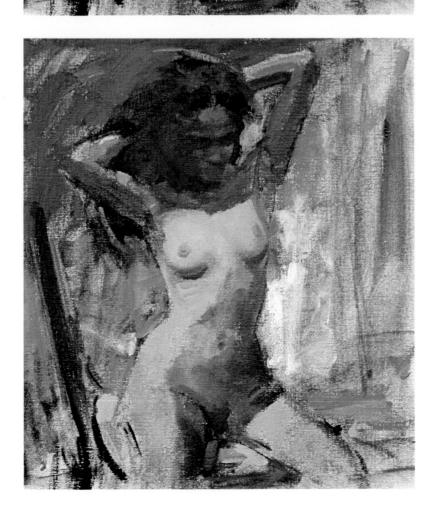

Step 6. Although the face is in shadow, there are still subdued patches of light, which a small bristle brush defines with burnt umber, Venetian red, ultramarine blue, and white. The same mixture with less white is used to paint the dark notes of the features. The light areas of the hair are suggested with a few strokes of the background mixture, which is the same combination of ultramarine blue, burnt umber, Venetian red, and white, but with more ultramarine blue. Then a flat brush begins to blend the lights, halftones, and shadows on the breasts, adding a touch of shadow beneath. For the color of the nipples the slightest touch of cadmium red is added to the halftone mixture.

Step 7. Continuing to work downward, a flat brush begins to blend the lights, halftones, and shadows on the midriff, abdomen, hips, and thighs. The lines of the original brush drawing have almost completely disappeared by now. Notice how the shadow on the abdomen flows over the outstretched thigh in one continuous tone. The background tone is carried down to the bottom of the picture on the left, where the corner is warmed with an extra touch of burnt umber. This warm tone also modifies the lower corner at the right.

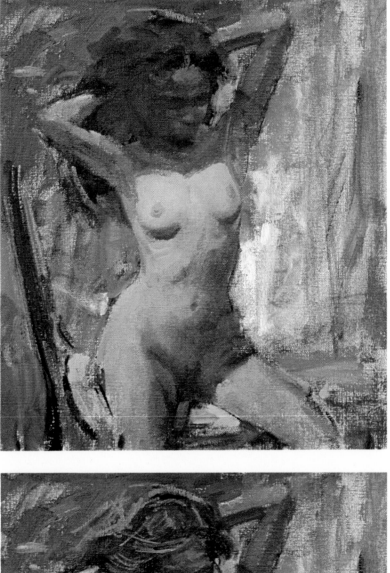

Step 8. A flat brush continues to blend the tones of the lower torso. Then a bit more white is blended into the shadow mixtures to lighten the face, making the cheeks, nose, and chin emerge from the shadow. A faint touch of cadmium red is added to this mixture for the lips. More white is added to the hair mixture, and then a round brush begins to pick out individual locks of hair. More white is added to the flesh mixture to strengthen the lighted areas of the torso and thighs.

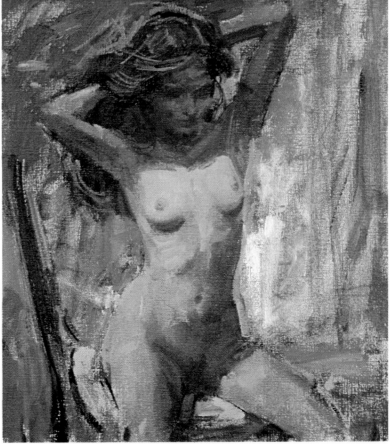

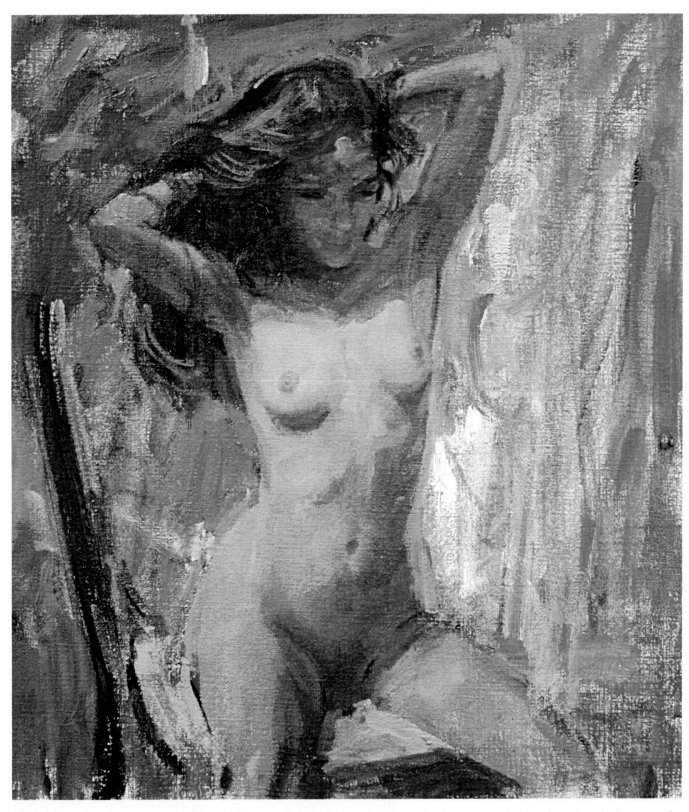

Step 9. A flat brush blends the lights, halftones, and shadows on the arms. The artist continues to build up and blend the lights on the midriff and abdomen. More white is blended into the cool background mixture, which is then carried carefully down the shadow side of the figure to define the curving shapes of the arms and torso more precisely. A few inconspicuous touches of this cool background mixture are blended into the shadows on the torso. A bristle brush blends the lighted area of the hair. Then a round brush picks out a few more locks of hair and uses the hair mixture to darken the eyes. The warm and cool colors of the background are roughly blended at the lower right. The background is completed with some thick strokes of rich, dark color above the head.

Step 1. A large bristle brush tones the canvas with broad, random strokes of raw sienna and turpentine. The tip of a smaller bristle brush draws a few rough lines simply to locate the figure on the canvas. The head is nothing more than an oval with a couple of curving strokes for the hair. The shoulders are located with a single horizontal stroke. The rest of the figure is identified by a few vertical strokes.

Step 2. The artist switches to a round softhair brush to draw the figure more precisely. The tip of the brush follows the oval contours of the face and then locates the features with horizontal lines. The sloping lines of the shoulders are placed above the horizontal guideline. The arms are suggested with quick strokes, and then the shapes of the hips and thighs are drawn with curving strokes. A cloth begins to wipe away the lighted areas on the torso, arms, and lighted thigh. The lower half of the background is darkened to suggest the distant trees.

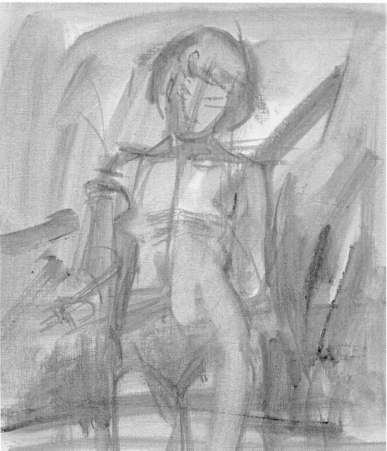

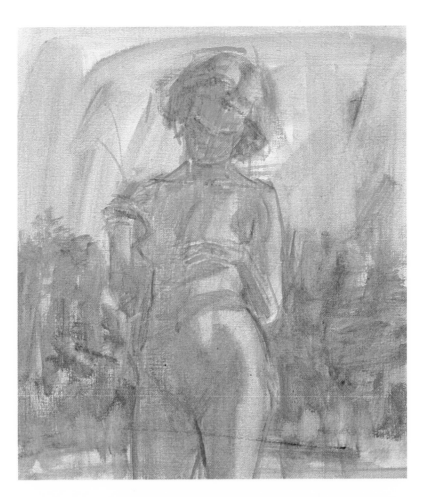

Step 3. As a rag wipes away the excess strokes and lightens the upper background, a round brush sharpens the contours of the figure with slender strokes. A flat softhair brush covers the shadow tones of the figure, while the rag wipes away the lights. Finally, the flat brush scrubs in the dark tone of the trees that cover the lower half of the picture. The entire preliminary brush drawing is executed in a mixture of raw sienna and turpentine.

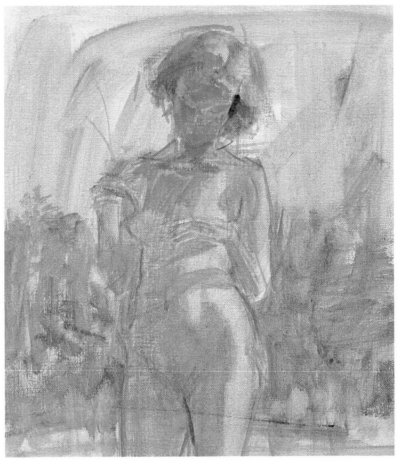

Step 4. A small bristle brush establishes the color scheme of the figure by placing three important tones on the head, chest, and hair. These are all mixtures of Venetian red, raw sienna, raw umber, and white, with lots of painting medium. The ruddy tone on the face and chest contains more Venetian red, while the paler tone contains more white. The hair tone contains more raw umber, particularly in the touch of shadow next to the brow. This mixture will be repeated—with varying proportions of the different colors—throughout the figure. That's why it's valuable to test out the different variations of this mixture on a small area of the painting.

Step 5. Now the mixture of Venetian red, raw sienna, raw umber, and white is carried down the entire shadow side of the face and figure with a big bristle brush. The shadow on the upraised arm, the torso, and the thighs is treated as one continuous mass, growing slightly darker at the bottom, where the mixture contains a bit less white. The same mixture is placed on the arm on the lighted side of the body and is carried upward into the chin. Notice how the arm casts a horizontal band of shadow over the midriff. A bit more burnt sienna and raw umber are added to the mixture for the shadow under one arm and for the dark notes on the face. With more white blended into the basic mixture, a bristle brush begins to block in the lights on one arm and shoulder. Another bristle brush starts to indicate the cool, dark tone of the foliage with viridian, burnt umber, raw sienna, and a little white.

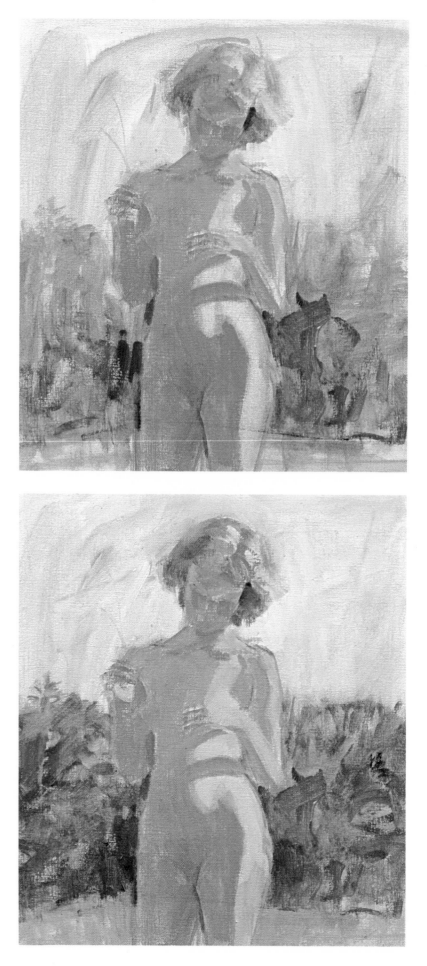

Step 6. The foliage is now covered with broad, rough strokes of viridian, burnt umber, raw sienna, and white. More white is added to this mixture for the strip of grass at the bottom of the picture. The pale sky tone is painted with white tinted with raw umber and raw sienna. Blending lots of white into the basic flesh mixture, a bristle brush completes the job of blocking in the lights on the figure. Adding more white and raw sienna, a small bristle brush indicates the lighted top of the hair. At this stage the entire canvas is covered with color; thus the artist can see how the figure relates to the background.

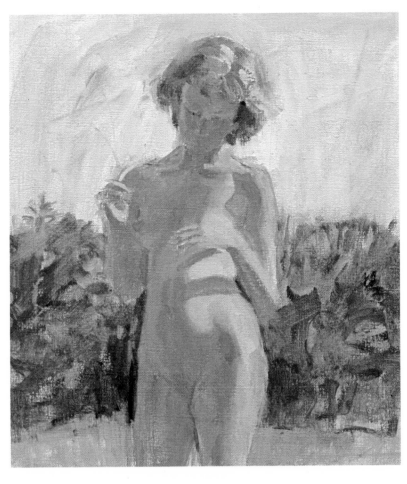

Step 7. Within the broad tone of the shadow area there are distinctly darker patches. With a little more raw umber and Venetian red added to the shadow mixture, a bristle brush places these darks on the face, neck, chest, arms, midriff, abdomen, and thighs. There are also subtle variations in the lighted area. A small bristle brush darkens the lighted forearm and thigh. The tip of a round brush also introduces some patches of light within the face and then paints some pale strokes on the shoulders, which reflect the light of the sky.

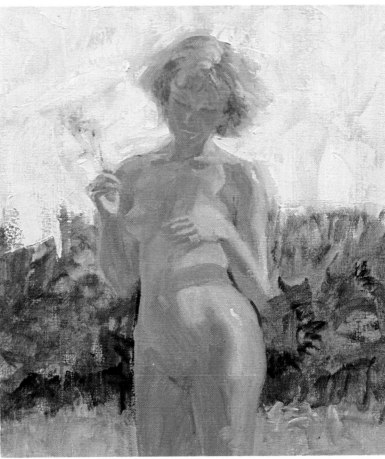

Step 8. A flat brush begins to blend the lighted areas into the shadows to make the forms look softer and rounder. The undersides of the arms, lower abdomen, and thighs are enriched with a darker, warmer version of the original shadow mixture. The upper portion of the figure—the hair, face, shoulders, and chest—becomes slightly paler as a small brush blends in touches of white, raw sienna, raw umber, and cobalt blue to suggest the light of the sky falling on the skin. Then the sky itself is brightened with thick strokes of the same mixture, which is essentially pure white tinted with minute quantities of raw sienna, raw umber, and cobalt blue. Highlights of this mixture are placed on the hair, shoulder, and hips. A bristle brush begins to enrich the foliage with strokes of cobalt blue, viridian, raw umber, and white. The wildflowers in the model's hand are suggested with touches of raw sienna, raw umber, and white.

Step 9. A flat brush continues to blend the light and dark areas of the figure. Within the shadow area of the figure lighter tones are added with a slightly paler version of the original shadow mixture; you can see these modifications most clearly on the breasts and midriff. The cool, dark tone of the foliage is painted with thick strokes of cobalt blue, viridian, raw umber, and white. More white is added to this mixture, and then a few strokes are carried over the grass. The tip of a round brush defines the wildflowers in the model's hand with tiny touches of raw sienna, raw umber, viridian, and white. The sharp end of a brush handle scratches the stem into the wet paint.

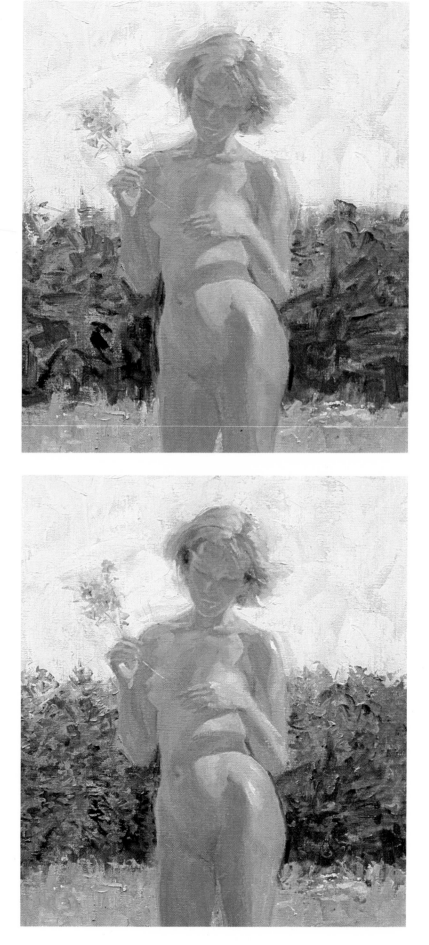

Step 10. A small bristle brush suggests the details of the background foliage with short, quick strokes of cobalt blue, viridian, raw umber, and white—with more cobalt blue and raw umber in the darks and more white in the lighted areas. Touches of cadmium red, alizarin crimson, and white suggest wildflowers among the grass. A small bristle brush adds more white to the pale flesh mixture and builds up the lighted areas on the shoulders, breast, midriff, abdomen, arm, and hips.

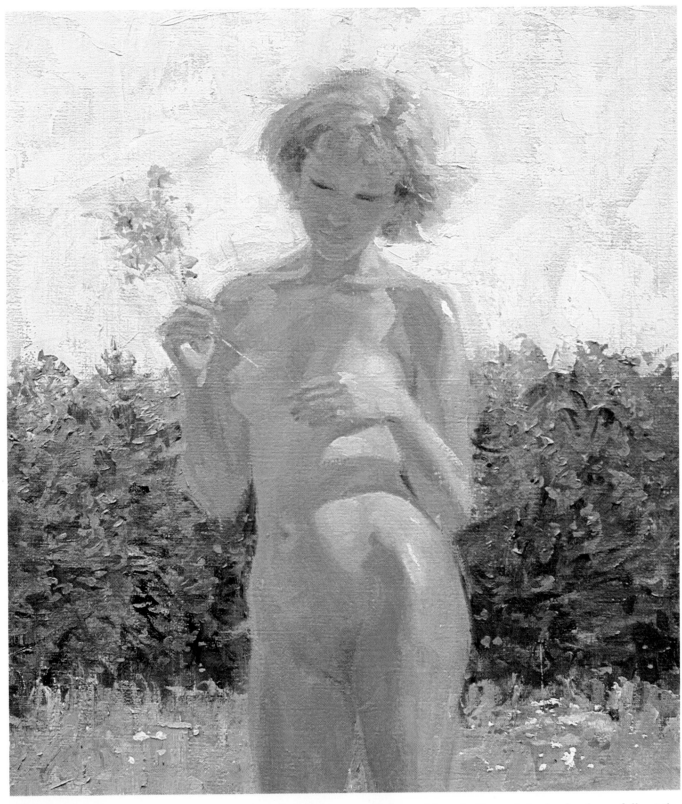

Step 11. The tip of a round brush places touches of sunlight on the foliage with raw sienna, raw umber, and white. A round brush also brightens the hair with a few thick touches of sky mixture. The very tip of a round brush darkens the eyes with delicate strokes of raw umber and blends a hint of cadmium red into the lips and cheeks. Look carefully at the shoulders and the upper torso to see where the warm tone of the skin is enriched with pale touches of cool sky tone. When you paint the figure outdoors, always look for reflections of sky color on the model's skin.

Step 1. The bare canvas is toned with a few broad brush strokes of raw umber, Venetian red, and turpentine. Then a round softhair brush draws the shape of the figure with this same mixture. A horizontal guideline establishes the alignment of the shoulders. A single curving line defines the spine, which also serves as a vertical center line which makes it easier to draw a symmetrical figure. Initially many of the lines are surprisingly straight; later on the contours of the figure will become rounded. A big flat brush covers the hair with a darker mixture of raw umber, Venetian red, and turpentine and then begins to block in the dark tone of the background.

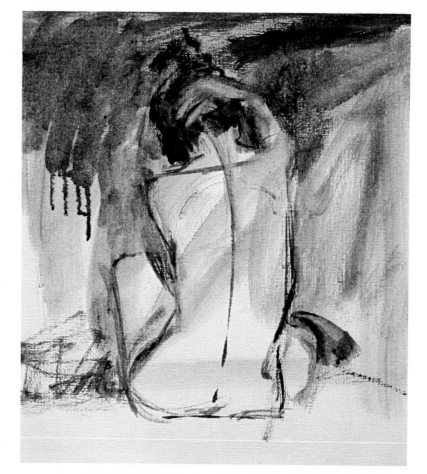

Step 2. A rag lightens the heavy lines that were drawn in Step 1. The tip of the brush redraws these contours more carefully, and then the dark background tone is carried down alongside the figure. The straight guideline for the shoulders is wiped away entirely. The dark strokes of the spine and buttocks are wiped down to pale lines. A flat bristle brush carries a broad plane of shadow down one side of the back, over the hip, and then over the upraised thigh. Paler shadows are also suggested on the dark sides of the thighs, on the arm and neck, and down the spine.

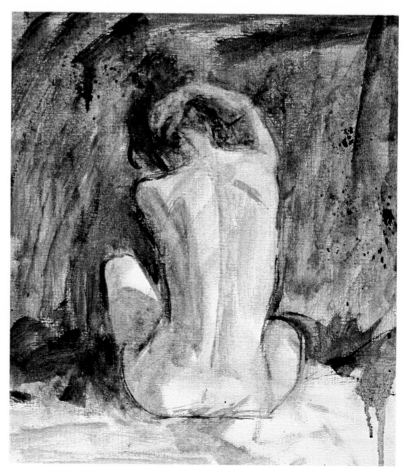

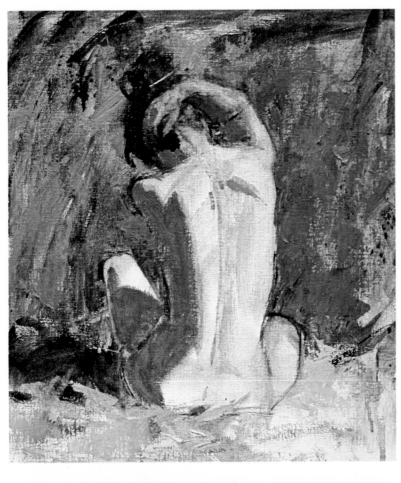

Step 3. A big bristle brush paints the solid tone of the shadow with raw umber, raw sienna, Venetian red, and white. This tone is placed not only on the back, hip, and thigh, but also on the shadow sides of the face, arm, and shoulder blade. The dark tone of the hair is reinforced with burnt umber, ultramarine blue, raw sienna, and a touch of white. The warm tone of the background is cooled with scrubby strokes of cobalt blue, cadmium red, and white—with more white at the left and more blue at the right. A paler version of this mixture suggests the fabric on which the model is seated.

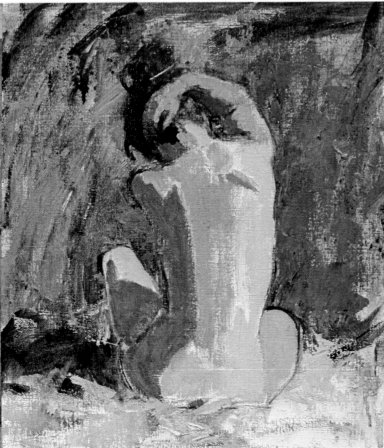

Step 4. A bristle brush covers the lighted side of the figure with a pale blend of raw umber, raw sienna, Venetian red, and plenty of white, making the mixture just a bit darker on the arm and thigh. The same mixture becomes just a bit darker—containing a little more raw umber—as the brush places the big patch of halftone down the center of the back between the light and shadow planes. This same halftone mixture is carried up the neck and along the arm. Most of the arm is now shadow and halftone, with just a small rim of light.

Step 5. A bristle brush carries the halftone further down the back to the base of the spine and then up over the shoulder to the arm. The artist begins to blend the lights, halftones, and shadows where they meet on the back and neck. A little halftone mixture is brushed into the edge of the shadow side of the figure to make the dark tone more luminous and transparent. Further in from the edge the shadow tone is darkened with more raw umber. A dark line reinforces the spine. The lighted patches of hair are painted with touches of burnt umber, raw sienna, and white.

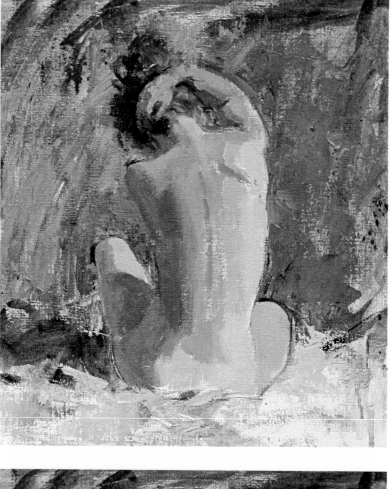

Step 6. A flat softhair brush moves over the entire back and thighs to soften and blend the meeting places of light, halftone, and shadow. Now the forms look smoother and rounder. The brush carefully retraces the curves of the lighted side of the back and then darkens the lighted thigh, which doesn't receive quite as much light as the back.

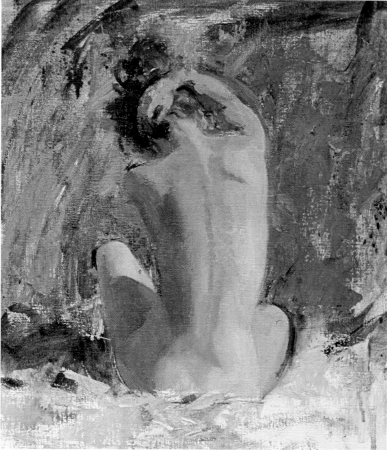

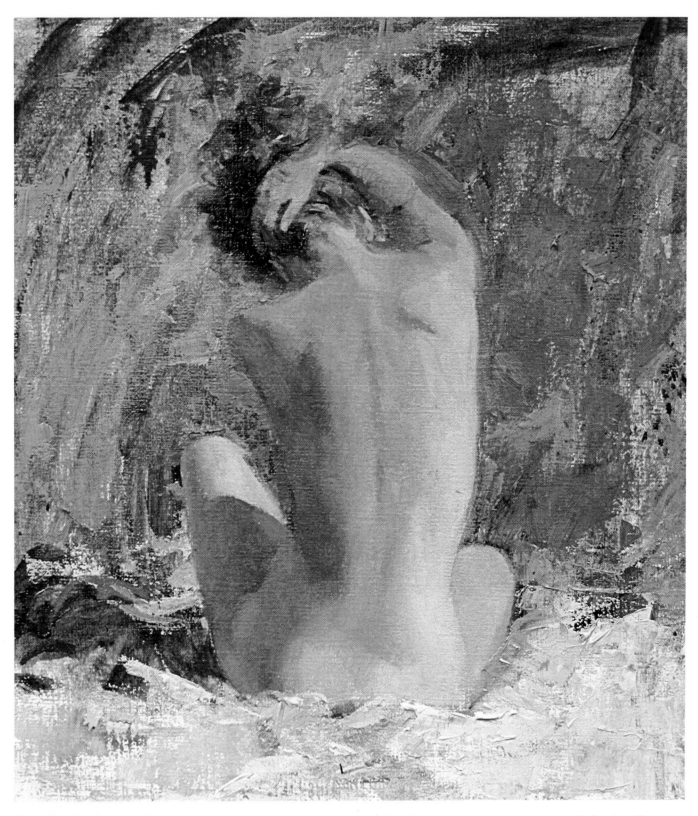

Step 7. A small, flat softhair brush blends the lights, shadows, and halftones on the upraised arm. Then the same brush blends a little more pale color into the lighted side of the figure, which now stands out more boldly against the darker background. The flexible blade of a painting knife places thick strokes of cobalt blue, cadmium red, and white on the foreground to suggest the soft fabric. The cast shadow at the left is the mixture that was originally placed there in Step 2—and left untouched. The red ribbon is a few quick strokes of cadmium red, alizarin crimson, a hint of cobalt blue, and white.

Step 1. A rag tones the canvas with cobalt blue and turpentine. The major lines of the figure are drawn with the tip of a round softhair brush that carries this same mixture. The brush defines the forms with the fewest possible strokes—looking for lines that interconnect. Thus a single diagonal stroke shows the alignment of one forearm with the sloping line of the buttocks. Another stroke shows that the back of the head aligns with the back of the arm. Still another line shows the relationship of the chin to the high point of the buttock. Finding these interlocking lines will not only help you draw the figure more accurately, but it will make the pose look much more harmonious.

Step 2. Moving over the simple shapes established in Step 1, the tip of the brush refines the contours with more precise strokes. A rag wipes away the unnecessary lines. Eventually all these lines will disappear as more paint is applied to the canvas. Notice that a smudge of darkness indicates the shadow that's cast on the ground by the model's body. A few more strokes darken the background.

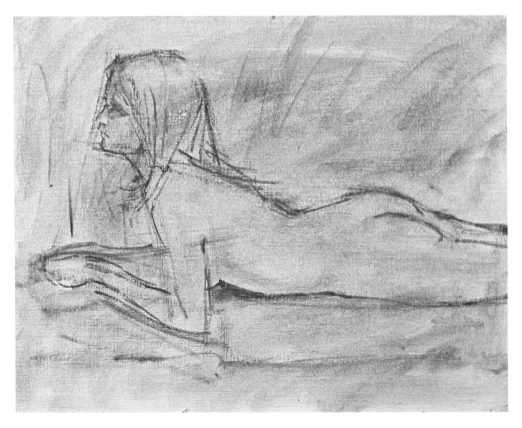

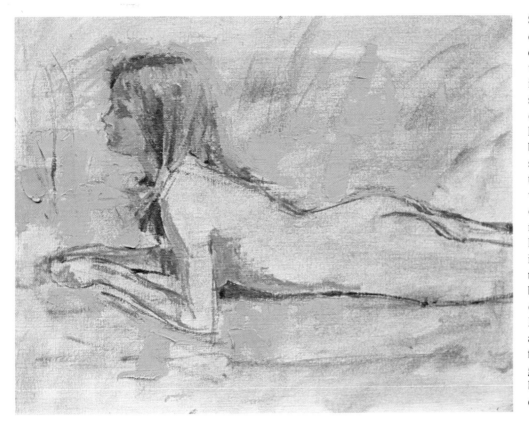

Step 3. The model is posing outdoors on a wet beach. The day is slightly overcast, which means that the sunlight is delicate and diffused. The shadows on the figure are only a bit darker than the lighted areas. The bristle brush indicates the first few shadows on the arms and torso with raw sienna and white, softened with a touch of burnt umber. The same mixture is used to paint the hair—with more burnt umber in the darks and more white in the lighted areas. A small brush paints the shadow areas of the face with this mixture. More white and cadmium red are blended into this mixture for the cheek. A few background strokes are cobalt blue, raw umber, alizarin crimson, and white.

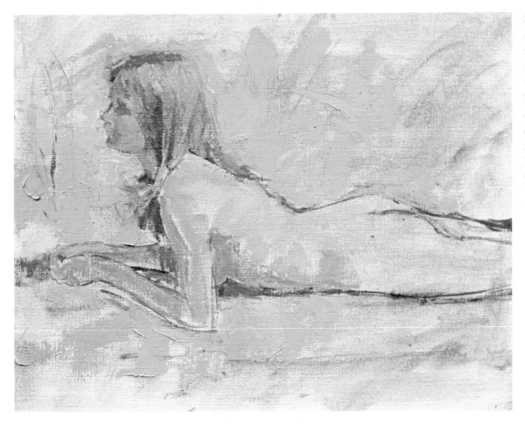

Step 4. A large bristle brush continues to work on the skin tones, covering the arms, shoulders, and upper torso with strokes of raw sienna, burnt umber, and white. Because there's so little difference between the light and shadow areas of the body, the brush works on them both at the same time.

Step 5. A bristle brush moves down the length of the body, covering the skin with subtle variations of the basic flesh mixture of raw sienna, burnt umber, and white. The mixture is darkened with a bit more burnt umber in the region of the hips. The warm tone of the shoulder and the back contains just a speck of cadmium red. The changes in tone are very gradual and delicate, so each brushstroke is carefully placed. A hint of warm flesh tone containing a little cadmium red is blended into the shadow between the arms and beneath the model's midriff.

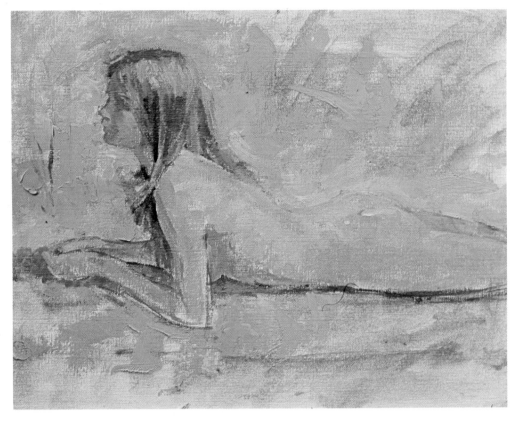

Step 6. Now the brush moves back over the entire figure, gradually adjusting the flesh tones. The arms and the underside of the figure are warmed with a faintly darker blend of raw sienna, burnt umber, cadmium red, and white. More white is blended into this mixture to brighten the paler areas of the back, the buttocks, and the thighs. A hint of cobalt blue is added to the mixture to strengthen the shadows on the face, neck, arms, hips and thighs. More warm color is blended into the thighs. The background and foreground are covered with thick strokes of cobalt blue, raw sienna, alizarin crimson, and white. A darker version of this mixture extends the shadow on the ground.

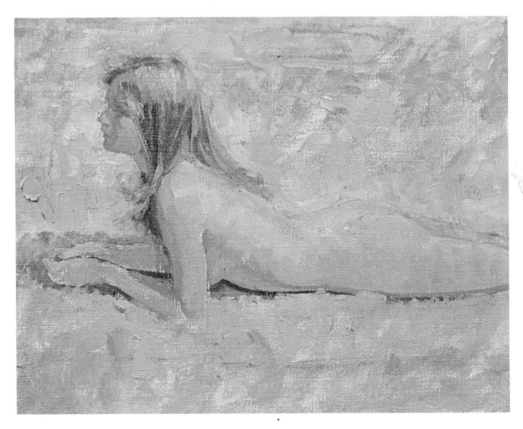

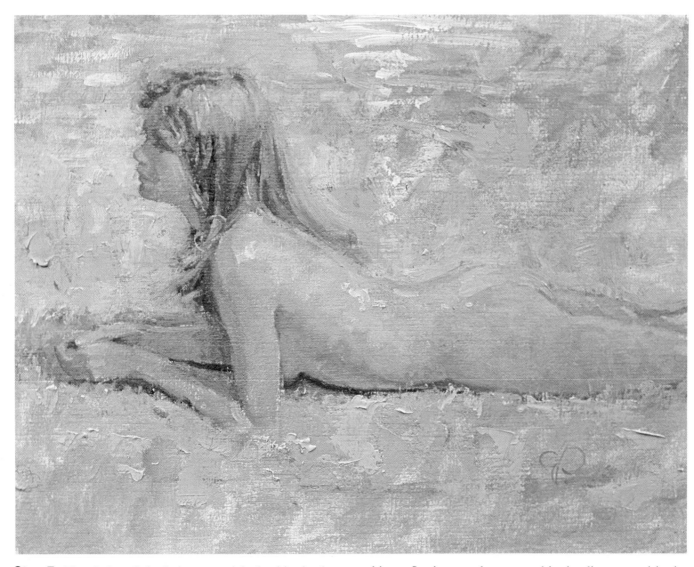

Step 7. The darks of the hair are enriched with slender strokes of burnt umber, raw sienna, a little cobalt blue, and white. More white is added to this mixture, and it's then brushed over the lighted plane of the hair. The tip of a round brush defines the eyes, the underside of the nose, and the chin more precisely with the darker hair mixture. The same tone appears in the tiny touches of shadow within the hands. Adding more white to the pale skin tone, a bristle brush builds up the lights on the back, buttocks, and thighs. Then adding even more white, the brush places highlights on the shoulders, back, and buttocks. A dark line suggests the spine in the upper back and then reappears between the buttocks. A softhair brush blurs the shadow beneath the midriff; now the figure seems to rest more firmly on the ground. Thick white, straight from the tube, is tinted with just a little cobalt blue, alizarin crimson, and raw sienna to paint the shiny reflections on the wet sand in the distance and in the foreground. Notice how the shadow plane of the fingers is completed by painting the fingers as a single mass of tone. Aside from the head there's very little precise detail—except for the bit of ribbon, which is added with slender strokes of cadmium red, alizarin crimson, and white. Observe how the scrubby tone of the foreground is carried upward over the edge of the thigh to anchor the legs more firmly on the sand. In the same way, the point of the elbow is buried in the sand. You may ask whether the color of sand can really be this blue. Remember that water is a reflecting surface that picks up the color of the sky. The next time you walk on a wet beach on a slightly overcast day, look carefully at the wet surface of the sand—you may be surprised to see how much sky color is reflected on the shiny surface beneath your feet.

Step 1. A large bristle brush tones the background with raw sienna, burnt umber, a little cadmium orange, and turpentine. The top half of the canvas is darkened with more burnt umber. A round brush draws the contours of the figure with the same mixture, while a clean rag wipes away the lighted areas. More burnt umber is blended into the mixture to brush on the dark area of the hair. The face isn't wiped clean; some tone is left by the rag because the face is in shadow. The shadow tone is also carried over one shoulder and over the upper arm. The rest of the torso and the thighs are brightly lit—with few shadows—and these few darks are indicated with pale tones.

Step 2. The tip of the round brush carefully draws the shape of the figure with a darker version of the background tone. Features are suggested within the shadowy tone of the face. Small brushstrokes indicate the curly texture of the model's hair. A flat, softhair brush and a rag work together—the brush adding subtle tones to the figure and the rag wiping away the lights. The sketch is completed.

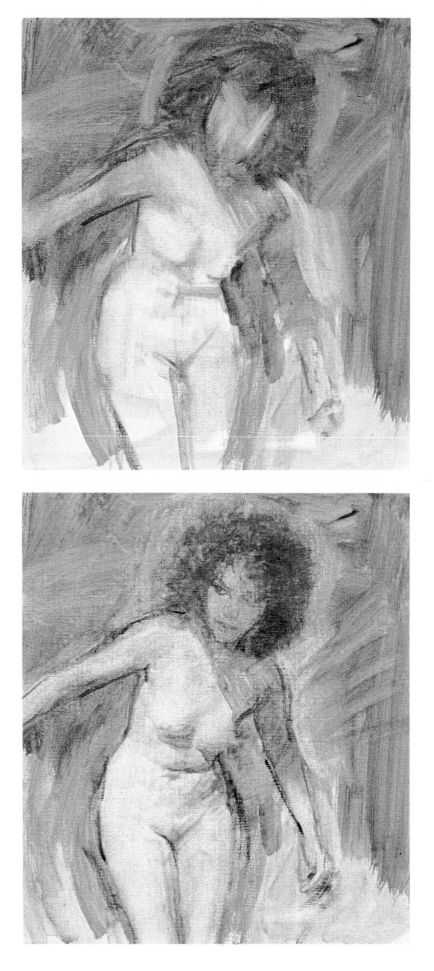

Step 3. The deep shadow on the chest, shoulder, and arm is darkened with burnt umber, raw sienna, cadmium orange, and white. Smaller strokes of this mixture indicate the shadow beneath the opposite arm and the shadow that runs from the midriff to the hips. The same color combination, but with much more white, is brushed over the lighted areas of the figure. Notice that the upraised arm, midriff, and thighs are just slightly darker than the chest and abdomen. A darker version of this flesh tone is brushed over the face. At this point all the work is done with bristle brushes.

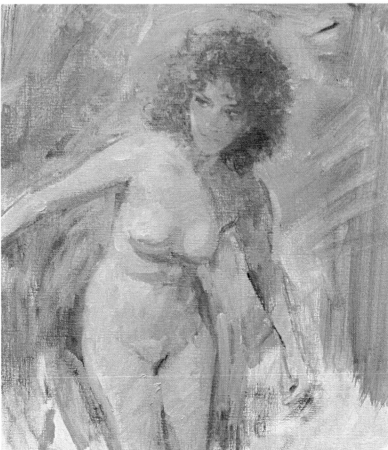

Step 4. There's so little difference between the lights and the halftones that the artist develops both at the same time. Working with a darker version of the pale skin mixture, one brush deepens the tones of the upraised arm, chest, midriff, abdomen, and thigh on the shadow side of the figure. At the same time another bristle brush blends more white into the skin mixture and builds up the lights on the upraised shoulder and the breasts; on the lighted areas of the midriff, abdomen, and thighs; as well as on the lighted wrist and hand of the opposite arm. The same combination of colors is used to paint the hair—with more burnt umber on the shadow side and more cadmium orange and white on the light side. The lighter hair tone is used to brighten the face; the eyes are added with the dark hair tone. The background is lightened around the head and darkened at the upper left.

Step 5. A flat softhair brush begins to blend the lights and halftones on the upper torso. The rough brushwork of Step 4 melts away into smooth tones. A warmer version of the shadow mixture—containing more cadmium orange—is blended into the dark area on the chest, shoulder, and upper arm. Some of this mixture is added to the underside of the breast to suggest reflected light. Then the shadows beneath the breasts are darkened with more burnt umber. The tip of the painting knife scratches away some wet color from the hair to indicate light falling on the curls.

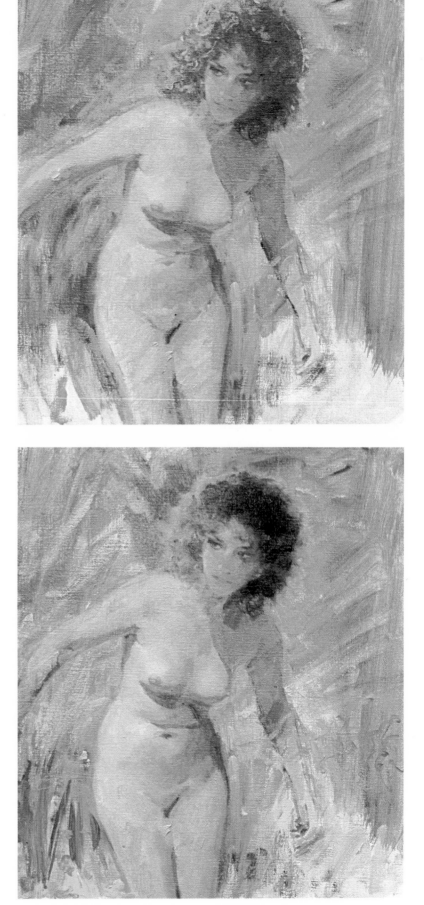

Step 6. The flat softhair brush continues to work down the figure, blending the tones of the lower torso and the thighs. Adding more white to the pale flesh tone, a small bristle brush builds up the lights on the brightly lit sides of one breast, the abdomen, and the hip. Adding still more cadmium orange and burnt umber to the shadow mixture, a small bristle brush deepens the shadows on the dark sides of the neck, midriff, and hips; crisp lines of the same mixture are added to the crease at the waist, the navel, and the dividing lines of the crotch and thighs. A little white is added to this mixture, which is then scrubbed around the hair.

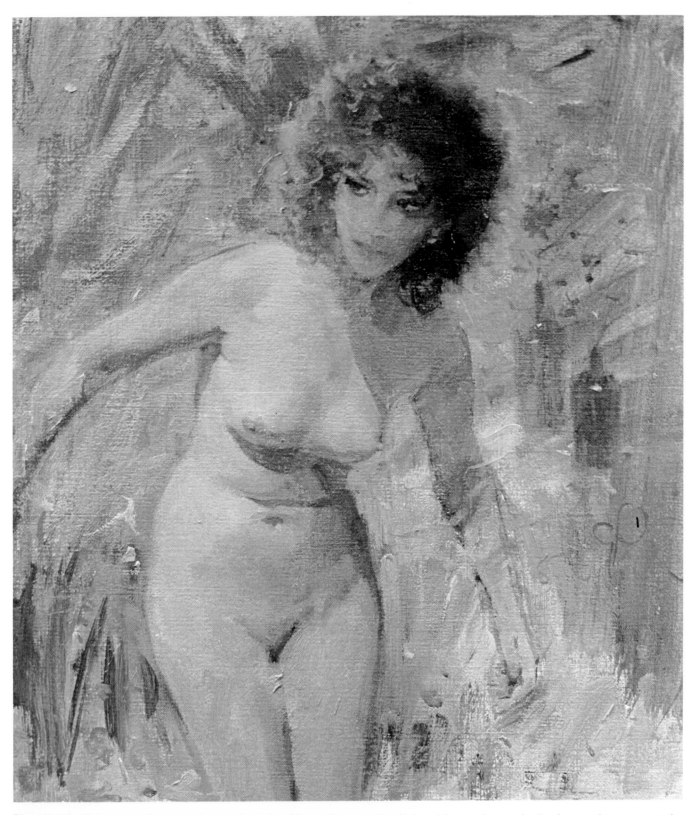

Step 7. The lights are built up on the upraised shoulder and along the upper edge of the arm. Touches of bright color enrich the shadow on the underside of that same arm, the lighted edges of the hair, the dark side of the cheek, the shadow beneath the chin, the shadows on the midriff and abdomen, and the upper half of the arm that's in shadow. Free strokes of this same bright mixture—still the same combination of cadmium orange, burnt umber, raw sienna, and a little white—animate the background to suggest the color of autumn foliage. For the bright touches of gold around the figure and in the lower right, cadmium yellow is substituted for raw sienna. The tip of a round brush adds the last few dark lines to sharpen the upraised shoulder, the features, the nipples, the side of the thigh that's in shadow, and the fingers. Tiny dabs of bright yellow suggest wildflowers.

Step 1. A wash of cobalt blue and turpentine is swept over the canvas by a big bristle brush. A darker tone of cobalt blue is scrubbed over the hair. Then a round brush begins the sketch with long, simple lines that capture the overall form and movement of the figure. A single curve defines the contour of the face, and two short lines are enough to suggest the eck. A horizontal stroke aligns the shoulders. Long, arc-like lines follow the contours of the arms, torso, and legs. A curving center line runs through the torso and helps locate the breasts, the waist, and the division between the legs.

Step 2. Darker strokes of cobalt blue, containing much less turpentine, cover the entire background. A clean rag wipes away the pale tone of the skin as the tip of a round brush sharpens the contours of the feet and indicates the details of the features, breasts, and hands. The figure is evenly lit and contains no strong areas of shadow.

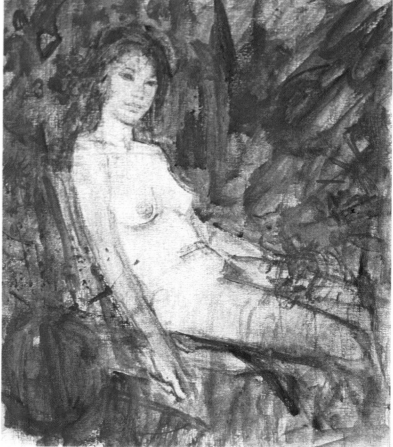

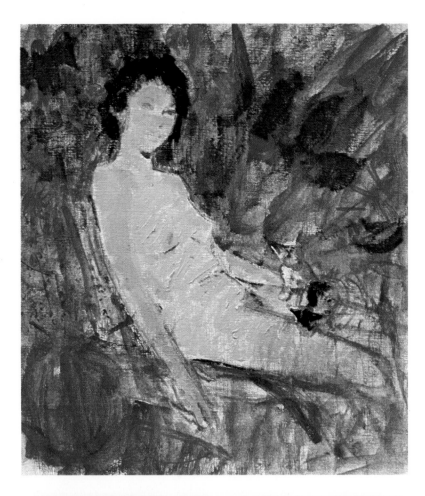

Step 3. A bristle brush covers the entire figure with a pale mixture of raw umber, raw sienna, a little Venetian red, and white. Because there are no strong shadows, the artist pays careful attention to very slight variations in tone. The cheeks, nose, arms, and thigh are slightly darker than the torso. A hint of shadow appears on the breast and on one side of the midriff and hips. A much darker version of the same mixture—containing less white and more Venetian red—is brushed over the upper background. The dark shape of the hair is blocked in with burnt umber and ultramarine blue. A small brush sketches in the kittens on the model's lap with the dark hair mixture repeated on one kitten, the warm background tone repeated on the other.

Step 4. Still searching for the subtle color variations, a small brush deepens the flesh mixture with a little more raw umber and Venetian red and adds dark touches to the chin, neck, shoulders, arms, breasts, and midriff. Still more Venetian red and raw sienna are added to the mixture to enrich the tones of the face, nipples, and thighs. A little cadmium red is added to this mixture for the lips.

Step 5. Darkening the flesh mixture with more raw umber, a round brush sharpens the features and continues to strengthen the contours of the torso. A flat bristle brush darkens the edges of the forms, while another bristle brush adds more white to the basic flesh mixture to build up the lights all over the figure. A small brush begins to define individual strands of hair. Bristle brushes start to suggest a floral background with warm strokes of cadmium orange, raw sienna, raw umber, and white, plus cooler strokes of cobalt blue, raw sienna, and white. The chair is painted with thick strokes of cobalt blue and white.

Step 6. A flat softhair brush blends the rough strokes of Step 5. The tip of a round brush adds shadow lines beneath the chin, on the neck, and beneath the breasts. The cheeks and nipples are warmed with just a little cadmium red added to the flesh mixture. The brilliant patch of red on the seat is cadmium red, alizarin crimson, a little cobalt blue, and white. The floral background grows more detailed as a small brush adds bright touches of cadmium orange, raw sienna, raw umber, and white.

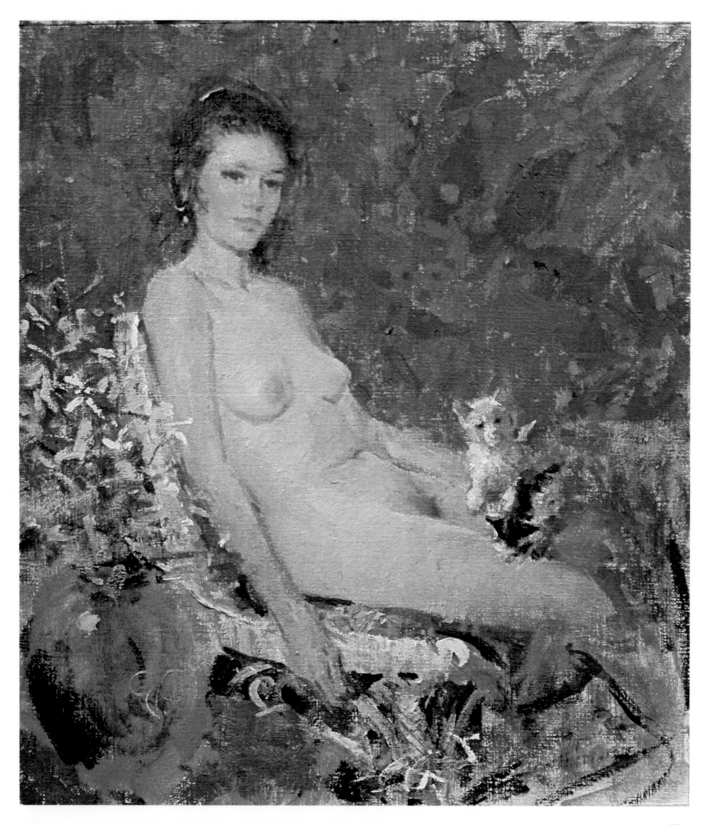

Step 7. The tip of a round brush moves over the entire figure, sharpening the edges of the forms with slender strokes of Venetian red, raw umber, raw sienna, and white. You can see where the brush has strengthened the lines of the nose and lips, the curve of the jaw, and the edges of the arm and breasts. The forearm and hand are completed with small strokes of the same mixture. The hair is carried down the sides of the face with burnt umber and ultramarine blue; the eyes and eyebrows are darkened with this mixture. The warm background tone is carried closer to the face and blended into the edges of the hair. Two tiny dabs of flesh tone suggest the ear. The patch of blue in the lower left suddenly becomes a vase as a shadow is added with a broad stroke of the hair mixture. Wildflowers are added with quick, spontaneous strokes of cobalt blue and white.

Step 1. The canvas is toned with cobalt blue and turpentine. Then the preliminary sketch is begun with a bristle brush that carries the same mixture. The brush scrubs in the dark tone of the distant trees in the upper half of the picture. The shapes of the model are blocked in with thick, straight strokes. The brush indicates a few masses of shadow. Notice that the face and most of the hair are in shadow. As always, the artist looks for alignments. The vertical line of the neck lines up with the vertical line of the inner thigh; a single diagonal line connects the shoulders; and another diagonal line connects the undersides of the buttocks.

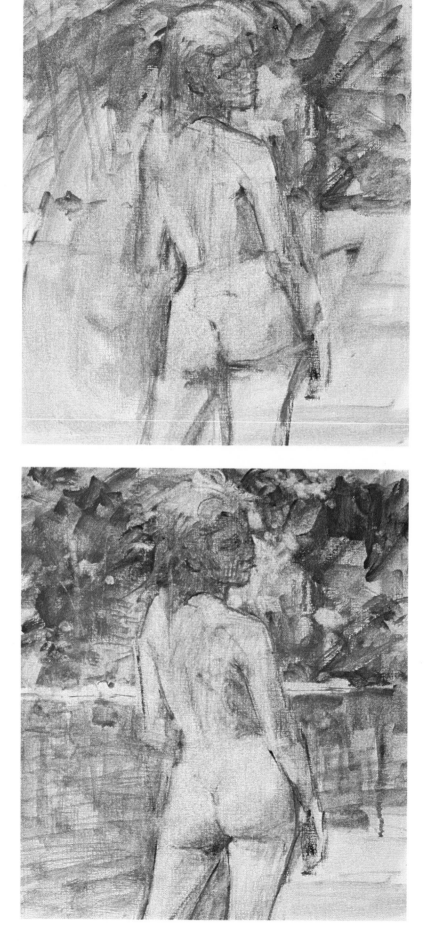

Step 2. A flat bristle brush continues to darken the trees in the upper half of the canvas and then indicates their reflections in the pond that fills the lower half of the picture. The sharp point of a round softhair brush goes over the contours of the figure, drawing them more precisely as a rag wipes away the lights and the unnecessary strokes. Most of the figure is brightly lit, but there are strong patches of shadow on the face, arms, back, and buttocks.

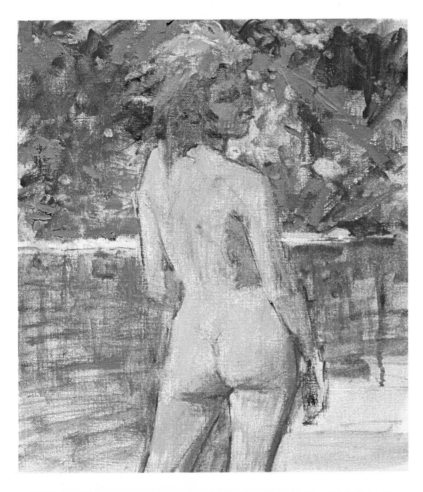

Step 3. A mixture of raw umber, cadmium orange, Venetian red, and white is lightly brushed over the shadow tone, with some of the underlying blue allowed to shine through. Then a big brush blends raw umber, yellow ochre, Venetian red, and white, and scrubs this lightly over the sunlit areas of the body, again with some of the underlying blue allowed to come through. More yellow ochre is added to the flesh mixture for the sunlit patches on the hair. Strokes of soft green are brushed into the foliage and carried downward into the reflecting surface of the water; this is a mixture of ultramarine blue, cadmium yellow, raw umber, and white. A warmer, more subdued tone is brushed around the head and over the foliage with a mixture of ultramarine blue, Venetian red, and white.

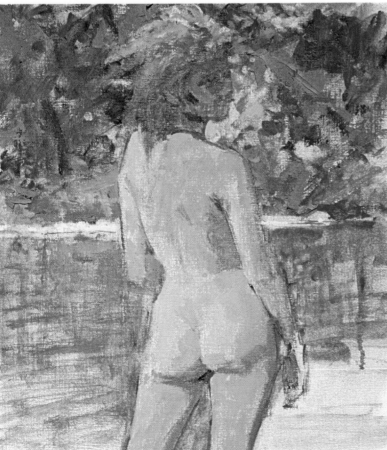

Step 4. Working with thicker paint diluted with painting medium to a creamy consistency, bristle brushes now begin to apply more solid color to the figure. The pale skin mixture is enriched with more yellow ochre and Venetian red to darken the upper back, arms, and thighs. A paler version of this mixture is carried down over the buttocks, and this mixture is cooled with a speck of cobalt blue for the halftones. Brighter, thicker color is added to the shadow areas of the face and body.

Step 5. Having covered the upper back with a darker tone, a bristle brush blends more raw umber into the shadow mixture to strengthen the darks on the back and shoulder. This darker tone is brushed into the shadow areas of the hair and carried into the face to define the features. The sunlit top of the hair is brightened with thick strokes of yellow ochre, raw umber, and white. Foliage reflections are added to the water with ultramarine blue, cadmium yellow, raw umber, and white. The patch of beach in the lower right is covered with broad strokes of Venetian red, cobalt blue, and lots of white.

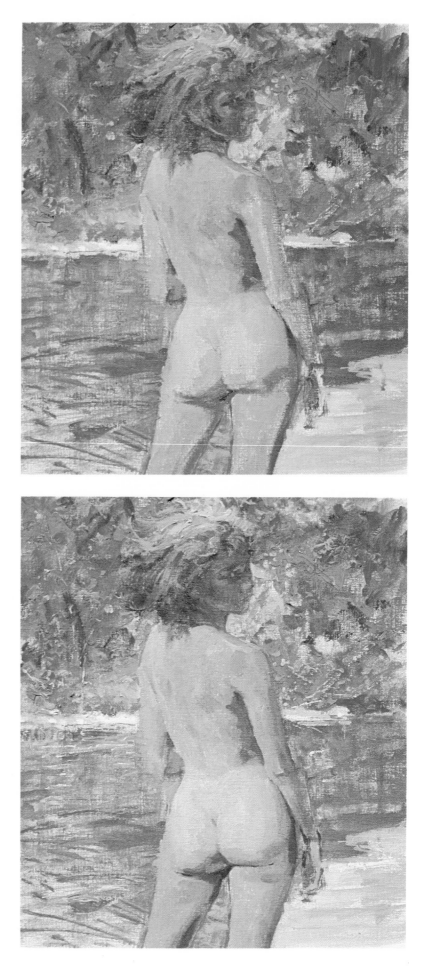

Step 6. Now a flat brush concentrates on the arms, buttocks and thighs. Warmer, darker tones are brushed down the length of the down-stretched arm and thighs, since the limbs are normally darker than the torso. A hint of darkness is added inside the crook of the bent arm. Adding more white to the pale flesh mixture, the brush begins to build up the lights on the buttocks. Notice the cool notes of cobalt blue blended into the shadows beneath the buttocks and in the halftones. The tip of a round brush continues to brighten the sunlit hair with yellow ochre, raw umber, and white, and adds some touches of light to the features with the same mixture.

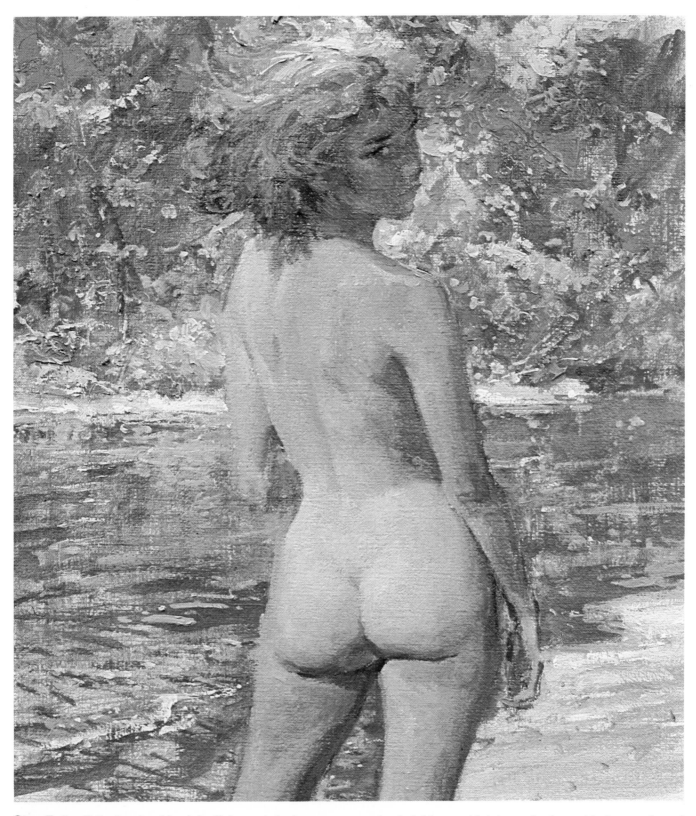

Step 7. Small flat brushes blend the lights and shadows on the back and downstretched arm, build up the lights on the back and buttocks, and darken the shadow sides of the thighs. The tip of a round brush sharpens the features, blends touches of the cadmium orange and bluish background tone into the hair, sharpens the eyes with raw umber and cobalt blue, and brightens the face with tiny touches of cadmium orange, cadmium red, and blue background color. Finally a small brush moves over the entire background, suggesting sparkling sunlight on the leaves and water with thick strokes of white tinted with cobalt blue and alizarin crimson.

Step 1. The painting surface is toned with random strokes of raw umber and turpentine. A round brush picks up a darker version of this mixture to sketch in the major lines of the figure—without making any attempt to draw the figure precisely. At this point the hair is simply a blur of tone; the arms are nothing more than diagonal lines; the upper torso is represented by two straight lines for the outer edges plus a center line that runs through the abdomen; and the lower torso is described with straight lines for the hips and thighs plus a curving stroke for the raised hip.

Step 2. The tip of the brush begins to draw the figure more precisely as a rag wipes away the excess lines. The face and most of the torso are in shadow, which a bristle brush scrubs in with free strokes. As the rag wipes away the lights along the upper edge of the figure, the bristle brush darkens the background to accentuate the lighted contours of the body.

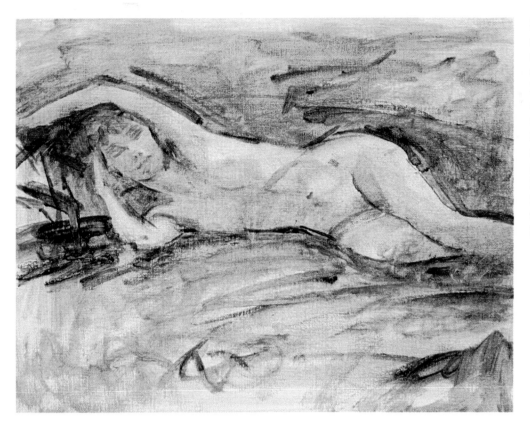

Step 3. A flat brush smoothes and blends the shadow tones on the upraised arm, face, neck, torso, and lower legs. A round brush darkens the edges of the figure and scribbles the dark tone over the background. A rag, wrapped around a fingertip, carefully wipes away the light along the edge of the torso, on the thighs, and on the arm that supports the head.

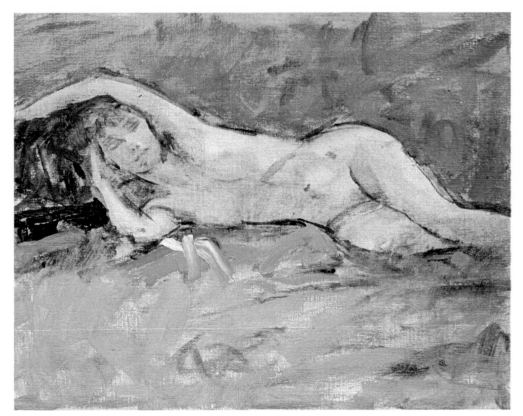

Step 4. Bristle brushes surround the figure with tones that emphasize the paler shape of the body. The background is brushed with a mixture of raw umber, raw sienna, and white. Then the brush blends cobalt blue, raw umber, raw sienna, and white into the wet undertone. The blue cushion under the model's head is indicated with strokes of cobalt blue, raw umber, and white. Alizarin crimson and more white are added to this mixture for the cool tone of the foreground. The hot color of the drapery beneath the torso is painted with rough strokes of cadmium red, yellow ochre, and white.

Step 5. The warm shadow tone on the front of the figure is painted with a bristle brush that carries a mixture of raw sienna, burnt umber, cadmium orange, and white. Notice how a bit of the cool foreground tone is blended into the midriff and abdomen. More white is added to the shadow mixture and applied in thick strokes over the lighted planes of the torso, thighs, cheek, and the arm beneath the model's head. Darker strokes of cobalt blue, raw sienna, raw umber, and white enrich the background and dramatize the lighted edge of the figure.

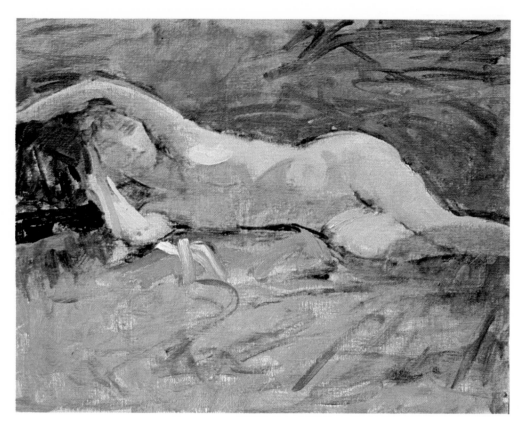

Step 6. The shadow mixture is darkened with more burnt umber, and a small brush sharpens the shadowy contours of the head, breasts, midriff, and abdomen. Adding more cadmium orange to this tone, a small bristle brush brightens the face and hair, indicates the nipples, and adds touches of warm color to the knees. Thick strokes of white tinted with flesh tone illuminate the thighs. More touches of the cool foreground mixture are blended into the shadow plane of the torso.

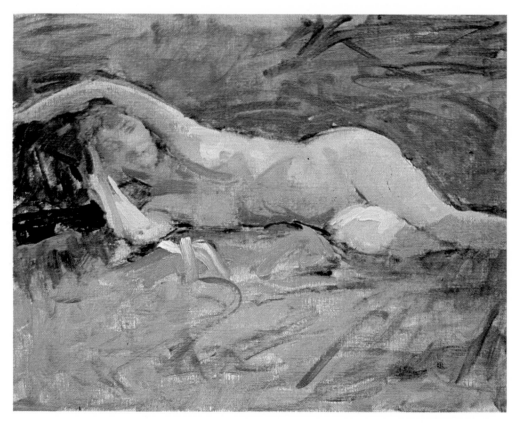

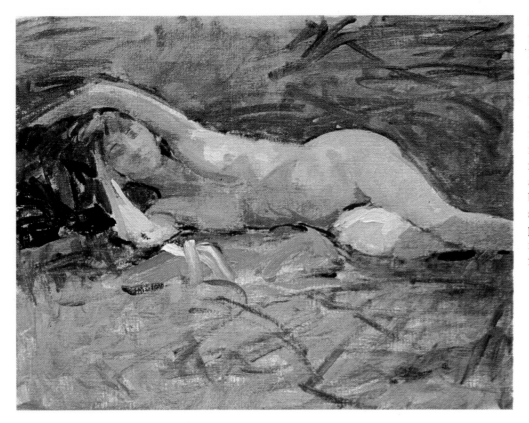

Step 7. A round brush paints the hair with crisp strokes of burnt umber, Venetian red, and raw sienna, with an occasional dark touch of cobalt blue. This mixture (with more white) darkens the eyes and the nose. A speck of cadmium red is added to this mixture to warm the cheek and the lips. The tip of the brush draws a dark line of shadow beneath the neck and places another shadow beneath the legs to anchor the figure to the ground.

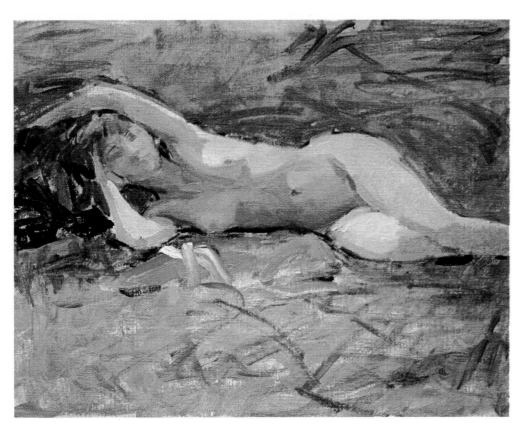

Step 8. A flat softhair brush moves down the torso, blending the tones together to make the forms look smoother and rounder. The thick touch of white on the lower thigh (see Step 7) is now blended smoothly into the surrounding color. A small bristle brush travels over the lighted contours of the torso, modifying the color with a cool mixture of white tinted with a speck of raw sienna and ultramarine blue. This strengthens the contrast between the lighted planes and the shadow planes of the body.

Step 9. The pillow beneath the model's head is brightened with thick strokes of cobalt blue, raw umber, and white. The tip of a round brush builds up the lights on the face with a pale mixture of white, ultramarine blue, and raw sienna. The tip of the brush sharpens the features and blends the shadow on the neck. A flat brush blends the light and shadow planes on the arm beneath the model's head and then continues to blend the tones on the thighs. Another blue pillow is placed on the far side of the model's legs with cobalt blue, raw umber, and white. The bright drapery is extended with cadmium red, raw sienna, and white. The foreground is covered with strokes of cobalt blue, raw umber, and white.

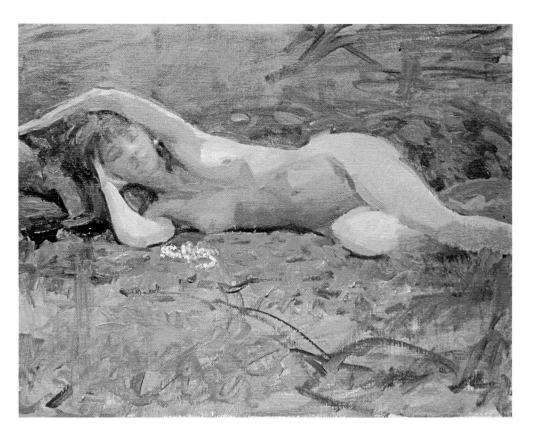

Step 10. Small flat brushes continue to build up the lights on the figure with pale strokes of white tinted with raw sienna and ultramarine blue. The lighted areas on the abdomen and thighs become brighter and cooler. The lighted edge of the figure is blended softly into the dark background. Compare the hard edge of the midriff in Step 9 with the softer edge in Step 10.

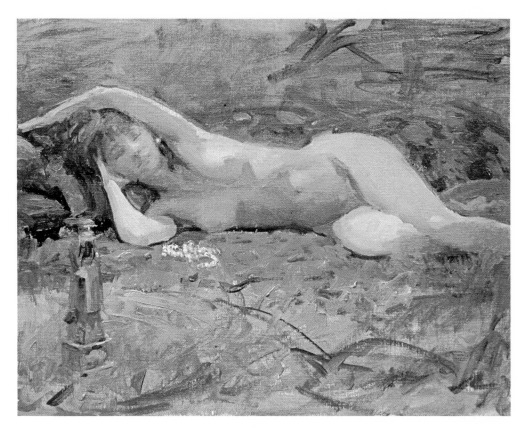

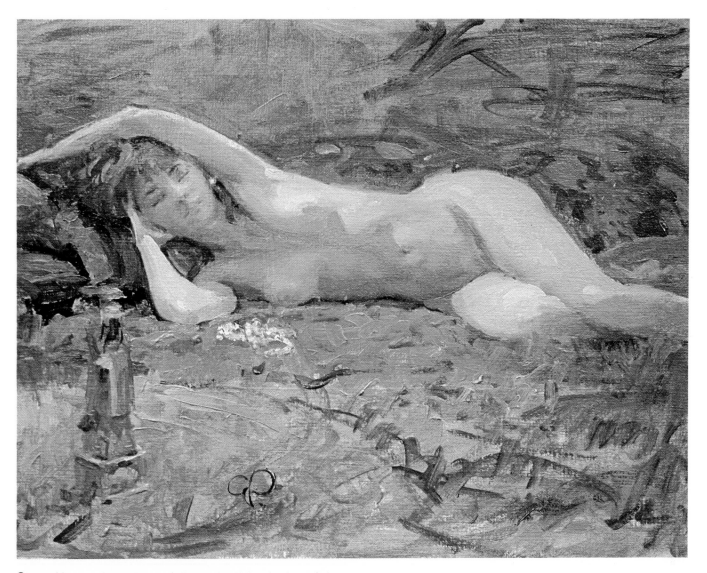

Step. 11. A pointed brush follows the lighted edge of the raised arm, brightening the contour with a single, rhythmic stroke. The same brush adds highlights of pure white tinted with a speck of raw sienna and ultramarine blue to the lighted breast, midriff, hips, thighs, and the elbow of the arm beneath the model's head. Notice how touches of the warm drapery color are blended into the shadow areas of the torso—the breasts, midriff, and abdomen. It's worthwhile to remember that the skin can serve as a reflecting surface, picking up hints of the surrounding colors. A small, pointed brush sharpens the lines of the eyebrows and the eyelids. The dark shadow lines beneath the figure have been blended softly into the warm tone of the drapery; the lines are still there, but they are less prominent, conveying the feeling that the figure rests more solidly on the ground. This painting demonstrates how colorful a shadow can really be—and how much detail can be suggested within the shadow.

Step 1. The canvas is toned with a pale mixture of ultramarine blue, ivory black, just a little white, and plenty of turpentine. A round brush begins the sketch with this same mixture. The first lines do nothing more than establish the placement, proportions, and general shapes of the figure. The artist works mainly with straight lines that will become a guide for the more careful drawing that will come next. The limbs are mainly vertical lines, while the back is a diagonal stroke, and the hair is just a blur of darker tone.

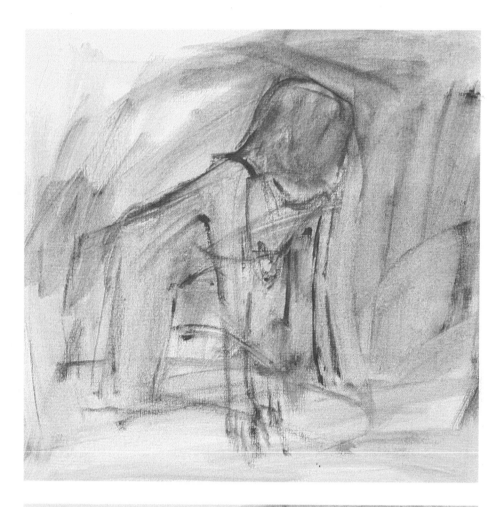

Step 2. The tip of a round brush begins to redraw the lines more carefully. The curve of the back is particularly important; the line is drawn with a much more precise stroke. The brush also traces the curves of the shoulder and buttocks, adding the shape of the diagonal thigh on the far side of the figure. A flat bristle brush scrubs in the shadows on the underside of the torso as well as on the arm and thigh on the far side of the figure. A rag wipes away excess strokes. Wrapped around a fingertip the rag also wipes away a strip of light on the shadowy thigh; this strip of light momentarily obliterates part of arm in the foreground, but these lines will be re-established in the next steps.

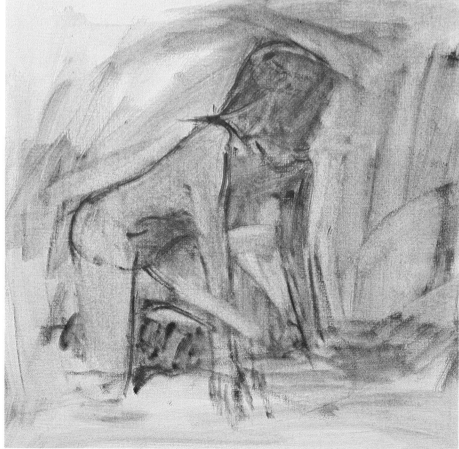

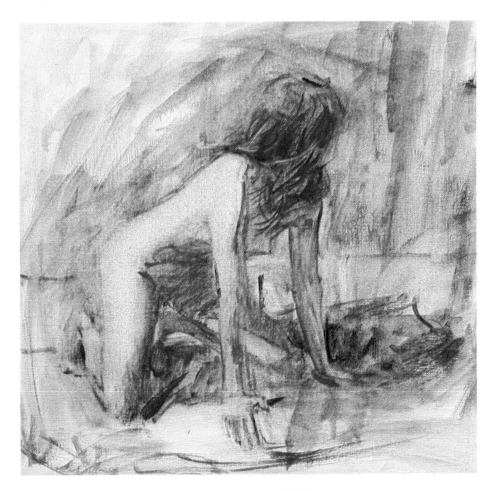

Step 3. More black is blended into the original mixture, and the preliminary brush drawing is completed with darker tones. The arms, legs, and breast are more carefully drawn. The shadows on the figure are darkened. The figure casts a shadow on the ground, and this shape is painted in dark tones. The dark shape of the hair is painted with expressive strokes that also capture the texture of the hair. Finally, the background is darkened; then the lighted areas of the shoulder, back, and thigh are wiped away to contrast more strongly with the darker tones that surround them.

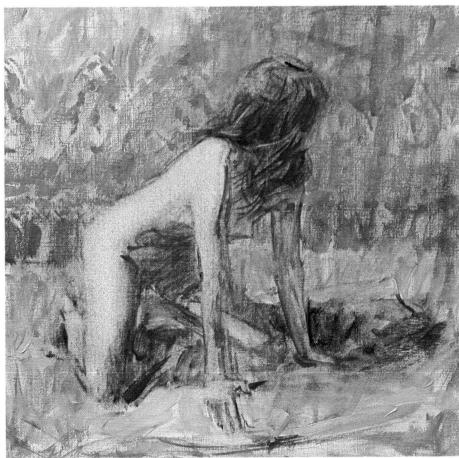

Step 4. The warm tones of the patterned drapery in the background are suggested with rough strokes of cadmium red, cadmium orange, raw sienna, and white. The cool notes of the drapery are added with touches of cobalt blue, raw umber, and white. It's unusual for the background to be painted first, but it's the right thing to do in this picture because the background tone will be *darker* than the lighted areas of the figure but *lighter* than the shadow areas of the figure. Once the background is painted, it will be easier to judge how light and how dark to make the tones on the figure. The cool tones of the drapery on the floor are painted with casual strokes of cobalt blue, raw umber, and white.

Step 5. The artist begins to test his flesh tones by placing just a few strokes on the figure. The dark strokes on the shadowy areas of the chest, abdomen, and thigh are burnt umber, alizarin crimson, just a little raw sienna, and white. The pale strokes on the back are raw sienna, a hint of ultramarine blue, and white. Some cool shadow tone is spotted on the drapery beneath the model—a darker mixture of cobalt blue, raw umber, and a little white. Having tried out his flesh tones on a limited scale, the artist can now proceed to block in the lights and darks on the figure.

Step 6. A bristle brush paints the deep shadows on the torso, arms, legs, and feet with dark strokes of burnt umber, alizarin crimson, raw sienna, and a little white to heighten the color. More raw sienna and white are added for the paler, warmer tones in the lighted areas of the arms and legs. The brightly lit plane of the back is brushed with raw sienna, a little ultramarine blue, and lots of white. Touches of the shadow are also brushed into the hair.

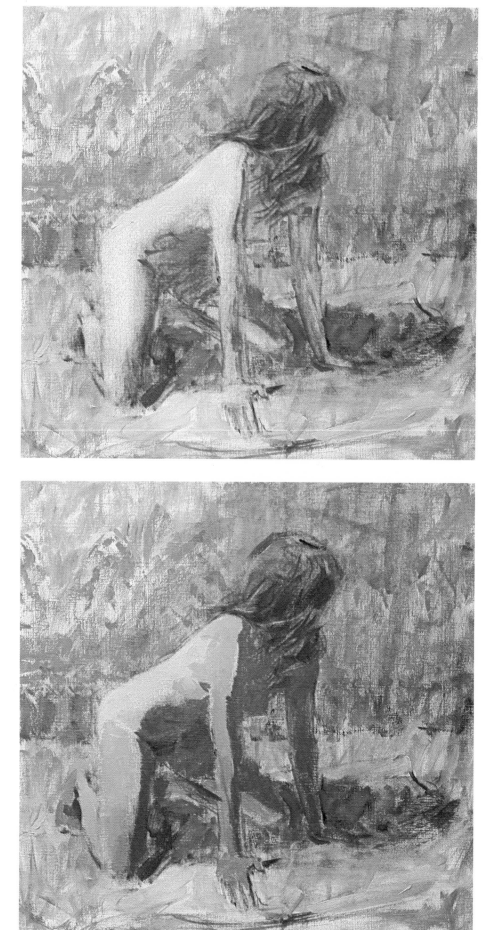

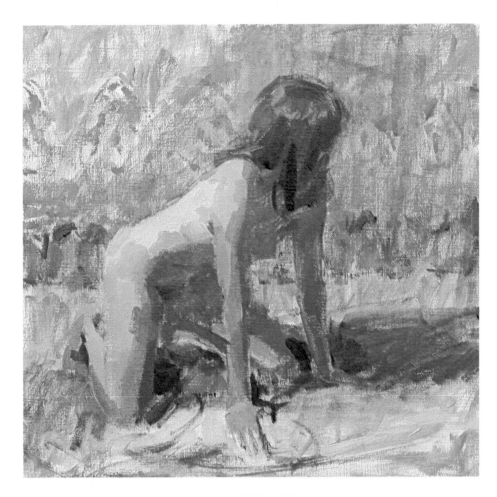

Step 7. Where the lights and shadows meet on the figure, a big bristle brush blocks in the halftones with a subdued mixture of ultramarine blue, raw umber, raw sienna, and lots of white. You can see these tones most clearly where the plane of the torso curves around into the shadow. This halftone mixture is also carried down the lighted thigh and forearm—and a few strokes of the halftone mixture are blended into dark shadows themselves. A darker version of this same mixture—containing more ultramarine blue and raw umber—is brushed over the shadow areas of the hair. The shadow on the drapery beneath the figure is extended to the edge of the picture with strokes of cobalt blue, raw umber, and white.

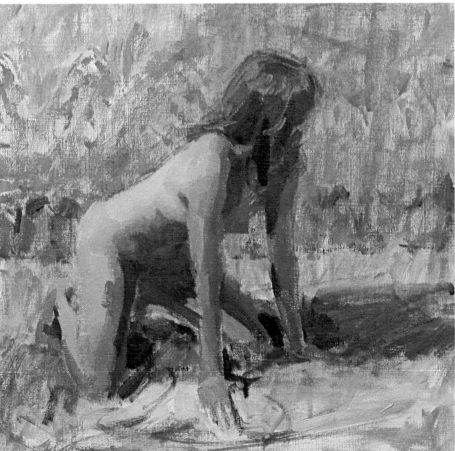

Step 8. A flat softhair brush begins to blend the lights, halftones, and shadows on the torso and shoulder. With firm strokes of burnt umber, raw sienna, ultramarine blue, and a little white, the darks are strengthened on the chest, the underside of the torso, the thighs, and the arm on the shadow side of the figure.

Step 9. A flat brush moves over the rest of the figure, blending the lights, halftones, and shadows. As the brush blends these tones, it adds richer, warmer color to the lighted areas of the arms and legs and also blends richer tones into the shadows. These warm tones are all mixtures of burnt umber, alizarin crimson, raw sienna, and white. A round brush picks out lighted locks of hair with strokes of burnt umber, raw sienna, a little ultramarine blue and white. Then the brush sharpens the details of the hands and feet with darker strokes of this same mixture. Heavier strokes of this mixture darken the shadow on the ground. Working with the mixtures that first appeared in Step 4, a small bristle brush adds details to the background drapery.

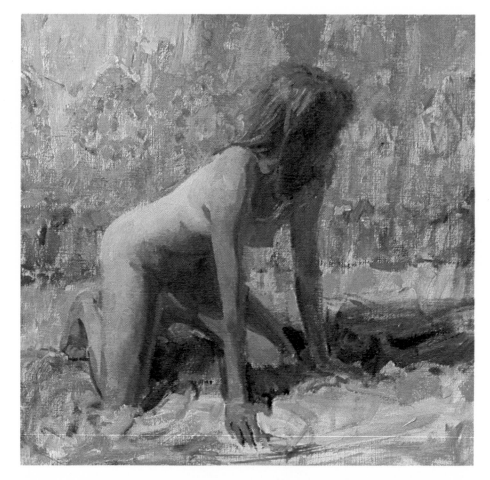

Step 10. A round brush continues to define the details of the hair with dark and light strokes. A small bristle brush builds up the lights on the shoulder, back, and buttocks with a very pale mixture of raw sienna, a speck of ultramarine blue, and lots of white. A small bristle brush enriches the shadows on the arms and thighs with a warmer mixture of burnt umber, alizarin crimson, raw sienna, and white—with a little extra alizarin crimson—and then softly blends the tones on the near arm. The shoulder and upper arm now look much rounder.

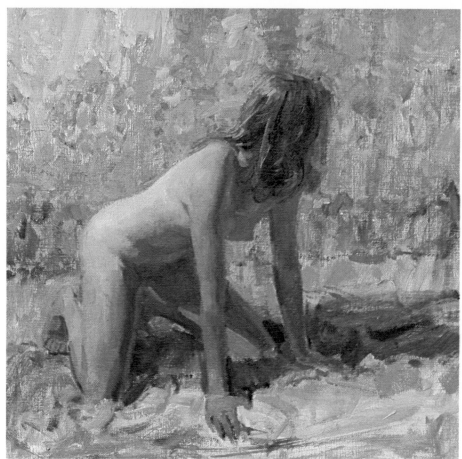

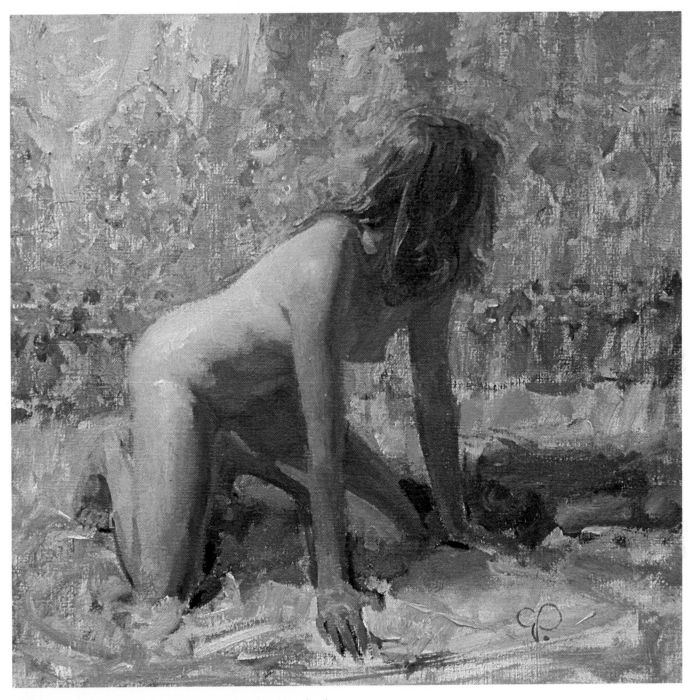

Step 11. Thick highlights are placed on the shoulder, back, and thigh with pure white tinted with raw sienna and ultramarine blue. Small strokes of shadow are added beside the knee on the lighted side of the body and beneath the hand on the shadow side of the body to make the model kneel more firmly on the ground. Heavy strokes of white, cobalt blue, and a little raw umber enrich the texture of the drapery in the foreground; more strokes of this mixture soften the tone of the big, dark shadow; and tiny touches of this mixture make the background drapery seem paler so that it won't distract attention from the figure. Study the fascinating variety of warm and cool tones that appear within the shadows on the finished figure.

Step 1. A large bristle brush tones the canvas with ragged strokes of raw umber and turpentine. A round brush picks up the same mixture to sketch the major lines of the figure. Notice how few lines there really are. A single curving line defines the underside of the torso, traveling from the armpit down under the buttock. On the upper contour of the body, one line defines the back, while another line travels from the waist over the buttock and along the top of the thigh. A curving center line moves down the back, connecting the back of the neck, the spine, the division between the buttocks, and the underside of the thigh.

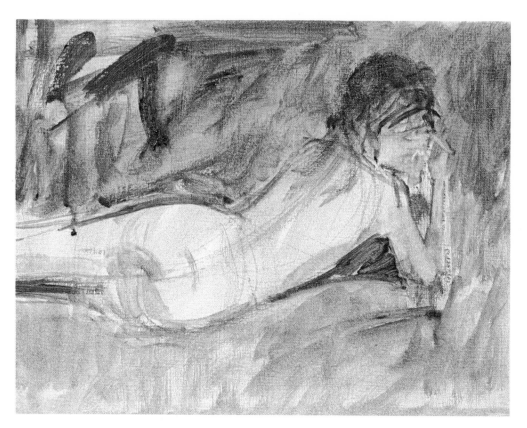

Step 2. The tip of the round brush retraces the lines of the figure more carefully, still following the original guidelines. The small brush also defines the features and hair. A flat brush blocks in the shadow tones on the face and arm, the underside of the torso, the buttocks, and the thigh. A rag wipes away the lights, and a big bristle brush darkens the foreground and background.

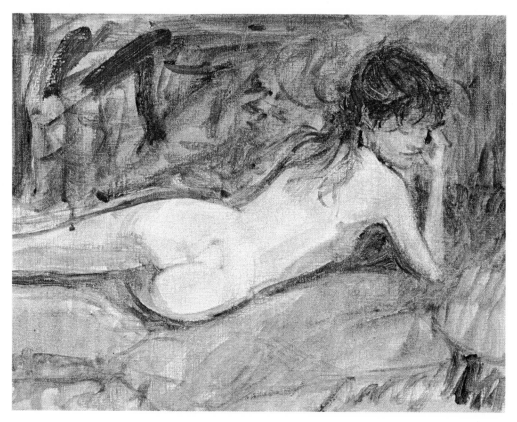

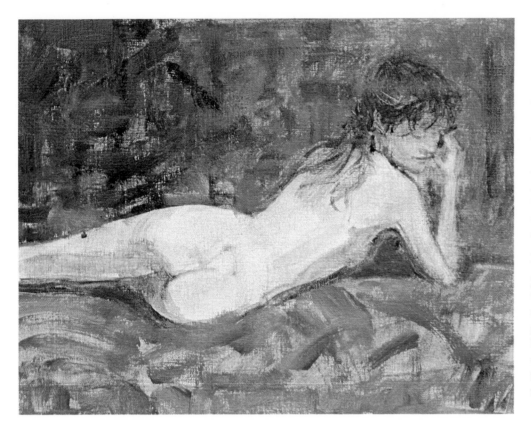

Step 3. Because the figure is essentially a pale shape surrounded by a dark background and foreground, work begins on these dark areas. The upper half of the picture is covered with broad strokes of ultramarine blue, burnt umber, viridian, and white. Just above the hip the background is warmed with a few strokes of ultramarine blue, alizarin crimson, raw umber, and white. The subdued foreground tone is a blend of ultramarine blue, burnt umber, yellow ochre, and white. As these dark tones are carried up against the edges of the figure, the silhouette of the body can be seen more precisely—and it will be easier to mix the light and dark flesh tones.

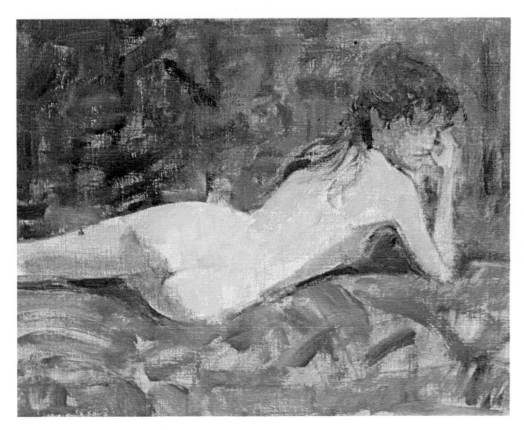

Step 4. A large bristle brush covers the few shadow areas of the torso and leg with a mixture of burnt umber, cadmium orange, yellow ochre, and white—scrubbing some of this mixture into the shadow side of the face. Then another big bristle brush covers the back with raw umber, yellow ochre, Venetian red, and lots of white. A bit more white is blended into the buttocks, while the thigh and the upper arm are painted slightly darker.

Step 5. A small bristle brush blocks in the hair with a warm, dark mixture of burnt umber, ultramarine blue, a little Venetian red, and white. The shadow side of the face is darkened with the mixture that first appeared in Step 4: burnt umber, yellow ochre, cadmium orange, and white. The pale flesh mixture is warmed with more yellow ochre and Venetian red to enrich the tone of the face and add more warm tones to the lighted areas of the back and arm. The lighted area of the face is distinctly darker than the lighted plane of the back. The upper half of the back is darkened where the hair will fall and where the spine creates a soft depression just above the waist.

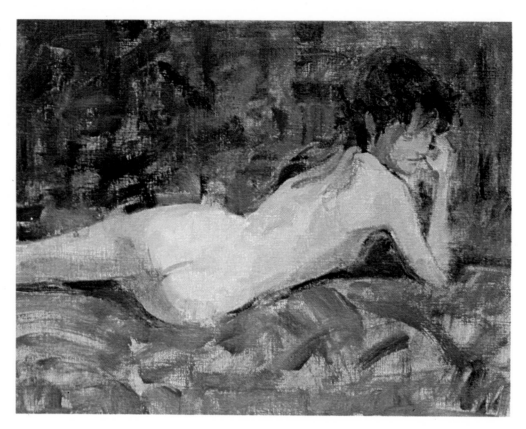

Step 6. The artist concentrates on the head with small brushes. The shadow area of the forehead and cheek are carefully shaped, and then the bright patches are placed on the forehead, cheek, nose and chin. The tip of a small brush paints the eyes, the shadowy underside of the nose, the lips, and the individual strands of hair, some of which wander over the neck and down the back. The shadow areas of the face are burnt umber, yellow ochre, cadmium orange, and white, while the lighter areas are raw umber, yellow ochre, Venetian red, and white, with a hint of cadmium red on the cheeks and lips.

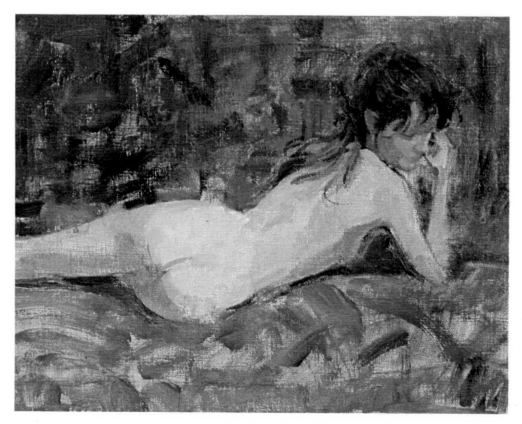

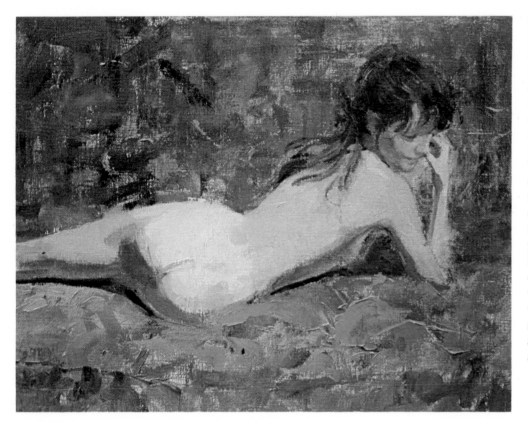

Step 7. A flat softhair brush blends the lights and shadows on the face. A round brush sharpens the eyes, mouth, and chin. A flat brush works down the back, shoulders, and upper arm, darkening and blending the tones. The thigh is also darkened and blended. Then a small bristle brush darkens the shadows under the arm, along the underside of the torso, beneath the buttocks, and along the thigh. A painting knife goes over the foreground with thick strokes of ultramarine blue, burnt umber, viridian, and white, while a bristle brush adds strokes of ultramarine blue, alizarin crimson, raw umber, and white beneath the thigh.

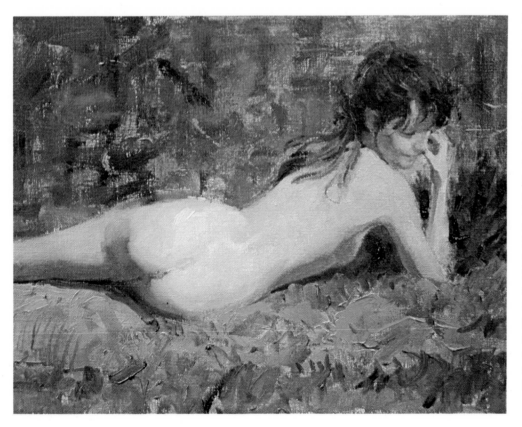

Step 8. Blending more white into the original pale skin mixture, a bristle brush builds up the lights on the buttocks, carrying a stroke into the lower back to suggest the lighted edge of the spine. Touches of white are also blended into the upper edge of the thigh, the back beneath the hair, and the shoulder area. A flat softhair brush blends the edges of the shadows where they meet the lights. This blending process produces halftones between the lights and shadows. You can see this effect most clearly on the buttocks and thigh. A bristle brush continues to build up the texture of the foreground drapery with the colors that appear in Step 7.

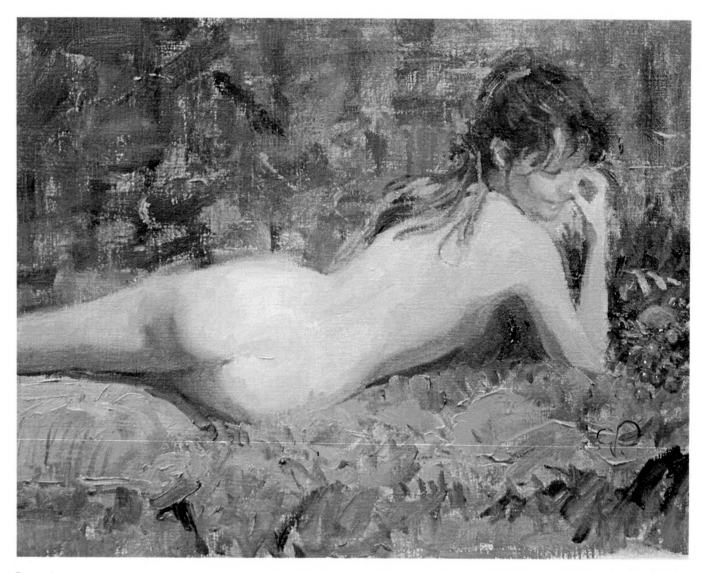

Step 9. Wandering over the dark background, a bristle brush adds occasional touches of warmth with ultramarine blue, alizarin crimson, raw umber, and white. Where the background meets the hip and thigh, a small bristle brush softens the edge of the figure, blending the flesh tone so that it merges softly with the darker tone of the background. In the same way the hair that drapes over the forehead is blended softly into the background color. Adding an extra touch of cadmium orange to the shadow mixture, a flat soft-hair brush adds more warmth to the thigh and buttocks. Thick white, straight from the tube, is tinted with minute amounts of raw umber, yellow ochre, and Venetian red; highlights of this pale, luminous tone are placed on the but-

tocks, spinal area, and shoulder and then blended so softly into the surrounding flesh that they're almost invisible. A pointed brush places tiny highlights (with the same mixture) on the nose, chin, and ear. Beside the elbow a bunch of grapes is added with a small brush that carries various mixtures of ultramarine blue, burnt umber, alizarin crimson, and white. The orange is painted with cadmium red, cadmium orange, yellow ochre, and white. Four separate strokes of pale flesh tone suggest the fingers of the hand reaching for the grapes. And the painting is completed with a few strokes of ultramarine blue, alizarin crimson, and white for the ribbon that holds the model's hair.

Deciding the Pose. The most important thing to remember is that the pose ought to look natural. The simplest poses are usually best. If the model is standing, let her plant her feet firmly on the ground so she can hold the pose without stress; don't ask her to take a dancing pose or twist her body into some dramatic contortion that she can't possibly hold long enough to paint. A seated pose is particularly easy to hold for a long time; if the model naturally slouches or leans in one direction, let her do what's most comfortable. Of course, reclining poses are the easiest for the model because she can relax totally and hold the pose indefinitely. Whatever pose you agree upon, let the model move around until she feels stable and relaxed. Remember that what's naturally comfortable for *one* model may not be right for *another*. If the model feels right in a particular pose, she'll look right too—and your painting will reflect her sense of comfort, relaxation, and stability. If she feels awkward, your painting will look awkward. In short, although you may start out with a general idea of the kind of pose you want to paint, work along with the model to establish a pose that's most natural for her particular build and temperament.

Lighting. In most cases, you'll probably work indoors, preferably with natural light that comes from a fixed location like a window or a skylight. In the pages that follow, you'll find examples of different kinds of lighting. Move the model around your work area to see how she looks in different kinds of light. It's usually best to start out with 3/4 lighting because it's the easiest to paint. When you've painted a number of pictures in 3/4 light, then you can go on to the more complex effects of frontal lighting, back lighting, and rim lighting. Of course, if you're working with artificial light, you can let the model stay in one place and just move the light fixtures around to get the effect you want. The lighting, like the pose, ought to be as simple as possible. If you have a big window or a skylight that illuminates the whole room, that's probably all the light you need. If you're working with artificial light, don't surround the model with lighting fixtures which hit her from so many different directions that you can no longer tell the lights from the shadows. Arrange the lighting fixtures so that the rays strike her from just one direction, perhaps adding a very small lamp on the opposite side to make the shadows a bit more transparent. For artificial lighting, choose the warm light of incandescent bulbs or "warm white" fluorescent tubes; avoid the harsh, mechanical light of "cool white" fluorescent tubes.

Outdoor Light. If you can find some secluded place to paint the figure outdoors, keep in mind the same guidelines. You'll find it easiest to paint the model when the sun strikes her from one side and also from slightly in front, producing 3/4 or "form lighting." Later on, you can try placing her with the sun directly in front or directly behind to produce frontal or back lighting. You'll get the best outdoor lighting effects in the early morning, mid-morning, and middle or late afternoon—rather than midday, when the sun is directly above the model, creating harsh lights and shadows. (Besides, the model can get a nasty burn from the midday sun.) And don't neglect the soft, diffused light of an overcast day, which can be particularly delicate and beautiful.

Background and Props. Whether you're painting the figure indoors or outdoors, the model will be surrounded by the shapes and colors of walls, floors, furniture, trees, ground, or sky. These background elements are an important part of the picture. Pay careful attention to them; choose colors that flatter the model's skin and hair; but avoid any distracting details that might divert attention from the model. The cool tone of a blue wall or drape, or perhaps a mass of green trees, will heighten the warmth of the model's skin. But paint these with broad strokes that minimize the pattern in the wallpaper, the weave of the drape, or the detail of the foliage. Work in broad strokes that simplify the background to a mass of color. Save your more precise, intricate brushwork for the figure itself. Look for backgrounds that will provide flattering contrasts with the figure. A dark background tone will accentuate the light falling on the figure. A pale background will accentuate the shadows on the figure—particularly if the figure is lit from behind, with most of the front in shadow. Keep the background colors more subdued than the figure, so the flesh looks luminous and vital. If the model sits on a chair or reclines on a couch, choose the simplest furniture and avoid upholstery with an elaborate pattern. Professional figure painters often collect inexpensive fabrics (in flat, simple colors) to create various background colors. The model can sit or recline on an old blanket or bedspread. Or the fabric can be draped behind the model on a folding screen.

Some Do's and Don'ts. Avoid "glamor" poses that exaggerate the model's charms like a publicity photograph of a star. Such paintings tend to look like caricatures. For the same reason, don't exaggerate details like eyelashes, ruby lips, pink cheeks, painted fingernails or toenails. In fact, it's usually best for the model to wear a minimum of makeup. In general, avoid *all* kinds of exaggeration. A nude figure in a natural, relaxed, harmonious pose is *inherently* beautiful.

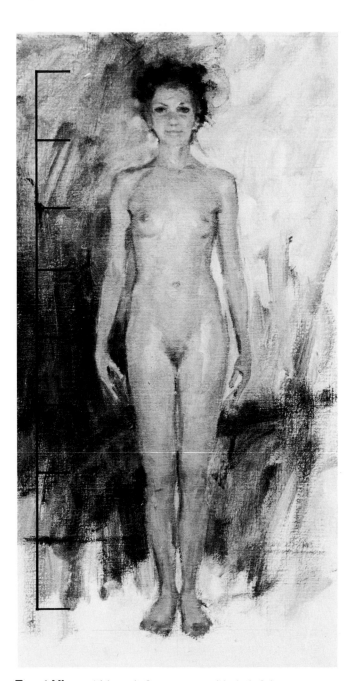

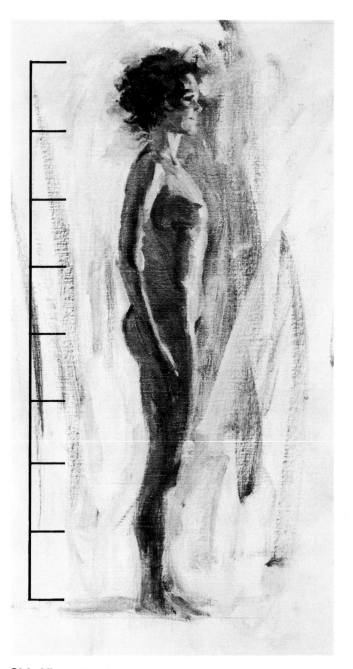

Front View. Although figures vary, it's helpful to memorize the proportions of an "ideal" figure and keep these proportions in mind as you paint. The most convenient method is to use the head as the unit of measurement. Painters generally visualize a figure which is eight heads tall. The torso is approximately three heads tall from the chin to the crotch, divided into thirds at the nipples and navel. The upper leg is two heads tall, and so is the lower leg. At the widest points—the shoulders and hips—the torso measures about two head lengths. It's obvious that not every model will have these "ideal" proportions. Nor will every pose be as easy to measure as this standing figure. But if you stay *reasonably* close to these measurements, making some adaptations to suit the particular build of the model, the proportions of your figures will always be convincing.

Side View. It's also important to remember the alignments of the various forms of the figure. The lower edge of the breast is halfway down the upper arm, while the elbow usually aligns with the waist. Comparing the front and side views, you can see that the wrist aligns with the crotch and with the widest points of the hips.

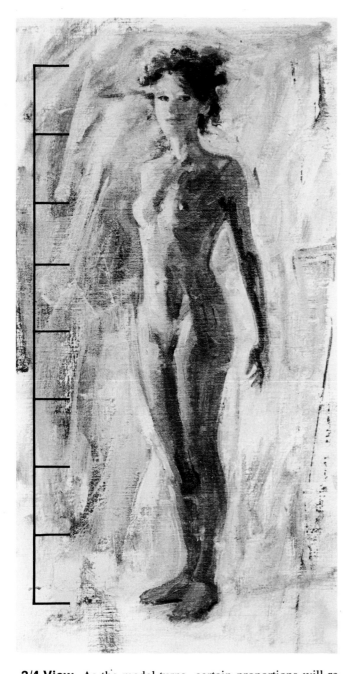

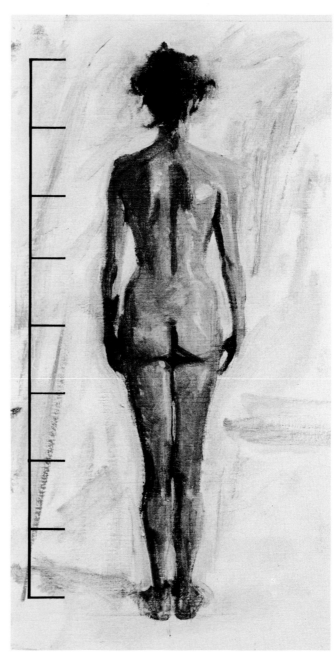

3/4 View. As the model turns, certain proportions will remain the same, while others will obviously change. In this 3/4 view, the model is still roughly eight heads tall; the torso is three heads tall; and the legs are four heads tall, which means two head lengths for the upper legs and two head lengths for the lower legs. The elbow still aligns with the waist, while the wrist still aligns with the crotch and the widest points of the hips. In this view, however, the figure is less than two heads wide at the shoulders and the hips. The foot, by the way, is usually just a bit less than one head length from toe to heel.

Back View. Seen from behind the figure displays essentially the same proportions as the front view. The figure is still eight heads tall, of course, and about two heads wide at the shoulders and at the widest points of the hips. Notice that the hips are widest just above the lower line of the buttocks. It's always useful to look for other alignments when you draw or paint the figure. For example, in this view the points of the shoulders line up with the wide points of the hips, while the armpits line up with the bulges of the hips just below the waist.

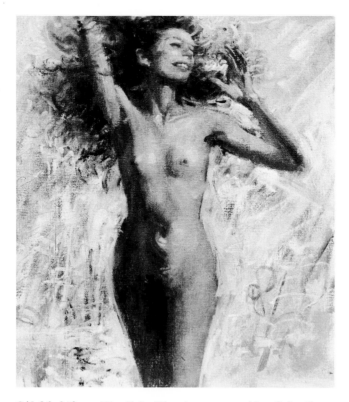

3/4 Lighting. The light illuminates one side of the figure and part of the front, throwing the other side into shadow. The light source is also slightly above, illuminating the tops of such forms as the head and arms.

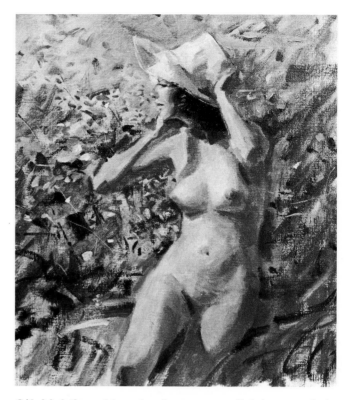

3/4 Lighting. Now the figure turns slightly toward the light. In this example of 3/4 lighting, most of the figure is illuminated, but there are still strong darks on the shadow sides of the forms.

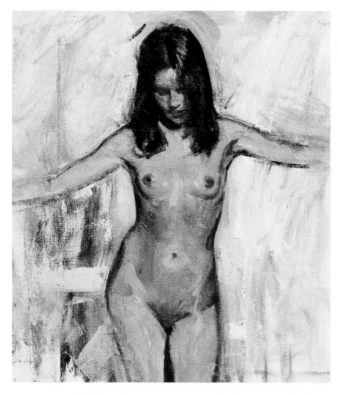

Frontal Lighting. In this type of lighting the entire front of the figure is flooded with light. There are no clearly defined masses of light and shadow. Instead there are simply shadowy edges around the forms.

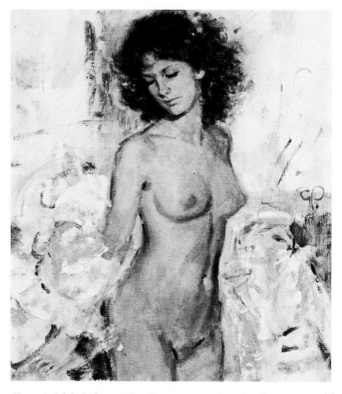

Frontal Lighting. The figure turns, but the forms are still flooded with light, and the strongest darks are just around the edges. A bit more darkness appears on the abdomen where the form curves away from the light.

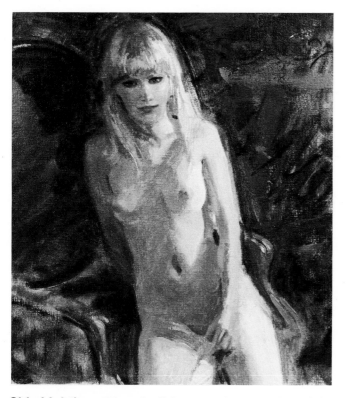

Side Lighting. When the light source is to one side of the figure, there's a clear division between light and shadow. In this frontal view of the figure, the sides of the forms are brightly lit, and the rest is in shadow.

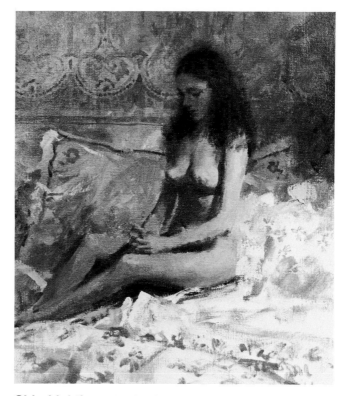

Side Lighting. As the figure turns away from the light source, there are still bright patches of light on one arm, the breasts, and one thigh, but the rest of the figure (including the head) grows dark.

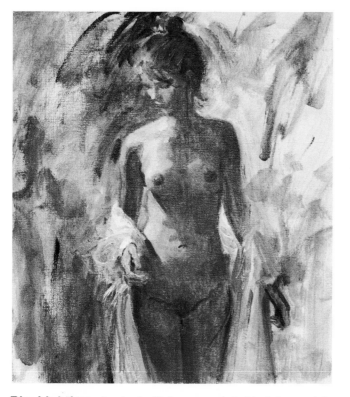

Rim Lighting. Again the light source is behind the model. Most of the figure is in shadow. A bit of light creeps around the edge to create an illuminated "rim" on the hair, shoulder, breast, abdomen, and thighs.

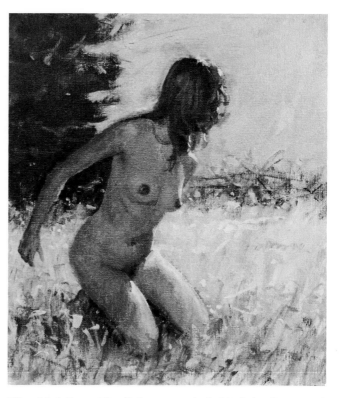

Rim Lighting. The light source is *behind* the figure and slightly above, spilling just a bit of light over one edge of the torso, but leaving most of the figure in shadow.

Step 1. The pencil moves lightly over the paper, tracing the contours of the forms with curving, rhythmic strokes. At times the pencil redraws the same contour several times to get the shape right.

Step 2. Pale, parallel lines fill in the dark shapes on the shadow sides of the forms as well as the dark mass of the hair. This is very much like blocking in the dark areas of a painting with broad brushstrokes.

Step 3. Pressing a bit harder the pencil moves back and forth to strengthen the darks. The pencil begins to define the shapes of the hair and such details as the features, nipples, and navel.

Step 4. The pencil continues to darken the shadows and retraces the contours with firm lines—as a kneaded rubber (putty rubber) eraser removes excess lines. The point picks out individual locks of hair and sharpens the features.

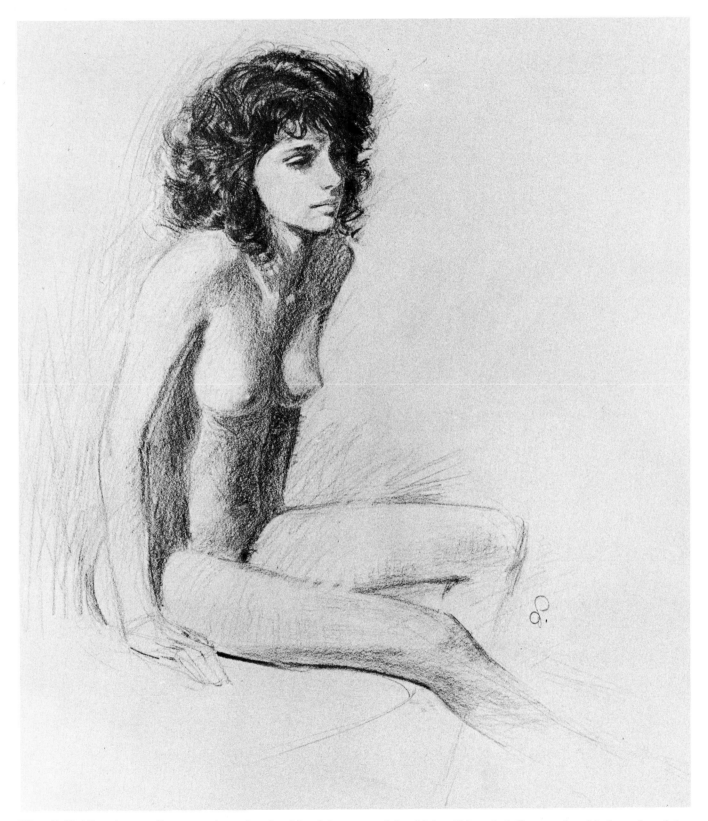

Step 5. Holding the pencil at an angle so that the side of the lead strikes the paper, the artist strengthens the darks with firm, parallel lines which you can see most clearly on the shoulder and on the torso beneath the arm. Pressing more lightly and still working with parallel lines, the pencil defines the halftones, which are most evident on the forearm and the thighs. Crisp, dark lines made with the point of the pencil define individual locks of hair, strengthen the features, and add a line of shadow where the thigh rests on the model stand. A few strokes curve around the edges of the figure to suggest the background.

Step 1. A stick of natural charcoal glides lightly over the textured surface of a sheet of charcoal paper, suggesting the shapes of the figure with a minimum number of lines. The charcoal stick accentuates the relaxed rhythm of the figure by seeking out connecting lines: the line of the raised thigh flows into the waist, while the lines of the outstretched arm flow into the line of the outstretched thigh. A few broad strokes, made by holding the charcoal stick at an angle so that the side touches the paper, suggest the two strongest darks—the hair and the shadow on the upraised thigh.

Step 2. The artist continues to hold the charcoal stick at an angle to the paper, pressing hard to darken the hair, then pressing more lightly to darken the upraised thigh with parallel strokes. Long, parallel strokes begin to define the tones on the torso, arm, and outstretched leg. The side of the charcoal is moved lightly around the figure to suggest a background tone.

Step 3. The shape of the hair is darkened and more precisely defined with firm strokes. Then the charcoal stick gradually moves down the body, suggesting the features, darkening the shadows on the neck and chest, and defining the contours of the breasts and the midriff.

Step 4. The dark patches on the abdomen and both thighs are strengthened with parallel strokes. Then the sharp tip of the charcoal stick defines the contours of the upraised thigh and places dark lines of shadow at the shoulder and armpit.

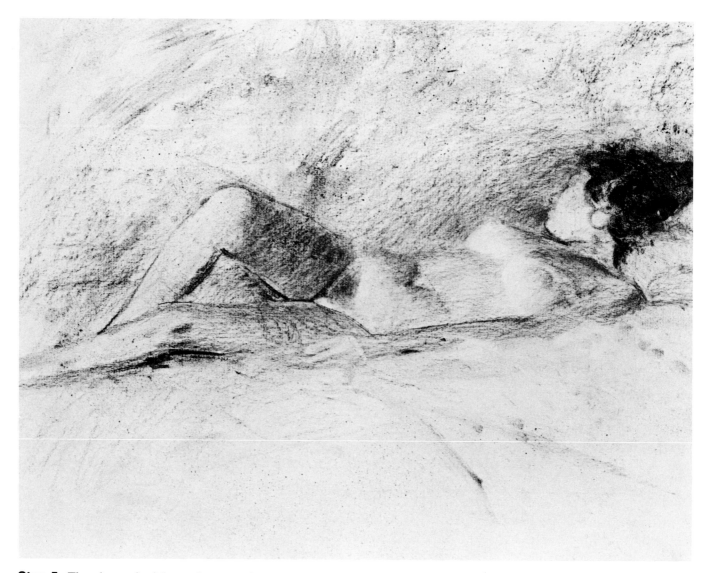

Step 5. The charcoal stick continues to sharpen the contours of the forms and darken the shadow areas. The thighs are darkened still further, and the tip of the charcoal stick defines the contours of the knees and lower legs. Working back up the figure the charcoal strengthens the shadows on the abdomen, outstretched arm, chest, and shoulder. A crisp line defines the edge of the forearm. The lightstruck hand is "drawn" with strokes of the kneaded rubber eraser; the rubber is as plastic as clay and is squeezed to a point, which then removes small bands of tone to suggest the fingers. The charcoal moves lightly over the background to suggest more tone around the edges of the figure.

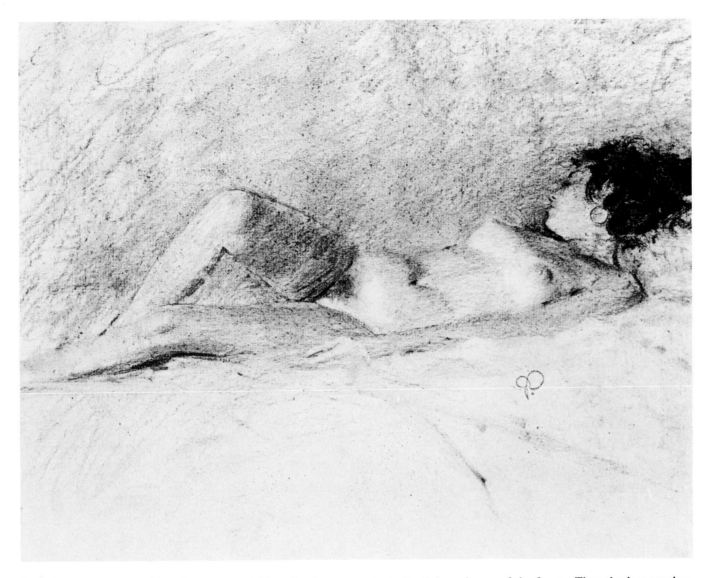

Step 6. Natural charcoal handles very much like oil paint—the tones can be smudged with a fingertip just as you'd blend wet paint with a brush. A fingertip lightly blends the tones on the chest, arm, abdomen, and thighs, not pressing hard enough to obliterate the strokes. Now these tones grow smoother and lighter. The kneaded rubber eraser is pressed gently against the paper and then pulled away to lighten the face, breasts, lower abdomen, and upraised knee. The side of the charcoal darkens the background a bit more to accentuate the lighter shapes of the figure. Then the last touches are added with the tip of the charcoal stick, which can be sharpened by rubbing it against a piece of sandpaper or any rough piece of paper. Dark lines define the profile of the head and suggest the features. The last few dark touches pick out individual locks of hair, darken the nipples and the navel, and sharpen the shadow line of a single finger. Notice how a few casual strokes in the foreground suggest the drapery on which the model is lying.

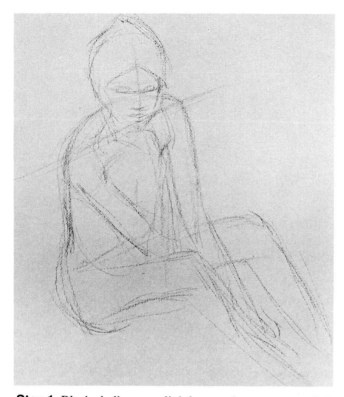

Step 1. Black chalk moves lightly over the gray paper, defining the contours. Diagonal guidelines align the shoulders and hips. Vertical and horizontal guidelines also aid in placing the features.

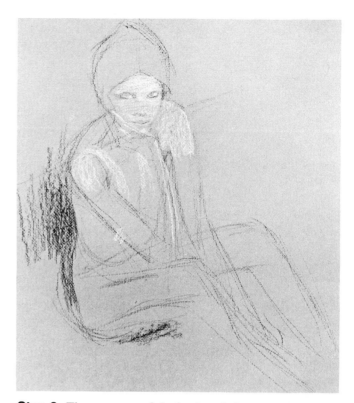

Step 2. The contours of the back and the underside of the thigh are defined by surrounding them with a dark background tone. A stick of white chalk begins to cover the lighted face and shoulders.

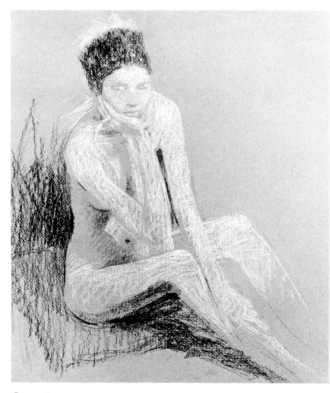

Step 3. The white chalk covers all the lighted areas, leaving the gray paper to suggest halftones. The black chalk starts to suggest the darks on the figure and also strengthens the darks of the background.

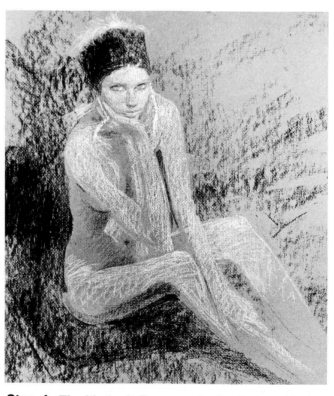

Step 4. The black chalk surrounds the figure with dark strokes that accentuate the lighted contours. Then the black chalk works on the darks within the figure, darkening the hat and sharpening the features.

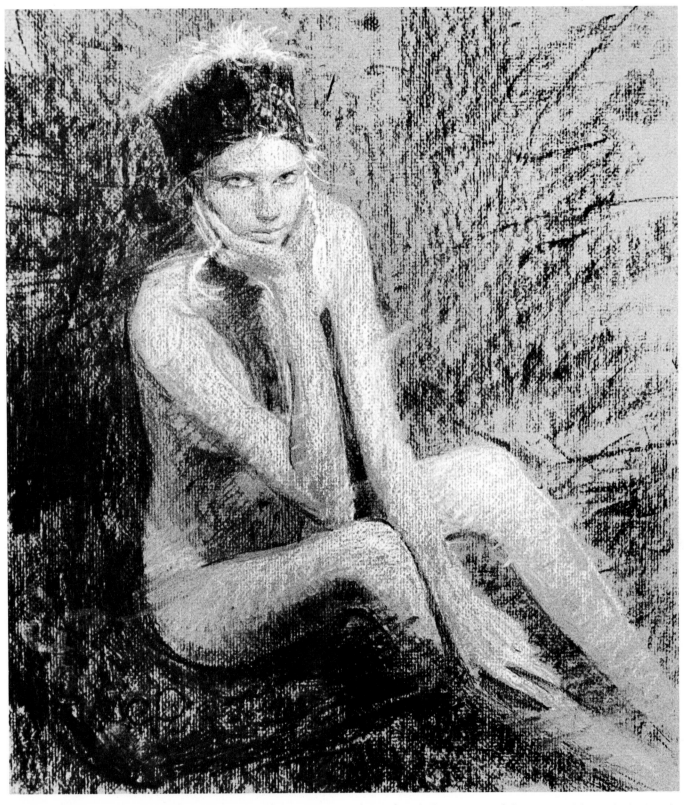

Step 5. Firm strokes of both chalks solidify the darks within the figure: the cast shadow on the chest, the shadow on the abdomen, the small patch of dark on the far thigh, and the dark underside of the near leg. Dark lines are added very selectively, sharpening the features, the fingers, and just a few dark contours of the arms and legs. A shadow is added beneath the lower hand. The background is filled with more tone, and strokes of white chalk finish the drawing by strengthening the lights, particularly on the shoulders, upper arms, thighs, and knees.

Step 1. An oil sketch is like a highly simplified oil painting. The canvas is toned with a rag that carries tube color and lots of turpentine. Then the tip of a round brush quickly sketches the shapes of the figure. The sketch emphasizes proportions and visualizes the forms as simply as possible. As you can see, the artist isn't concerned with precise drawing—the shapes will be refined as the painting progresses.

Step 2. Still working with tube color, but with much less turpentine, a small bristle brush locks in the dark masses of the shadows. At this point the painting hardly looks like a human figure, but the artist knows that if he gets the shapes of the shadows right, the figure will turn out right too.

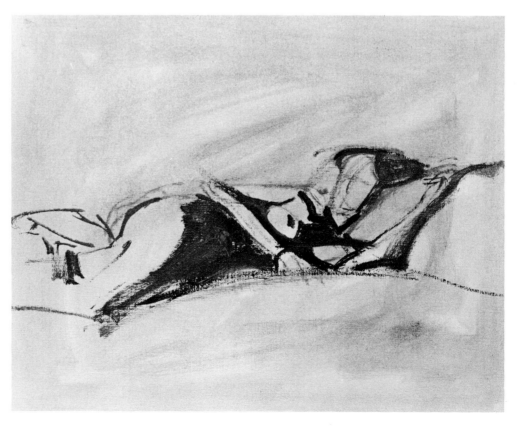

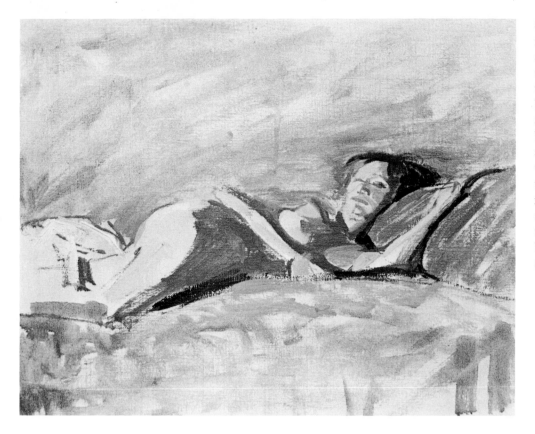

Step 3. A big bristle brush rapidly covers the lighted areas of the figure with a pale tone and brushes some of this tone into the shadows. A big brush darkens the background and the bed. Then a small bristle brush darkens the hair and adds strokes of shadow where the head and body touch the bed. The tip of a round brush adds a few strokes to suggest the features. Now all that rough brushwork begins to look like a figure.

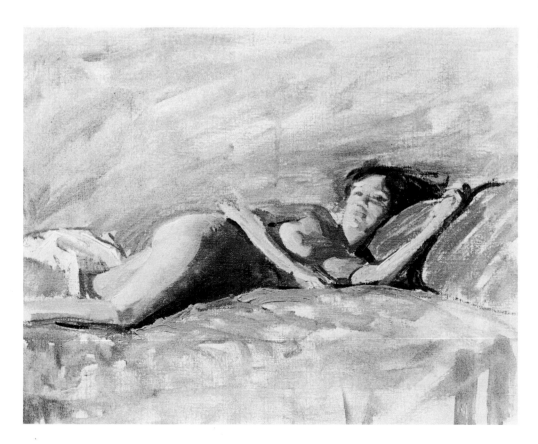

Step 4. A flat softhair brush starts to blend the lights and shadows, making the shapes seem smoother and more life-like. Thick touches of pale color build up the lights on the head, breast, arms, and thigh. The tip of a round brush adds some dark lines of shadow to the figure and then defines the features more sharply.

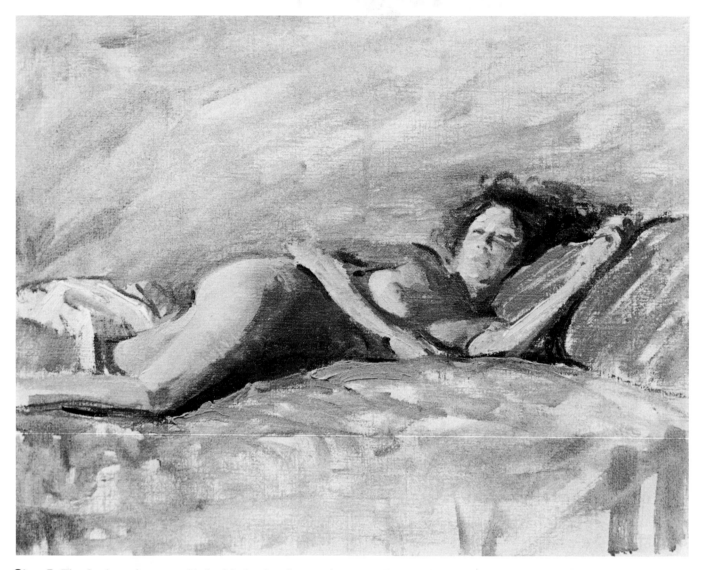

Step 5. The final touches are added with the tip of a round brush. The brush picks out a few ragged locks of hair and then sharpens the darks of the eyes, the nose, the chin, and the nipple. A single dark line of shadow sharpens the curve of the upraised shoulder. The entire oil sketch is painted with mixtures of ivory black and titanium white tube color, diluted only with turpentine. Much of the paint is as thin and washy as watercolor. The brushwork is broad and rapid. There are practically no small brushstrokes except for the few precise touches that define the features. The purpose of the oil sketch is to capture the shapes of the lights and shadows, the pose, and the mood. It's often worthwhile to make such an oil sketch as a preliminary study for a larger painting that will be executed more slowly and deliberately. It's also good experience, however, to make lots of small oil sketches in order to learn how to visualize lights and shadows as simply as possible.